CIVILIZATION

'It is humanity's duty today to see that civilization does not destroy culture, nor technology the human being.'

Wilhelm Mommsen (1892–1966), historian

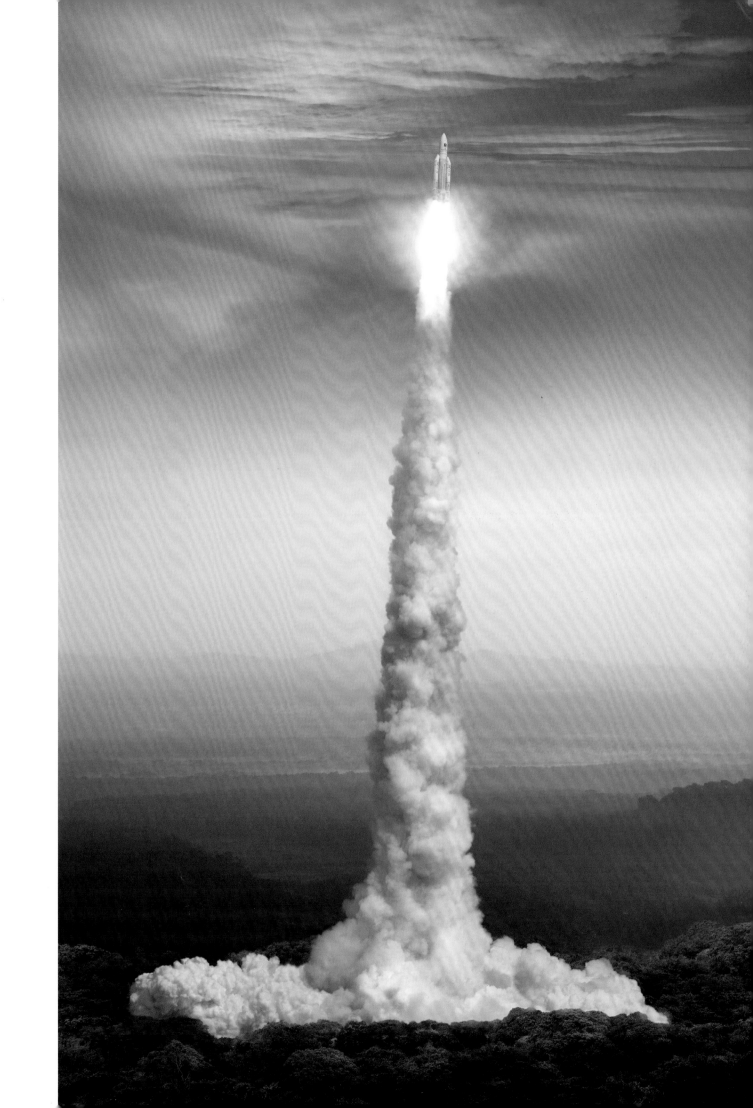

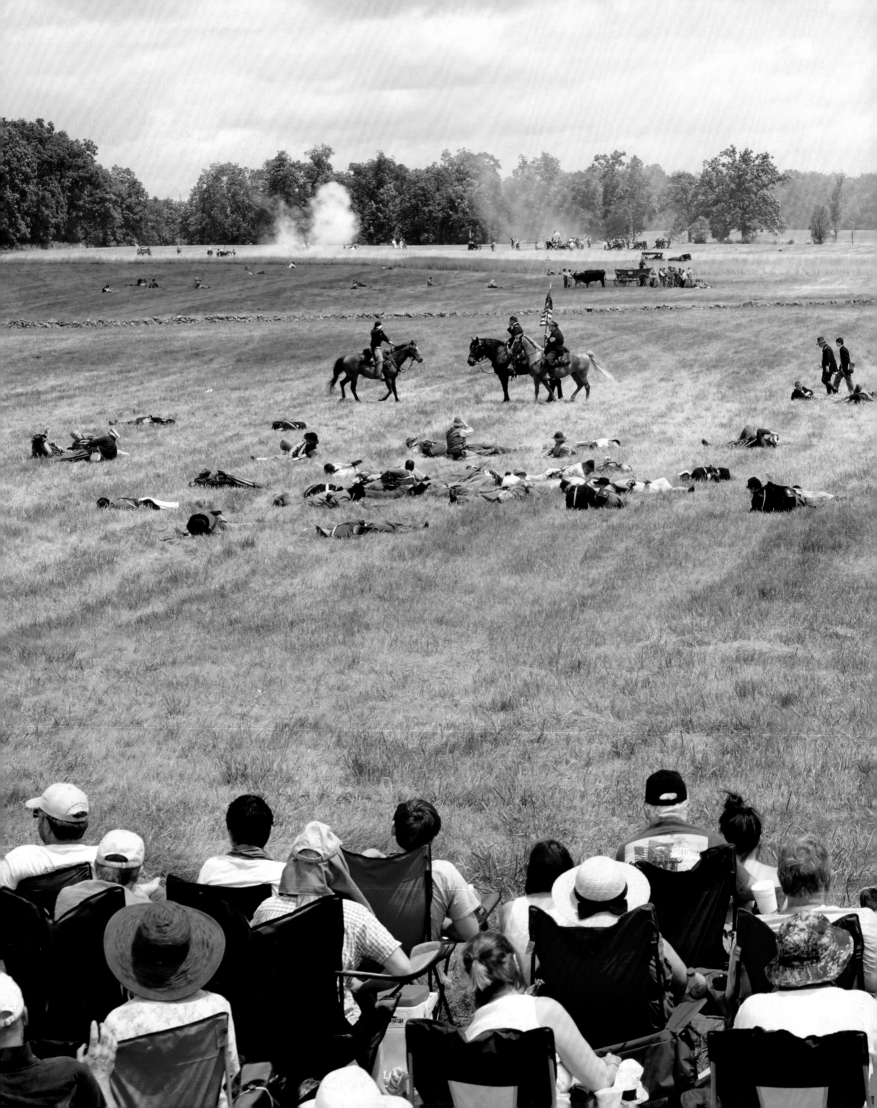

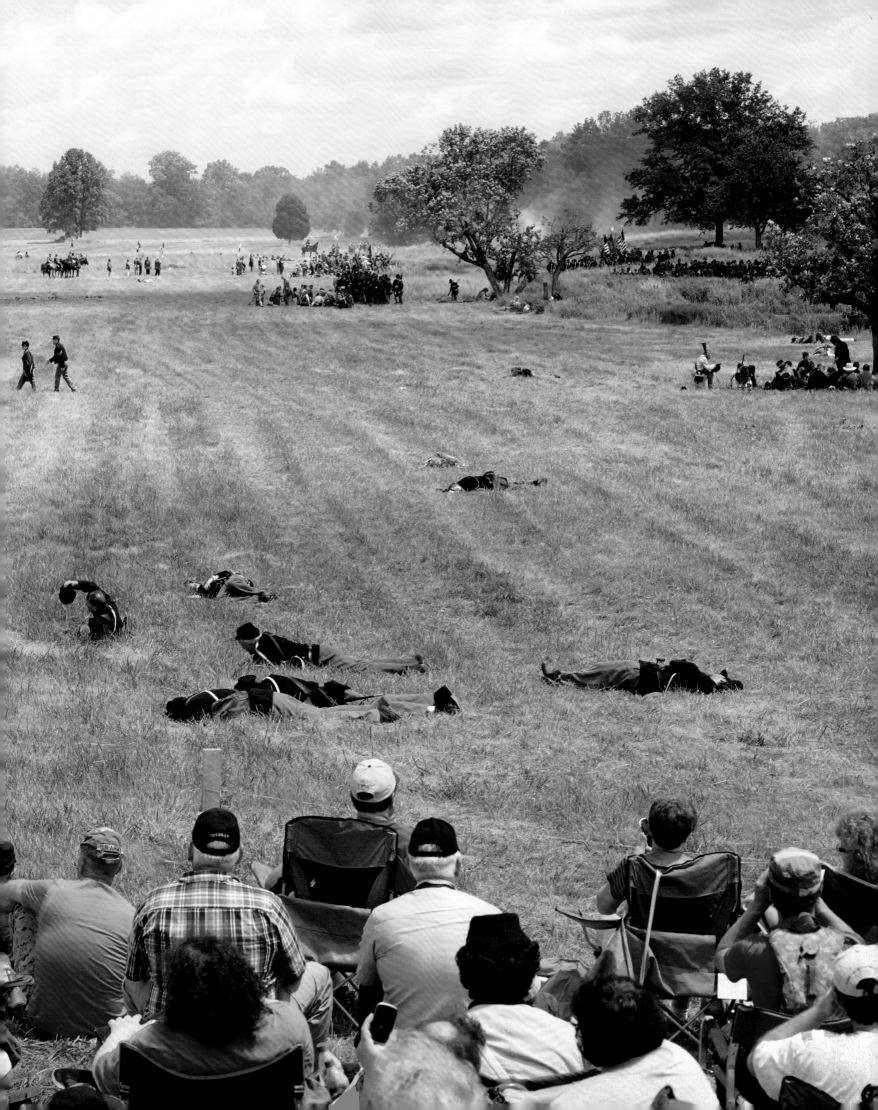

'In 2008, humanity as a whole passed a significant milestone.
For the first time in our species' history, a majority of us dwelt in cities.
We are an urban animal now.'

Ian Goldin / Chris Kutarna, *Age of Discovery*, 2016

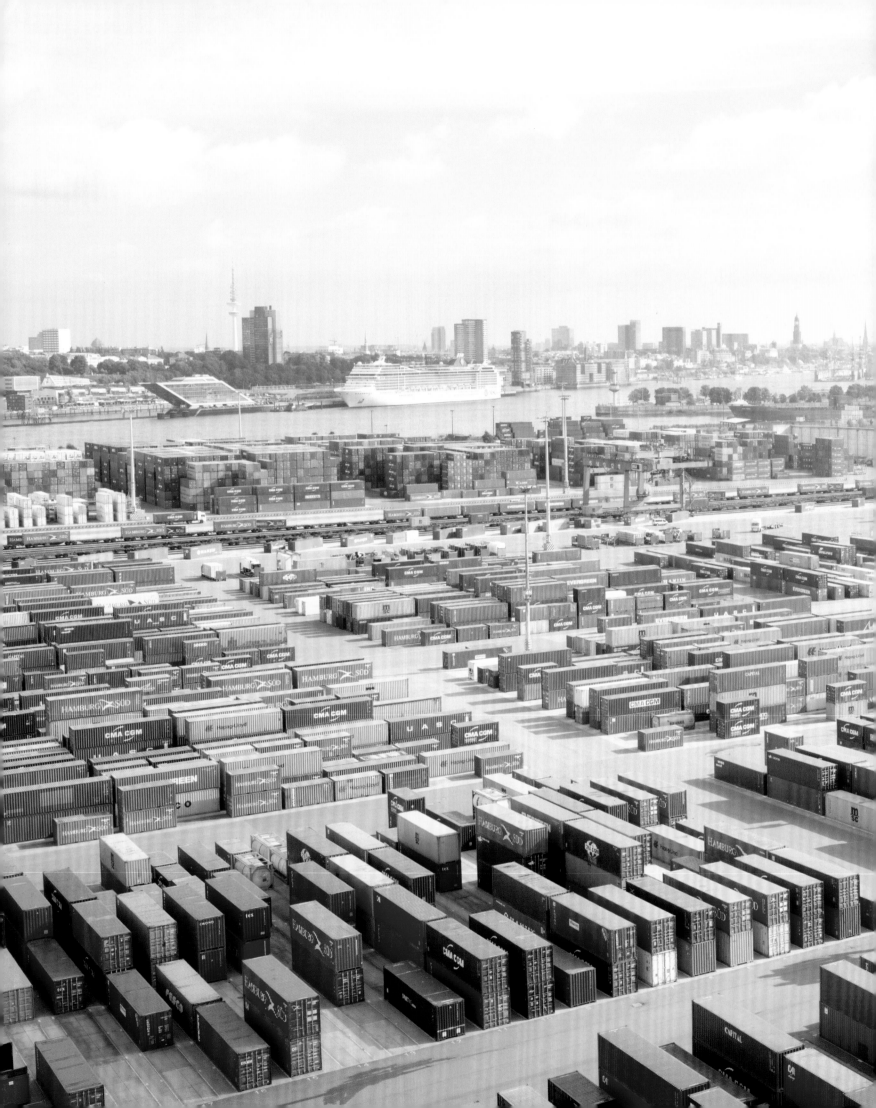

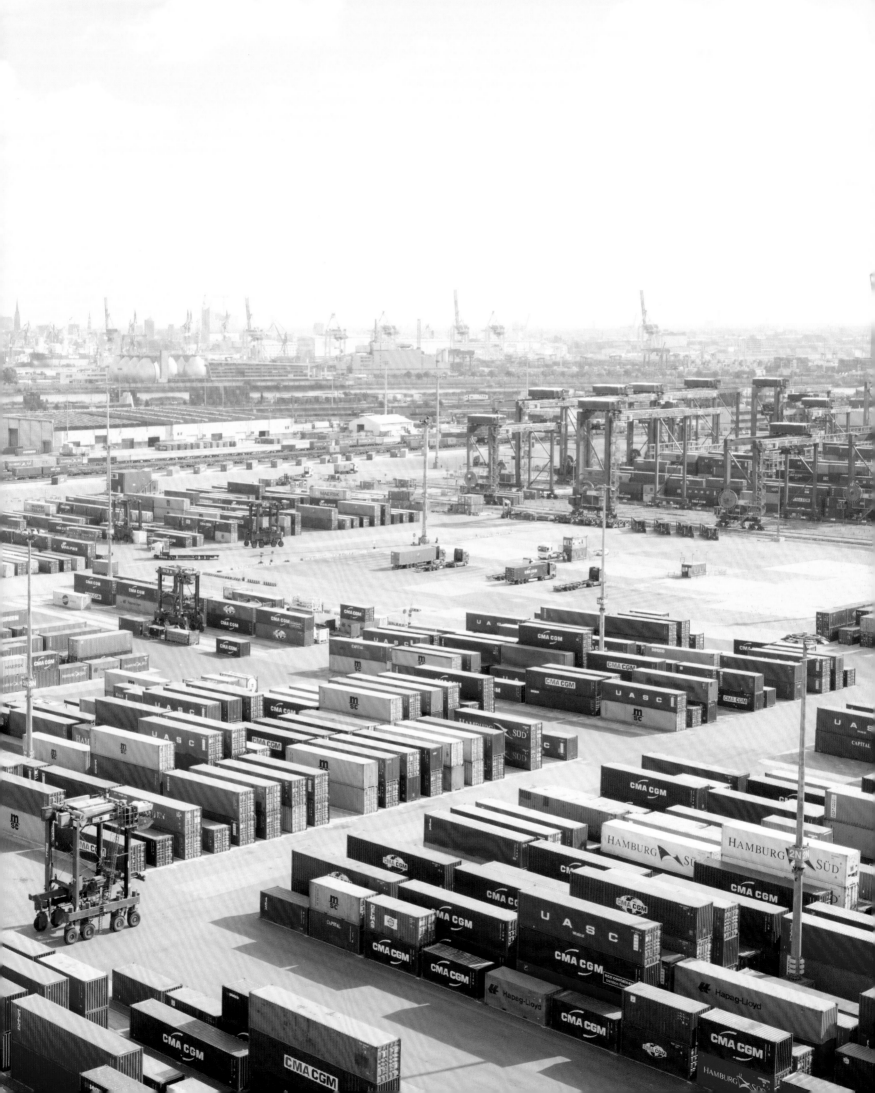

'Civilized order survives on its merits and is transformed
by its power of recognizing its imperfections.'

Alfred North Whitehead (1861–1947), mathematician and philosopher

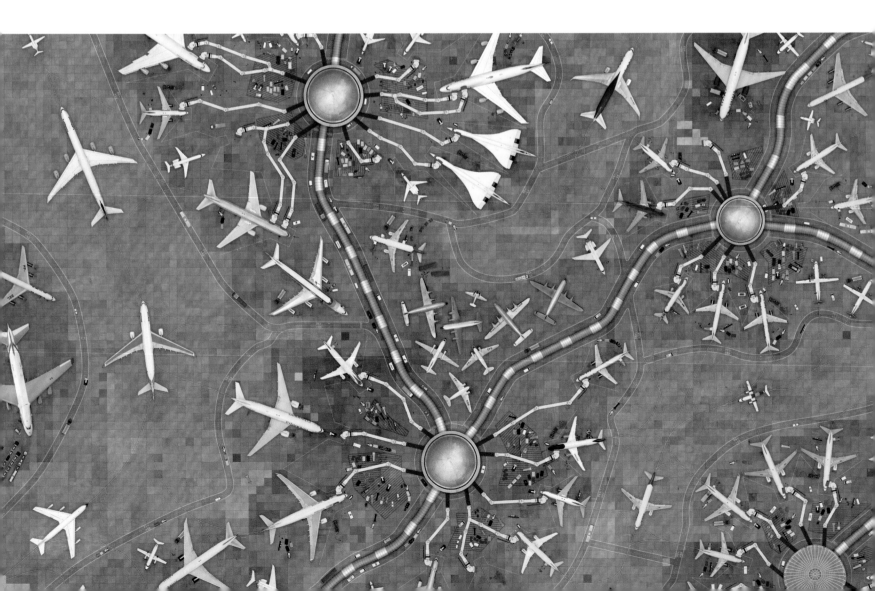

WILLIAM A. EWING HOLLY ROUSSELL

CIVILIZATION

THE WAY WE LIVE NOW

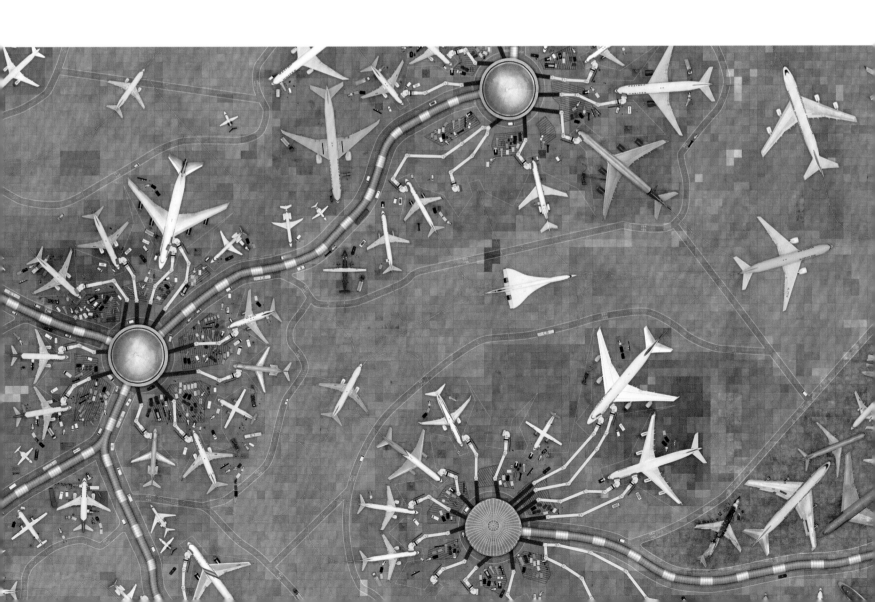

Published to accompany the exhibition *Civilization: The Way We Live Now*, co-produced by the Foundation for the Exhibition of Photography, Minneapolis/New York/Paris/Lausanne, and the National Museum of Modern and Contemporary Art, Seoul, South Korea, curated by William A. Ewing, Bartomeu Marí and Holly Roussell

Civilization: The Way We Live Now © 2018 Thames & Hudson Ltd, London

Texts by William A. Ewing and Holly Roussell © 2018
William A. Ewing and Holly Roussell
All other texts © 2018 their respective authors

All images © 2018 the copyright holders: see page 352 for details

Images sequenced by William A. Ewing
Chapter introductions by Holly Roussell
Quotations selected by Cynthia Gonzalez-Bréart
Designed by Maggi Smith

First published in 2018 in the United States of America by
Thames & Hudson Inc., 500 Fifth Avenue, New York, New York 10110

www.thameshudsonusa.com

Library of Congress Control Number 2018932297

ISBN 978-0-500-02170-5

Printed and bound in China by C&C Offset Printing Co. Ltd

On the cover
MICHAEL WOLF
Architecture of Density #91 (detail) 2006
© Michael Wolf, courtesy of M97 Shanghai

Page 3
MICHAEL NAJJAR
orbital ascent, from the series *outer space* 2016

Pages 4–5
GILES PRICE
Presumed dead. Gettysburg Readdressed 2013

Pages 6–7
OLIVIER CHRISTINAT
Figurations II 2016

Pages 8–9
HENRIK SPOHLER
In Between, 29 Container terminal, Hamburg, Germany nd

Pages 10–11
CÁSSIO VASCONCELLOS
Aeroporto, from the series *Collectives* 2012

William A. Ewing is an author, lecturer and curator of photography. He was director of the Musée de l'Elysée in Lausanne from 1996 to 2010. His many publications on photography include *The Body*; *Landmark: The Fields of Landscape Photography*; *Light Lines: Ray Metzker*; *Edward Burtynsky: Essential Elements*; *The Polaroid Project: At the Intersection of Art and Technology* and *William Wegman: Being Human*.

Holly Roussell is a curator and art historian specializing In photography and contemporary art from Asia. She has served as coordinator of the international exhibitions programme and photography prize, the Prix Elysée, for the Musée de l'Elysée, Lausanne, and has contributed to numerous exhibitions and publications on photography, including *Landmark: The Fields of Landscape Photography* and *The Thames & Hudson Dictionary of Photography*.

Bartomeu Marí is the director of the National Museum of Modern and Contemporary Art (MMCA), Seoul, South Korea, and a co-curator of the *Civilization* exhibition.

Todd Brandow is the founder and executive director of the Foundation for the Exhibition of Photography, Minneapolis/New York/Paris/Lausanne.

CONTENTS

FOREWORD

TODD BRANDOW & BARTOMEU MARÍ

This book began as a very simple idea, proposed to the Foundation for the Exhibition of Photography by the author and curator William A. Ewing: namely that one could step back from a focus on the work of individual photographers and take a wide look at what they've accomplished *collectively*. What are they telling us about the state of early 21st-century civilization?

Seeing the images together, we find that photographers have provided us with an extremely rich and varied portrait of our times, sometimes exhilarating, sometimes disturbing, always intriguing. Along with China-based curator Holly Roussell, William Ewing has selected representative work of exceptionally high quality from many of the world's top photographers, often working directly with them to identify key works, a good number of which have not been exhibited or published before. By partnering with the National Museum of Modern and Contemporary Art in Korea, and consulting with the National Gallery of Victoria in Melbourne, both well informed on photography from their parts of the world, the curators were ensured of a broad perspective.

Very few exhibition and publishing projects in our field dare such an ambitious scope. Edward Steichen's famous *Family of Man* attempted a collective overview in the middle of the last century, but since then curators have been less at ease with sweeping overviews. We feel this is a missed opportunity. Photographers are at work *everywhere*, looking at *everything*. Why not step back and try to take in the big picture?

There are sober voices today that wonder if human civilization will survive this century, while other voices trumpet a 'new Renaissance'. It is not up to photographers to say which of the two realities will triumph, but they can certainly lay out for us the state of the world, and help us think about where we want to take it.

Civilization: The Way We Live Now also tells us something about the state of photography at a time when photography as we've known it is fast disappearing, overpowered by technological inventions within the digital world. The mid-19th-century invention that became one of the most powerful media – an essential mass media, in fact, preceding cinema and propelling the ruptures that gave birth to modern art – has come to an end with the irruption/ disruption of the digital era. In the 19th century photography profoundly transformed our way to look at the world; right through the 20th century it fought for recognition within the fine arts, entering museums, galleries and the art system with equal rights, coinciding with the deep transformation into a new form/medium/ phenomenon we are all trying to understand.

As directors of the initiating institutions of this ambitious project, on each side of the globe, we would like to thank all the participating artists, lenders and partner institutions who have joined us on this photographic journey through our complex planetary civilization.

THOMAS STRUTH
Pergamon Museum 1, Berlin 2001

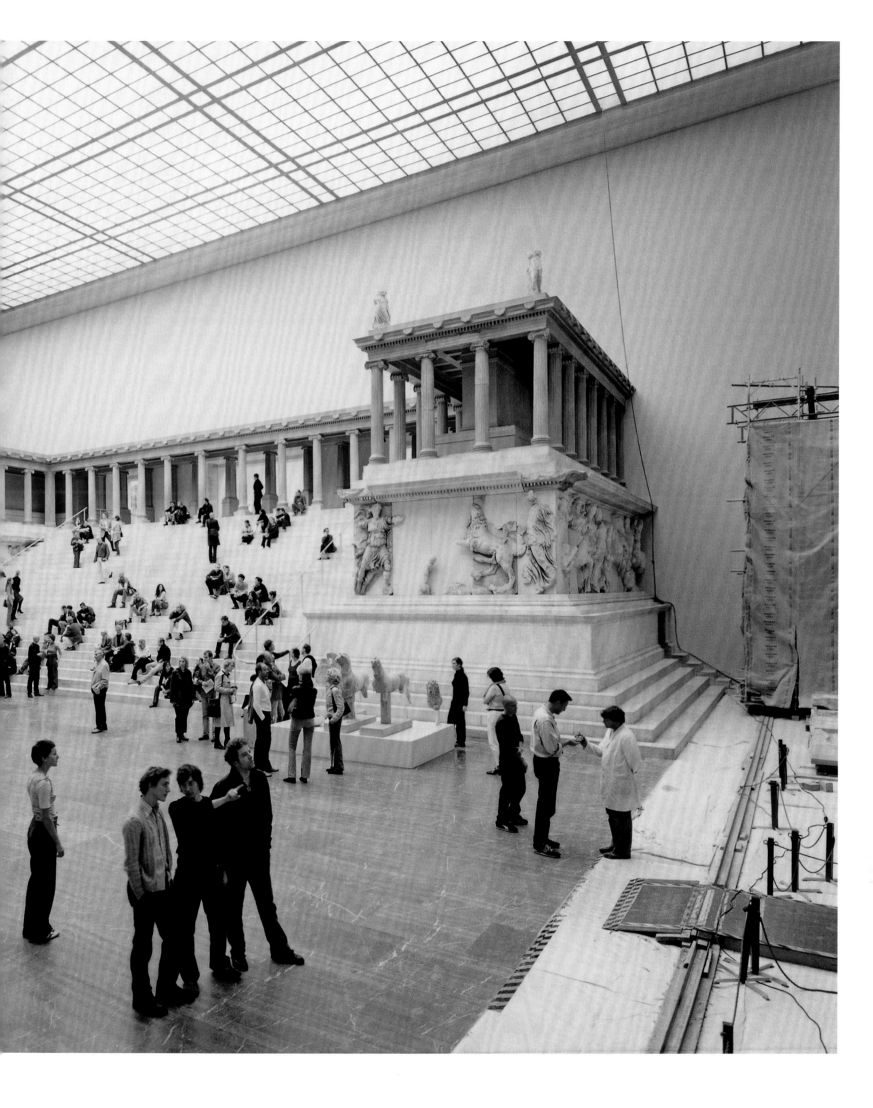

THE CLEAR MIRROR

WILLIAM A. EWING

A boundless mass of human Being, flowing in a stream without banks; upstream a dark past wherein our time-sense loses all powers of definition and restless or uneasy fancy conjures up geological periods to hide away an eternally unsolvable riddle; downstream, a future even so dark and timeless...Over the expanse of the water pass the endless uniform ripples of the generations. Here and there bright shafts of light broaden out, everywhere dancing flashes confuse and disturb the clear mirror, changing, sparkling, vanishing.

Oswald Spengler, 1918[1]

In every epoch keen minds like Spengler's, with greater or lesser insight, have occupied themselves with an accounting of their own civilization – the Western form in Spengler's case – or human civilization in the aggregate. Fewer, perhaps, have been those who saw into the future and sketched credible plans for it, the fertile mind of Leonardo da Vinci being one. But while Leonardo imagined many things that have come to pass, even he would have been astonished to know that just seven lifetimes hence (taking his own span of 67 years as a yardstick), billions of human beings would have in their hands sleek slabs of metal and glass that would, at the press of a finger, come alive with pictures from every corner of the world, and at another tap, bring them into direct contact with anyone else in that world. We have all this now, and more, and clearly, it's not enough. We want our 'next', and we want it now!

We hurtle together into the future – Spengler's 'downstream' – at ever-increasing speed, or so it seems to the collective psyche, simultaneously building, demolishing, improving, discarding. We're pretty good at ingenious ideas and quick fixes, but generally disastrous at long-term planning. The vast works we engineer and the grand buildings we erect – always reaching for *something* just out of our grasp; the complex wars we wage, often at great distances and increasingly virtual; the intricate machines we construct (CERN's Large Hadron Collider, for one, is the biggest and most complex machine ever built by humankind); and the dazzling spectacles we choreograph – for billions; these achievements and more signal modern civilization's pharaonic ambitions, whether in New York, Dubai or Beijing.

Then there are the ingenious products we come up with daily (Bitcoins, anyone? Genetically modified mice? Tiny drones with facial recognition, programmed to find you in a crowd and kill you? A few online clicks and you'll have them); the miracle fibres and composite materials with super-natural strengths; the mind-bending and shape-shifting drugs; the wonders we discover at the edge of time and space – or even right under our noses (the Higgs boson, for one, the Tau neutrino for another[2]), while future discoveries are expected from our faithful probes such as Voyager 1,

set to report back on its travels until the year 40,272, whether or not any civilization on earth or elsewhere is still listening. We have even learned to see deep into the past; the Hubble telescope, floating high above our heads, has the pointing accuracy of .007 arc seconds, which, NASA tells us, is like being able to shine a laser beam focused on Franklin D. Roosevelt's head on a dime roughly 200 miles away, or like seeing a pair of fireflies in Tokyo from a home in Maryland. Not good enough, say our intrepid cosmologists, so from next year the James Webb Space Telescope will enable us to look back at every phase in the history of the universe, right to the first luminous glows following the Big Bang [see p. 22].

Meanwhile, in January 2018, as mortals' minds were recharging during their Christmas break, electronic brains at the Great Internet Mersenne Prime Search (GIMPS) were busily number-crunching, the fruit of their labours being the discovery of the largest-known prime number, $277,232,971-1$, with more than 23 million digits.[3]

A significant milestone of a different order was passed in 2017: 'most slices of carrots sliced while blindfolded in 30 seconds!'[4] Moreover, as I write this book (and undoubtedly this next record will have been surpassed by the time you are reading it), 'the most liked image on Instagram is an image of Beyoncé Knowles-Carter (USA) announcing her pregnancy with twins, posted on 1 February 2017, and "liked" 7,402,706 times'. Millions, however, or even tens or hundreds of millions, are of little interest to our brilliant entrepreneurs. Happily for all of us, Mark Zuckerberg's team is 'working on a system that will let you type straight from your brain about five times faster than you can type on your phone today'.[5] It's flocks and swarms of *billions* now that matter.

However, progress in the great human need for record-breaking is not uniform. We have not yet surpassed the loudest-ever scream managed by a group of Scouts in Finland on 16 April 2005, which measured a level of 127.2 dBA.[6] Surely we can do better! Not to belabour the point, on the one hand our civilization is simultaneously discovering 'the fundamental structure of the universe' at CERN and elsewhere, and reaping the benefits of its Cassini probe, sent soaring spectacularly between the rings of Saturn in 2017; while on the other, congratulating itself for the fastest-ever slicing of raw carrots and the loudest scream in recorded history. Despite entrepreneur Peter Thiel's cynical reminder that 'we were promised flying cars and what we got was 140 characters', in many areas of our lives change *has* been dramatic.[7] The words awesome and amazing *do* come to mind, and they are not always the usual clichés.

Nor are such words any longer reserved for the work of God, as they have been for millennia; to paraphrase the writer Alain

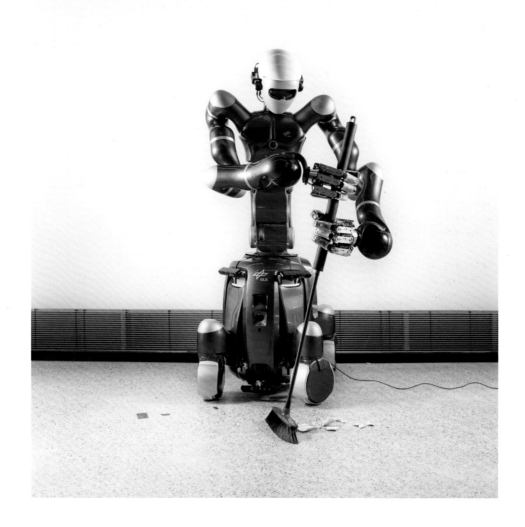

The present catches up with the future

REINER RIEDLER
Humanoid robot 'Rollin' Justin', DLR German Aerospace Center, Institute of Robotics
and Mechatronics, Oberpfaffenhofen, Germany, from the series WILL 2016

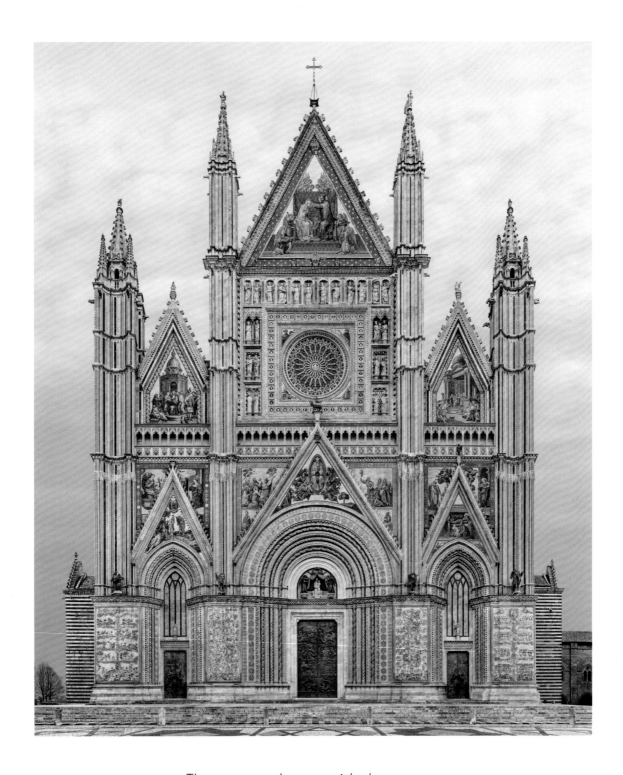

The past catches up with the present

MARKUS BRUNETTI
Orvieto, Duomo di Santa Maria Assunta, from the series *FACADES* 2006–14

de Botton's thoughts on the sublime, today we are mostly in awe of...*ourselves*. And why not, since those supermagnets at CERN are 100,000 times more powerful than the gravitational pull of earth?

Furthermore, we live in an age not just of speed, but of acceleration, and even if the most cautious among us suggest that we should consider applying the brakes, in his aptly titled 2017 book *Homo Deus*, the historian Yuval Noah Harari wryly notes that no one even knows where the brake pedal is![8] Meanwhile, our bodies are rebuilt and resurfaced, our emotions chemically remodelled. There is now serious talk of head transplants (about time! We passed the face milestone way back in 2005), and to hear our techno-prophets, even immortality is around the corner. We manipulate our genes. Our robots begin to walk, talk and think. Each day and every hour human civilization evolves, dissolves, mutates. Some days, that adjective *human* sounds suspect.

Increasingly, our fast globalizing world throws us into closer and closer contact with each other, and the new-found intimacy can be exhilarating or distressing, or both. We are surveilled, observed, spied-upon, measured biometrically, fed news and seductive propositions tailored to our behaviours and desires. Privacy is increasingly a thing of the past, or turned into a luxury commodity reserved for a privileged few. A film star tweets to millions that she wants to be 'left alone' so that she can 'process her grief' – then feeds us the salacious details. A tennis star gives a vivid account of her mental anguish after her baby's birth, and asks her legions of worshippers for advice. Meanwhile, the sibling of this modern-day Big Sister, Big Brother, also seems to hover ever closer, albeit with an attractive smiling face, his features soon to be tailored to each of our deepest desires and fears.

We are swept up into mass movements of profound social significance or unspeakable banality. We buy the latest must-have products – not to be left behind – only to find the next day they're outmoded, possession an embarrassment! The current virtue is no longer permanence and solidity; now it's imperative to discard and replace, acutely responsive to the flows of data. Increasingly we live collectively, in new kinds of herds and tribes, in novel constellations of 'families', restructured relationships and 'partnerships'. We can now identify ourselves as allosexual (someone who is not asexual) or aromantic (having a romantic orientation generally characterized by not feeling romantic attraction or a desire for romance); or as Furry People (also known as Furries or Furry Fandom), that is, people 'playing primarily as anthropomorphic animals, creatures or characters, either through costumes, or/and varying art mediums'.[9] Mirroring this blossoming profusion of newly styled bondings, acronyms try to keep up: LGBTQIA now encompasses Lesbian, Gay, Bisexual, Transgender, Queer, Intersex and Asexual proclivities. With the lightning diffusion of novelty via social media, terms unfamiliar to most people one day (Cisgender, Transphobia, Incel, etc.) become buzzwords the next. Desires, beliefs and values once thought to be best held privately or communicated only to people close to oneself, are now subject to the sudden, blinding glare of public scrutiny, to be celebrated ecstatically or condemned vociferously, with death threats all too often thrown into the bargain.

Modern life is a curious mix of following the crowd – or more accurately, crowds – while loudly proclaiming our individuality, which we trumpet through allegiances to brands and prepackaged slogans. Even our individuality has been collectivized. And monetized. As reported in 2017, 'Harper Beckham is only 5 years old, but her famous mother already is taking steps to protect her brand. [She] has registered daughter Harper's name with intellectual property authorities in Britain and Europe [which] will make it easier for Harper to market items in her own name and also offer her legal protections if she goes into show business.'[10]

Never has a civilization held in its hand so many powers, and so many new ones. The eminent geographer Karl Butzer once mused that had an Egyptian pharaoh been given the secrets of the internal combustion engine, and tried to build a *single* one with the engagement of every able-bodied subject, the effort entailed – to find, extract, refine and mould the necessary materials – would have exhausted the resources of his empire.[11] Now many hundreds of millions of us have one of these machines at our whim, and the biggest problem has been how to avoid bumping into everyone else's. Most recently, we've decided to let the machines do the driving for us, acknowledging that they'll probably do a better job of it, and we've mandated a few bright young engineers to make it happen – fast. And, as always, to make it happen *now*.

And why not? In only one hundred years (a blink of the eye in terms of Homo sapiens' approximately 300,000 years existence) the species has managed to double life expectancy. Also during the same period, the global population saw its greatest increase in known history, rising from about 1.6 billion in 1900 to over 6 billion in 2000 (and now at 7.6 billion). For better or worse, an astonishing achievement.

As the popular saying goes, *what can possibly go wrong?*

Well, as we well know, the ingenious tools we devise can also backfire. The financial storms, some at hurricane force; the weapons of mass destruction, ever more powerful; the catastrophes we inflict on the environment; the experiments with nature gone wrong; the systems that unexpectedly explode or implode, or are found to be infected, etc.,...every hour and every day somewhere, something unexpectedly fails, threatening to tear the thin fabric of our civilization. Collapse is no longer only something that happened to Romans, Greeks or Aztecs millennia ago. The unspoken thought we all now share is – *could it soon be our turn?* Living under what sociologist Zygmunt Bauman aptly calls 'liquid modernity' is like 'walking in a minefield: everyone knows an explosion might happen at any moment and in any place, but no one knows when the moment will come and where the place will be'.[12] Our novels and films are full of what the journalist Alexandra Alter has called 'a collective panic attack', and far from having dissipated our nightmares, have only heightened them.[13] Those who live through disasters now gauge them through media fictions: *it was just like a film!*

Parallel to the dystopian excitement, concern is mounting for our own techno-scientific civilization's more risky ventures: the nuclear demon, out of the bottle and still restless (by the way, how is that concrete shell encasing Chernobyl doing? And Fukushima? Well, radiation is still at 530 sieverts per hour, when ten would kill

a person within three weeks – the 'good' news being that clearing up the mess will be accomplished in fifty years; or so we're told).[14]

Then there is nanotechnology, with its visions of tiny, predatory machines floating like dust, sent to spy or infect; artificial intelligence, beating us handily at chess and Go; and augmented and/or virtual reality, at the expense of the increasingly boring 'real' thing. A half-century ago, before computers had taken hold of our minds and bodies, historian Daniel J. Boorstin warned that 'we risk being the first people in history to have been able to make their illusions so vivid, so persuasive, so "realistic" that they can live in them'.[15] We're just about there now. And while we're at it, why not rewrite past unpleasantness out of history? Speaking of the decision in 2017 to rescind an award to a famous television host because of his predatory sexual behaviour, the dean of a major American journalism school argued that the celebrity in question's alleged transgressions were 'so egregious that they demand nothing less than *a reversal of history*'.[16] Others who would rewrite history call for the destruction of historical monuments of people who have fallen out of favour. As George Orwell famously observed, 'the very concept of objective truth is fading out of the world.'[17]

On the negative side of the balance sheet we might also list the threat of pandemics, possibly at horrendous scale (we are not prepared, and we know it); artificial intelligence running amok, and in the meantime sowing well-founded fear in the populace with its nightmare of the rapidly nearing 'Singularity', when 'the invention of artificial superintelligence will abruptly trigger runaway technological growth, resulting in unfathomable changes to human civilization'[18] and genetic engineering, with miracle cures soon to make this or that disease a thing of the past, and/or going disastrously wrong, either in the form of new biological weapons or simply accidents in careless laboratories. And finally the myriad issues of climate degradation, a list too long to enumerate here but including depletion of clean water resources, desertification and deforestation on a massive scale, overfishing, destruction of coral reefs; that stubborn ozone hole; rising sea levels, the air in many cities unfit to breath, etc. No longer can we look up to the sky for solace, as we have done for millennia: light pollution obscures the stars, while clouds give way to contrails – pretty enough in their own way if we close our eyes to those nasty particles floating earthward. And high above these remodelled clouds, though not visible, 100 million pieces of 'space junk' orbit our planet at 17,500 miles per hour, threatening to collide with and destroy the satellites on which our civilization is now thoroughly dependent. On the earth or away from it, no brake pedal is anywhere in sight. 'This is the first century in which Homo sapiens could be terminated,' warns James Martin in his 2006 book *The Meaning of the 21st Century*. He concludes: 'Even if Homo sapiens survives, civilization may not.'[19]

And yet, while it lasts, how heady it all is! Speed is an aphrodisiac. What invention will we wake up to tomorrow morning? What new dimension, fundamental particle, new planet, galaxy or parallel universe (or distant civilization) will be discovered overnight? More down to earth, what job, even profession, will have been taken over by *super*humanly

skilled robots? What disease will be cured? Or be invented, like *affluenza*, for example ('a social disease caused by consumerism, commercialism, and rampant materialism', a diagnosis used in a successful defence for a rich teen who killed a family of four while driving intoxicated).[20]

Yet we might remind ourselves that in other periods of history men and women thought that *their* age was the fastest or most decadent ever. 'It was the best of times, it was the worst of times, it was the age of wisdom, it was the age of foolishness...' wrote Charles Dickens in his 1859 novel *A Tale of Two Cities,* while Malcolm Bradbury, looking back in time at Aldous Huxley's novel *Crome Yellow*, published in 1921, saw 'an age of apocalyptic unease, sexual confusion, intellectual doubt, changing gender roles, and an awareness among the young that the age of their elders...was somehow over and done'.[21] Sound familiar? In the first volume (1911–1914) of *The World Crisis*, Winston Churchill looked further back at the speed of the preceding Victorian Age: 'Every morning when the world woke up, some new machinery had started running. Every night while the world had supper, it was running still. It ran on while all men slept.'[22] Apparently no one was thinking much of brakes then, either.

Like civilization, that wide practice known as photography also expands, evolves and mutates. The digital revolution (no hyperbole here, as anyone with a smartphone knows) has allowed us to see new things, or old things with more sharpness or clarity (inexorably megapixels are up, apertures and sensors enlarging). Our doctors order us to swallow a pill with a camera in it; we attach a camera to the back of a bird or a bee, we instruct the camera to prettify our features, or change a frown into a smile. Engineers 'recently built a system that can automatically alter a street photo taken on a summer's day so that it looks like a snowy winter scene. Researchers at the University of California, Berkeley, have designed another that learns to convert horses into zebras and Monets into Van Goghs.'[23] Even Orwell would have to admit he hadn't foreseen that great cultural leap forward!

In the past century, photography quickly went from being a privilege of an army of professionals and wealthier, first-world amateurs, to a mass medium of almost universal access. Critic Brian Droitcour has described the rise of social media as a rebalancing of image-making power: the 'aestheticization of everyday life in social media...[that] has leeched the authority of image-making from mass media and from art'.[24] Now, in the 21st century, only a tiny minority of people is cameraless, and the steady streaming of pictures – billions each day – increasingly characterizes our lives, even if most of them have the lifespan of a mayfly. No one knows where it's all heading, though we suspect it's heading somewhere. Industry engineers have in their sights 'casual capture', whereby thought alone will command the camera to take a picture (the thinking being that pushing a button will be too much work for the next generation). We can only be sure the present form of photography's 'downstream rush' will encounter more white-water rapids.

Reassuringly, some people have more thoughtful expectations for the medium. This book, with its complementary exhibition, looks at contemporary civilization through the multifaceted lens

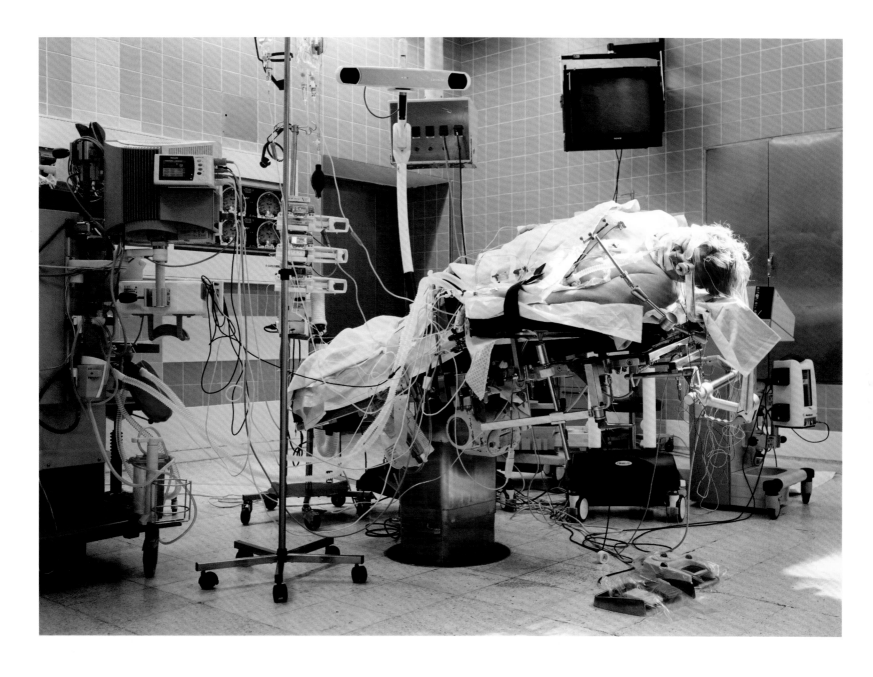

'My photograph relates to our one-sided belief in progress through machinery; the increasing surrender to this kind of hope.'

THOMAS STRUTH
Figure II, Charité, Berlin 2013

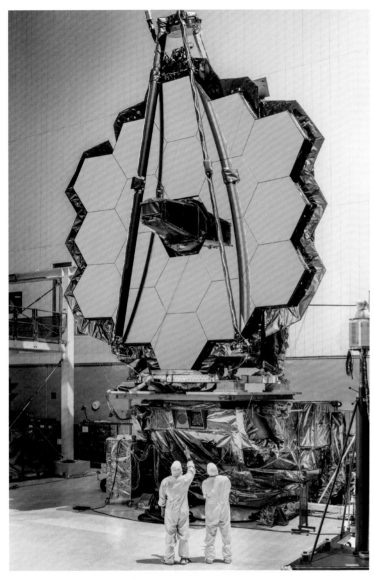

N A S A
*James Webb Space Telescope Mirrors Will Piece Together
Cosmic Puzzles 2017*

of photography, featuring the work of some 140 serious (or, put differently, *seriously committed*) practitioners, many of whom are well known and highly respected, while others are younger, emerging and well on their way to leaving a substantial mark. To cover such a vast subject in even a cursory fashion we curators have had to be extremely selective; many of the pictures are taken from large bodies of work, projects lasting several years or still unfinished, and a good number of these could easily fill the pages of a single volume – as indeed some have: Edward Burtynsky's series on oil, for example, was a project of years, as was Lauren Greenfield's work on wealth, or Henrik Spohler's study of the food industry, to name only a few. Lynne Cohen's study of spatial interiors was a project of an entire fifty-year career. Other bodies of work are necessarily of shorter duration, such as Daniel

Berehulak's study of the Philippines' 'war' on drug dealers, or Taryn Simon's 'Contraband' [Series titles are given when provided]. Yet other photographs aren't taken for *projects* as such but were taken spontaneously, when a significant moment presented itself. Considered as a whole – and here we are talking abstractly about *all* the photographers working right now round the world finding, studying, documenting and interpreting objects and events – it is evident that photography does indeed hold up Spengler's clear mirror to our current civilization.

While apologizing to the photographers for a reductive approach (mitigated, we feel, by having many practitioners represented), we hope that a sampling of their work will encourage readers to seek out more of it. We therefore see this book as a kind of aerial survey, or rather grand satellite composite image; it aims to provide the reader with a wide-angled overview of how photography deals with an exceedingly complex and abstract idea – that is, civilization – and how it contributes to our understanding. And if not our understanding, at least our awareness. What does photography elucidate? What does it explain – indeed, *can* it explain? What are photography's successes, its triumphs? As we shall see in the chapters that follow, 'civilization' is a helpful and appropriate framework to make sense of what photographers – in the collective sense – are up to. One has only to think of what a vivid idea we'd have today of Greek, Roman, Mayan or Incan life (etc.) had photographers been roaming their streets and plazas, visiting their homes, or sneaking a camera into a bathhouse. Future civilizations may well feel like voyeurs when they look back at the detailed visual records left by 21st-century photographers – provided, of course, that given our collective immaturity and mindlessness, we take care to preserve these fragile images.

———■———

It would be pleasant to be able to define the word 'civilization' simply and precisely, as one defines a straight line, a triangle, or a chemical element...

Fernand Braudel [25]

Civilization is one of those terms everyone can agree upon, until someone dares define it. One's colleagues will then pounce; historians, anthropologists, sociologists, geographers, philosophers and other students of civilization disagree vehemently about what it does or doesn't constitute. Writing his Editor's Note for the journal of the International Society for the Comparative Study of Civilizations in 2007, Joseph Drew states flatly 'it is also a fact that the [Society's] members have never been able to agree, except within broad parameters, on what constitutes a "civilization"'.[26] Yet these scholars still find it necessary to band together to tackle the subject! There are even thinkers who dedicate careers to the study of civilizational collapse: has a prior civilization ever felt that need? And given that we have, is it because we've actually learned something?

As we've used the key term in our title, we'll have to enter the definition fray. But we can take some solace from the anthropologist Claude Lévi-Strauss, who proposed that terms

like civilization could be used any way we like, as long as we say precisely what we mean by it. And while we're on the topic of usage, another question might be: why use the term at all, if we're talking about the art form of photography? Why not simply title the project 'The Way We Live Now'? We would argue that the concept of civilizations is useful, indeed vital; it's a way of stepping back and taking in 'the big picture', or at least sketching where human society, in the widest possible sense, is heading. Photographers are for the most part pragmatic workers: by definition they tackle real things, real events – what can be *seen*. Except by inference, they stay away from abstract philosophical problems, or they tackle them obliquely. There are many more photographic portfolios of transport systems for people and goods (roads, bridges, airports, container ships, etc.) than there are photographs that show us the invisible flows of capital, or the machinations of the military, or the workings of a university. 'What is civilisation? I do not know,' admitted the art historian Kenneth Clark in his famous 1969 television series *Civilisation*, 'but I think I can recognise it when I see it: and I am looking at it now... If I had to say which was telling the truth about society, a speech by a minister of housing or the actual buildings put up in his time, I should believe the buildings.'[27] Many more photographs are taken in or from public spaces than in boardrooms. In his 2001 book *Fast Food Nation*, Eric Schlosser imagines doomsday's residue: 'along with the high-tech marvels, the pale blue jumpsuits, comic books, and Bibles, future archaeologists may find other clues to the nature of our civilization – Big King wrappers, hardened crusts of Cheesy Bread, Barbecue Wing bones, and the red, white and blue of Domino's Pizza box', all things that would delight a photographer with a keen colour sensibility.[28]

At the simplest level (let's call it shorthand), civilization means living in cities. And living in cities means a people having achieved a mastery over their environment that permits them to do so – i.e., with most inhabitants freed from making food and therefore available for other specialized tasks, the undertaking of which propels the civilization to more complexity and more mastery in a virtuous cycle – were it not for the inevitable overreach, something of which many fine minds of our time are keenly aware.

Of the many definitions of civilization we find the following common elements: although it is sometimes used synonymously with culture, civilization refers to something quite different, though with overlap. A culture is the sum total of a particular people's way of life, and will include its language, its material artefacts (from the screwdriver to the International Space Station), along with a coherent system of beliefs about self and others, community, the world itself and the cosmos. Individuals identify with the culture, and consider people from other cultures different in a fundamental way (positively or negatively, mostly the latter). It's as if a culture says over time, *we've worked it out: this is how the world works, and should work, and why.*

Where things get messy is when culture is used in its elevated sense: the creation of music, literature, philosophy and the fine arts. The literary critic Terry Eagleton, however, reminds us that you can't have novels without printing presses, paper and paperclips (or, today, computers and software, etc.). No poets without engineers: 'Civilization is the precondition of culture.'[29]

So civilization is a broader term: all that culture entails and more: often more than one particular culture and one language, all that it builds and creates, how it organizes and polices itself, how it controls natural forces, how and what it worships and venerates and how it manages relations with other civilizations. And it will have writing, essential for the organizing and administration of urban life. For the historian Andrew Bosworth, 'Civilization is fundamentally a cultural infrastructure of information and knowledge that serves survival and continuity.'[30] What distinguishes a civilization from a culture (and we might note that we had human cultures hundreds of thousands of years before we had civilizations, beginning from the 5th millennium BC) is that this infrastructure, having reached a certain level of complexity, becomes autonomous from constituent cities, nations and empires. And the philosopher Feliks Koneczny argued almost a century ago: 'Civilization is the sum of everything which is common to a certain fragment of humanity; and at the same time is the sum of everything by which that fragment differs from others.'[31]

To clarify the distinction between culture and civilizations, we might think about how we sometimes describe people's behaviour. If we say someone is *uncultured*, we mean lacking in worldly knowledge of art and literature (private), but when we say *uncivilized,* we mean boorish social behaviour (public). In other words, the former is the person's own business, the latter is everyone's affair. In this sense 'civilization' stands for a well-ordered, properly functioning machine driving us all forward, or backwards as the case may be.

So how do we intend to use the term civilization for our purposes? Firstly, we are focusing on *contemporary* civilization; secondly, at *planetary-wide* civilization; thirdly, we are focusing essentially, though not exclusively, on mass behaviour – *the collective life.* Eccentricity and individualism are therefore of secondary interest here.

Finally, a brief word on civilization in the singular and the plural, another subject of ceaseless debate. We do not deny the separateness of civilizations: Islamic, Chinese, Western and the like (numbers of great civilizations in history have been estimated at anywhere from eight to twenty-three), and scholars such as Samuel Huntington or Niall Ferguson are quite adamant about acknowledging boundaries between them. Civilizations, however, are to varying degrees porous, increasingly so, and today it is almost impossible to keep foreign ideas out, even for a very self-isolated part of the globe such as North Korea. Equally, however, one can talk about human civilization in the aggregate, as we have chosen to do for reasons that will become clear.

The World We Live In. Now.

Become Ruler of the World by establishing and leading a civilization from the Stone Age to the Information Age. Wage war, conduct diplomacy, advance your culture, and go head-to-head with history's greatest leaders as you attempt to build the greatest civilization the world has ever known.
Sid Meier's Civilization VI Video Game[32]

'Civilizations are extraordinary creatures, whose longevity passes all understanding. Fabulously ancient, they live on in each of us; and they will still live on after we have passed away.'

Fernand Braudel, *Grammaire des Civilisations*, 1963

Just as the 20th century is said to have had a late birth, namely the First World War, most historians are more comfortable with an earlier start date for the 21st century: the 1990s. This gives our project a more or less twenty-five year or quarter-century 'reservoir' of images to draw from. A photograph from this period qualifies when it meets the test of realistically depicting the present 'moment', i.e., the world in which we find ourselves in 2018. Even though change seems rapid and dramatic in many areas, some aspects of our lives have not changed much, even if marketeers do their best to convince us otherwise. The school, the hotel, the law court, the urban parking garage and the shopping mall, the train, station, the airport, etc., at least in their basic physical forms of 2015 are not appreciably different from their counterparts of the 1990s, though usually bigger. The last decade of the 20th century saw a world reordered with the rise of China, the breakup of the Soviet empire and the reunification of Germany, while new technologies impacted all corners of the globe. The first webpage went live in 1991, while quantum computing and gene therapy, 3D printing, nanotechnology and many of the dazzling developments of our present decade were well under way in the 1990s. Meanwhile, the Mars Exploration Rovers, and Jupiter and Saturn Probes, much in the news for their discoveries today, were launched in the 20th century. It is not because the current century stands on its own symbolically (i.e., the 'milestone' passed with the arrival of year 2000) that we should limit our viewpoint, if we wish to have a grasp of 'our times', that is to say the world with which and in which we all have to negotiate.

All this leads to a paradox: when we talk of civilization, we are referring to a phenomenon of thousands of years duration, what the French historian Fernand Braudel called the *longue durée*, not the events of this week, year, decade or even century. A civilization has its periods of growth, expansion, decontraction, collapse – or, not so dramatically, transformation into something else. So photography, specializing in the here-and-now, would seem ill suited to deal with it. On the other hand, any long-lasting civilization still exists in its day-to-day form, so a picture of a moment (i.e., our twenty-five-year span) is just as valid a

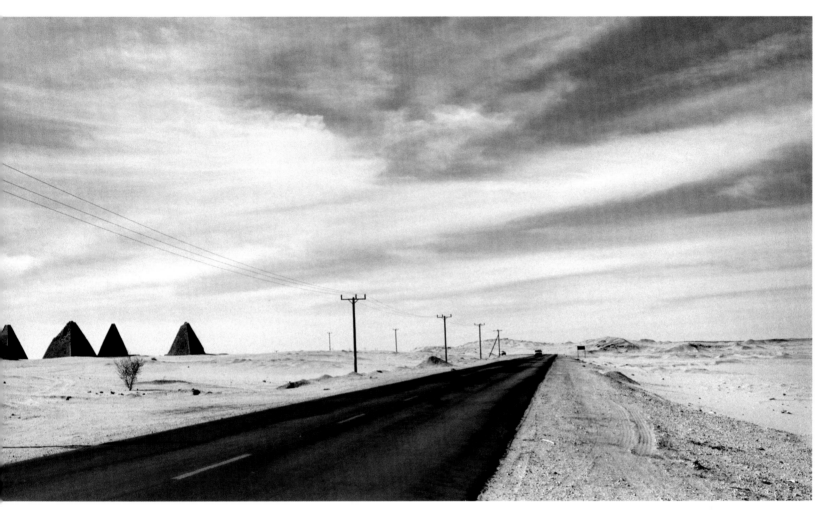

RICHARD DE TSCHARNER
Coexistence dans l'indifférence, from the series *Sudan* 2010

sampling as any other. Obviously, had this book been published in 1917, its subject matter would have looked very different, but underlying civilizational structures would still have been visible: dams, roads, tunnels, bridges, schools, hospitals, and so on (the Flatiron Building in New York is still standing proudly at the same intersection of Broadway and Fifth Avenue, just as it was for Edward Steichen or Alfred Stieglitz in the early 1900s).

Any debate on our own civilization's pluses and minuses is bound to be heated, and not surprisingly we find photographers' voices for and against the civilization of which they are a part. However, we curators did not set out with our own negative or positive view of the subject. We began with two ideas in mind: an appreciation of the phenomenal complexity of civilization, and a curiosity to see how different photographers have dealt with it. It turns out that some photographers are clearly critical, some are neutral, and others frankly celebratory. So we invite the reader to think of this book in two ways: as being about *civilization now* as seen through the eyes of photographers; or conversely, as being about *photography now*, as seen though the lens of civilization.

A Planetary-Wide Civilization

'The phase of civilisations is coming to an end, and for good or ill humanity is embarking on a new phase [that of a single civilisation]',wrote the philosopher Raymond Aron in the 1960s.[33] More recently, the political scientist Robert W. Cox has noted, 'Civilizations, once geographically based, are now loosened from fixed space, as migration of peoples and of ideas has accelerated...'[34]

We take as our focus this emerging planetary-wide civilization. This civilization embraces, not without conflict, a host of different empires, nations, groups of nations, cultures and ethnicities (not to mention seven or so billion eccentrics), but focuses on the elements shared. This is not to say that you or I will look at a particular photograph and say 'but I never go into a mosque'; we all know something about mosques (or synagogues, or churches), and certainly their central function. It is not that each of us can look at every picture in this book as a participant, but there is enough commonality in the scene for us to identify with it and feel to varying degrees a shared experience.

There is another sense in which we mean 'planetary', best served by examples. Take air travel. A reader of this book, say somewhere in the West, can decide to board a plane *tonight* for Beijing, Ulan Bator, Kyoto or Singapore, and have an almost certain chance of arriving there in the morning – rested, well-fed, and safer in fact than if they'd stayed at home. Our traveller would also have a variety of choice of routes, degrees of comfort, quality of food, and so on. All they would need is a piece of encoded plastic, and a passport, perhaps a visa, and the clothes on their back. There is no place on earth that our traveller can't access within twenty-four hours, as long as his or her 'net worth' allows (the banking system would determine that – another prime example of a truly planetary-wide system). Our civilization keeps some two million people in the air at all times – a city in the sky with more or less the populations of San Francisco, Seattle and Vancouver combined.

A second good example of planetary-wide civilization would be the Olympic Games. There is virtually no village on earth, rich or impoverished, that has not heard of the Games, and probably no single child that hasn't at some point dreamt of dashing or splashing to a gold medal. Every nation (more than 200) has an OG structure, and vast sums are spent (or misspent) on the event by individual nations and the central committee. (The Sochi budget for the Winter Games in 2014 was $51 billion.) So we have here one of planetary civilization's most complex, costly and visible social structures, with thousands of athletes playing (11,000-plus in 2016), hundreds of thousands of people implicated in running the organizations, and billions of people 'participating' vicariously. Moreover, this vast machine rolls forward towards a new city every two years. Writing before the Sochi Winter Games, when there were the usual doubts about them opening on time, the *New York Times* concluded, 'These Games will go on, the only consolation being that we're all in this together now, like nesting dolls.'[35]

Finally, we can imagine 'planetary' in a more abstract sense. It has been said that if Facebook were a nation, it would be the most populous one on earth. Historians and political scientists, like Samuel Huntington, have argued, often vociferously, that civilizations, plural that is, at best cooperating, at worst clashing, and hopefully at least mutually tolerating, are the correct framework for understanding the world; a world civilization is a distant dream. They point out that superficial resemblances between different peoples can distort the reality; hence a group of young men can sip Cokes and share pizza, sport Nike trainers and show off their latest model smartphones, and then go off to plant a bomb in the local mall. We do not deny the great differences between civilizations: we are only looking at the increasing points of convergence.

A planetary civilization implies that every human being alive today is a part of it. But can someone opt out? Not really. Or only superficially. All of the world's people are subject to its reach, overarching controls, influences and effects, whether they like it or not. It is simply no longer possible for someone in a remote part of the world to say 'this or that development does not concern me'. Terrorist groups, rogue states, unhinged presidents, amoral corporate behaviour (think for example of the worldwide effects of the rigging of the LIBOR rate, revealed in 2012: something I personally dimly understood beforehand had a very real impact afterwards on *my* bank account) – decisions made by a single individual or tiny group can actually influence billions. Rising sea levels, nuclear war (or accident), a man-made pathogen released intentionally or accidentally...No single person, rich or poor, can pretend to be entirely free of what are in fact existential risks for our species. Following a trip to Alaska in 2016, the author Brian Castner wrote about the Dene people, for whom globalization may be distant, but far from an abstract notion. One elderly man, he reported, 'has lived long enough to see powerboats and skidoos supplant canoes and snowshoes. This sort of globalization – the influx of modern conveniences and ubiquitous pop-culture – has invaded every aspect of Dene life, but at a cost...They can see global culture on satellite television, but cannot touch it, except to purchase its veneer on Amazon – yoga pants and smartphones...Wilfred told me this story while watching the news: coverage of the Republican National Convention and the shooting of six police officers in Baton Rouge. "I never used to care about news," he said. "I was in the bush. But now I want to know what's happening in my world."'[36]

We are more alike than we are different. Well over half the world's citizens have cell phones now, and many a traveller has been surprised to see them in the hands of old people in remote villages. A few massive corporations build planes for the world, even if each airline tries to disguise the uniformity with its own bright graphics and logos. Hundreds of millions of us have travelled in an Airbus or a Boeing aeroplane. Or ridden in a Volkswagen, Toyota or Mercedes automobile. These machines vary only superficially from each other, even if the salesman argues for the superiority of this or that brand. And if many people have never been on a Boeing or an Airbus, or attended the Academy Awards or met George Clooney or Angelina Jolie, we know all about them, whether we wish to or not. Most of us have never come face to face with an Al Qaeda operative either, but we all have to take off our shoes at airport security. One would have to live in a pretty tight bubble anywhere on earth not to have some idea of what these actors (in the figurative or literal sense) represent. Individual appreciation or aversion to one or the other is immaterial; we all have to 'live' with them, in the sense that they occupy a considerable part of our consciousness.

The Collective Life

'Humans are not special because of their big brains,' argues social anthropologist Kim Hill, 'that's not the reason we build rocket ships – no individual can. We have rockets because 10,000 individuals cooperate in producing the information.'[37] Science and technology scholar Andrew Russell felt compelled to debunk the myth, or at least exaggerated notion, of the genius entrepreneur. 'We were frustrated with the fetishization of innovation,' Russell recalls. His reaction was 'triggered by Walter Isaacson's book *The Innovators: How a Group of Hackers, Geniuses and Geeks Created the Digital Revolution*. I suggested a counter narrative – *The Maintainers: How a group of bureaucrats, introverts and standards engineers made technologies that kind of work most of the time*.'[38]

The cult of individuality (replacing religion for many people) disguises the nature of our collective achievement. I am reminded of this every time I watch the endless credits roll by after a blockbuster, or, for that matter, any film. And yet what we fixate on is the performance of a Matt Damon or a Scarlett Johansson. As for those Olympic Games, we have eyes only for that one man or woman who jumps higher or runs faster than everyone else. Billions of us watch, though, and watch transfixed. This is the sense of collective human behaviour to which our project is directed.

Take virtually any area of culture: the anthropologist David Graeber notes that the universally popular field of science fiction has become now so standardized, 'from teleportation to warp-drive that pretty much any teenager in Canada, Norway or Japan can be expected to know what they are'.[39] 'These days most people around the world dress in much the same way: the same jeans, the same sneakers, the same T-shirts,' observes Niall Ferguson in his 2011 book *Civilization*. 'It is one of the greatest paradoxes of modern history that a system designed to offer infinite choice to the individual has ended up homogenizing humanity.'[40]

In their 2016 book *Age of Discovery* (about our era, despite the purposely misleading title), Ian Goldin and Chris Kutarna argue that 'individual geniuses hog the headlines, distorting the reality of collective genius'. They believe the current age amounts to nothing less than a new renaissance, 'a rare moment of mass flourishing'. They also believe that 'we are finally building a new layer of group intelligence. We can convene, sense, speak and act as groups with greater ease, power and speed.'[41]

There is one final sense in which we are more alike than different, noted by Braudel: 'In every period a certain view of the world, a collective mentality, dominates the whole mass of society, dictating a society's attitude, guiding its choices, confirming its prejudices and directing its actions; this is very much a fact of civilisation.'[42] Although the historian was not talking about planetary civilization here, but specific variants, we can nevertheless argue that such a collective mind is indeed taking hold in certain areas of consciousness. So our book might have instead been titled, *Civilization: The Collective Life*, focusing as it does on shared human experiences the world over.

Civilization is Cumulative

The Gothic cathedrals date from almost one thousand years ago, and are still functional (one can only wonder which of our buildings will be in use in the year 3000). Armies of men and women toiled all their lives for those cathedrals, and it took the work of several generations to get them up and functioning. We still make use of them today almost as they were used in c. 1150, and even those who consider themselves atheists are drawn to these places of stupendous human accomplishment. Though we have many other sites of worship (of God, of Gods, of Apple and Amazon, of Celebrity and Money), we have not yet replaced these towers of faith with anything so inspiring, and without rupture each generation down the ages has felt the need to keep them operable and in repair. Even in war, efforts were made to avoid destroying them, and the flattening of Coventry Cathedral during the Second World War has been etched in the collective conscious as a quintessential act of barbarity, at the opposite end of the spectrum from civilization. The Gothic cathedral is still used as a measure of supreme human achievement: structures like the modern autoroute have been called 'cathedrals of our day', while great buildings are often blithely referred to as 'cathedrals of commerce'. The word itself embodies all that is felt to be noble in Western civilization.

By cumulative, it follows that I refer to the layers a sophisticated society builds, one upon the other. The social organizations and the material structures that arise in any civilization outlive any individual person, but during a person's lifetime they give him or her meaning, a space in which to exist, and sustenance of body and (though not always, or not for everyone) soul; some civilizations have been more democratic than others. Perhaps the best metaphor that's been proposed is civilization as an onion: we represent only one, thin skin, and yet we englobe the whole of what has gone before us. As I write this essay, I see on my screen this news: Bruce McCandless, first astronaut to float untethered in space, has died. The message is accompanied, it goes without saying, by a photograph.

But of course, he was tethered, tightly – by a civilization far below.

We have invited the photographers in this book to contribute short texts, if they wished to, either about how their work relates to the subject, or to address more precise thoughts. I take here one of these texts, from David Maisel, not to single out one artist but because his words convey an interesting thought about technology that I think many of his colleagues would share, concerning an essential aspect of our lives. He writes, 'Our sites of technological experimentation embody our collective aspirations for the future, though they are often hidden from view and difficult to access. Embedded in the architecture, the laboratories and other zones of technological inquiry and experimentation are issues about how human imagination and endeavour are made physical. My photographs...describe the aesthetics of such innovation, and consider how advanced technologies bring us to such questions as: *How do we form the future? How do we describe it? Where does it come from, and where does it lead us?*'

And in the *longue durée*? Earlier in our new century the artist Trevor Paglen collaborated with materials scientists at the Massachusetts Institute of Technology to develop a micro-etched disc with one hundred photographs, encased in a gold-plated shell, designed to withstand the rigours of space and to last for billions of years.[43] Since its launch in 2012, it sits above us, one of many geosynchronous spacecraft that will probably outlive many successive human civilizations. It's strange to think that this time capsule, hurled like a lifeboat into space, may be all that remains of human life on earth. Meanwhile, in the here-and-now, we have our legions of living, working photographers to help us evaluate just who we are and where we're headed.

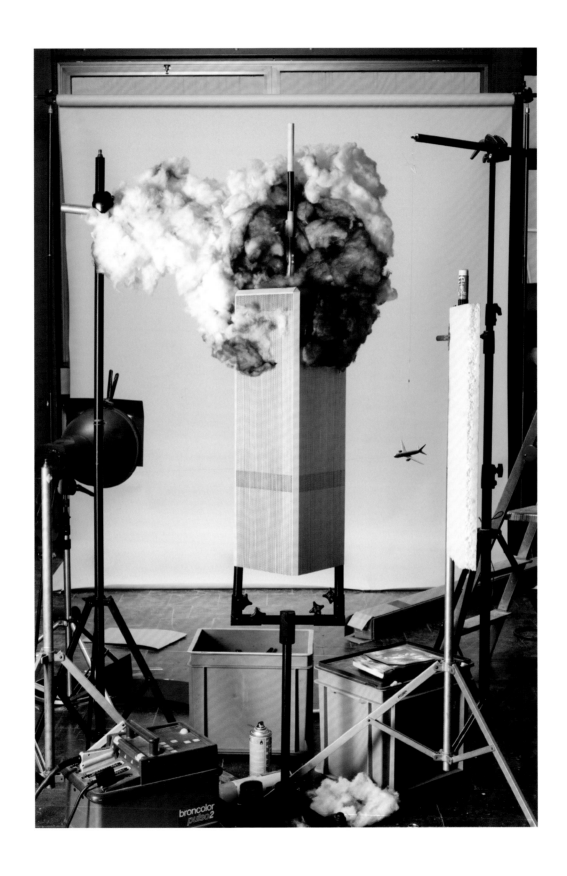

JOJAKIM CORTIS & ADRIAN SONDEREGGER
Making of '9/11' (by Tom Kaminski, 2001), from the series *Icons* 2013

CIVILIZATION

WE ARE ALL IN THIS TOGETHER NOW

'Our age is insistently, at times almost desperately,
in pursuit of a concept of world order. Chaos threatens side
by side with almost unprecedented interdependence...
New methods of accessing and communicating information
unite regions as never before and project events globally,
but in a manner which inhibits reflection...'

Henry Kissinger, *World Order*, 2014

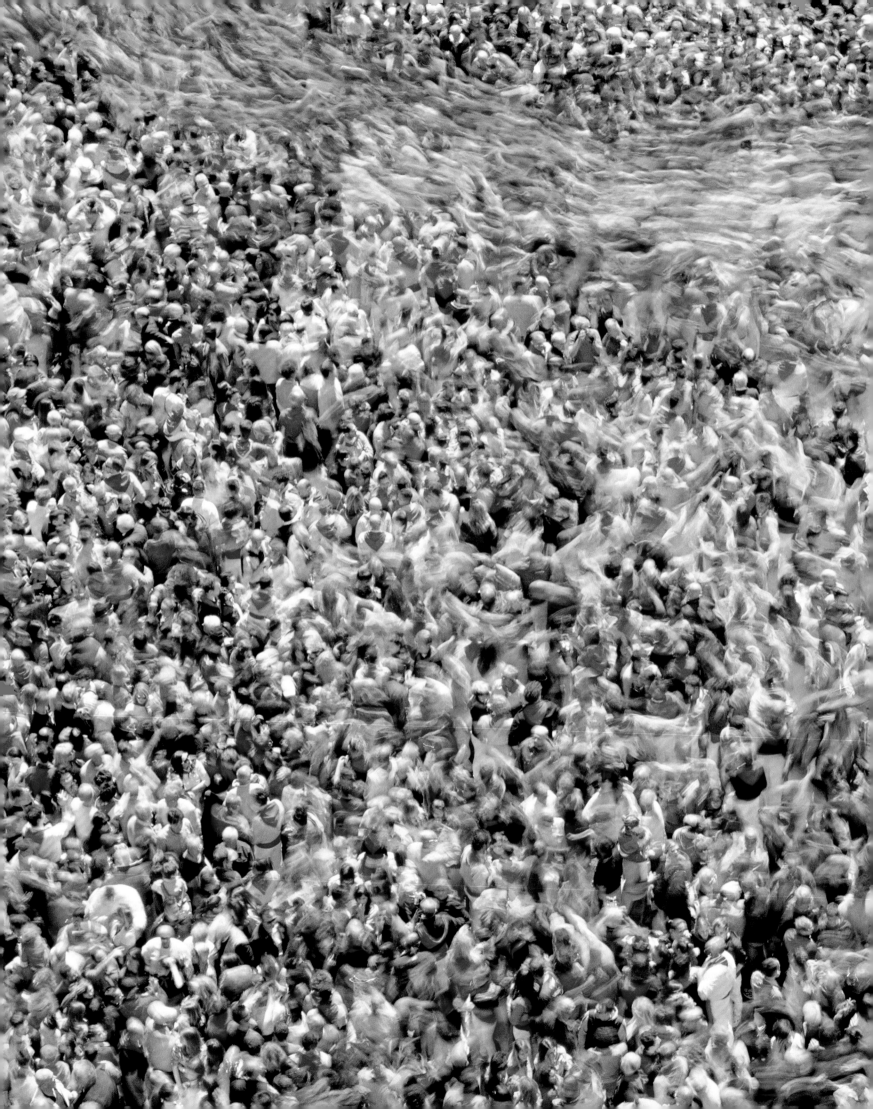

In his celebrated novel of 1987, *The Bonfire of the Vanities*, Tom Wolfe used the expression 'the hive' to refer to the frenetic social life of Manhattan. The allusion to a buzzing insect colony may of course be applied to any vibrant city – take Philippe Chancel's Dubai (p. 36) which resembles a gigantic ant colony, or Cyril Porchet's closely packed crowd (p. 41) evoking a swarm of bees. Civilizations press their citizens into cities, where specialization thrives and cultures are moulded. Being able to concentrate people tightly means freeing most of them from the task of food production, although some must still fulfil that basic function, as Edward Burtynsky (pp. 48–49), Henrik Spohler (p. 51) and Neil Pardington (p. 50) remind us.

For better or for worse, cities are our collective future. The 21st century has seen the long history of rural dominance come to a definitive end. For the first time in millions of years of human existence, more people now live in urban centres than outside them. The city is, literally and figuratively, a machine for manufacturing social complexity. The ever-vaster urban organisms we see now in the world are not only *passive* hives of comfortable living, but also *active* hives of learning, producing and thinking.

Photographers, too, tend to be urban people, taking delight in the pictorial possibilities offered by the unceasing ebb and flow of crowds, the often precarious plight of the individual, and the spectacular, ever-changing backdrop of the built environment. Is there a city without its master photographers? In the 19th century Paris had Eugène Atget and Charles Marville; in the 20th century New York had Weegee and Berenice Abbott, to name only a few.

Who are the photographers associated with the major cities of the 21st century? It would be wrong to proclaim any one photographer for any one city at this early stage; the distinction has to be earned over decades. And perhaps it is wrong to be thinking so narrowly in the first place. Thousands of fine photographers are at work worldwide at any moment, finding a niche or taking a wider view.

While photographers often remain rooted to their own cities, which they know intimately – like Hong Kong photographers Benny Lam (p. 46), Eason Tsang Ka Wai (p. 47) and Alfred Ko (p. 39) – others are stimulated by what they don't already know. Increasing mobility means some prefer to travel widely, interested sometimes as much in an abstract concept of a universal urbanism as in any one city's particularities. With modern media leading to a keener awareness of what's going on in the world, such as the arrival of an important new building in

settlement habitat megalopolis hive

one city – Renzo Piano's The Shard in London, for example (Olivo Barbieri, p. 60), or New York's New Museum (Irene Kung, p. 61) – it's increasingly as if there is one planetary city emerging in the collective mind, even if it's 'widely distributed'. While some photographers focus on iconic buildings and monuments, Robert Polidori pulls back to reveal the formless structure of what he calls 'dendritic cities' like Mumbai (pp. 44–45), unceasingly branching out in organic fashion. The wider view is also adopted by Pablo López Luz (p. 34) and Francesco Zizola (p. 35); the former depicts a megalopolis as if it were great waves washing across the landscape, while the latter presents an entire city that looks as if, with one great wave, it might be entirely swept away.

The individuality of cities (one reason many of us love to travel) is called into question by Roger Eberhard, who notes with irony the conflicting human needs for difference and sameness (pp. 56–57). It's also somewhat of a paradox, given that a common complaint is that main streets the world over are looking increasingly interchangeable, with standardized chain stores, coffee shops and sleek towers, not to mention the purely functional structures like massive parking garages (KDK, p. 40) that give us access to all that urban dazzle.

Nevertheless, there are photographers who take pleasure in visions of community, integral to the health of the hive, whether it's strolling in grand public spaces – Raimond Wouda's Paris (p. 38), Kim Taedong's Seoul (p. 37) or Walter Niedermayr's Isfahan (pp. 52–53) – or encounters in more compressed surroundings, such as Massimo Vitali's vibrant São Paulo market (p. 55), or Mark Power's regal Palazzo Ducale (p. 59).

Other photographers are intrigued by the interface of civilizations, sometimes frictional: Nick Hannes's Dubai, for example (p. 58), which at first glance may suggest a mosque, only to reveal itself on inspection as a mall, with (what else?) a Starbucks at its centre. Constant change, whether growth or decay, attracts photographers everywhere. Peter Bialobrzeski captures a telling urban moment – *Lost in Transition*, punning on *Lost in Translation* – as an 'old' building with a certain idiosyncratic character prepares to give way to a mass of functional towers which, the photographer seems to suggest, may or may not ever be ready, or fit, for human habitation (p. 42). A more reassuring thought about urban virtues comes to mind when viewing Candida Höfer's hive-like library in Madrid (p. 54), which perfectly illustrates Nietzsche's belief that 'our treasure lies in the beehive of our knowledge. We are perpetually on the way thither, being by nature winged insects and honey gatherers of the mind.'

CYRIL PORCHET
Untitled [detail, see p. 41]

overleaf
RAIMOND WOUDA
Paris [detail, see p. 38]

'At a time of the invention of the post-truth and of the dissolution of reality in virtuality, which some people call "the colonization of reality by fiction", I am fully aware of the danger of committing myself to the frontiers of the truth of document and the subjectivity of the point of view.

Wherever I go I am caught in a Gordian knot, between the fascination of what I see and the persistent feeling of indignation, where the only photographic escape is the beauty of disaster.'

Philippe Chancel

'In the years ahead there will be exponential growth of cities and metropolises such as has never been seen before in human history; this is due to the huge increase in world population and the consequent abandonment of the countryside. The challenges to be faced are sustainability, building speculation and the unknowns that earth and society hold in store for us, such as hurricanes, earthquakes, migration and terrorism.'

Olivo Barbieri

metropolis residence estate city nest

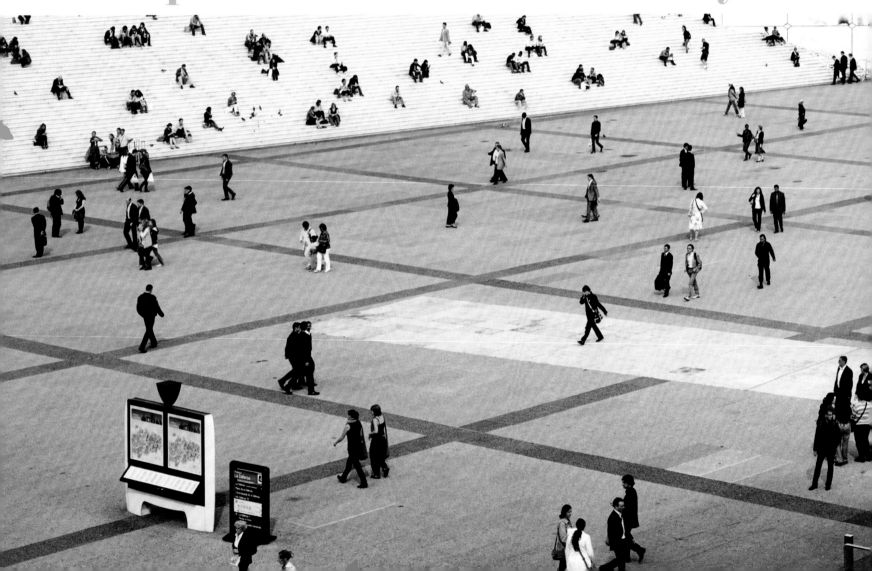

'I wonder whether Mumbai is already a city in Dystopia,
or just a prequel of it. You can't be sure.'
Peter Bialobrzeski

'Ancient ruins are poignant
reminders that complex and
sophisticated civilizations
have collapsed.

Will our fabulous monuments
be the only testimonies
of our civilization?'

Irene Kung

'...folk gatherings...release a particular strength in an age
in which everything seems to move towards globalization.
This idea of gathering clans, the domination of colours,
in relation to tradition, etc...all contribute to give distinctive
tones and interlacing to the different crowds.'

Cyril Porchet

enclosure box abode urban dwelling

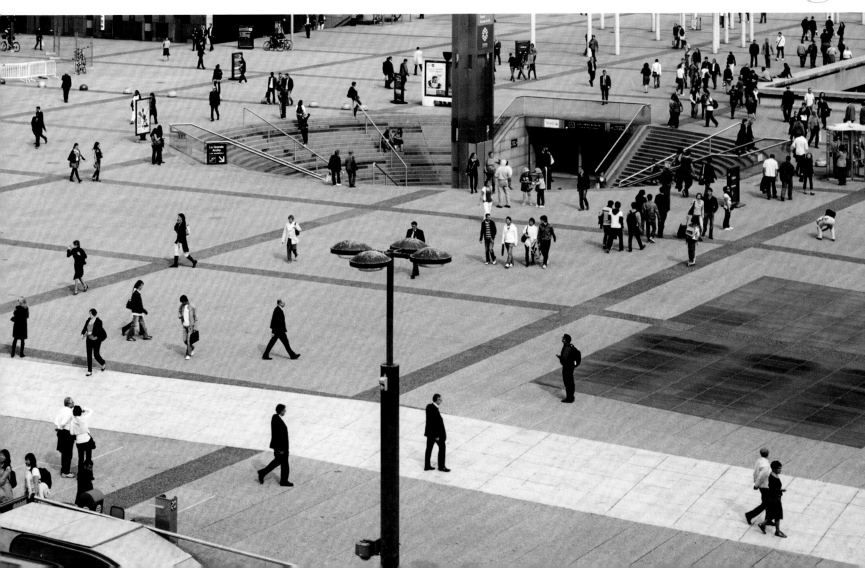

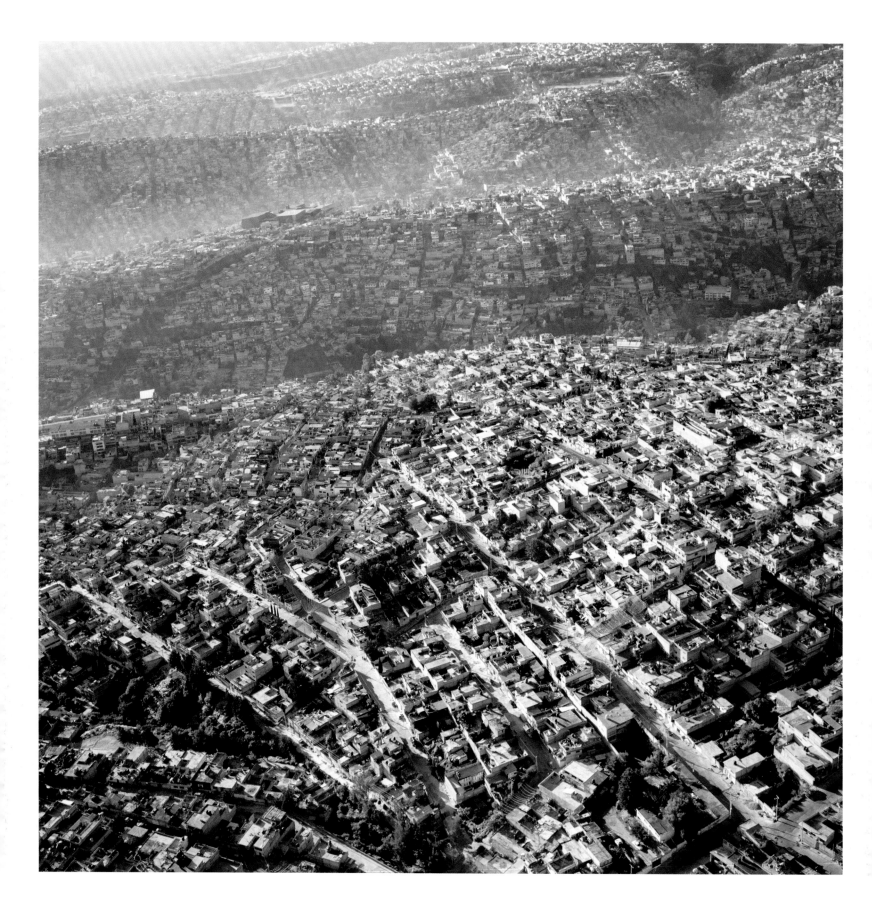

PABLO LÓPEZ LUZ
Vista Aerea de la Ciudad de Mexico, XIII, from the series *Terrazo* 2006

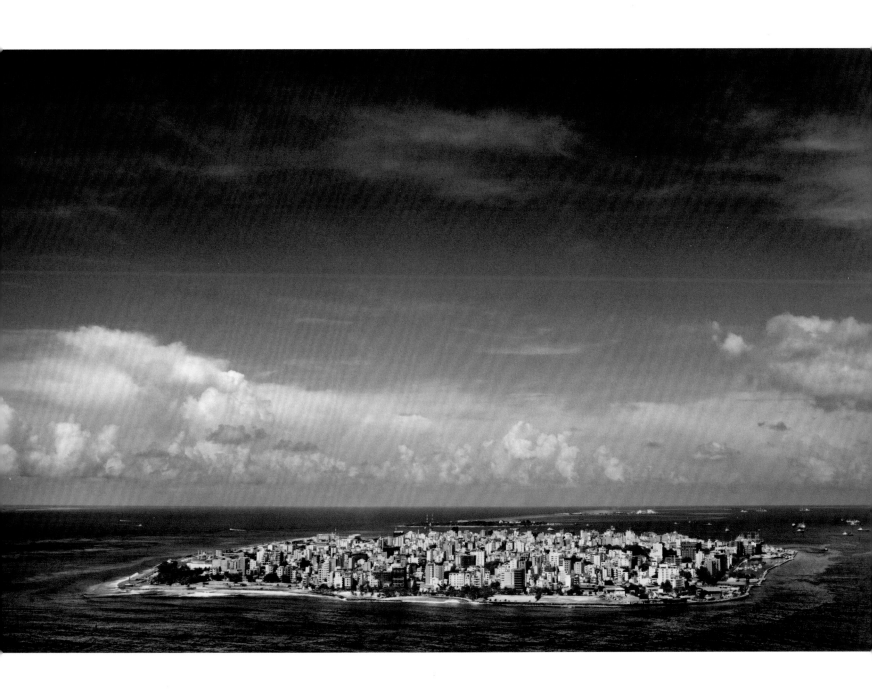

FRANCESCO ZIZOLA
A paradise in peril: the Maldives [Malé], from the series *Consequences* 2009

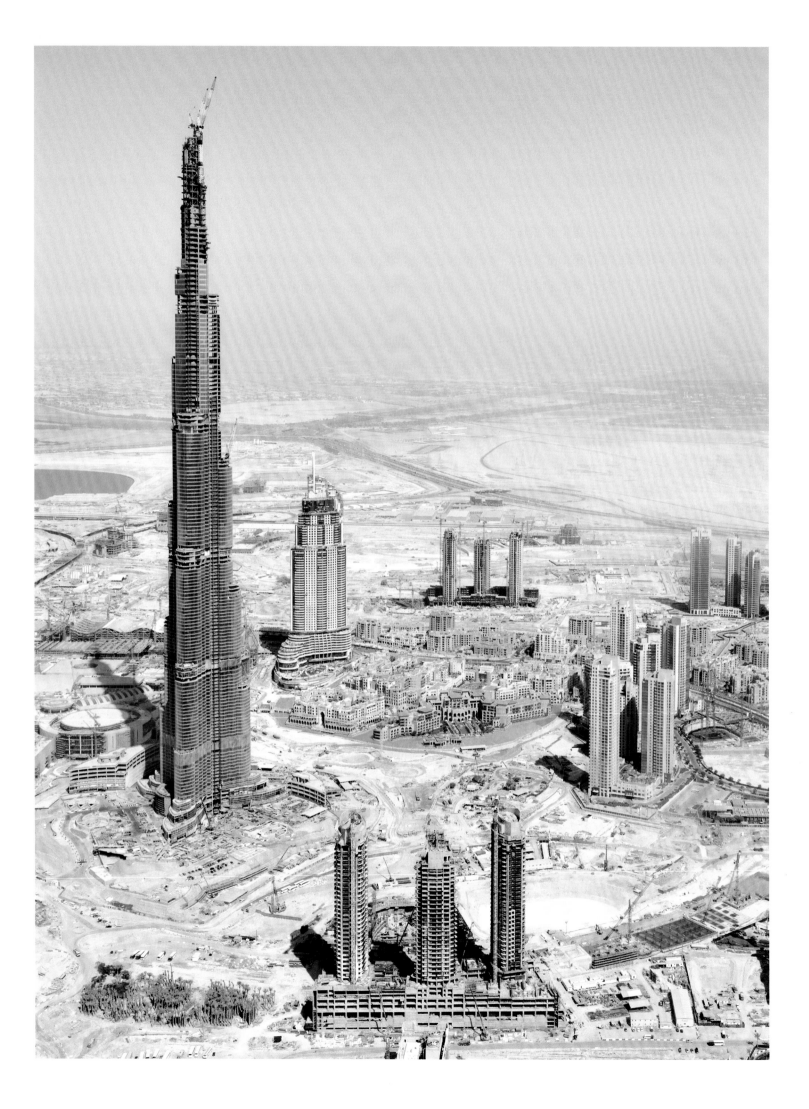

PHILIPPE CHANCEL
Construction of the Burj Khalifa Tower, Dubai,
from the series Datazone 2008

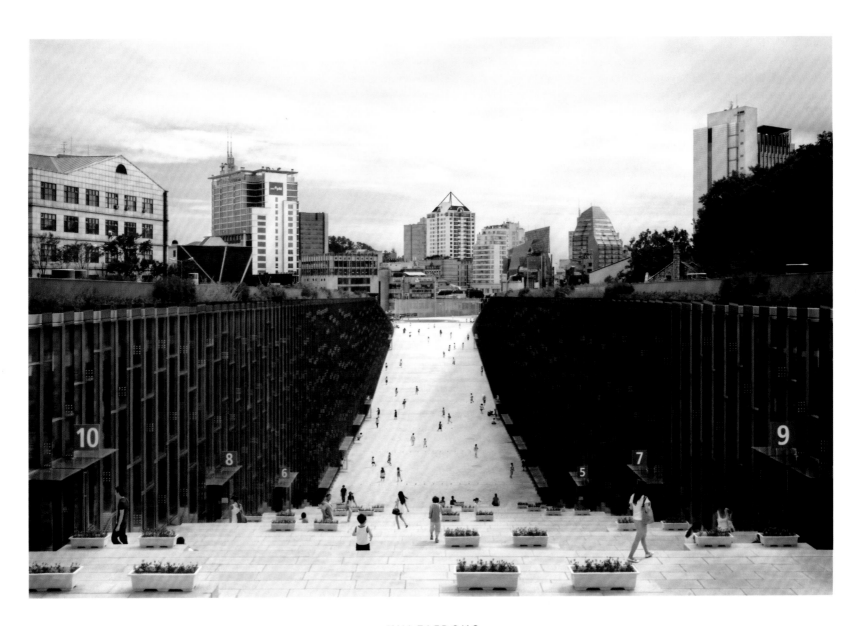

KIM TAEDONG
Man-made 030 2008

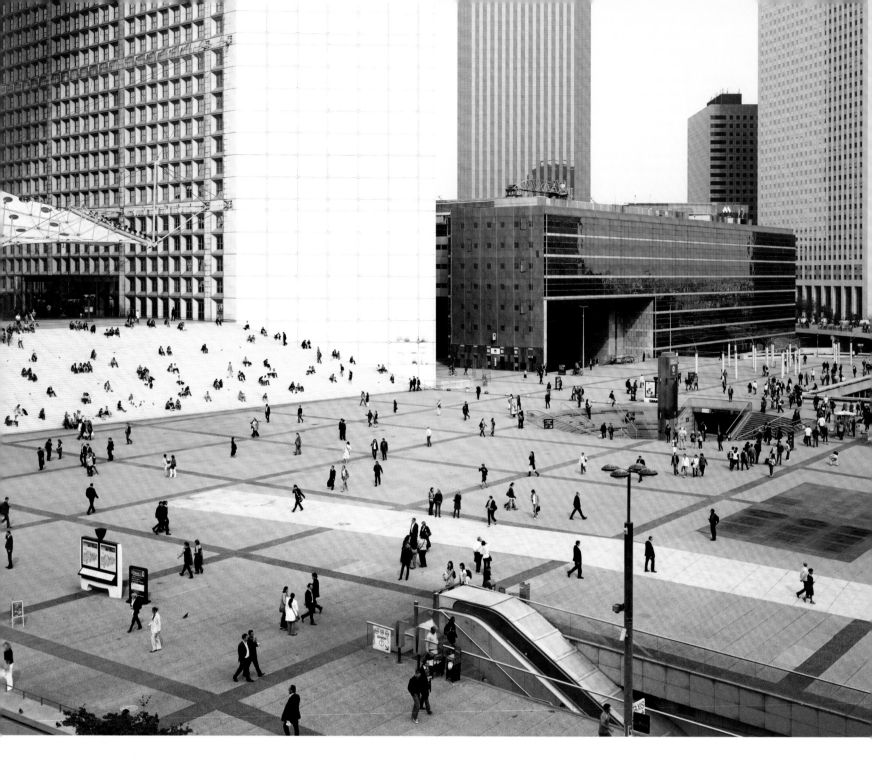

RAIMOND WOUDA
Paris, from the series *Squares* 2009

'In recent years, living in a highly developed city like Hong Kong has been like living inside a park or zoo with an invisible boundary, especially in the aftermath of the "umbrella movement" of 2014. It has so many dazzling colours, garnished by so many colonial memories. Unfortunately it is like an imaginary dream: nothing but emptiness.'

ALFRED KO
A walk in the Park – Central 2015

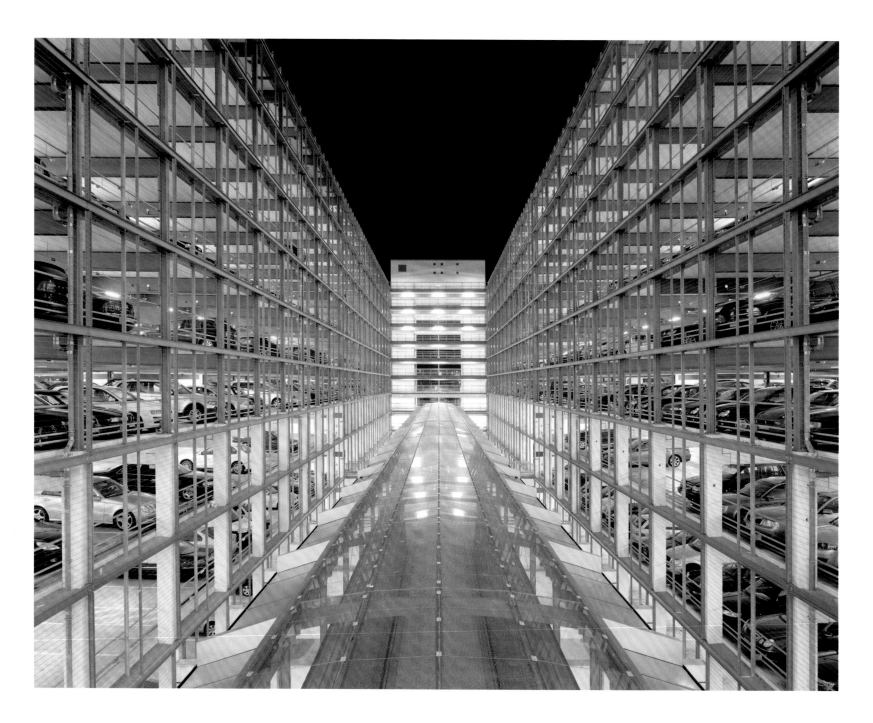

KDK
sf.M-1, from the series *sf (Space Faction)* 2005

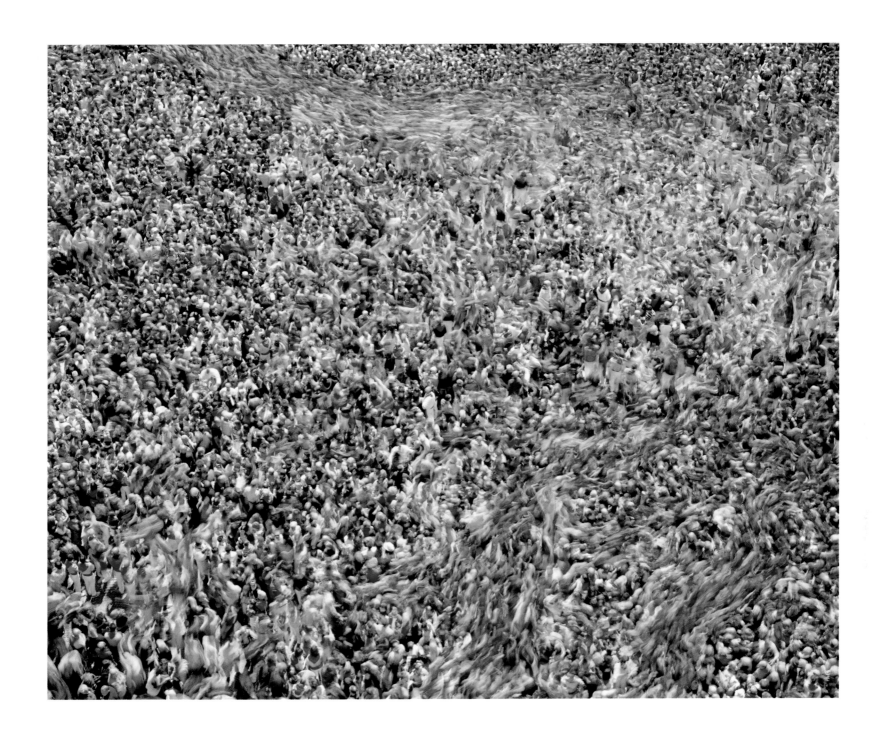

CYRIL PORCHET
Untitled, from the series *Crowd* 2014

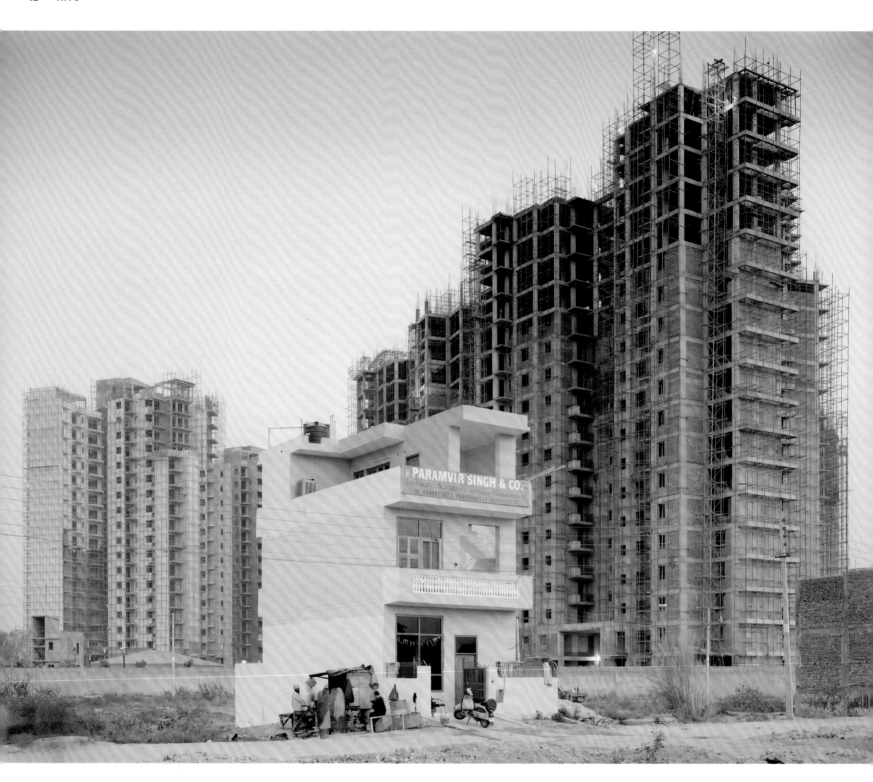

PETER BIALOBRZESKI
Transition-12, from the series *Lost in Transition* 2005

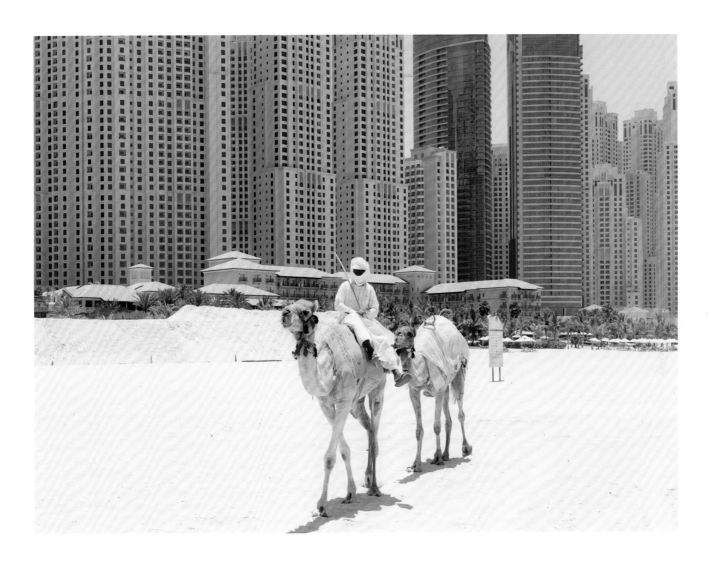

PHILIPPE CHANCEL
Desert spirit – Dubai, from the series *Datazone* 2010

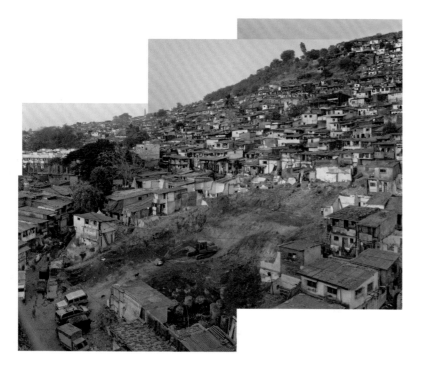
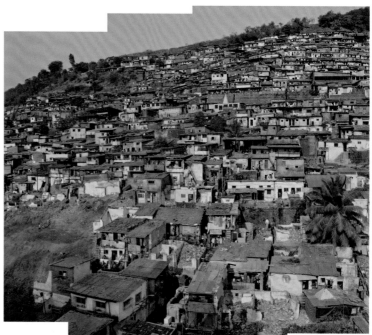

'We are witnessing the end of industrialism. The promise of industrialism was that more and more people could live longer and longer, get richer and richer. Now you can have only one of the three. You can have fewer people who live longer and longer, richer and richer, or you can have more people who live less long, poorer.'

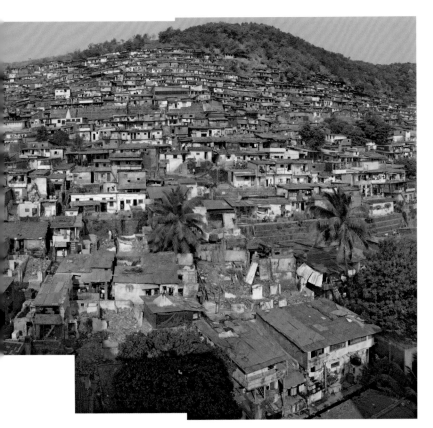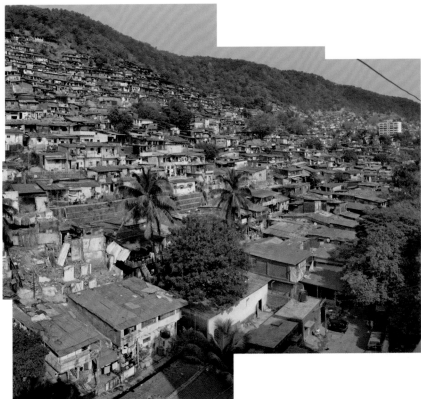

ROBERT POLIDORI
Amrut Nagar #3, Mumbai, India, from the series *Dendritic Cities* 2011

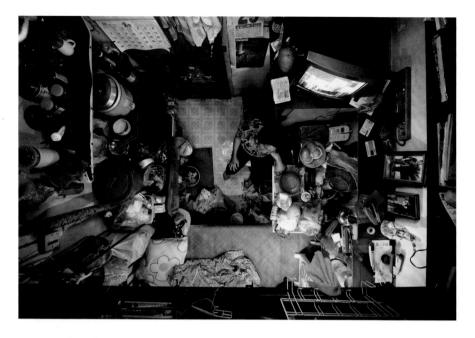

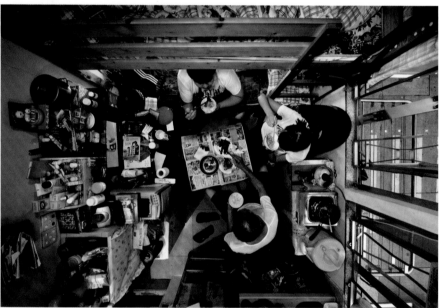

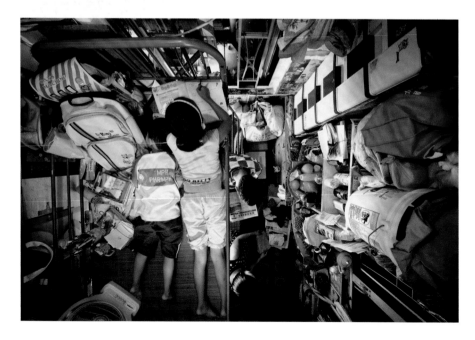

BENNY LAM
Trapped - sub-divided 06 2012

Trapped - sub-divided 03 2012

Trapped - sub-divided 01 2012

This 50-square-foot cubicle is a multi-function space
for the Leung family: sleeping room, dining room and
kitchen. Children curl up on the upper bunk bed, doing
their homework or playing. The father, who has difficulty
moving, stays on the lower bunk bed reading the newspaper
and constantly reminding the children not to disrupt their
neighbours. The mother sits beside him chopping vegetables,
preparing dinner.

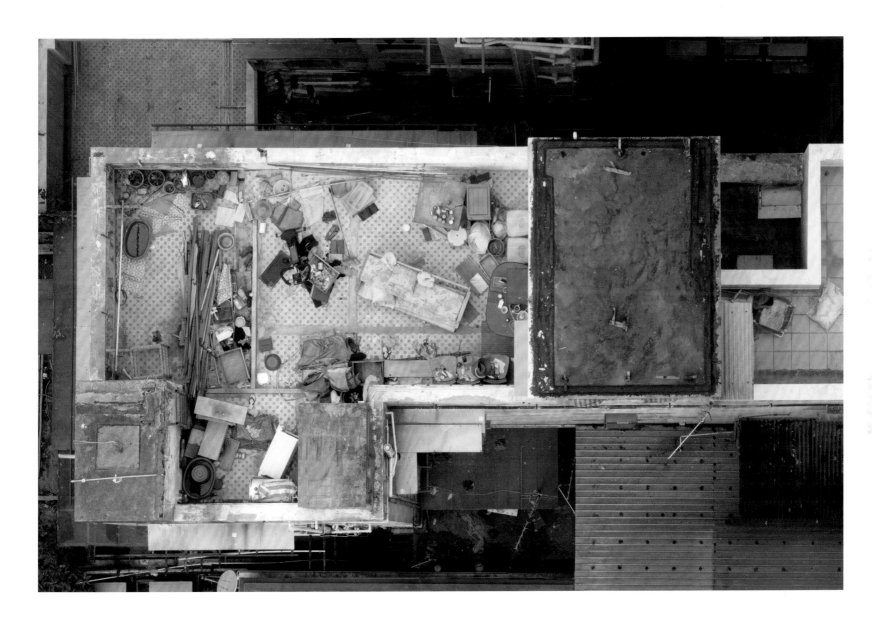

EASON TSANG KA WAI
Rooftop No.1 2011

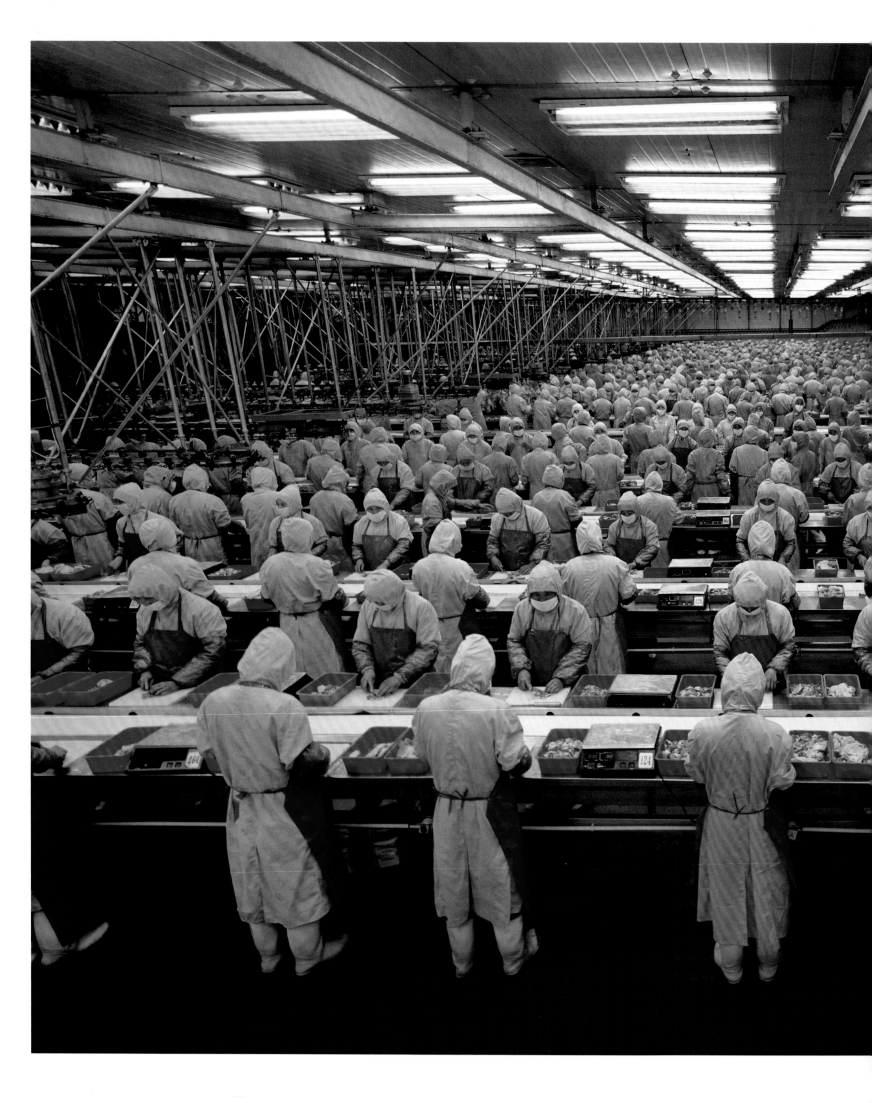

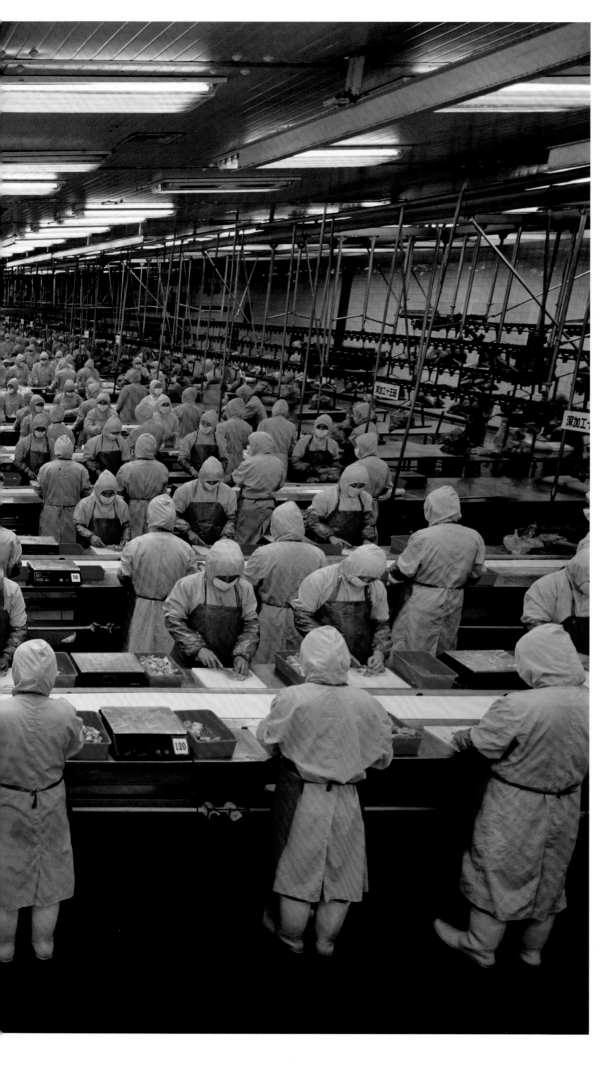

EDWARD BURTYNSKY
*Manufacturing #17, Deda Chicken Processing
Plant, Dehui City, Jilin Province, China 2005*

NEIL PARDINGTON
Abattoir #12 2010

Abattoir #7 2010

HENRIK SPOHLER
The Third Day, Tomato plantation in Middenmeer, The Netherlands nd

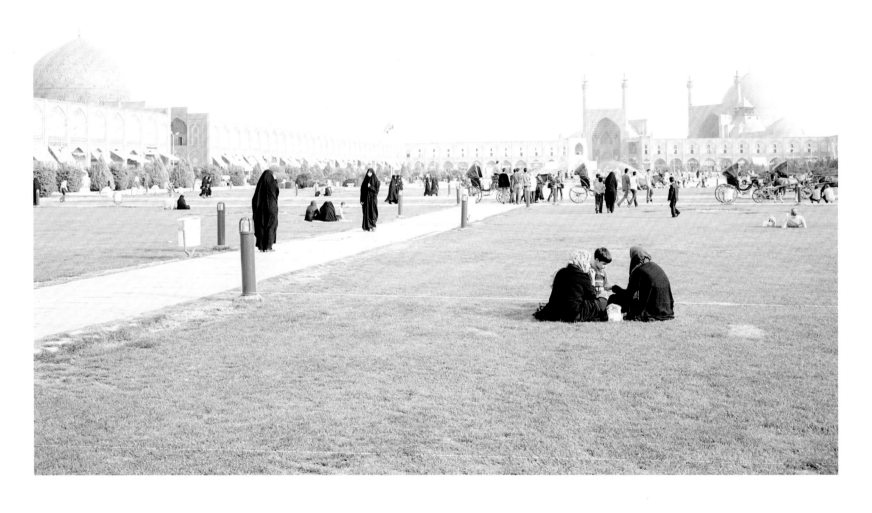

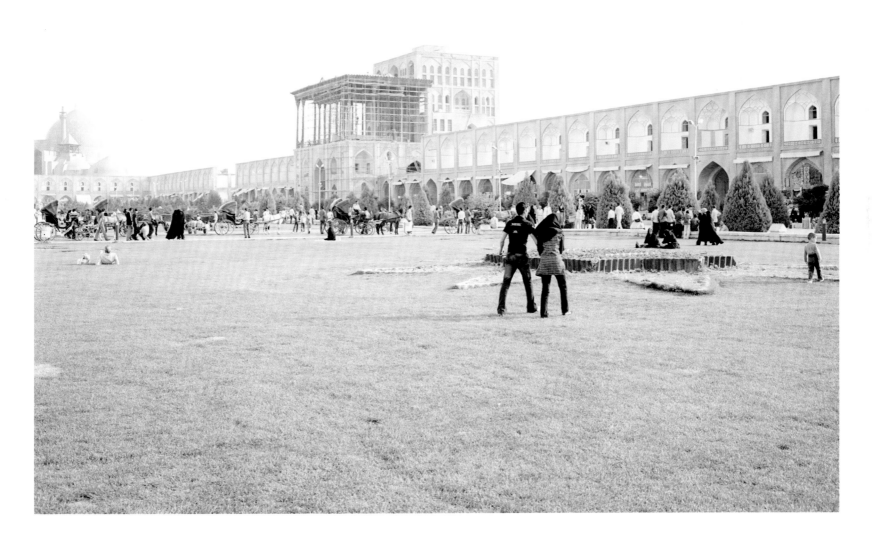

WALTER NIEDERMAYR
Isfahan, Iran 176, from the series *Iran* 2008

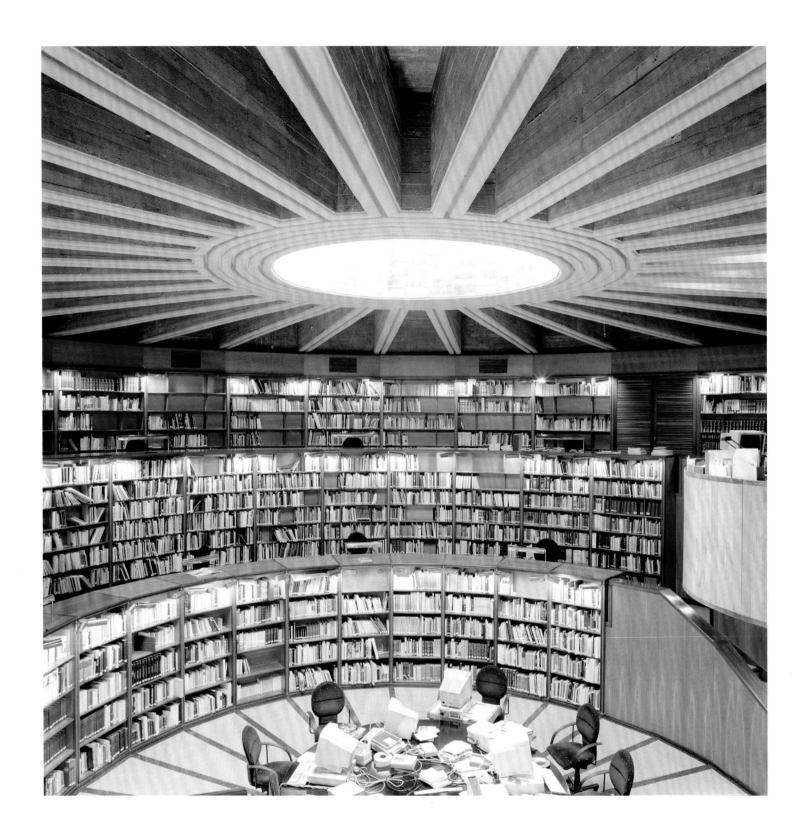

CANDIDA HÖFER
Biblioteca PHE Madrid I 2000

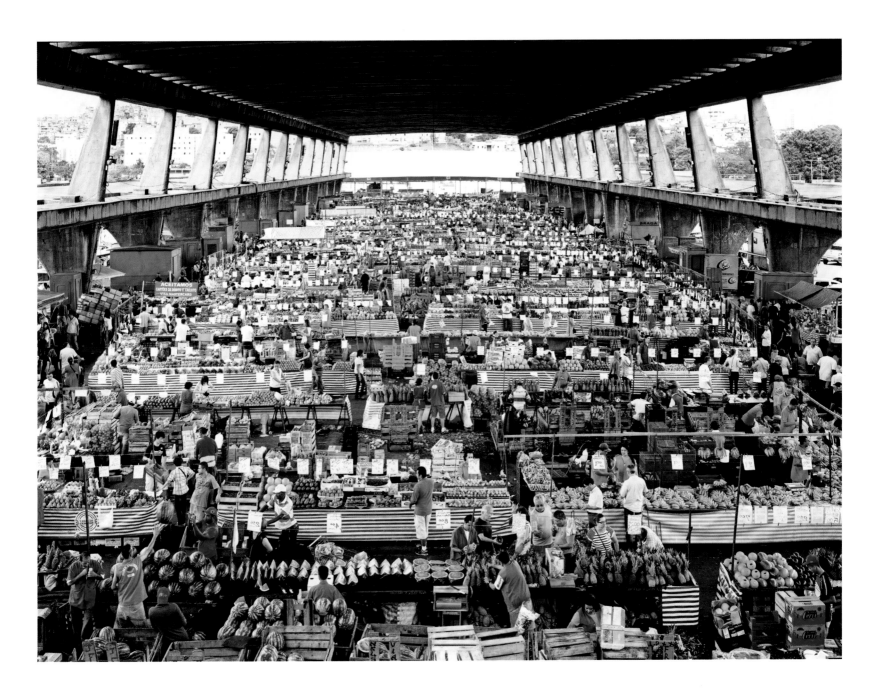

MASSIMO VITALI
CEAGESP São Paulo Analog Digital Diptych [shown here, only digital image] 2012

(first line, from left): Berlin; London; Stockholm; Cairo. (second line, from left): Athens; New York; Vienna; Basel. (third line, from left): Paris; São Paulo; Reykjavik; Lima. (fourth line, from left): Panama City; Mexico City; Sydney; Seoul. (fifth line, from left): Shanghai; Tokyo; Hanoi; Bangkok. (sixth line, from left): Dubai; Istanbul; Cape Town; Addis Ababa. (seventh line, from left): Nairobi; Venice; Tel Aviv; Prague

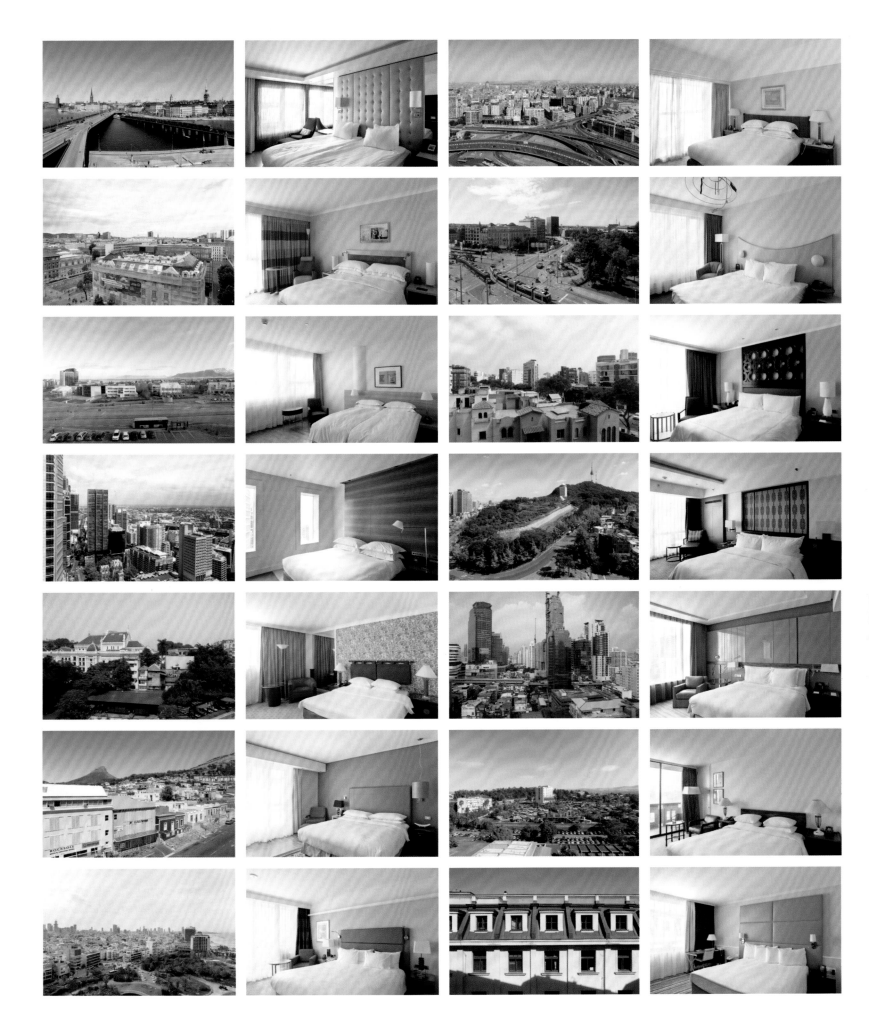

ROGER EBERHARD
from the series *Standard* 2015–16

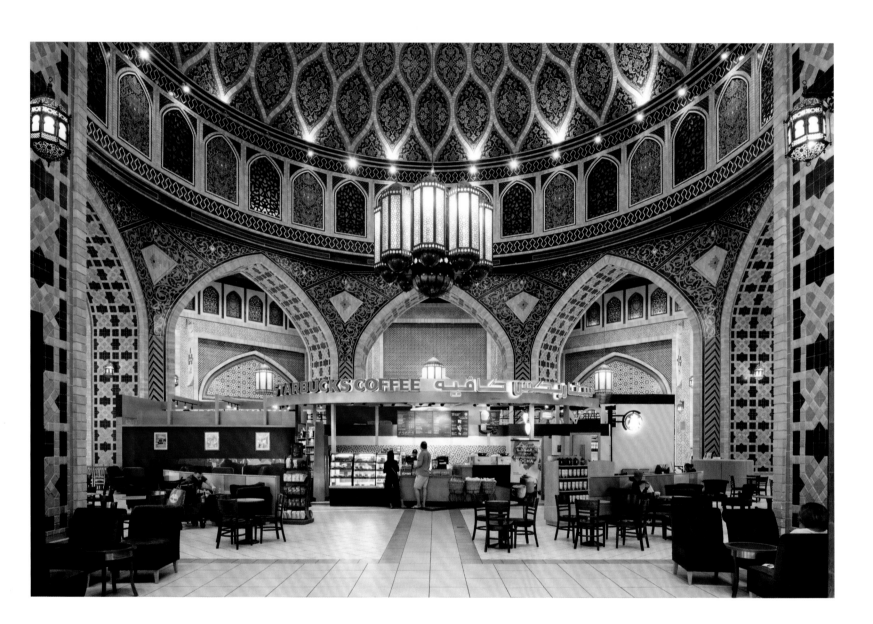

NICK HANNES
The Persian Court at the Ibn Battuta Mall, Dubai, 2016, from the series *Dubai. Bread and Circuses*

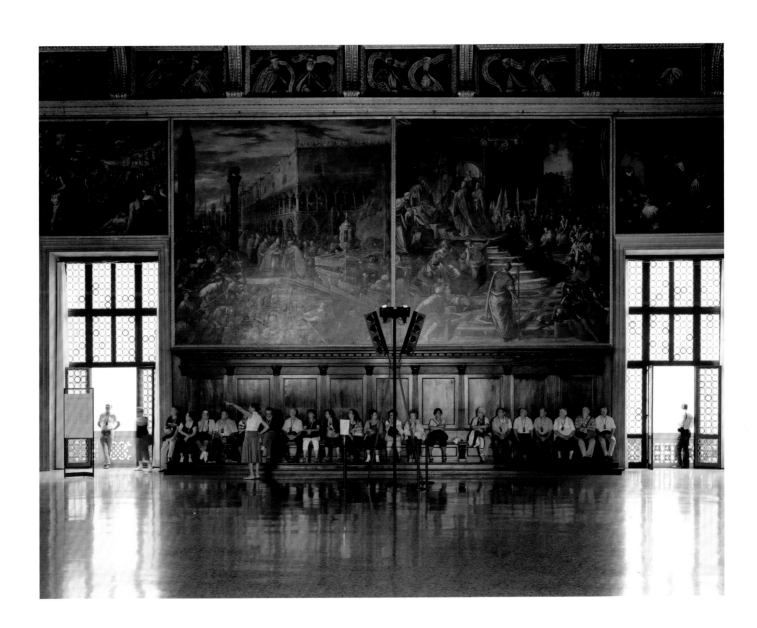

MARK POWER
Palazzo Ducale, Venice, Italy, from the series L'Italia E Gli Italiani 2013

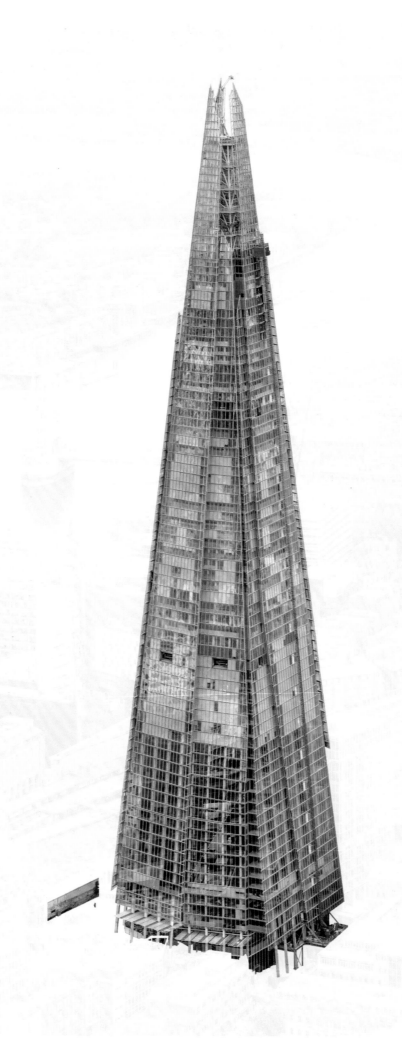

OLIVO BARBIERI
site specific_LONDON 12 2012

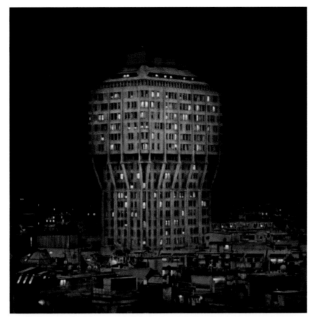
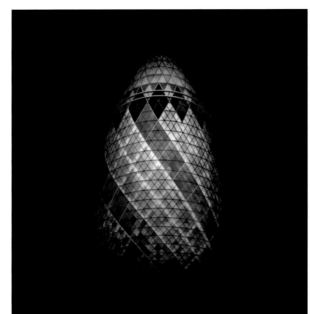
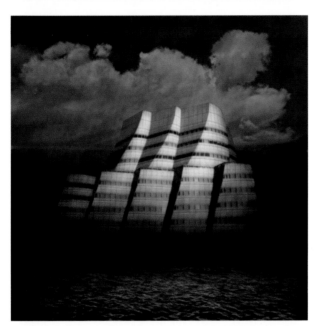
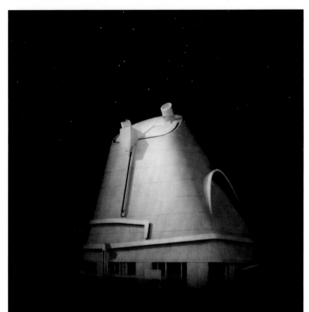

IRENE KUNG
from the series *The Invisible City*

(above left, right)
Torre Velasca [Milan] 2010

Gherkin London 2008

(centre left, right)
IAC Gehry NY 2010

Eglise Le Corbusier [Firminy] 2011

(below left, right)
Grande Arche Paris 2007

New Museum [NY] 2008

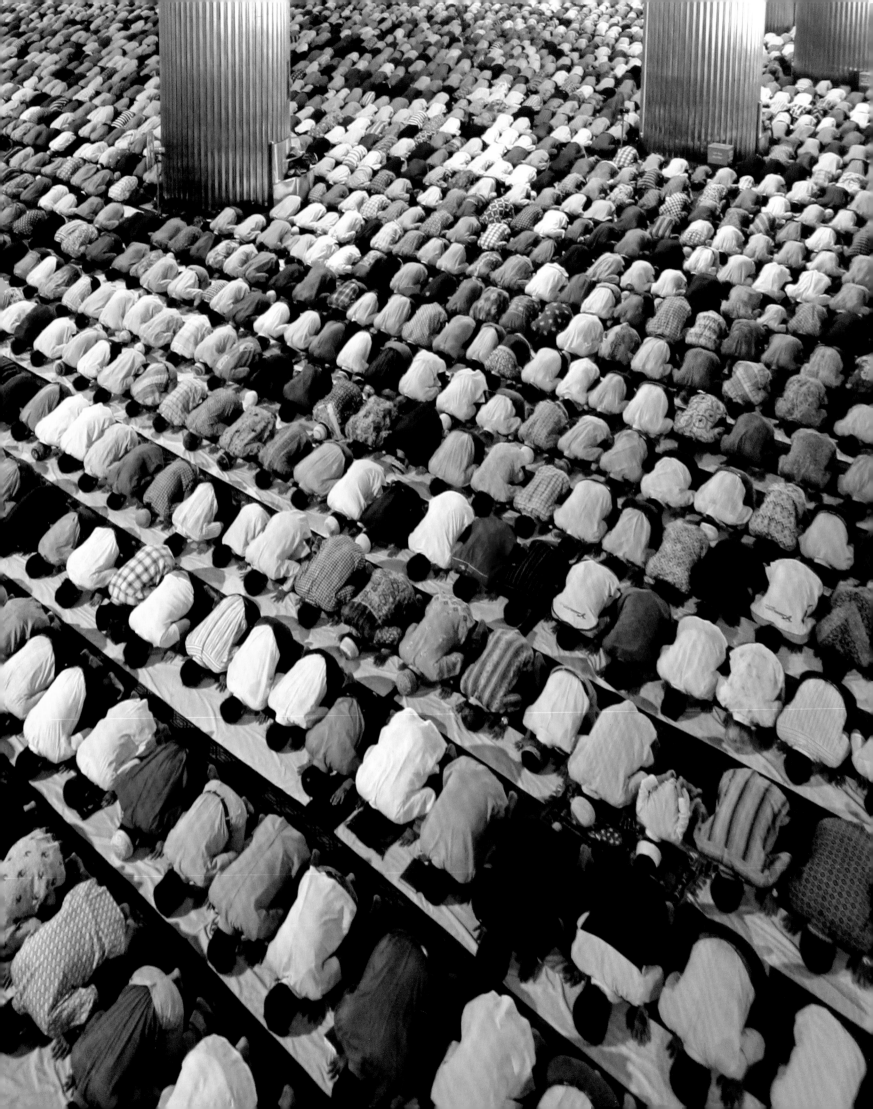

'We are not solitary mammals, like the fox and the tiger; we are genetically social, like the elephant, the whale, and the ape', wrote Ben Maddow in *Faces* (1977), a historical overview of photographic portraiture. The massive demand for portraits at all levels of society, from the medium's earliest years to this day, attests to this fact. Today, where there is a camera, there is a 'selfie', instantly shared with friends and strangers, sometimes with unforeseen consequences. Evan Baden lets us in on these private/public, social/anti-social stagings (pp. 100–01), widespread behaviour nourished by the cult of celebrity. Retreat from reality – seen increasingly as dull and boring – seems to be leading all of us towards an 'augmented' form: jazzed-up, dazzling, fast-paced; or even to a fully 'virtual form', where we escape the limitations of our bodies and our minds, not to mention acknowledging the physical presence of others (Trent Parke, p. 94). Lest we think that all social interaction is trending towards the isolation of the individual (Baden, p. 95), Lauren Greenfield and Raimond Wouda remind us that the social instinct is still alive and well in adolescent culture (pp. 98 and 99).

Yet the human being is a strange animal, equally *unsocial* at times, either by choice or by circumstance. From infancy most of us are drawn to others – or repelled – and the feelings are often mutual. Sometimes, it's part of a game. While Andy Freeberg's art gallery workers (p. 69) are there ostensibly to welcome potential clients, they barricade themselves off, not so subtly hinting to any who dare approach that they may not have the status worthy of a conversation, let alone ownership of a valuable work of art.

Many observers of shifting social patterns have noted the increasing atomization of society. In *Bowling Alone* (2000), Robert Putnam identified a disturbing behavioural change in American life, and signs of a similar fraying of the social fabric have been appearing in many other countries for decades now, suggesting some form of malaise at the heart of our civilization. Not surprisingly, darkness characterizes a number of pictures: Kim Taedong's young woman (p. 81), frozen still in a bleak urban scene, neither quite coming nor going; Adam Ferguson's soldiers (p. 67), alone with the weight of their heavy responsibilities; and David Moore's cocooned office workers, as if under a hypnotic spell (p. 83). An equally bleak vision of office work in Japan is given by Hiroshi Okamoto (p. 68); his subjects are primed and ready to enter the workforce – if it will have them, a sobering thought in today's fast-robotizing age. Wang Qingsong's (staged)

individual combined alonetogether

architect's workshop (pp. 104–05), on the other hand, suggests the doors are wide open for workers provided they behave as absolute conformists and *work! work! work!* at a feverish pitch.

Nor do the warm trappings of wealth seem to protect people from loneliness, as Ann Mandelbaum appears to suggest (p. 80). A lighter, more ambiguous feeling permeates the pictures of Larry Sultan's 'adult film' workers (pp. 90–91), who give the impression of being at ease with their roles, though the sites and accoutrements suggest a precarious, nomadic existence.

A similar darkness describes the work of Katy Grannan (pp. 106–07), even if searing sunlight envelopes the figures, people for whom the Californian variant of the American dream has remained a mirage. Struggle of another sort characterizes Cindy Sherman's female 'characters' (pp. 110–11): unlike Grannan's subjects, life has treated them well enough, it would seem…and yet one feels a vague sense of resignation and disappointment.

This is not to suggest that universal gloom in the matter of social cohesion pervades photography. Nor does 'alone' always mean 'lonely'. Natan Dvir's (p. 82) commuters are a case in point: young urbanites, whether students or workers, wait impatiently for the train, respectful of each other's space. Penelope Umbrico (pp. 88–89) even proposes that people can form communities without quite realizing it. Her intriguing if impersonal inventories of things we love but ultimately discard might be contrasted to Hong Hao's very personal hoard (pp. 108–09) of accumulated *things* – banal individually, fascinating collectively; one has only to think of the thousands of people involved in all that manufacture to appreciate our mutual interdependence.

Ordered structures of sociability attract other photographers like Paul Bulteel (p. 71), Mitch Epstein (p. 77), Andrew Moore (p. 76) and Paul Shambroom (p. 85), each of whom provides us with a wider and informative context for the groups they picture, whether children, footballers, cattlemen or town councillors – all visible evidence that social institutions of varied types and complexities appear to be *working*. A healthy social order is also evoked in the vibrant scenes of religious life shown to us by Ahmad Zamroni (p. 72), Michele Borzoni (p. 73) and Andrew Esiebo (p. 86), while non-religious rites of deep social significance – like American parades – have been documented in depth by George Georgiou (pp. 74–75).

That family life is alive and well, though shifting in its forms, is seen in work from three continents, thanks to Yeondoo Jung (pp. 102–03), Anne Zahalka (pp. 96–97) and Dona Schwartz (pp. 92–93). We all go on, one way or another, generation following generation, *alonetogether*.

AHMAD ZAMRONI
Muslims at prayer, Jakarta
[detail, see p. 72]

overleaf
ANDREW ESIEBO
God is Alive
[detail, see pp. 86–87]

'The global connectivity made possible by digital technologies has changed the way we live and navigate our world. The Internet seems like a magic carpet that can take us anywhere and everywhere. We feel as if we are omniscient – we have seen all that civilization has to offer – but of course that's not possible. Despite our sense that we grasp the contours of our civilization, there are vast areas we have yet to colour in. Certainly, we have extended our reach but have we also extended our understanding of what we've encountered? Do we embrace civilization's rich diversity or circle the wagons to keep difference at bay?'

Dona Schwartz

'As Chris Hedges said: "Social media is the end of friendship." We're offering our presentational selves but friendship is all about being vulnerable. So we have this so-called "friendship" where we're on Facebook with 5,000 friends as a replacement for the real vulnerable friendship. Friendship on social media is curating the photographs of ourselves, curating how we're presenting ourselves. It's an image-based expression.'

Lauren Greenfield

'I wonder, given the promise of connection that the Internet fosters, if there's a subconscious undercurrent of exhibitionism here; a plea for attention.'

Penelope Umbrico

simultaneous unique joint deserted

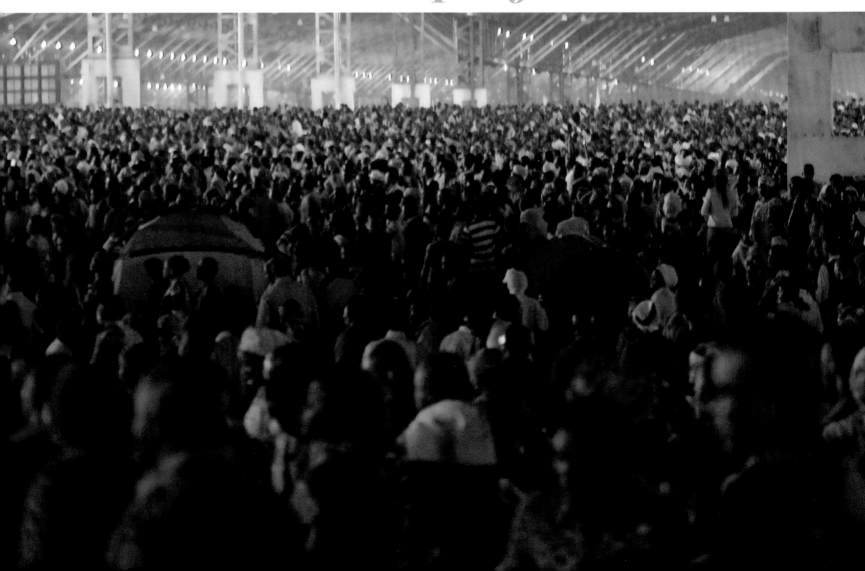

'Our civilization continuously bounces between collective needs and the aspiration of the individual, between the ideals of the citizen and the self-orientation of the consumer, between solidarity and greed, between inclusiveness and loneliness.'

Paul Bulteel

'...a man is shown standing in the kitchen, looking out the window. He happens not to have any clothes on, but for me, that picture recalls a really poignant moment where, in the middle of the day, you have a glass of cold water and you look out the window and wonder, what am I doing here?'

Larry Sultan

'In our current stage of social development as an increasingly digitized civilization we have become accustomed to the distractedness of mobile devices in public spaces, whether on the street or in the mall. Being there but not there, being explicitly detached, would seem to be a common sign not only of an increasingly affectless public realm, but also of fundamental shifts in the way we understand and value communal experience.'

Simon Roberts

crowd outcast united solitary group

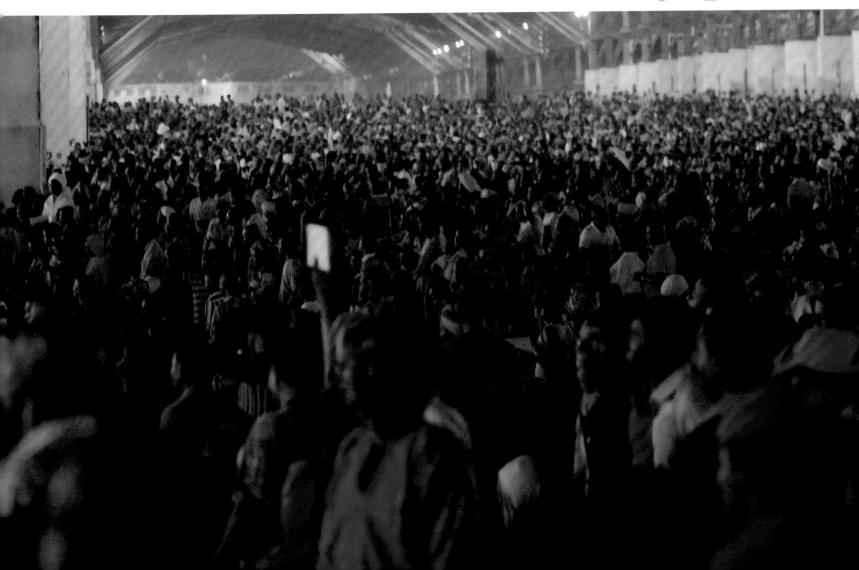

ADAM FERGUSON
from the series *Pilots, USS Theodore Roosevelt*

Skull 2015

Pickle 2016

Bones 2015

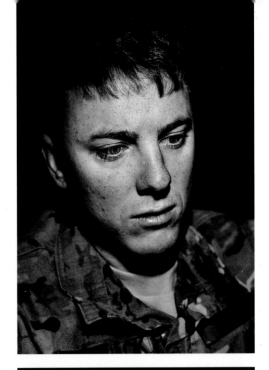

'The fear comes after the climaxes of danger. It's easy to be fuelled by adrenaline and get consumed by a gunfight or seeing someone get hurt. It doesn't take a hero to thrive on violence – it's one of the most fundamental, primal urges humans have. It can be a shock to the self to realize how easy one can be enthralled by it.

But after, when the violence has passed physically, it leaves behind an emotional footprint you have to walk in. While the war is seemingly over, it still rolls on. That's the toughest part, that's when the real courage is required. Waking up at home and feeling war, that's the scariest moment I have had.'

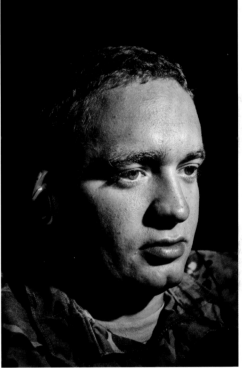

ADAM FERGUSON

Skyping Soldier 3 2011

Skyping Soldier 4 2011

Skyping Soldier 1 2011

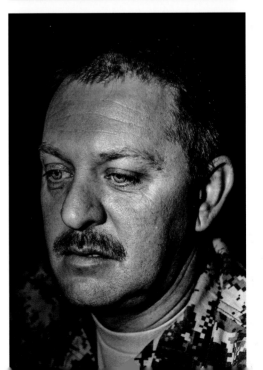

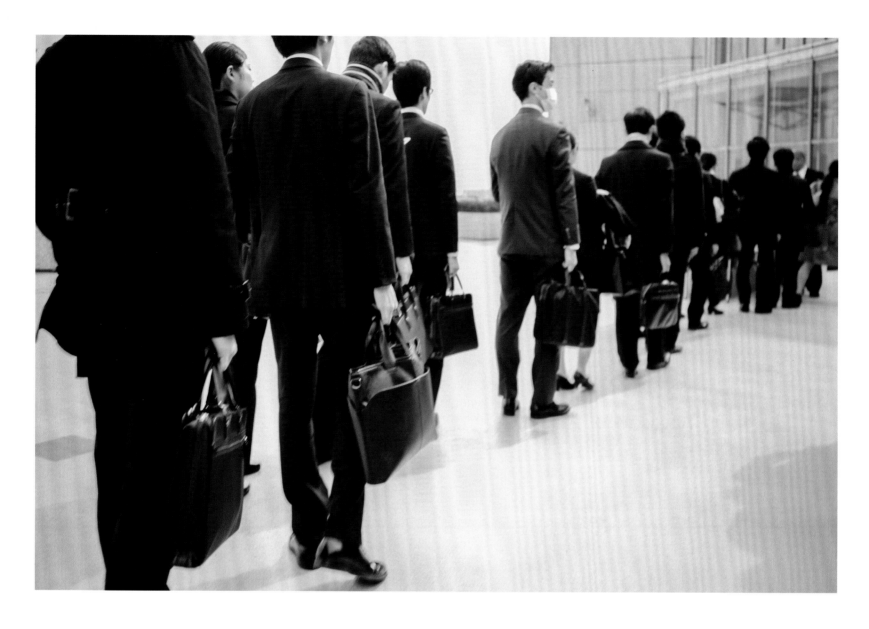

'I want to die.' During February 2013, this email was sent by my best friend at university who was job-hunting. In Japan, more than half a million students participate in job-hunting every year. Students go into this frantic game with desire and anxiety for their future careers. *Recruit* is the personal experience of Yo Toshino searching for a job. It is just one of the stories among the country's numerous job-seekers.

HIROSHI OKAMOTO
Recruit 2014

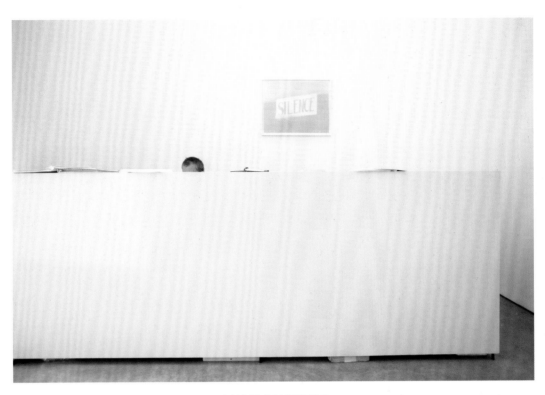

ANDY FREEBERG
Paula Cooper Gallery, from the series *Sentry* 2006

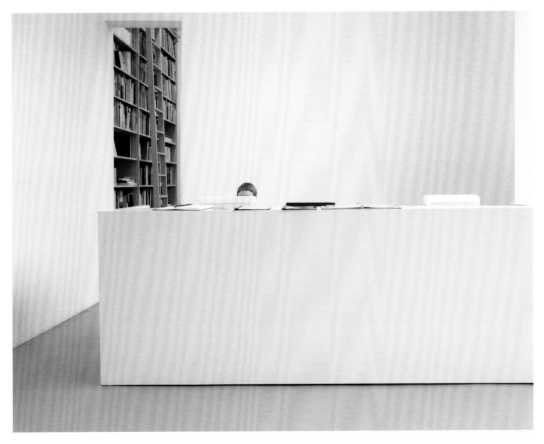

ANDY FREEBERG
Mitchell Innes & Nash Gallery, from the series *Sentry* 2006

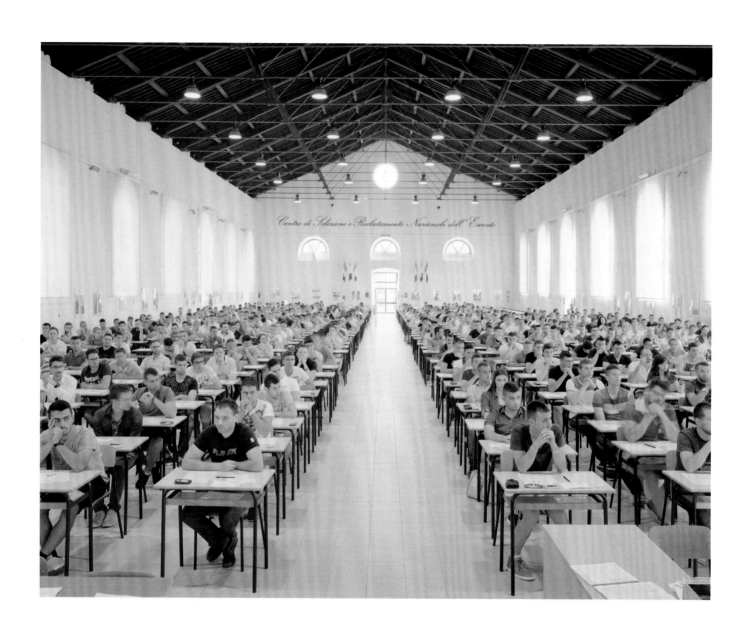

MICHELE BORZONI
*Open competitive examination for recruitment of 860 non-commissioned military officers. 7672 people applied
to the examination at the recruitment centre of the Italian army in Foligno, 2014, from the series Workforce*

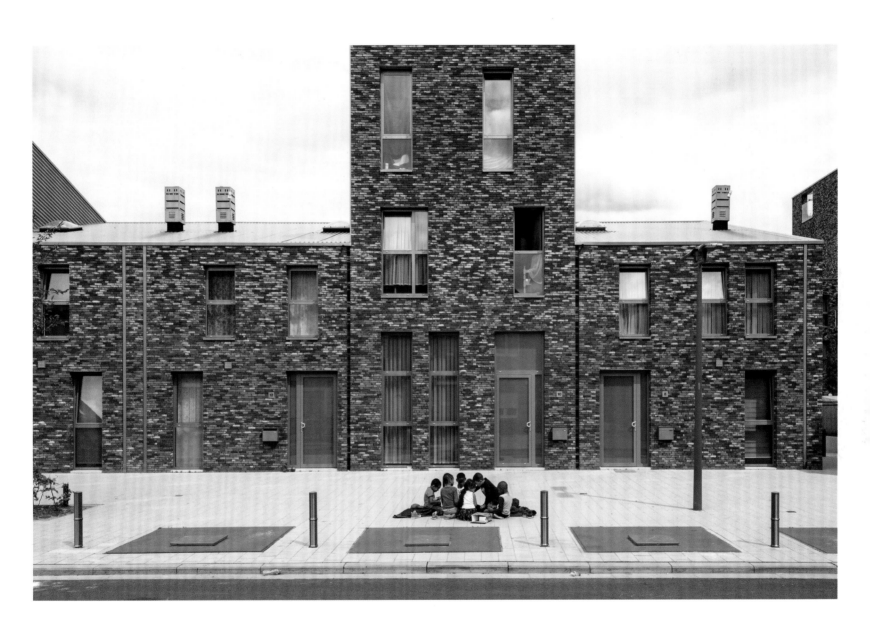

PAUL BULTEEL
Untitled (Figurants series) 2016

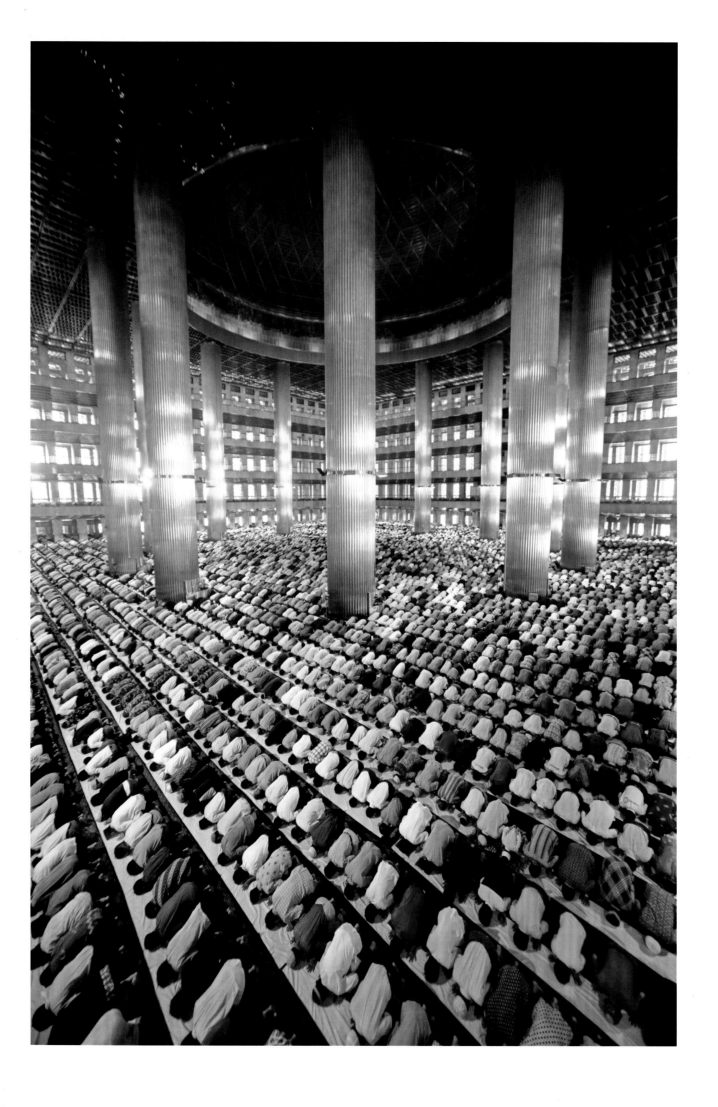

AHMAD ZAMRONI
*Muslims at prayer, Jakarta. More than 90 per cent
of Indonesia's some 220 million people follow Islam,
making it the world's biggest Muslim nation 2007*

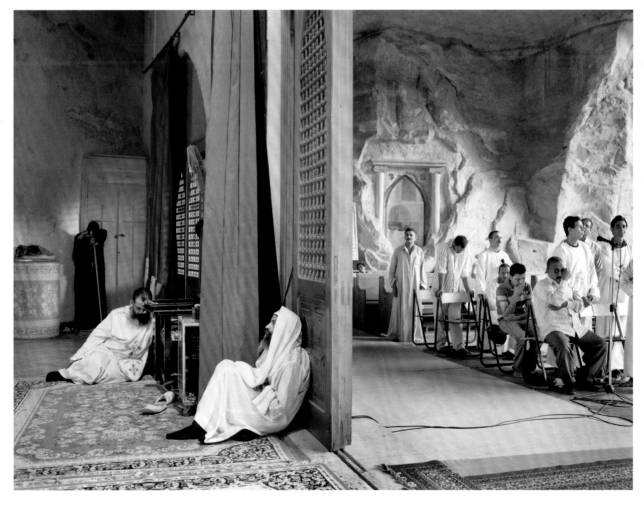

MICHELE BORZONI
*The church, believed to be the largest in the Middle East, is built within the rock. The inhabitants of Cairo's Garbage City, the
Zebelin, collect the garbage and recycle it in this neighbourhood on the outskirts of the capital, from the series Inshallah 2011*

'Parades make the community visible to itself. In a lot of places, a community doesn't see itself – then you have that day when you can see people you haven't seen for ages. And an outsider can see that community too and lose any prejudices of that neighbourhood.'

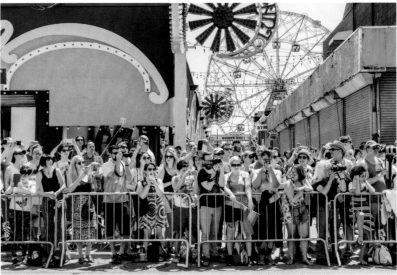

GEORGE GEORGIOU
from the series *In the Company of Strangers: Americans Parade*
George Washington Day Parade, Laredo, Texas, USA. 20/02/2016

Mermaid Parade, Coney Island, New York, USA. 18/06/2016

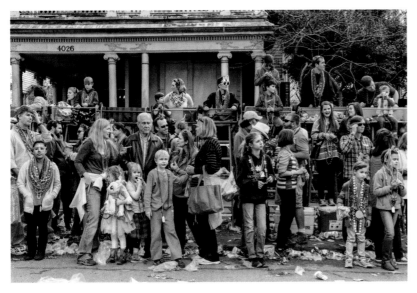

Mardi Gras Parade, Algiers, New Orleans, Louisiana, USA. 06/02/2016 *Mardi Gras Parade, Algiers, New Orleans, Louisiana, USA. 06/02/2016*

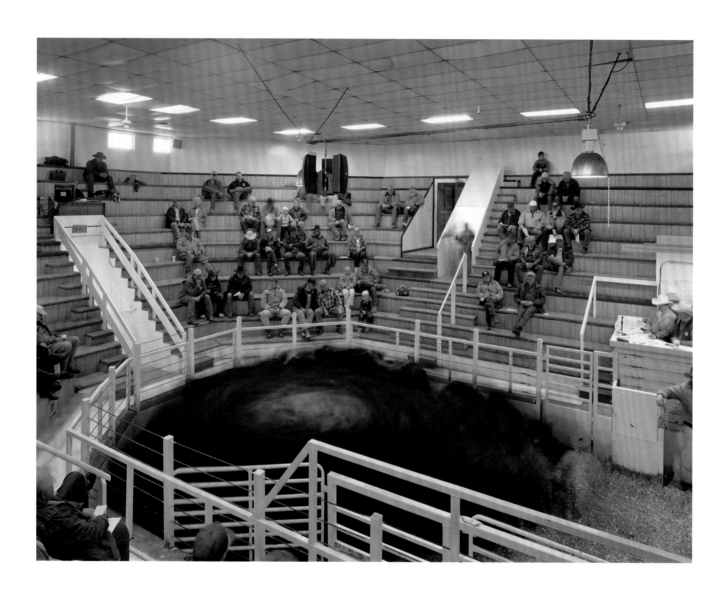

ANDREW MOORE
Bassett Cattle Auction, Rock County, Nebraska, from the series *Dirt Meridian* 2006

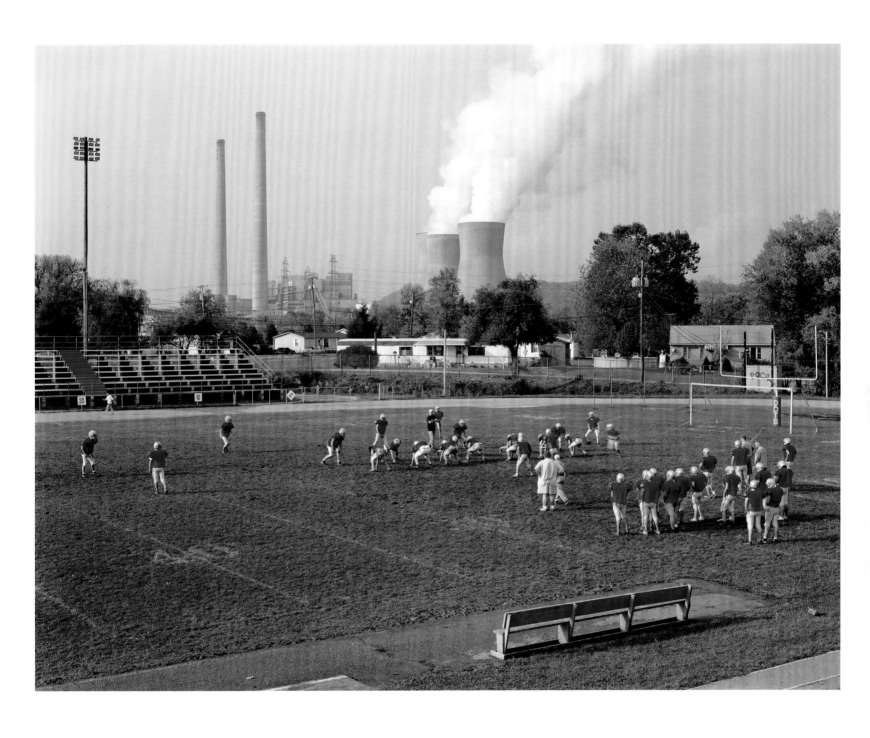

MITCH EPSTEIN
Poca High School and Amos Plant, West Virginia, 2004, **from the series** *American Power*

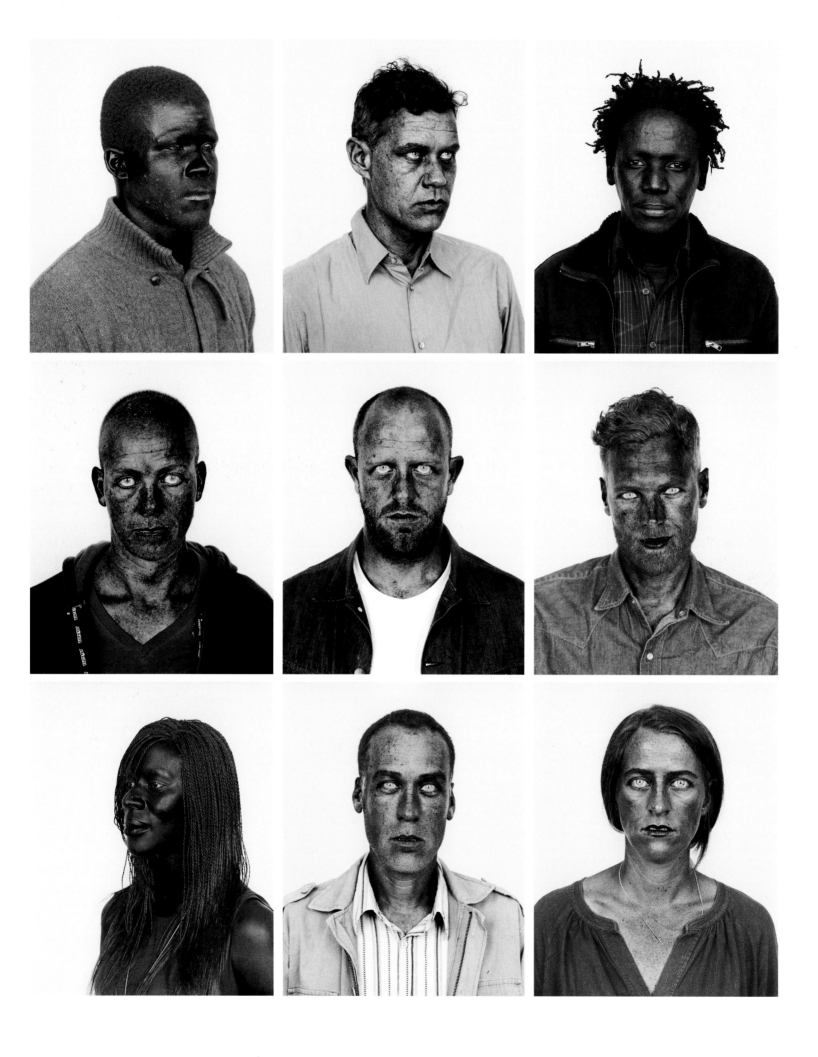

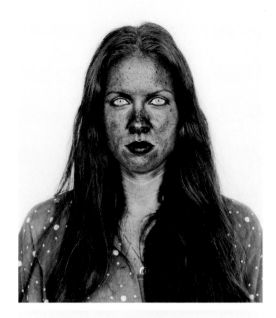

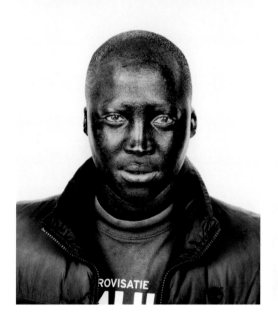

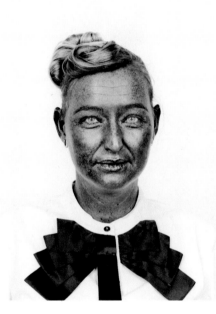

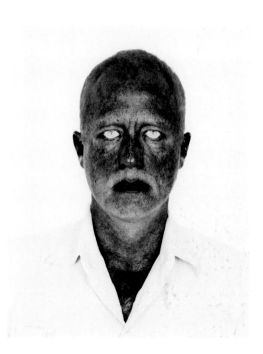

Through a digital process of converting colour images to black and white while manipulating the colour channels, Hugo emphasizes the pigment (melanin) in his sitters' skins so they appear heavily marked by blemishes and sun damage. The resulting portraits are the antithesis of the airbrushed images that determine the canons of beauty in popular culture, and expose the contradictions of racial distinctions based on skin colour.

PIETER HUGO
from the series *There's a Place in Hell For Me and My Friends* 2011–12
(opposite above, left to right) *Thabiso Sekgala (2); Matthew Hindley (1); Lebo Tlali (2);*
(opposite centre, left to right) *David Scholtz; Pieter Hugo; Hayden Phipps;*
(opposite below, left to right) *Nandipha Mntambo (4); John Murray (2); Annebelle Schreuders (1);*
(top) *Manuela Kacinari;* (above, left to right) *Themba Tshabalala; Ashleigh McLean; Michael Stevenson (1)*

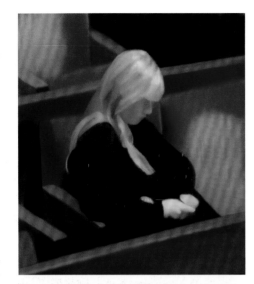

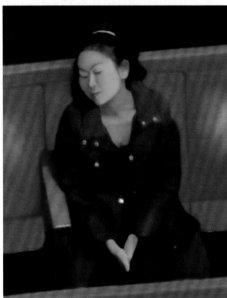

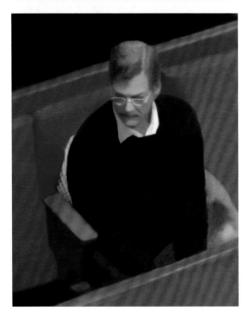

'Born to a root which offers a choice:
we turn toward or back, plug-in or reject,
group and regroup, sit still or branch out,
as order reverses and time fans the race.'

ANN MANDELBAUM

#3, 6, 2 from the series Audience 2012

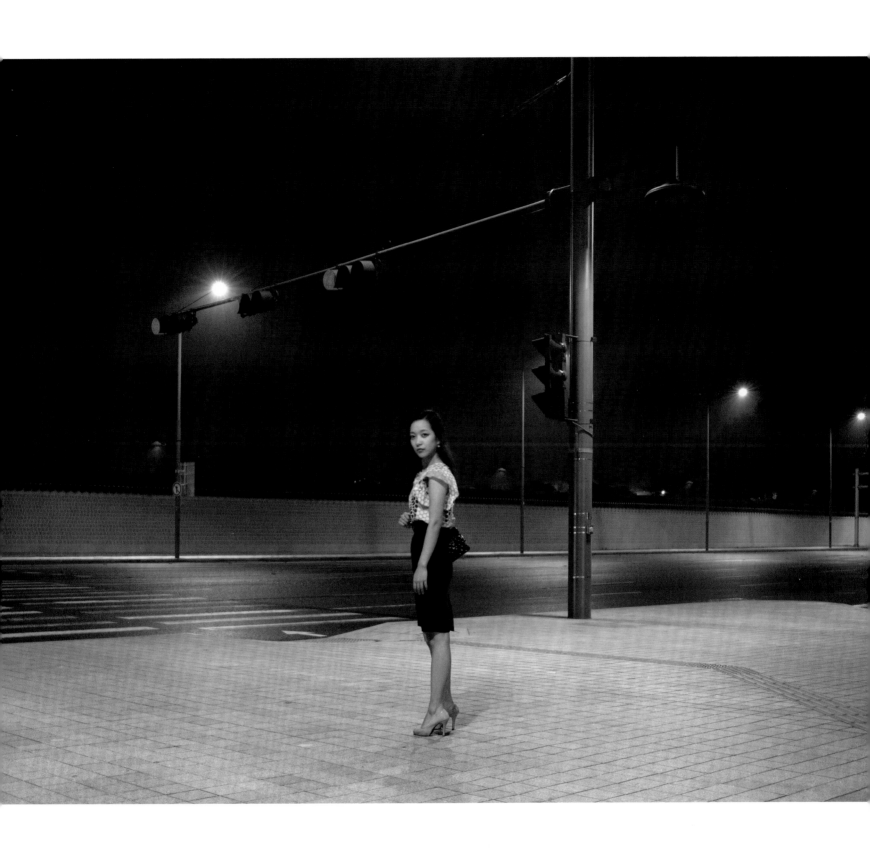

KIM TAEDONG
Day Break-001 2011

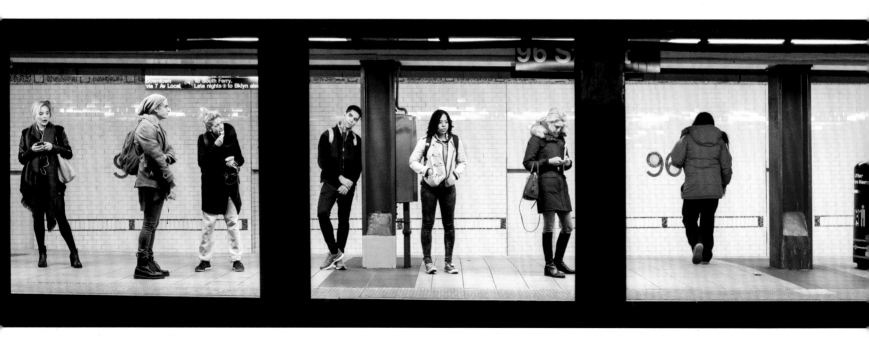

NATAN DVIR
96th St, 6:42pm, from the series *Platforms* 2016

DAVID MOORE
Untitled, from the series *Office* 2003

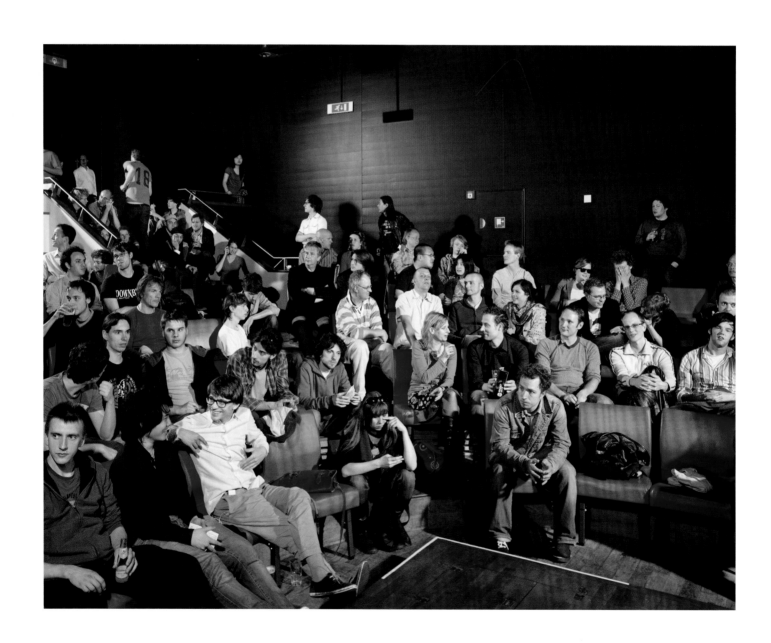

RAIMOND WOUDA
Bimhuis, from the series *Audience* 2009

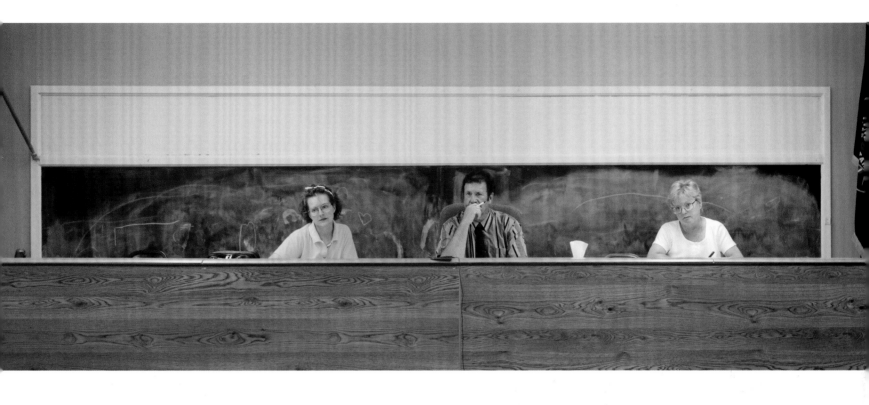

PAUL SHAMBROOM
Stockton, Utah (population 567) Town Council, June 11, 2001 (L to R): Angie Harrison, Barry Thomas (Mayor), Claudia Baker, from the series *Meetings* 2001

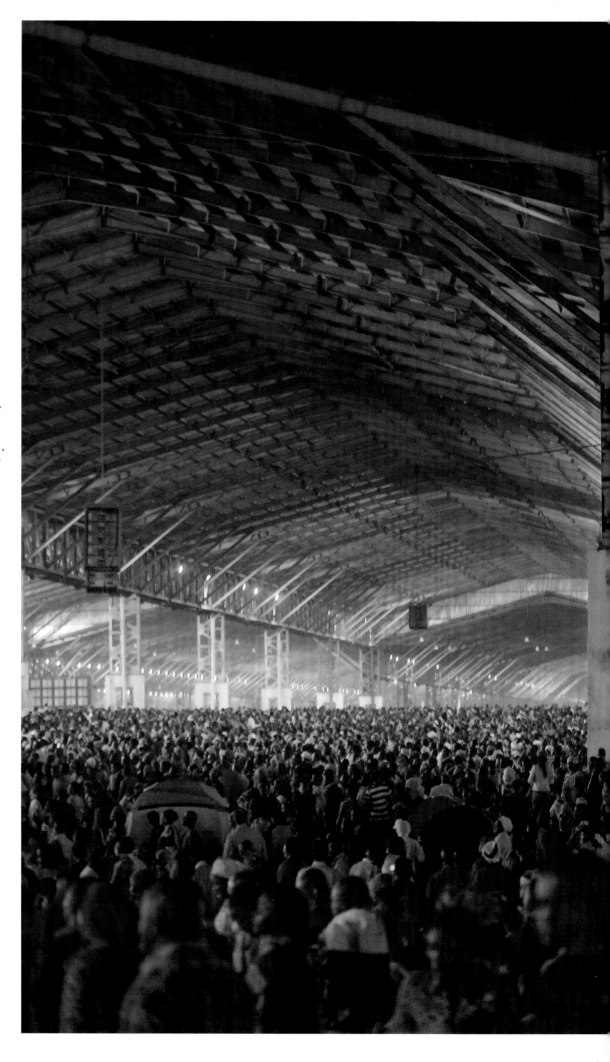

'God is at the heart of life in Nigeria. Religious spaces are found in every nook and cranny in the country.

A current wave is the Pentecostal and Charismatic movements that arose in the 1970s from the literate environment of Nigerian tertiary colleges and universities.'

ANDREW ESIEBO
God is Alive **2011**

Gathering during the monthly Prayer service called 'Holy Ghost Night' at the 1km-square auditorium of the Redeem Christian Church of God, one of the fastest-growing Pentecostal churches in the world.

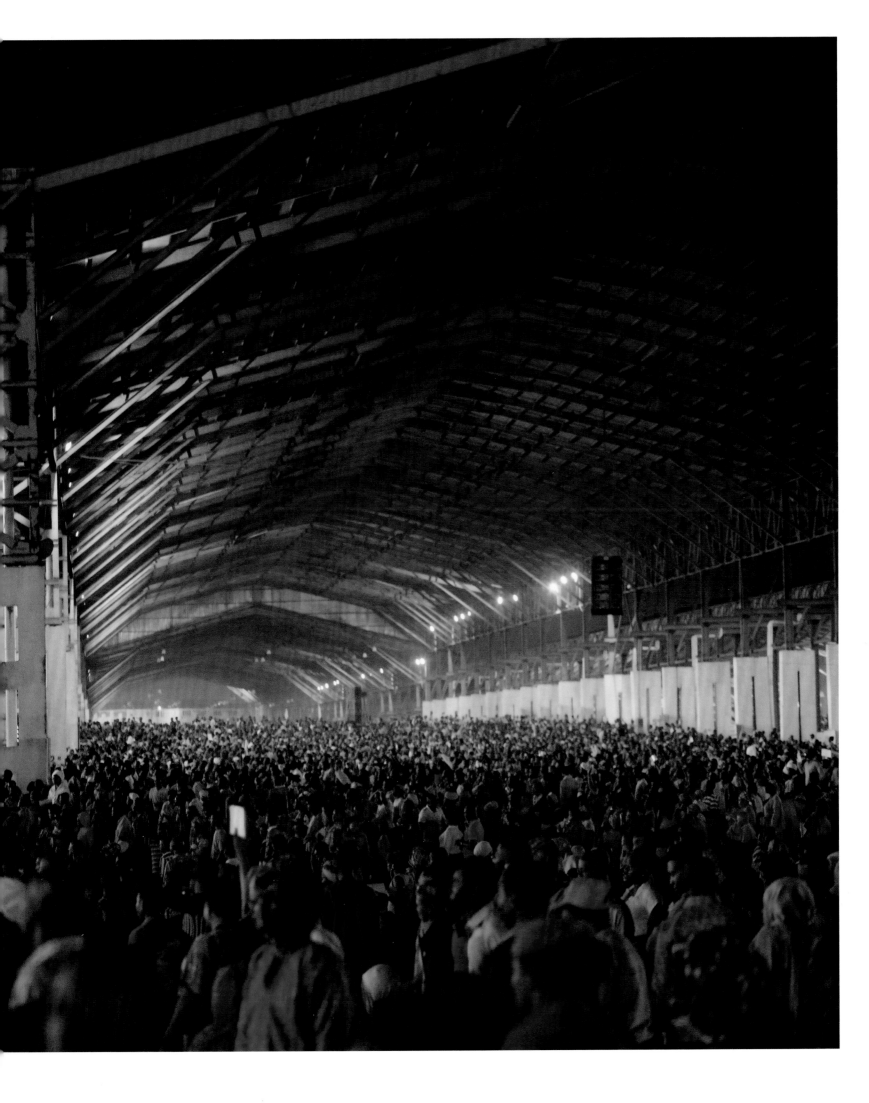

For *TVs from Craigslist* I downloaded images of used TVs for sale on Craigslist, cropped all but the screens from them, and enlarged them to the scale of the TV. The inadvertent reflections of the sellers become the subjects, within the dark screens of their unwanted used TVs. For each image, I make an edition of two. The first edition is available for purchase on Craigslist for the price of the original TV; the second edition is available for purchase at standard gallery prices.

PENELOPE UMBRICO
TVs from Craigslist 2008–ongoing

As with *TVs from Craigslist*, these images were downloaded from online advertisements. On eBay there are countless numbers of 'previously owned' ceramic cat figurines for sale. They are pictured in various domestic settings, often lovingly photographed 'looking' straight into the camera. They seem to pose for the shot, not as the cold ceramic objects they are, but, uncannily, as if they were the actual animals they portray: sometimes looking lovingly back at their owners/sellers.

PENELOPE UMBRICO
Ceramic Cats (eBay) **2015**

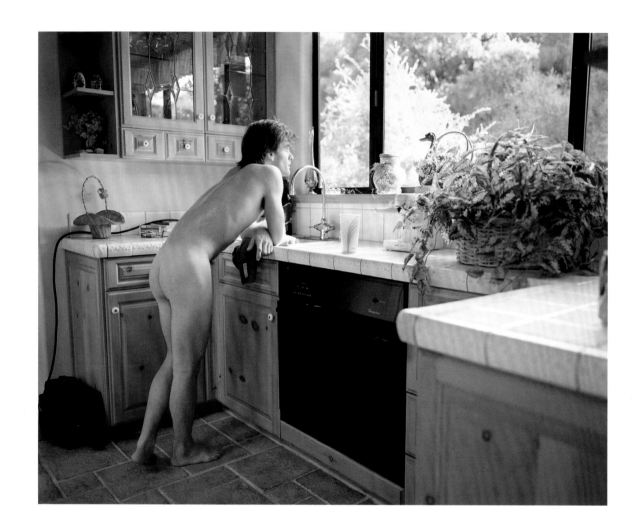

LARRY SULTAN
Topanga Skyline Drive #1, from the series *The Valley*　1999

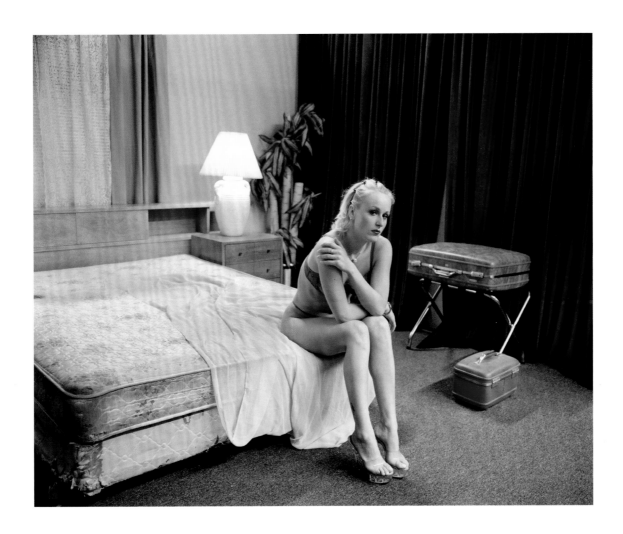

LARRY SULTAN
Sharon Wild, from the series *The Valley* 2001

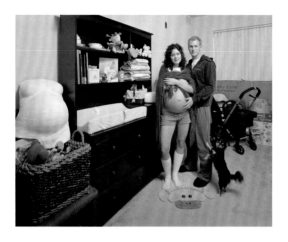

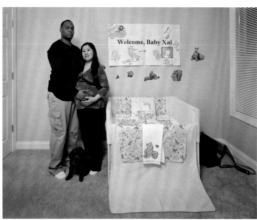

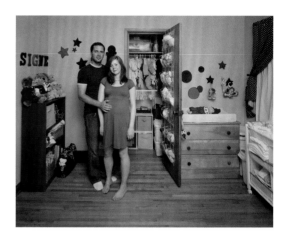

Kristen and Ryan, 18 days 2006

Liz and Deedrick, 14 days 2007

Nicole and Stephen, 14 days 2008

DONA SCHWARTZ
from the series *Expecting Parents*

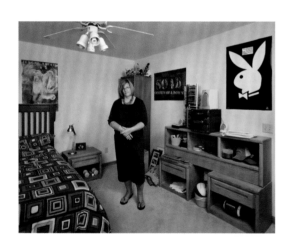

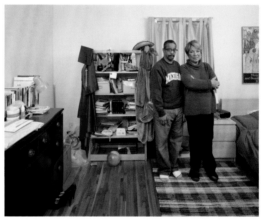

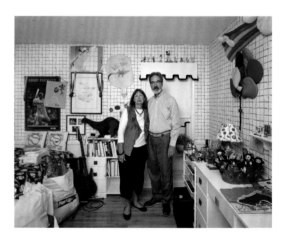

Jean, 2 years 2011

Kathy and Lyonel, 18 months 2010

Lollie and Alan, 3 months 2010

DONA SCHWARTZ
from the series *Empty Nesters*

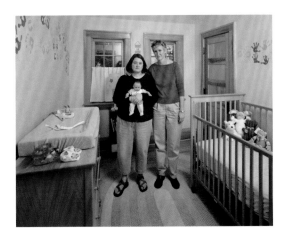

Desiree and Karen, 68 days 2006

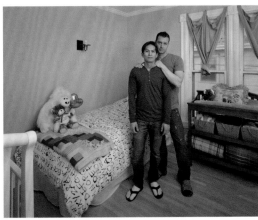

Bobby and Kevin, Waiting to Adopt 2012

Yejin and Hyung-il, 6 days 2011

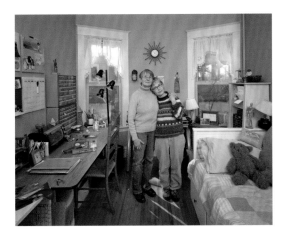

Chris and Susan, 7 months 2012

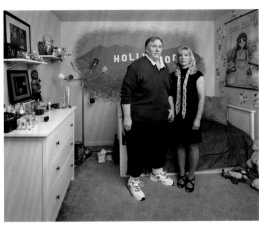

Pam and Bill, 2 months 2010

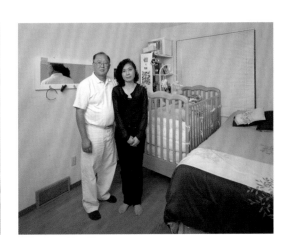

Younsu and Kyunghan, 1 year 2012

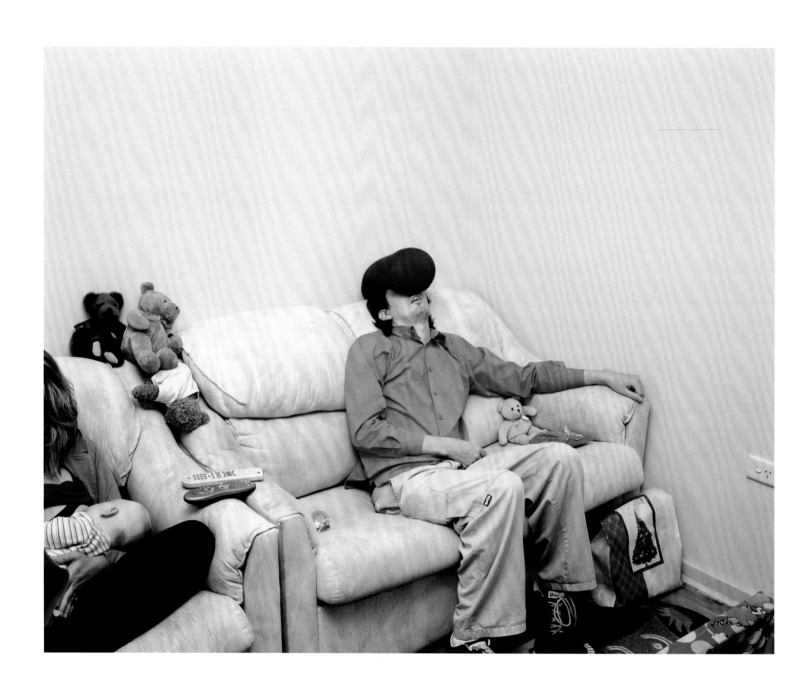

TRENT PARKE
Untitled, from the series *The Christmas Tree Bucket* 2006

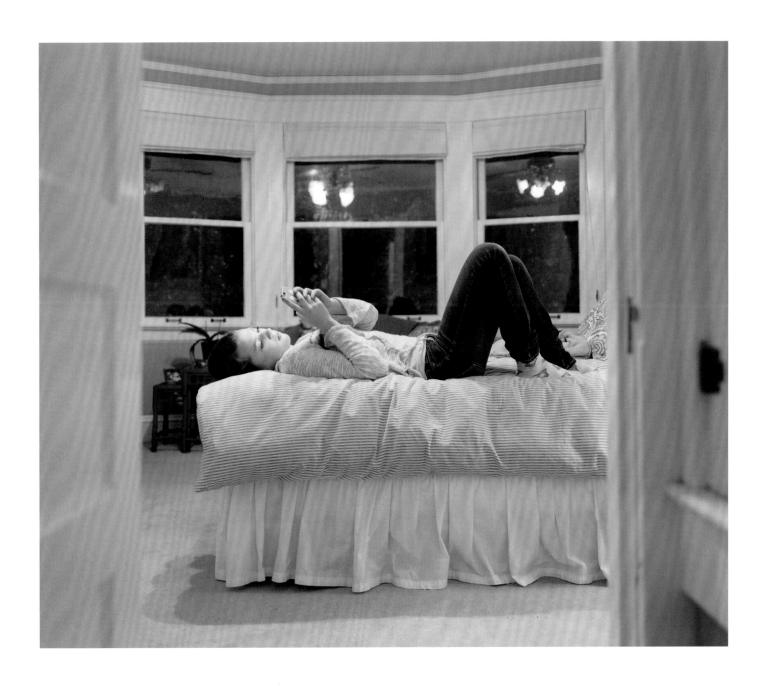

EVAN BADEN
Culla, Snapchat, from the series *The High School Yearbook Project* 2014

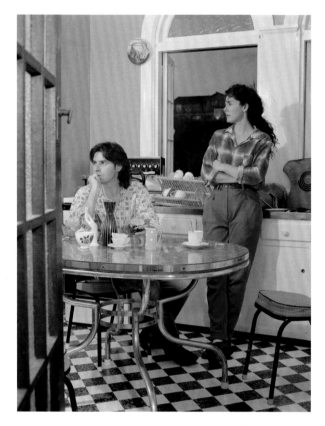

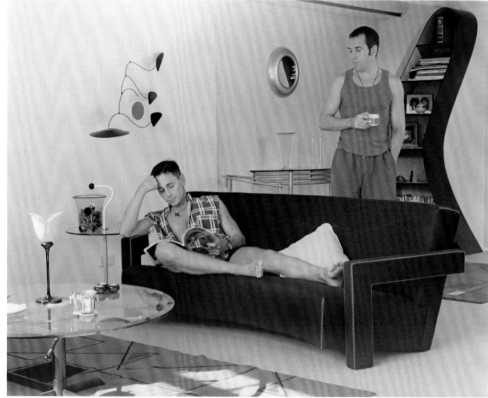

These photos taken of my social milieu in their rented homes in the mid-1990s document the relationships and living situations of the occupants through the small rituals performed within daily life.

ANNE ZAHALKA
from the series *Open House* 1995
Saturday, 5:18pm

Sunday, 11:08am

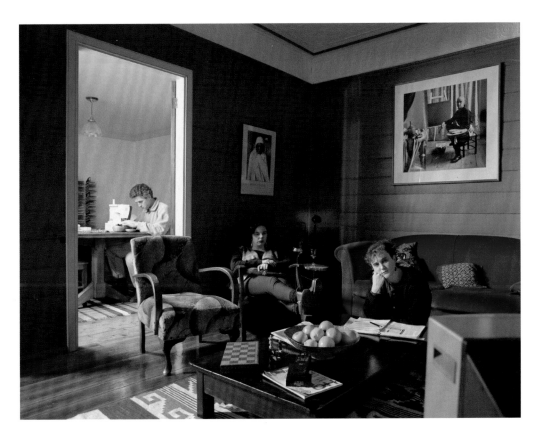

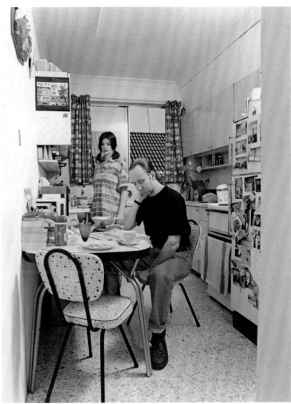

Wednesday, 8:40pm

Saturday, 2:48pm

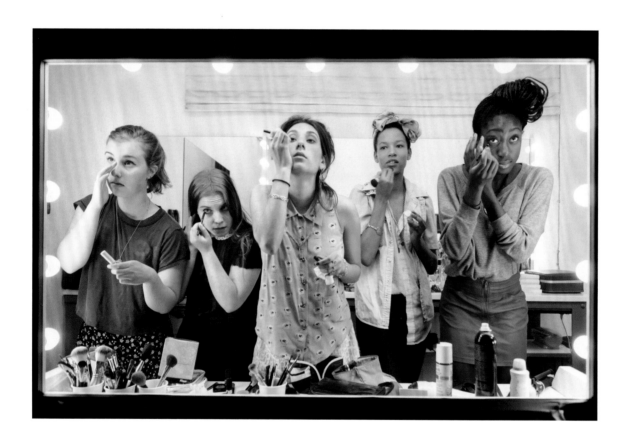

LAUREN GREENFIELD
*High school seniors (L to R) Lili, 17, Nicole, 18, Lauren, 18, Luna, 18 and Sam, 17, put on their makeup in front
of a two-way mirror for the author's Beauty CULTure documentary, Los Angeles, 2011*

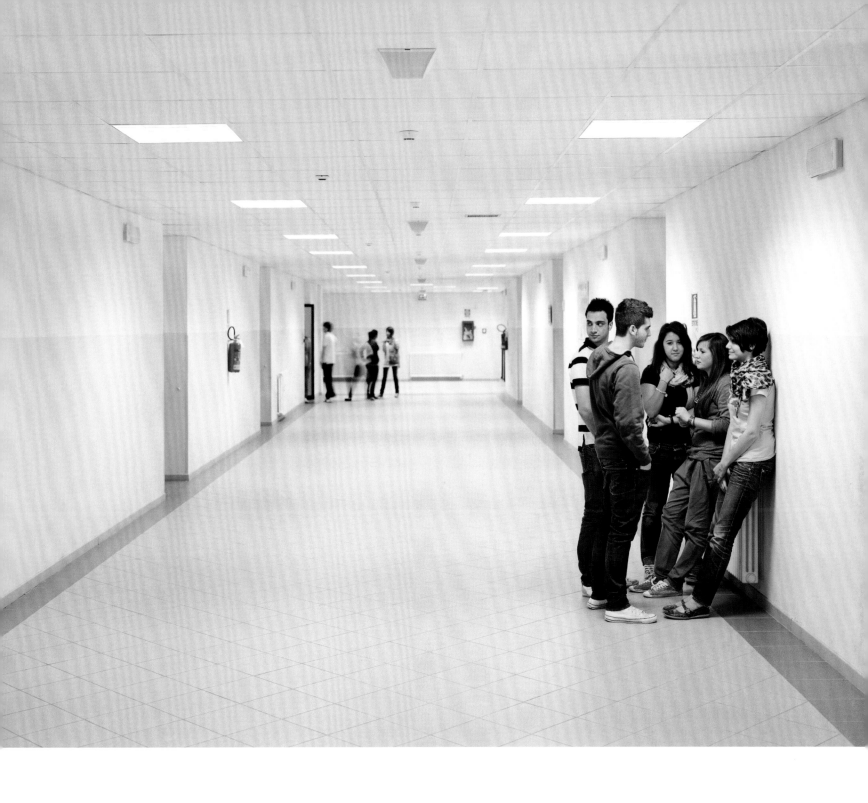

RAIMOND WOUDA
Istituto Marie Curie, Savignano sul Rubicone, from the series School II 2011

'*Technically Intimate* revolves around young people because they embody change. They have a mindset where identity is separate from them. They can adopt any identity they choose and, just as quickly, discard it for something new. The ways young people alter themselves and the world around them has a lasting effect on every aspect of the culture in which they live.'

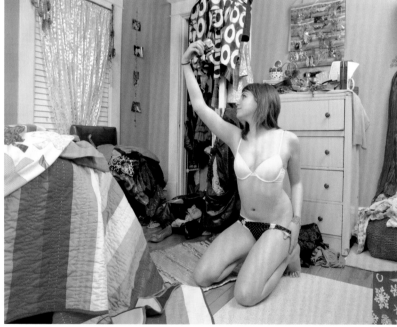

EVAN BADEN
from the series *Technically Intimate* 2010
Jacob

Nicole

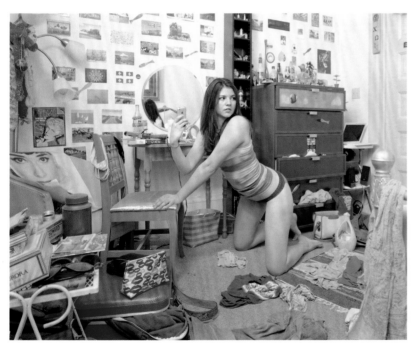

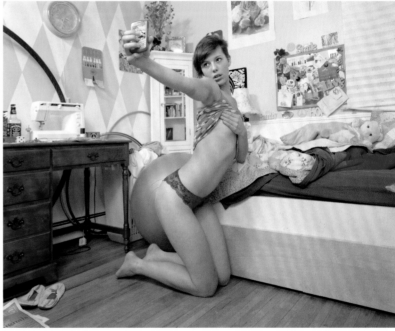

Helen

Emily

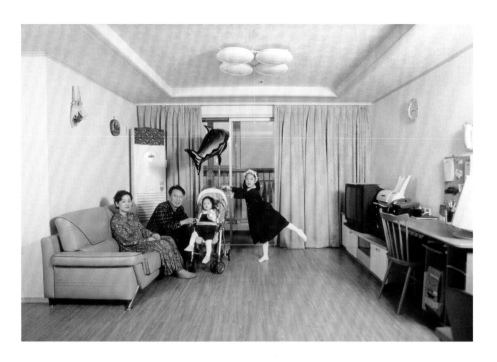

YEONDOO JUNG
Evergreen Tower 2001

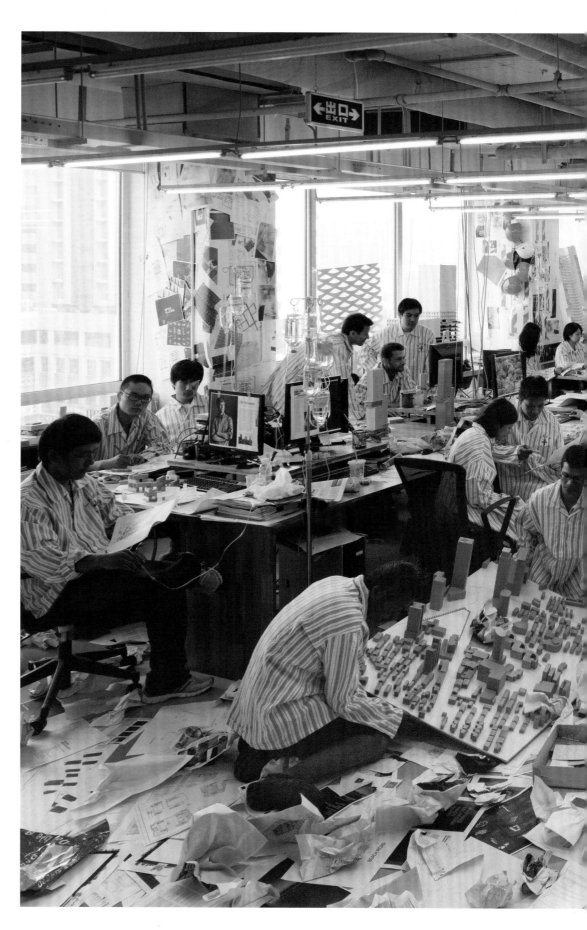

WANG QINGSONG
Work, Work, Work 2012

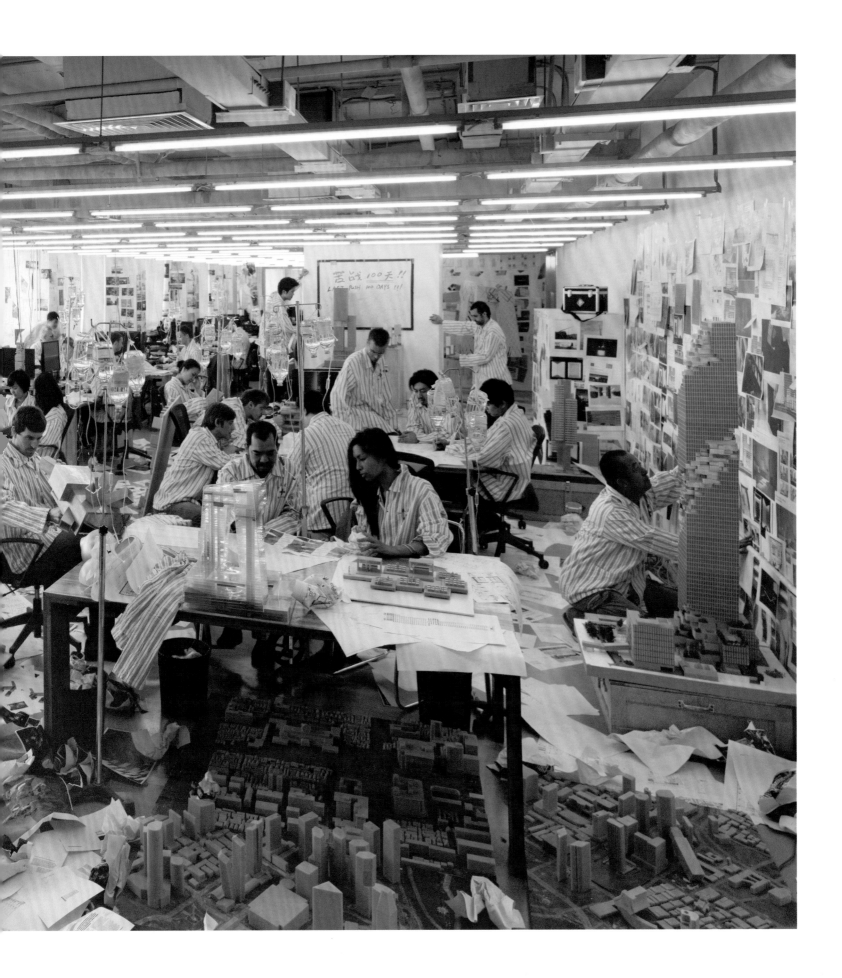

Anonymous, Bakersfield, CA 2011

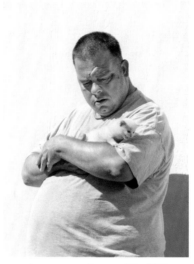

Anonymous, Fresno, CA 2011

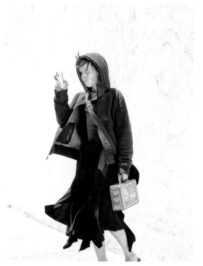

Anonymous, San Francisco 2010

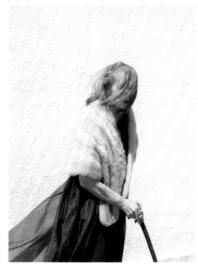

Anonymous, San Francisco 2009

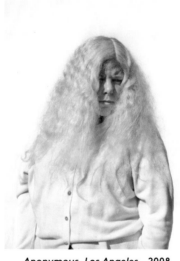

Anonymous, Los Angeles 2008

Anonymous, Fresno, CA 2011

Anonymous, Oakland, CA 2011

Anonymous, Los Angeles 2008

Anonymous, Los Angeles 2009

Anonymous, Modesto, CA 2012

Anonymous, San Francisco 2009

Anonymous, Los Angeles 2009

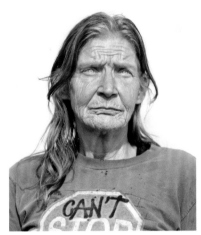

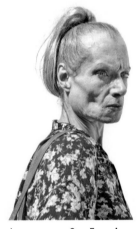

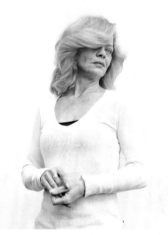

Anonymous, Modesto, CA 2012

Anonymous, San Francisco 2009

Anonymous, Modesto, CA 2012

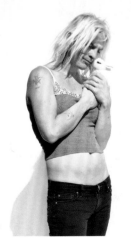

Anonymous, Los Angeles 2008

Anonymous, San Francisco 2010

Anonymous, Modesto, CA 2013

KATY GRANNAN
from the series *Boulevard* and *The 99*

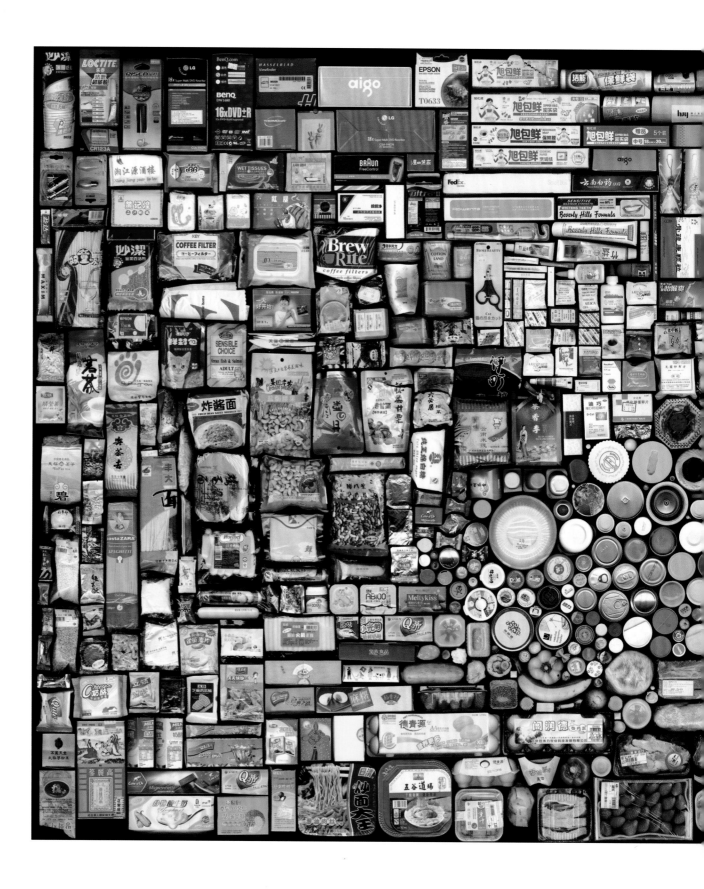

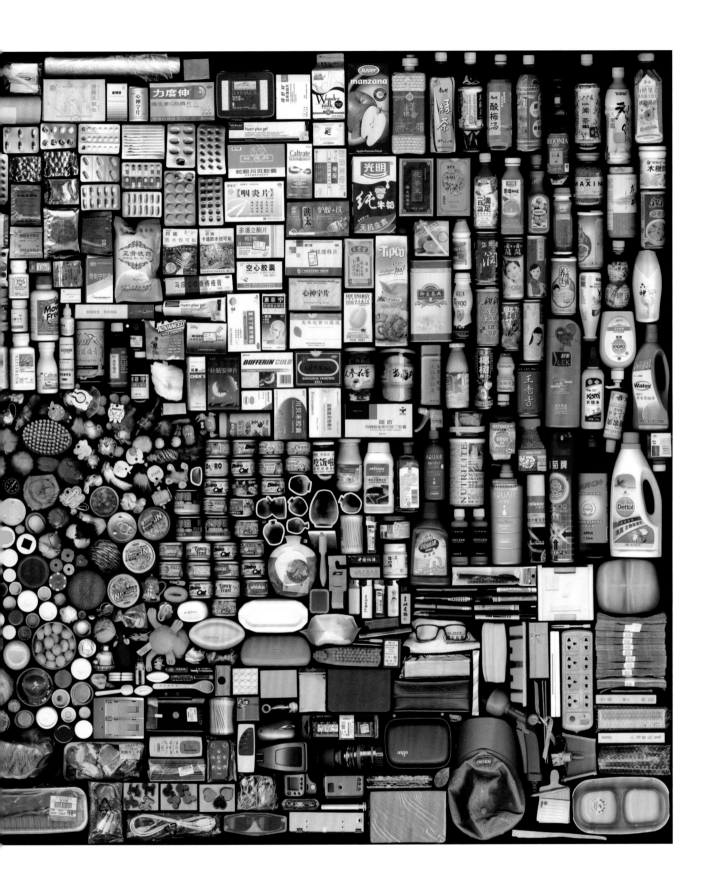

HONG HAO
Book Keeping of 2007 B, from the series *My Things* 2008

CINDY SHERMAN
from the series *Society Portraits* 2008
Untitled #470, 468, 474

'I, as an older woman, am struggling with
the idea of being an older woman.'

CINDY SHERMAN
from the series *Society Portraits* 2008
Untitled #466, 467, 476

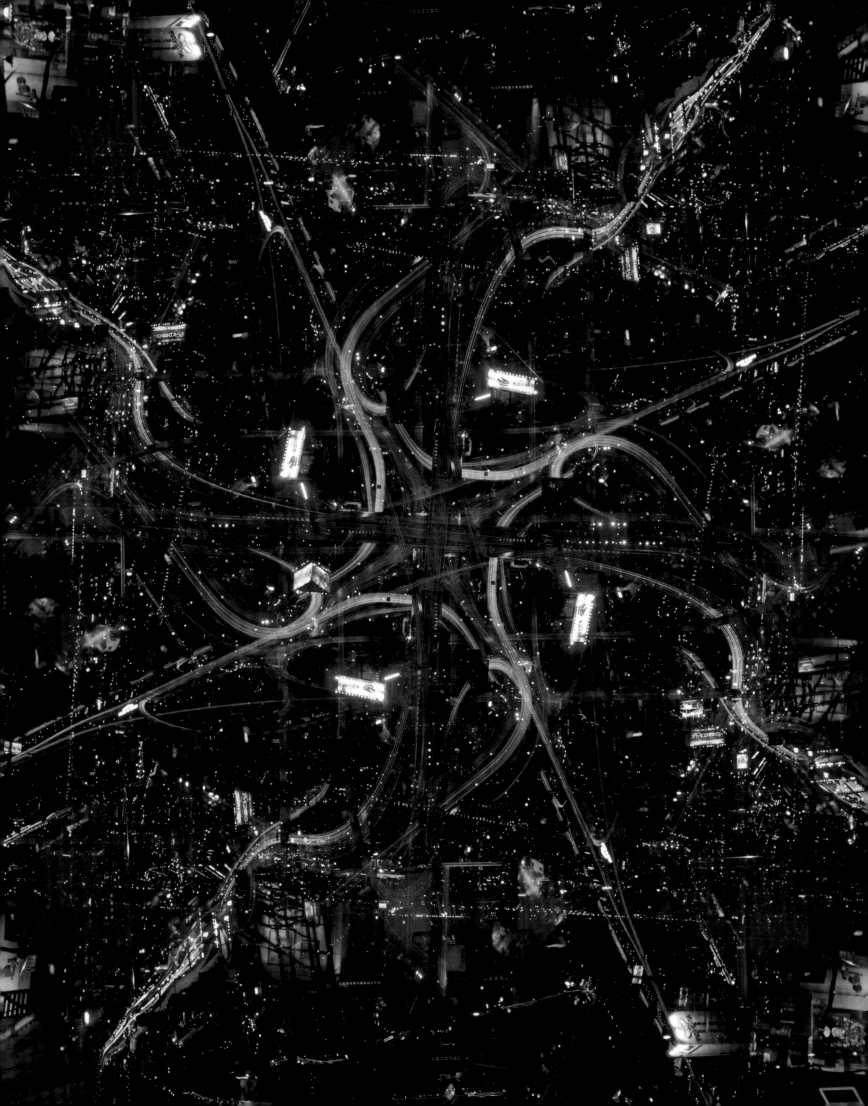

Twenty-first-century civilization now moves itself, its raw resources, material goods, its populations and its ideas at speeds unimaginable for people just one hundred years ago – on the ground, in the air or across the sea. We travel in magnetic levitation trains that achieve speeds of close to 450 km (280 miles) per hour, fly routinely at twice that, and send messages to each other at the speed of light. Marvels of engineering are so ubiquitous that we hardly notice them in our daily lives – until they seize up or break down. Automobiles are the most obvious example: blessing one moment, curse the next. Nevertheless, as Jesse Ausubel noted in a lecture in 2014, 'Cars multiplied human mobility 50-fold, reorganized civilization, and provided some of the greatest cultural expressions of the twentieth century.' Lee Friedlander (p. 133) testifies to the personal freedom these capsules allow; his open road, at least on this trip, bringing him to the doors of that marvellous urban pastiche, Las Vegas. By contrast with the more privileged mobile citizens of the world, Alejandro Cartagena (pp. 140–41) exposes a rougher form of automotive flow, as blue-collar workers make their way to temporary worksites in Mexico on flatbed trucks. Taking a more distanced view, Christoph Gielen (pp. 122–23) and Giles Price (p. 116) search for overall pattern, demonstrating why we sometimes refer to the impressive systems and structures of modern expressways as latter-day cathedrals.

Masses of humanity move at ease vertically as well as horizontally, enabling vast towers to house thousands (Michael Wolf, p. 117). Like Gielen and Price, Olivo Barbieri (pp. 129 and 142) takes advantage of this ease himself, flying high above cities to observe the ceaseless streams of traffic navigating around our glass and steel monoliths.

And yet…in one of those paradoxes of modern civilization, city dwellers often find themselves getting places faster on foot than in cars; as Trent Parke (p. 145) and Florian Böhm (p. 143) show, having to wait for *anything* is increasingly intolerable for the hyperactive 21st-century citizen. Christoph Gielen (p. 127) draws our attention to the way we lay out our newest cities to maximize efficient movement of people and goods. Meanwhile, Mintio (p. 112) and Michael Light (p. 144) soar skyward to take stock of the glowing, pulsating human organism. That glow is also a key element in Dan Holdsworth's (p. 118) night-time vision of a 'machine for living', suggesting only a momentary lull in the flow of commerce and industry.

All flows are not visible, of course. On the one hand, photographers have to find ways to make them so. For example, Vera Lutter (p. 124) celebrates the radio telescope technology that

arrive rush pattern circulation flow

expands our knowledge of the universe and our place in it. Taryn Simon (p. 121) gives concrete form to those nebulous ideas we have in our minds when we think about electronic communications: how minimal, how simple, is that telecom cable emerging from the depths: in equal parts banal, mysterious, vulnerable. Carlo Valsecchi (pp. 128 and 130) is also drawn to the largely unseen aspect of flows, finding unexpected beauty in industrial infrastructure, while Jo Choonman (p. 131) prefers to stress its impressive intricacy. Vincent Fournier (p. 125) takes us underground to the mammoth caverns of the Tokyo sewer system; here, musings about 'modern cathedrals' make perfect sense.

On the other hand, Andreas Gefeller (p. 126) finds his inspiration in the visible sphere: he turns his eyes skyward to take in the web of wires that bring light, heat and knowledge to our businesses and homes.

Although everything is not without friction, our systems function well enough that hundreds of millions of people can travel to distant parts of the world in almost total security and comfort. Mike Kelley (pp. 138–39) registers all the flights from Zurich in a single day; nearby a high-speed train, having deposited its hourly quota of 300 passengers, flashes through the Swiss countryside, the bucolic landscape in the foreground reminding us that not all in our lives is excessive motion.

As we're busy moving here and there, the flow of material goods, raw or finished, goes unnoticed by most of us, as traders, brokers, customs officials, transport managers, engineers, clerks, pilots and drivers keep to their schedules in a process that is, if not flawless, still essentially reliable. Concepts like 'just-in-time delivery' or 'shelf-life' and 'sell by date' attest to the narrow scope our exacting manufacturing and distribution systems permit. The massed containers and long snaking trains Victoria Sambunaris (p. 134) and Alex MacLean (p. 119) show us form small parts of the infrastructures that allow billions of us (though by no means all) to live rich material lives. Money, of course, also flows, and in the 21st century it flows more freely and surreptitiously than ever before, with governments either unwilling or unable to interfere. Gabriele Galimberti and Paolo Woods (p. 120) have approached the subject indirectly, showing the players at work in the global game as they gaze out on their fiscal paradise. But paradise is decidedly not what comes to mind in David Maisel's (p. 132) Los Angeles: deathly cold, ash-like, it could be a city of ruins seen after a nuclear apocalypse. Is this where the great flows of people, goods and ideas are heading?

MINTIO
Concrete Euphoria, Bangkok from the Baiyoke 2008

overleaf
DAN HOLDSWORTH
A Machine for Living 01
[detail, see p. 118]

'Art asks questions of itself and of each of us, but it does not give responses.'

Carlo Valsecchi

'The myth of America and particularly its western landscape largely underwrote the ideas of freedom and frontier independence found in much national political rhetoric and as the basis of much popular cultural imagery. Today these same landscapes are deeply charged with social interventions that contradict those mythologies and instead present a harshly pragmatic yet sometimes sublime and sometimes negative set of images. These mythic spaces are both aesthetically and politically linked, now inextricably.'

'"Civilization" culturally ingrains in us the ideas of progress, expansion and human supremacy. In the environment of a "civilized" society, architecture is one of the mediums where humans pursue urban progress to dominate and separate themselves from the natural world.'

Mintio

Victoria Sambunaris

continue drift stream emanate flux

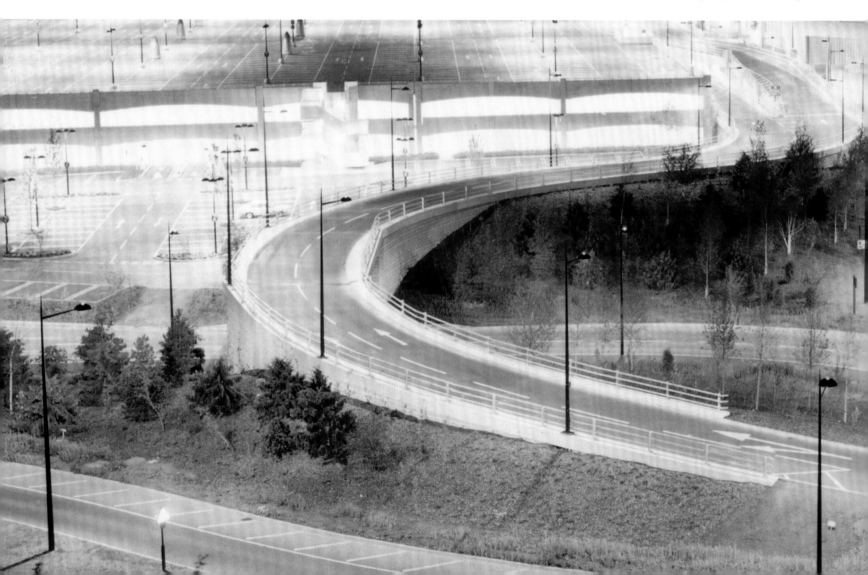

'The aerial vantage point is an excellent one from which to examine civilizational structures, offering a relentlessly wholesale view of our excessively retailed lives. Otherwise ignored infrastructure is laid bare, and one can see the duplicative structures of global capital running downhill like water to find its return on investment. As in Las Vegas, so in Dubai. As in Los Angeles, so in Shenzhen.'

Michael Light

'At countless airports around the world, tens of thousands of flights per day are taking off, landing, and crisscrossing the skies overhead. What of the environmental effects of aviation? One plane in the sky does not seem to have a huge environmental impact – but when we see a day's worth of traffic at one airport and multiply it by all the days in the year and all the airports in the world, these effects cannot be negligible.'

Mike Kelley

move passage slide depart sequence

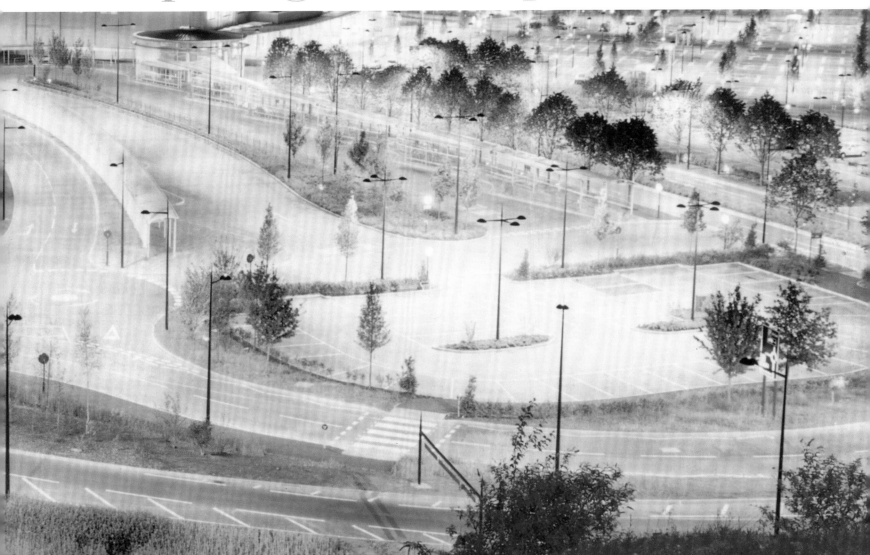

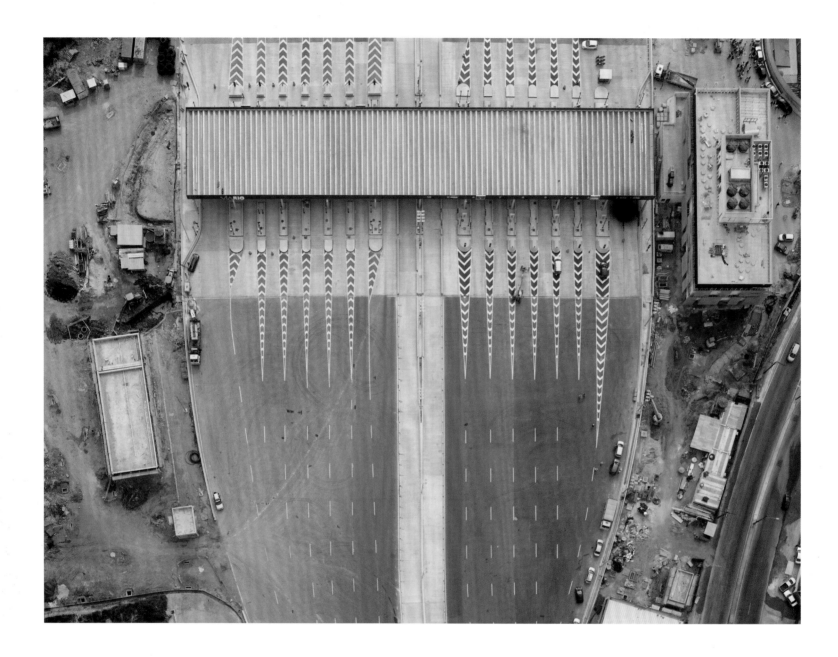

GILES PRICE
BRT Transolímpica toll station, Estrada do Catonho, Rio de Janeiro. Morar Olimpiadas 2016

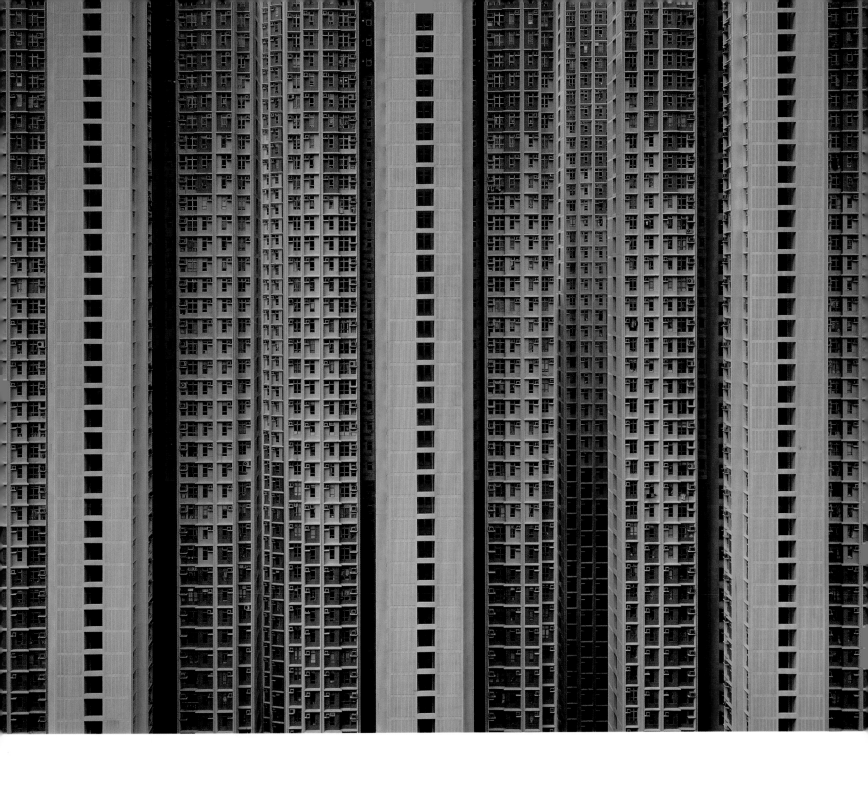

MICHAEL WOLF
Architecture of Density #91 2006

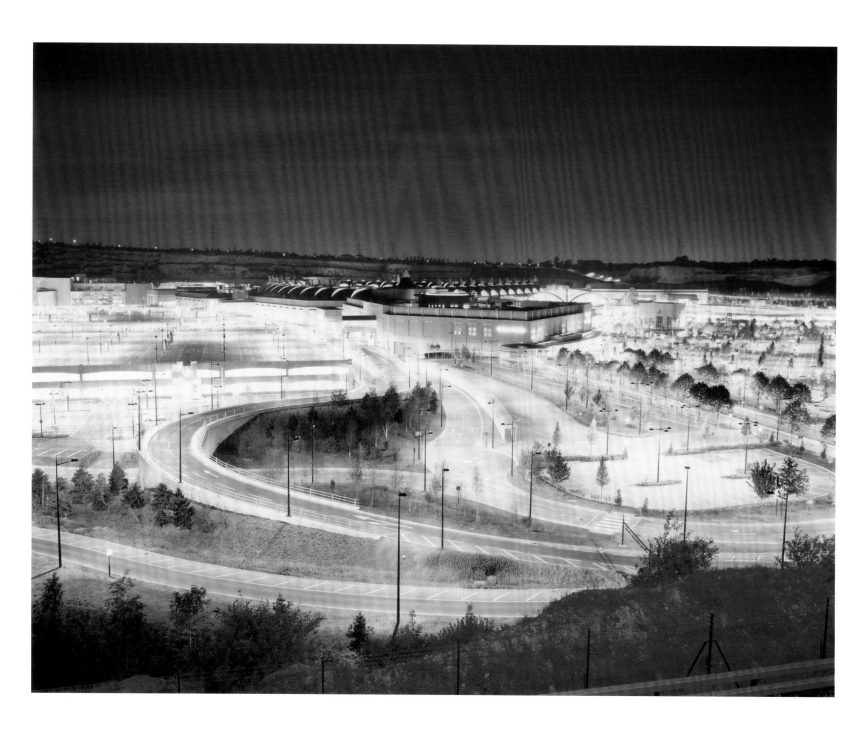

DAN HOLDSWORTH
A Machine for Living 01 1999–2000

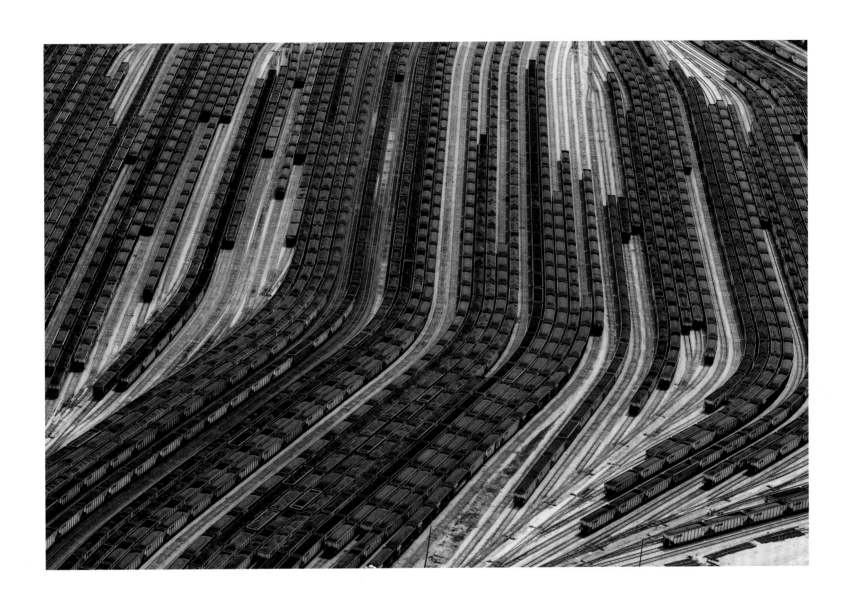

ALEX MACLEAN
Loaded Coal Train Cars, Norfolk, VA 2011

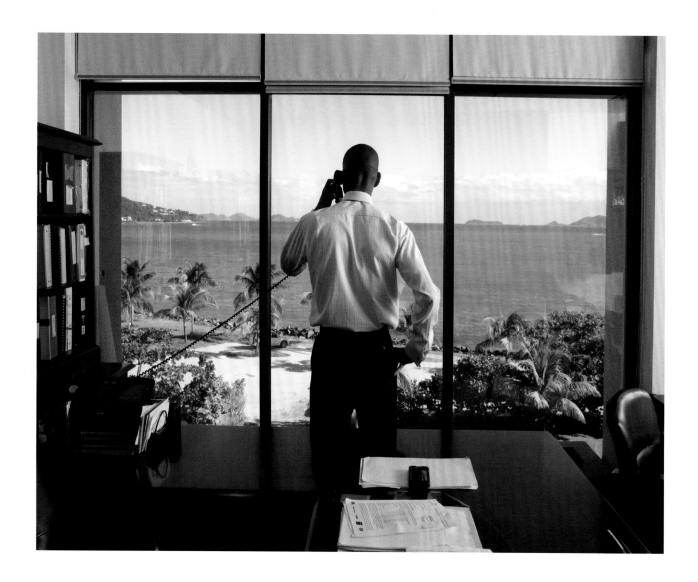

Mr Neil M. Smith is the British Virgin Islands' Finance Secretary, photographed here in his office in Road Town, Tortola. The BVI is one of the world's most important offshore financial service centres and the world leader for incorporating companies. There are more than 800,000 companies based in the BVI but only 28,000 inhabitants. The BVI are the second-biggest direct investors in China, just after Hong Kong.

GABRIELE GALIMBERTI AND PAOLO WOODS
from the series *The Heavens* 2012/2015

Transatlantic Sub-Marine Cables Reaching Land, VSNL International, Avon, New Jersey

These VSNL sub-marine telecommunications cables extend 8,037.4 miles across the Atlantic Ocean. Capable of transmitting over 60 million simultaneous voice conversations, these underwater fibre-optic cables stretch from Saunton Sands in the United Kingdom to the coast of New Jersey. The cables run below ground and emerge directly into the VSNL International headquarters, where signals are amplified and split into distinctive wavelengths enabling transatlantic phone calls and Internet transmissions.

TARYN SIMON
An American Index of the Hidden and Unfamiliar 2007

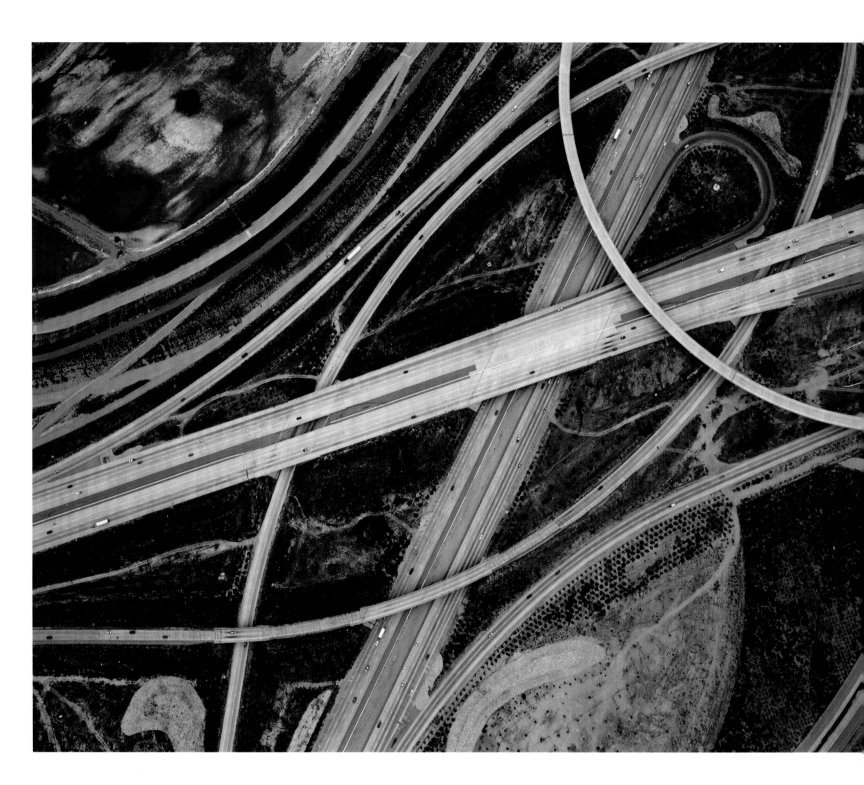

'Substantiating the widespread belief in the possibility of catastrophic climate change, my photographs also offer concrete insights as they trace the evidence of an energy-inefficient, urbanized existence. They aim to challenge our norms of comfort by jarring us loose from deeply held beliefs – the assumption that growth is unlimited and always beneficial.'

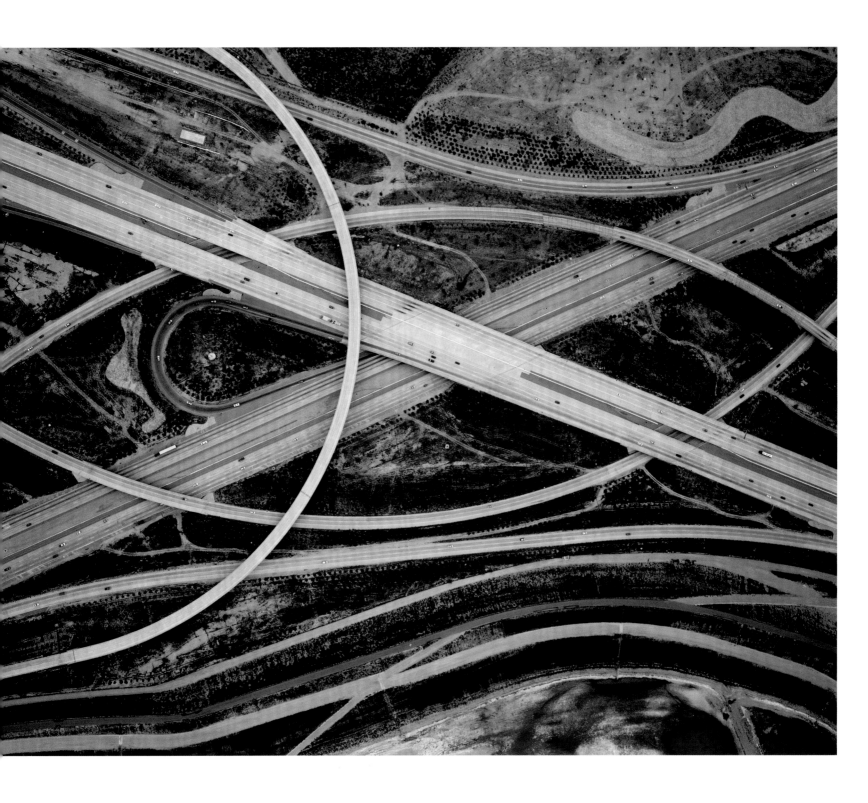

CHRISTOPH GIELEN
CONVERSIONS, Suburban California 2008

VERA LUTTER
Radio Telescope, Effelsberg, XX: September 17–18, 2013

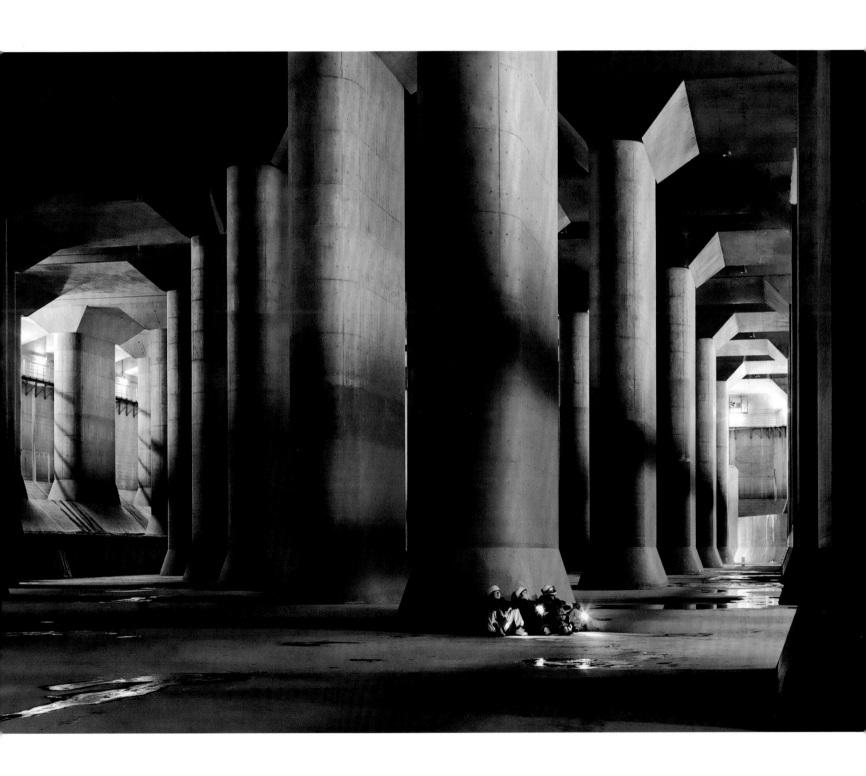

VINCENT FOURNIER
Tokyo Storm Sewer System #1, [Saitama], Japan, from the series *Tour Operator* 2009

ANDREAS GEFELLER
Poles 39, from *The Japan Series* 2010

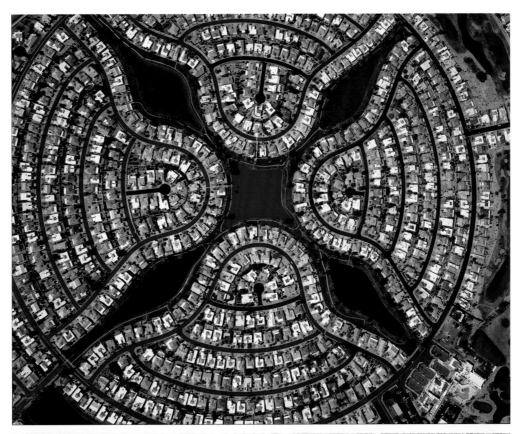

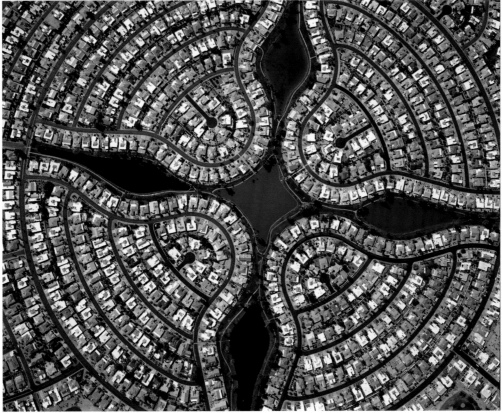

CHRISTOPH GIELEN
UNTITLED, Arizona 2010

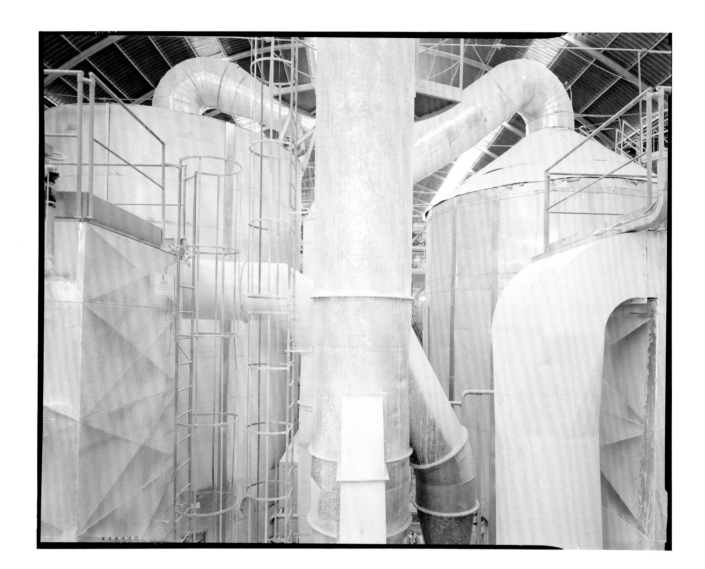

CARLO VALSECCHI
#0081 Castellarano, Reggio Emilia, IT. 2000, from the series industry

'Viewed from above everything is suddenly revealed and at the same time made more complicated. Nothing is where we thought it was, nothing matches the map of the places that we have in our minds. Nothing looks the way we are accustomed to thinking about it. Nevertheless we know that those bizarre shapes represent the world to which we belong, moulded by the desires and necessities of us humans. Do we recognize this scene? Do we recognize ourselves in this scene?'

Francesca Fabiani

OLIVO BARBIERI
site specific_MEXICO CITY 11 2011

CARLO VALSECCHI
#01005 Crespellano, Bologna, IT. 2016, from the series *industry*, *Philip Morris project*

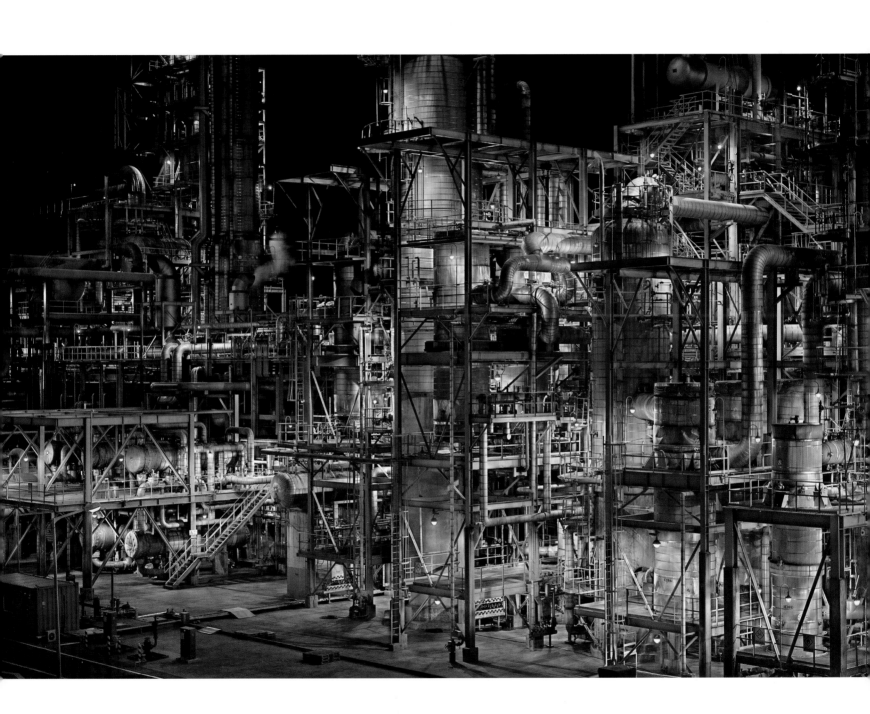

JO CHOONMAN
PETROCHEMICAL 179727, from the series *IK* 2017

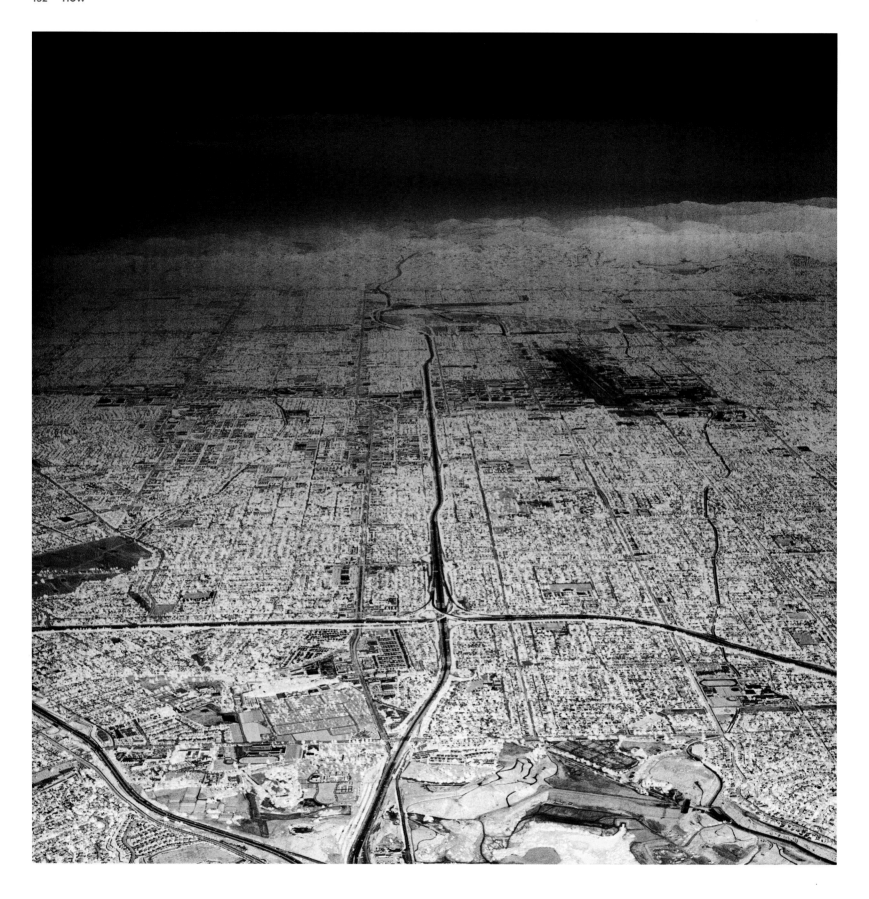

DAVID MAISEL
Oblivion 15n **2004**

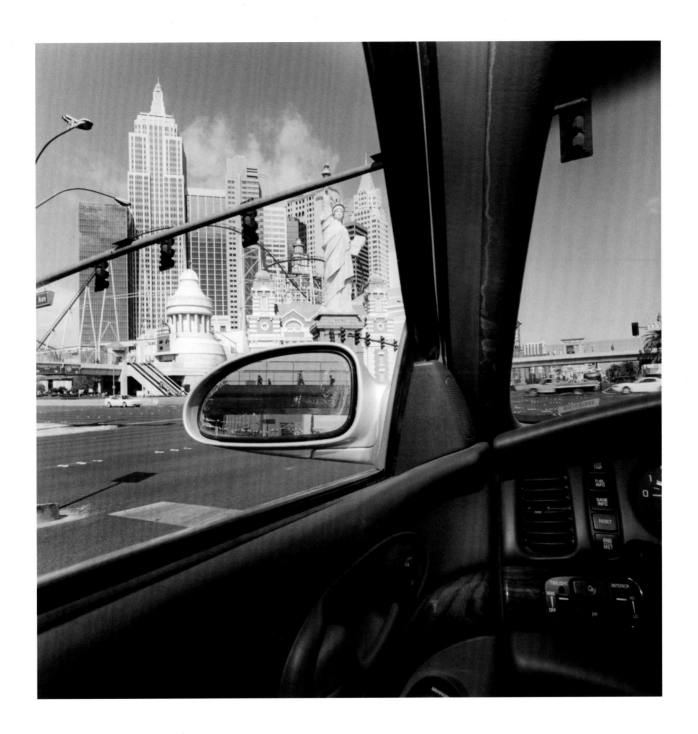

LEE FRIEDLANDER
Las Vegas 2002

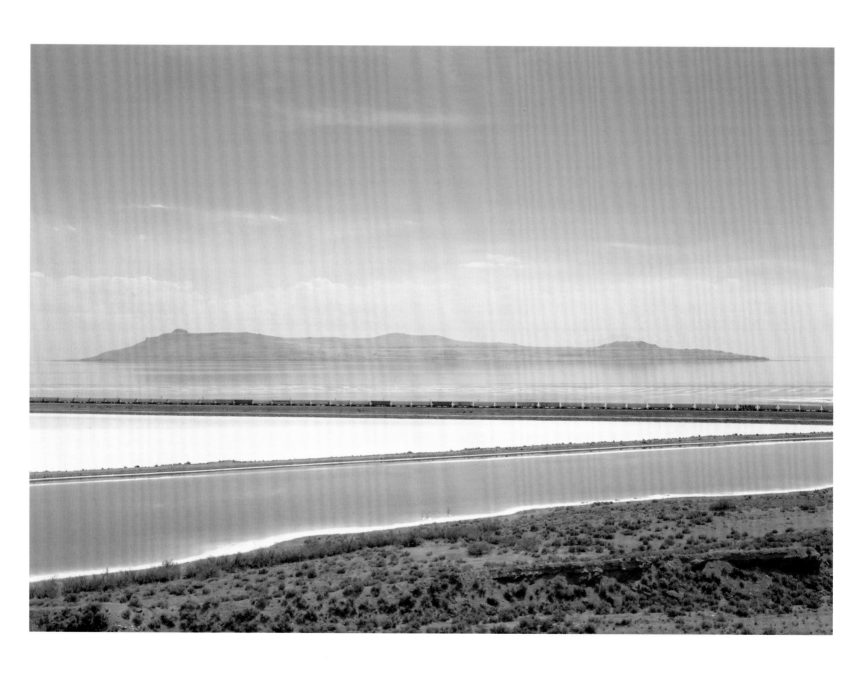

VICTORIA SAMBUNARIS
Untitled (Train Crossing), Great Salt Lake, Utah 2016

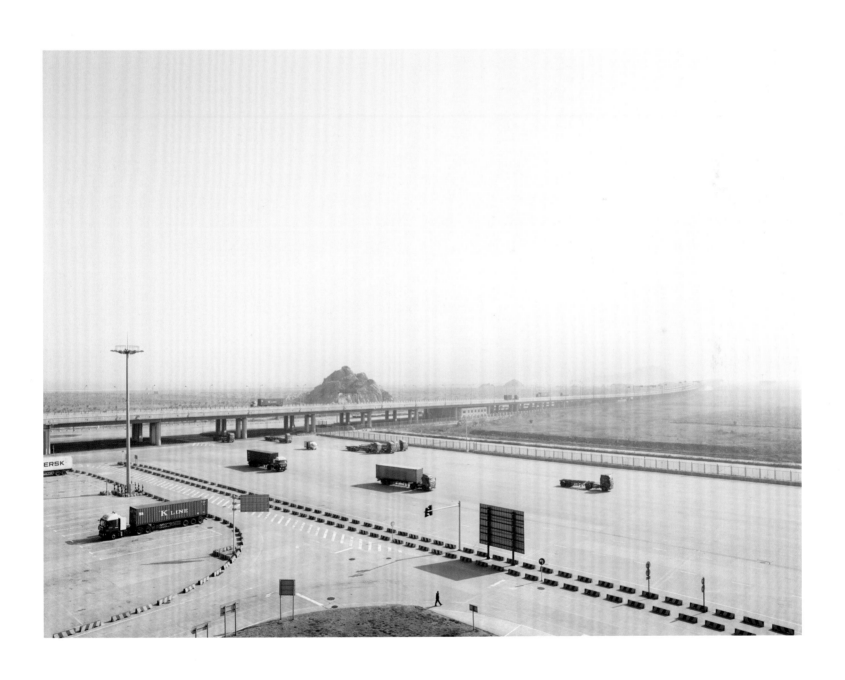

HENRIK SPOHLER
In Between, 28 Approaching the container terminal, Yangshan Island, China nd

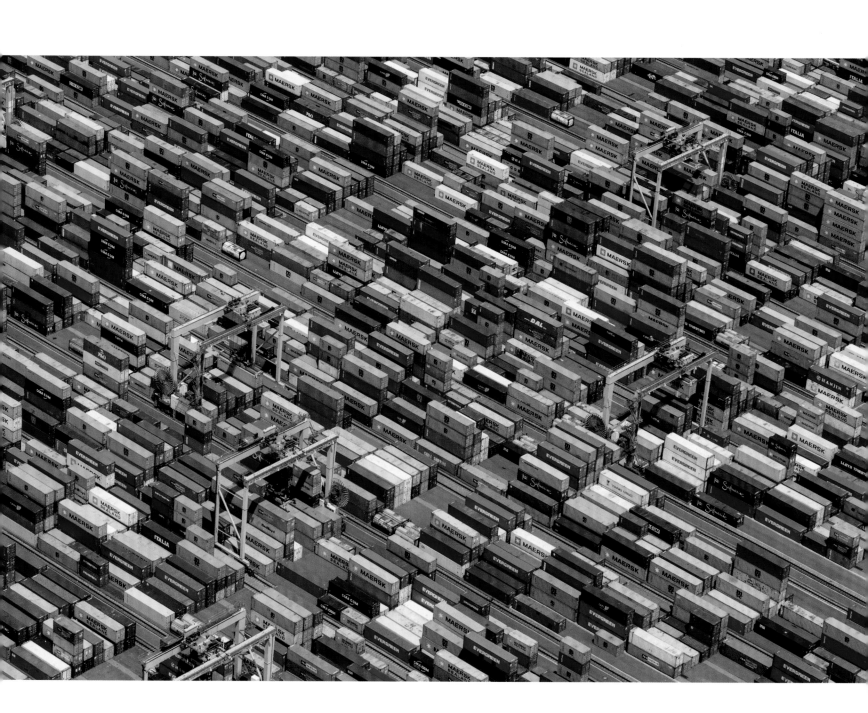

ALEX MACLEAN
Shipping Containers, Portsmouth, VA 2011

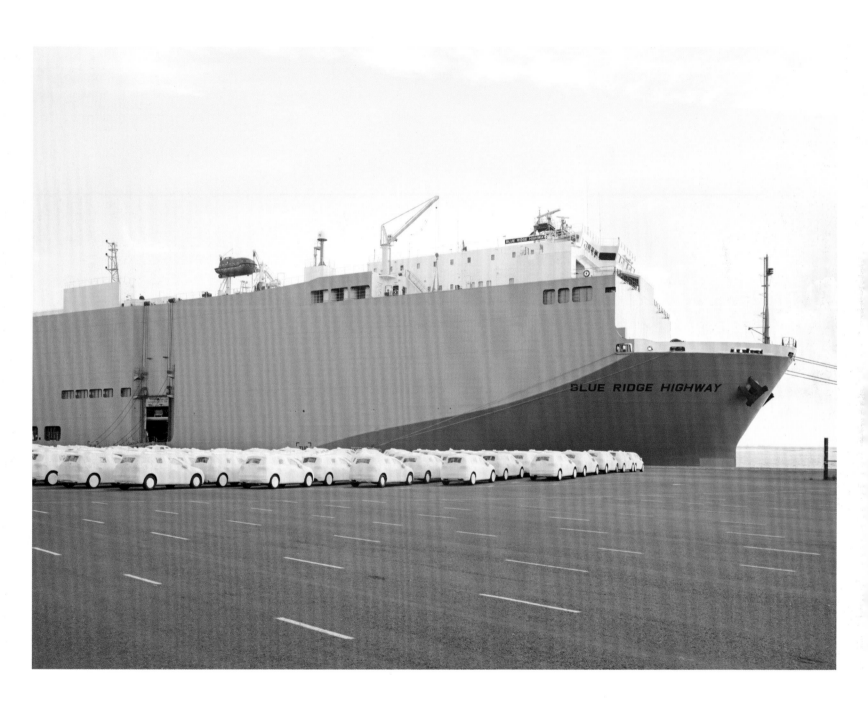

HENRIK SPOHLER
In Between, 30 Loading cars at Emden Harbour, Germany nd

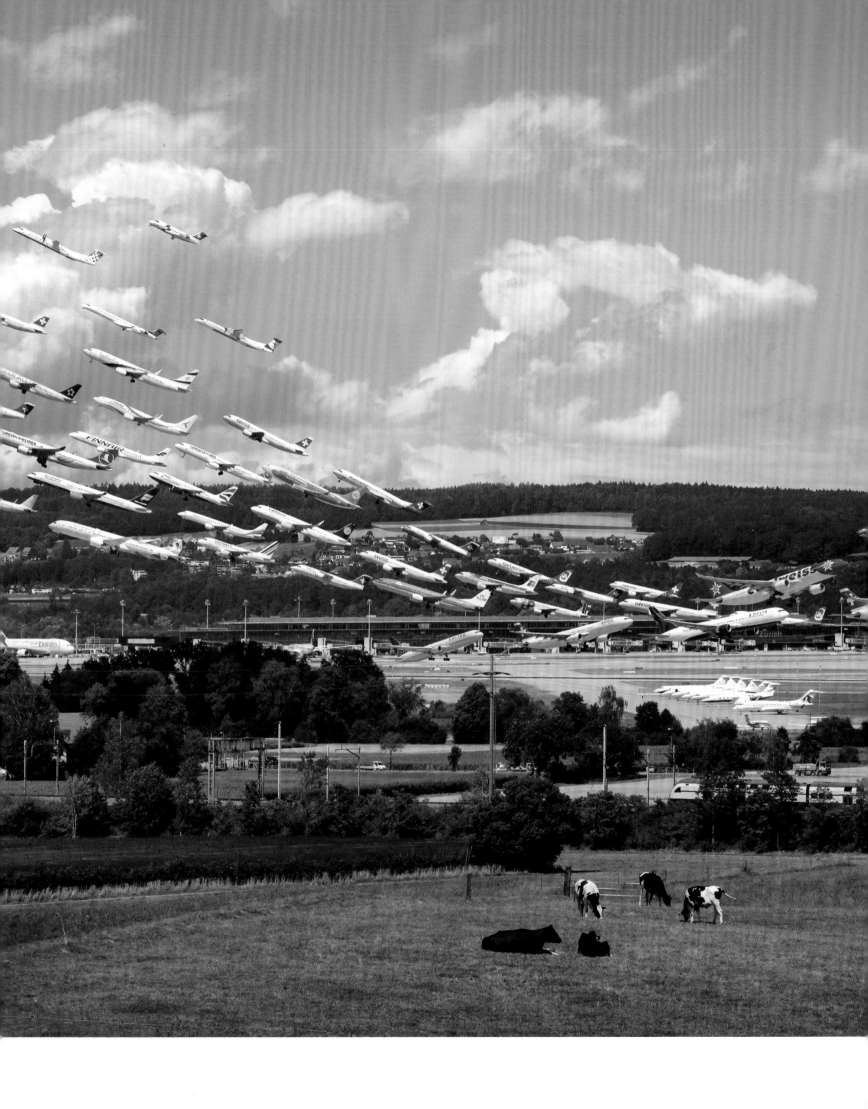

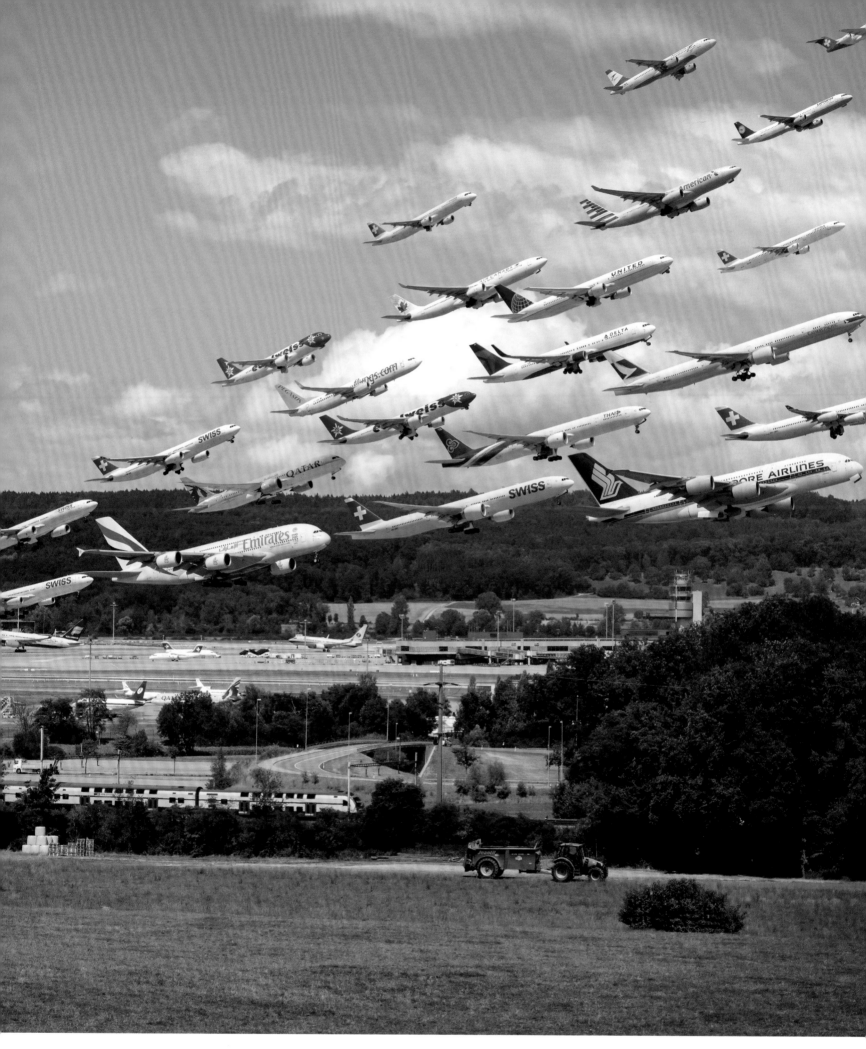

MIKE KELLEY
Flughafen Zürich 28 and 16 (Visual Separation), from the series *Airportraits* 2015

 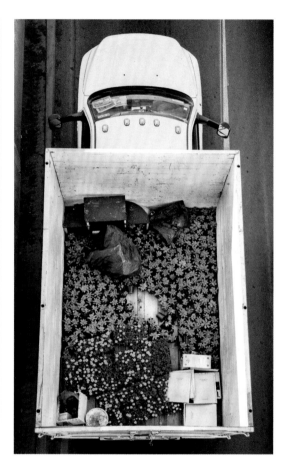

ALEJANDRO CARTAGENA
#17, 16, 4, from the series *Urban Transportation* 2011–2012

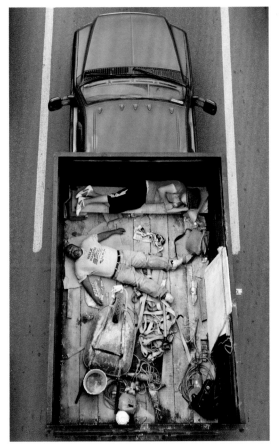
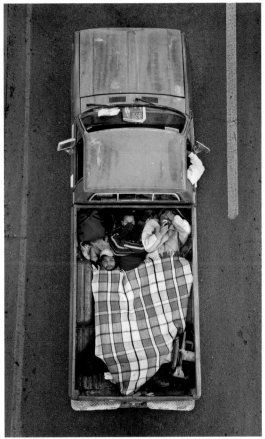
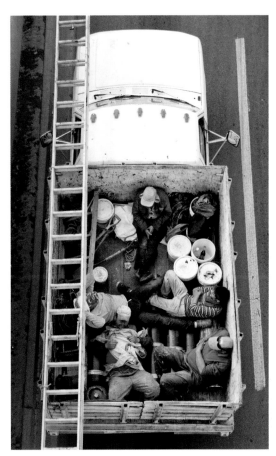

'Mexico is in the process of becoming a country of homeowners. The rapid growth and construction of the houses outstrips that of the infrastructure needed to inhabit these homes. Proper public transportation is lacking and so people have devised their own solutions to getting to work, even though they might be illegal and dangerous ones. Workers carpooling from the new housing developments in the northern lower- and middle-class suburbs to the wealthy southern suburbs of Monterrey show how the cost of aspiring to a better life is paid at a higher price by those with no money.'

ALEJANDRO CARTAGENA
#1, 10, 53, from the series Carpoolers 2011–2012

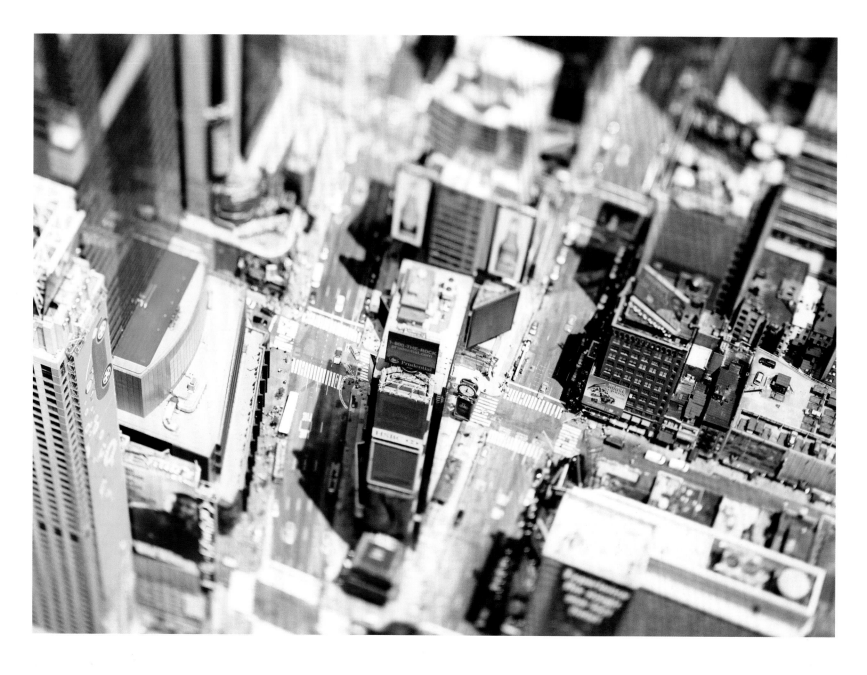

OLIVO BARBIERI
site specific_NYC 07 2007

'The sidewalk becomes a stage on which the pulsating activity
of the metropolis comes to a standstill for a brief moment.'

FLORIAN BÖHM
Broadway /34th Street, from the series *Wait for Walk* 2005

FLORIAN BÖHM
48th Street /5th Avenue, from the series *Wait for Walk* 2005

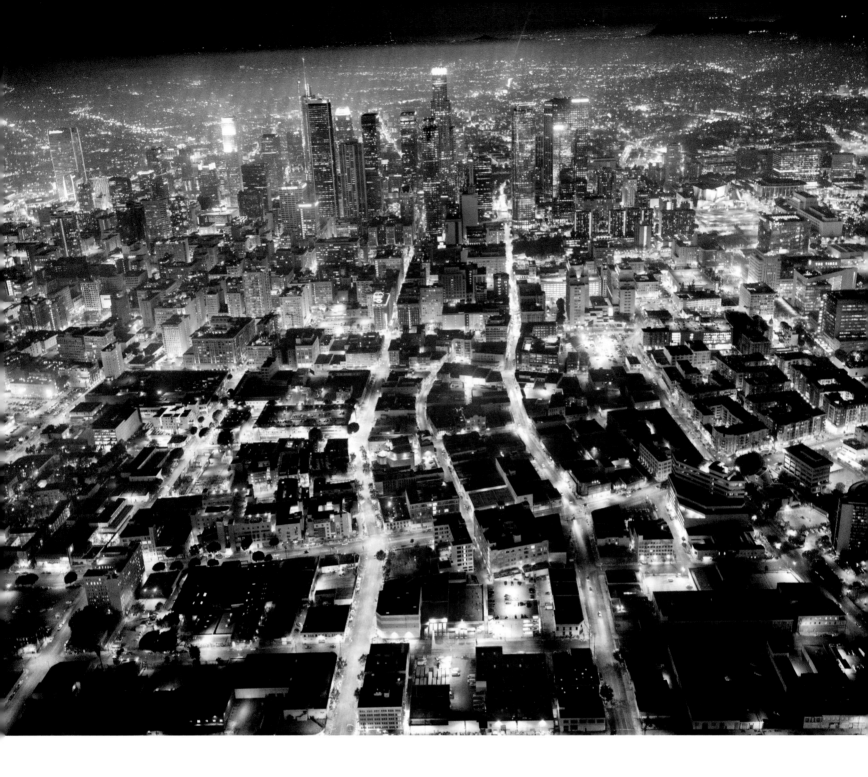

MICHAEL LIGHT
Downtown Looking West, Los Angeles, CA, from the series Los Angeles 09.10.16

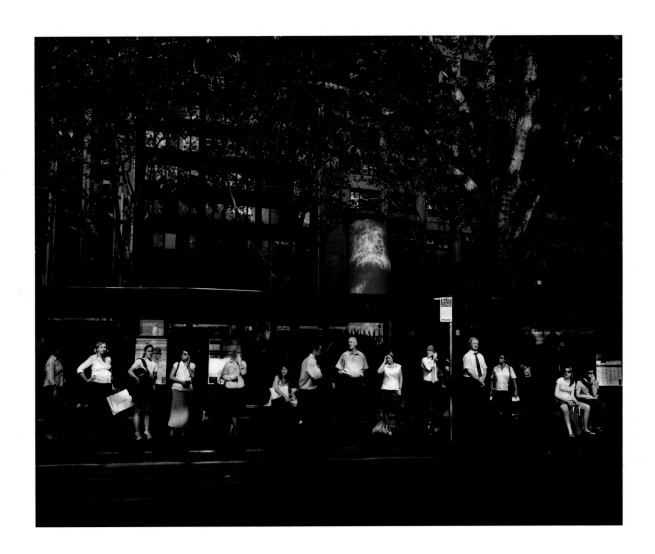

TRENT PARKE
Untitled, from the series *Coming Soon* 2006

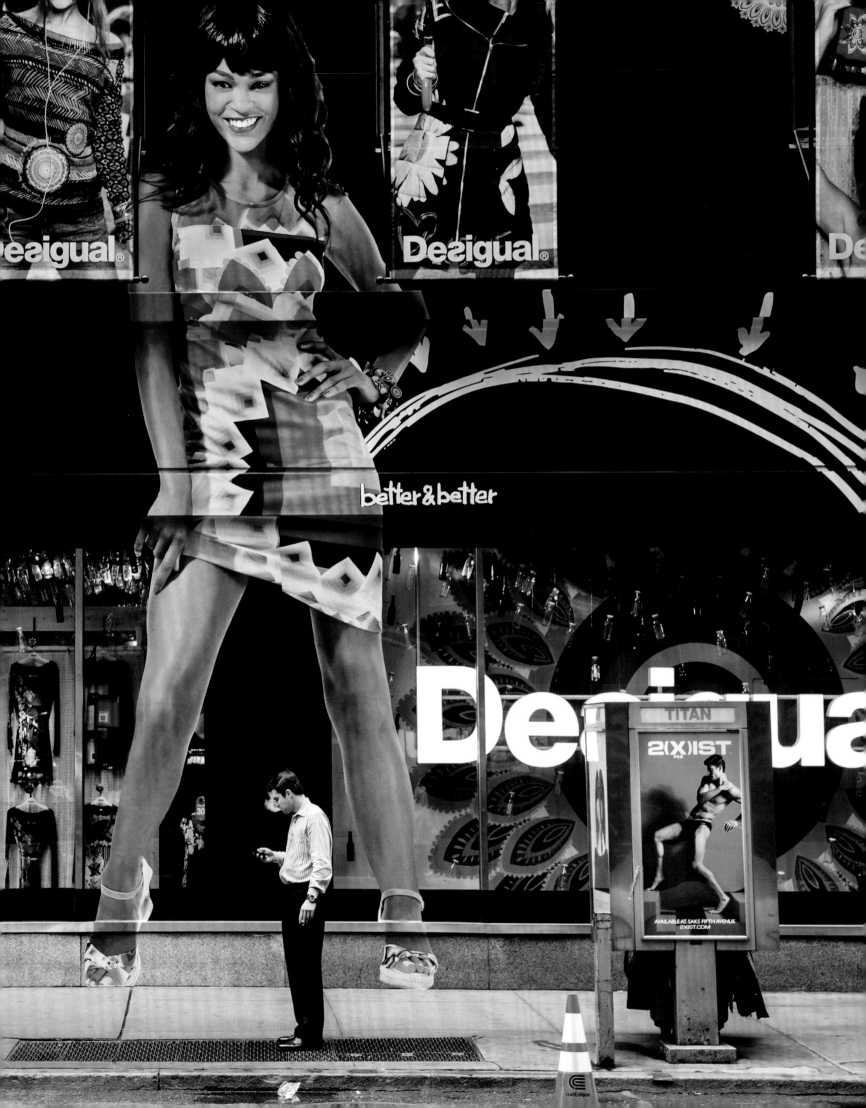

Better & Better / Happy ideas all the time / Step inside for your 15 seconds of fame! These are a few of the upbeat messages that assault the senses daily – ears as well as eyes – of people wherever they congregate. The word/image constructs are loud, slick and effective, as Brian Ulrich's (p. 173) young family group shows us, frozen spellbound before a bank of screens. But persuasion can also employ fear: *How are you protecting your identity?* reads a *trompe-l'œil* ad on a passing bus (Robert Walker, p. 164), playing on widely shared anxieties.

What's real? Who's real? Who knows? Han Sungpil (p. 180) shows how we allow our eyes to be shielded from unseemly building sites with façades of idealized urban harmony. Photographers like to look behind the clever slogans and façades, relishing in the ironies though never ignoring the spectacular aesthetic potential of explosive colour (Natan Dvir, p. 167) and seductive form (Vera Lutter, pp. 162–63). Other photographers show us places where persuasion is hatched and honed, some as slick as the slogans themselves. Alec Soth (p. 172) captures the image-savy fashion industrialist Karl Lagerfeld in a setting of nebulous fantasy, lending his iconic figure to both front and profile exposure. Lauren Greenfield (p. 181) treats us to another aspect of Hollywood dreamwork-in-the-making, one essential stage in the 'grooming of a multiplatform star'.

Social media stardom is tackled differently by Amalia Ulman (p. 161), whose fictitious performances (confounded with fact by some followers) challenge the construction of female personas and 'self-actualization' on popular Internet platforms such as Instagram and WeChat.

Photographers are also interested in the places where consumers are persuaded to snap up goods, sometimes referred to as impulse items. Mitch Epstein's (p. 175) Interstate truck stop presents an array of truckers' goods that seems to border on the infinite, the whole presided over by ostensibly happy and satisfied rig owners: the common man as credible authority. On the other hand, the authorities dominating Andrew Moore's study of Abu Dhabi's Al Meena Mall (p. 174) are anything but common, looking down from their Edenic garden on a sea of material plenty – and the common folk.

Persuaders are not just restricted to goods and services. As Andrew Esiebo (p. 170) shows us, religious faiths also have to convince non-believers and discipline those who stray. Faith of a different sort is required of the art world, as observed by Andy Freeberg (p. 171), where even smooth-talking salesmen sometimes arrive at the end of their tether.

cajolery faction sell force persuasion

That our consumerist society works so well, at least at the high end of the market, is suggested by Dougie Wallace's (p. 166) shopping shrine, 'Harrodsburg'. By contrast, Andreas Tschersich (p. 182) prefers to step back and show the reality of an upbeat billboard in the context of a forlorn, decaying community; Utopia in Detroit is for most people high up and out of reach.

A less direct tack is taken by Patrick Weidmann (p. 158), whose interest is less in specifics of consumerism than the underlying principles used to tap into our deepest desires: formless reflections, glitter, sleekness, illusions. Vance Packard once famously wrote of 'the hidden persuaders', but some of them are in plain sight. Shigeru Takato (p. 154) focuses on a vacant television studio, presenting its bizarre decor as if it were a spaceship just landed from a distant world, while Sean Hemmerle (p. 152) steps further back and shows the extraordinary jumble of hardware and imagery in one site where 'news' is fabricated and fed to an eager public. Backstage, too, we find Eric Thayer (p. 155), documenting the complex image-management preparations under way at a national political convention. A very different kind of behind-the-scenes (or rather behind the screens) is captured by Mark Power (p. 177). Conflating foreground (screens) and background (crowd), the photographer draws our attention to the dominance of new image technologies. A similar thought motivates Cyril Porchet (p. 176), who shows us how carefully image projection is considered by managers of important stockholder conventions.

Less dramatic sites, but equally spaces of concentrated power in the persuasion business, have been studied by Priscilla Briggs (p. 150) and Andreia Alves de Oliveira (p. 151): vacant lobbies, offices of advertising agencies, recruitment firms, banks, law firms and the like. 'Casual and friendly' is the new strategy of these places, which strive through their architecture to convince consumer and employee alike of their 'authenticity'.

Big cities vie for the loudest, most strident messages. In a subtle montage Sato Shintaro (pp. 168–69) amplifies the chaotic hype of Tokyo, removing the humans from the scene he illustrates how this busy street is ironically a perfectly bustling organism, even without our physical presence.

Simon Roberts provides two different kinds of theatrical propaganda: the first in the form of an embattled politician pitching her ideas to a sceptical press (p. 179); the second, a more subtle form of persuasion – nostalgia for the good old days of war and Empire, when small planes defended the nation and a defiant citizenry put up with the rain of bombs (p. 178).

NATAN DVIR
Desigual [detail, see p. 167]

overleaf
MARK POWER
The funeral of Pope John Paul II broadcast live from the Vatican. Warsaw, Poland [detail, see p. 177]

'Times Square, rather than being just a tourist Mecca, for me acts as a metaphor
for the excesses and pathologies of contemporary society. Overconsumption
and sensual indulgence are seductively encouraged by a hysterical
mélange of signs and symbols, coupled with the notion that
everyone is entitled to a few moments of celebrity,
regardless of real achievement or not.'
Robert Walker

'The media is a dominant player in civilization with its information-hungry
populations. As a viewer sitting comfortably on the couch in the living room,
I can allow myself to be bombarded by an endless stream of content.'
Shigeru Takato

seduction power suggestion opinion

'As China straddles an ideological gap between communism and capitalism, its accelerating appetite for material consumerism is reflected in the construction of some of the largest malls in the world…Mega shopping malls became icons of economic progress during this period. My photographs of these malls reflect the influence of Western culture, and its preoccupation with wealth and luxury, within burnished marble halls of Prada, Louis Vuitton and Gucci.'

Priscilla Briggs

'Entertainment districts in Japan are full of places that cater to human desires for food, sex and amusement. Gaudy billboards aiming to attract customers are all over the place, looking like flowers that bloom while breathing the air of obscenity…'

Sato Shintaro

'…today, the boundary between the original and its duplicate has become blurred; virtual reality and reality are mixed up.'

Han Sungpil

potential credo coercion hook belief

PRISCILLA BRIGGS
Welcome To My World (The Place, Beijing), from the series *Fortune* 2008

'The new "hot-desking", "hotelling", and "motelling" systems of desk assignment place workers in the position of guests, leading to speculation about a future where instead of using the workplace "for free" as part of the work contract, workers may be required to pay for it.'

ANDREIA ALVES DE OLIVEIRA
from the series *The Politics of the Office* 2013

Manager's office, Executive recruitment firm

Breakout area, Law firm

Games room, Transportation finance bank

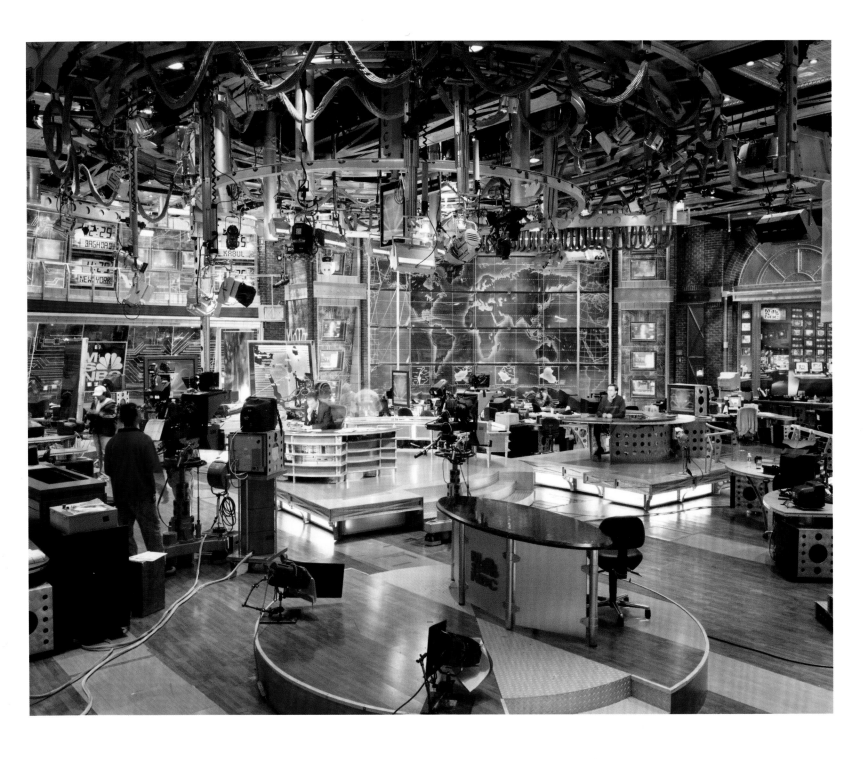

SEAN HEMMERLE
MSNBC, Seacaucus, NJ, 2003

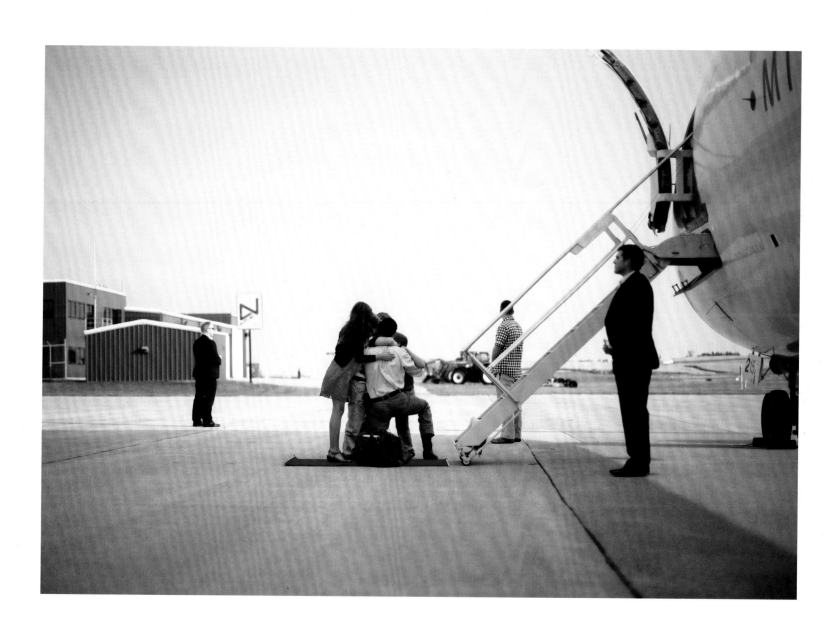

ERIC THAYER
*Republican vice presidential candidate Paul Ryan and his wife Janna greet their children
at Dubuque Airport in Dubuque, IA, October 1, 2012*

SHIGERU TAKATO
Cologne V, from the series *Television Studios* 2004

ERIC THAYER
*A test card pattern on a Jumbotron above the Quicken Loans Arena as preparations were under
way for the Republican National Convention in Cleveland 2016*

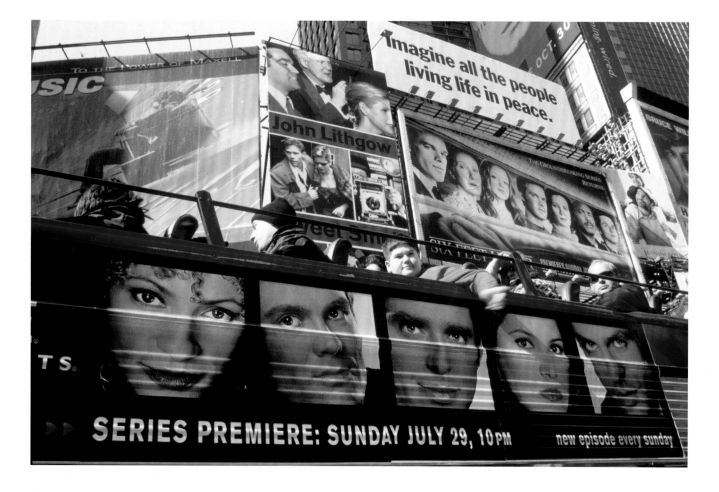

ROBERT WALKER
Times Square, New York **2002**

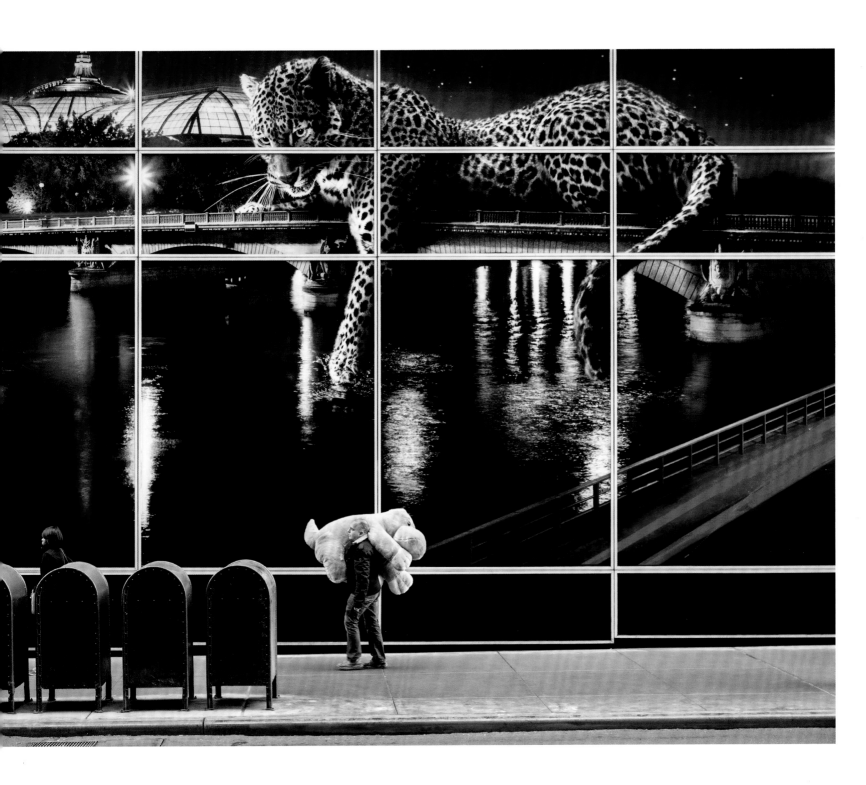

NATAN DVIR
Cartier 01, from the series Coming Soon 2013

'Consumerism is the hard core of our globalized civilization. My aim is to examine the juxtaposition between the promises of instant happiness and all kinds of accidents and unexpected disasters.'

PATRICK WEIDMANN
1132-30a-2012 1196-21-2014

DSC1324-2016 USA3108-2016

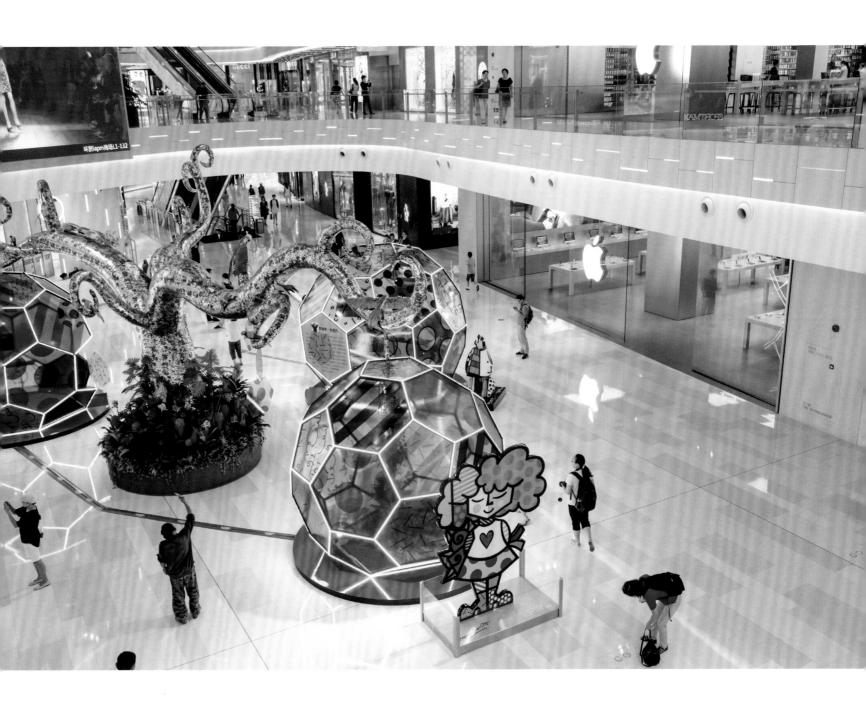

LAUREN GREENFIELD
Late-night shopping at the new IAPM Mall, which houses luxury brands, such as Gucci and Balmain,
Shanghai, 2014. In 2015 a woman jumped to her death into the mall's atrium
after a sudden dive in the volatile Chinese stock market

(opposite) Instagram performance *Excellences & Perfections* approaches often overlooked vehicles of persuasion on the Internet through a set of performances using the popular social-media platform, referencing influences such as branding, lifestyle choices or career direction. By the theatricalization of each fictitious 'self' online, Ulman has addressed how gender and identity are influenced and constructed by consumerism; how each of us 'naturally' builds a 'self-actualized' persona we choose to share with the world.

ROBERT WALKER
Times Square, New York 2010

AMALIA ULMAN
(from left, in columns) *Episodes 1, 2 & 3*
from the series *Excellences & Perfections* 2014

'There is a flood of images that is imposed on any spectator today in any context. Not only in the artistic environment but also in general. Our culture has started to replace language with imagery and the flood of images is constantly swelling higher and moving faster. Language is our most immediate tool for comprehension but the flood of imagery is blocking the critical mind.'

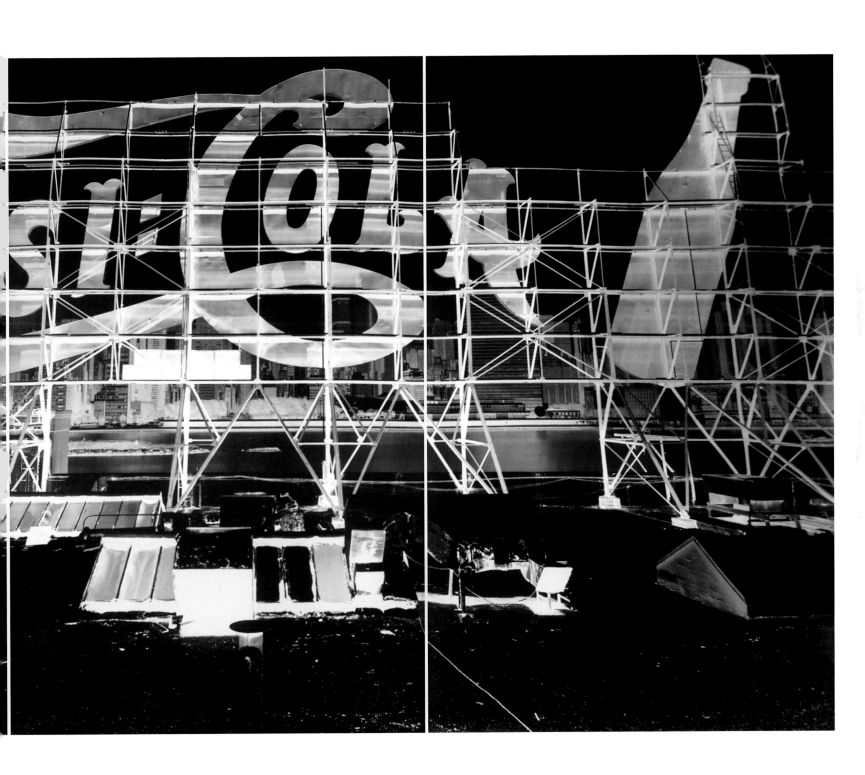

VERA LUTTER
Pepsi Cola, Long Island City, IX: July 2, 1998

'The whole city is a backdrop which could collapse at any moment or run together. Red and black, furnaces, oranges, the smell of burnt plastic and rotten citrus... Split pictures spliced to each other without a soul and so is the City itself. Photos are just that. The people who inhabit it...spliced photos.'

William S. Burroughs on the work of Robert Walker, 1985

ROBERT WALKER
Times Square, New York 2004

ROBERT WALKER
Times Square, New York 2009

ROBERT WALKER
Venice, Italy 2011

DOUGIE WALLACE
Harrodsburg **2016**

NATAN DVIR
Desigual, from the series *Coming Soon* 2013

SATO SHINTARO
Dotonbori, Chuo Ward, Osaka (left), Omori-Kita, Ota Ward, Tokyo (right), from the series *Night Lights* 1997–99

During the monthly Prayer service, 'Holy Ghost Night' of the Mountain of Fire and Miracle Ministries, pastors knelt down to seek forgiveness and prayers from their leader after they controversially left the church.

ANDREW ESIEBO
God is Alive **2011**

ANDY FREEBERG
Sean Kelly, from the series *Art Fare* 2010

ALEC SOTH
Grand Palais, from the series *Paris / Minnesota* 2007

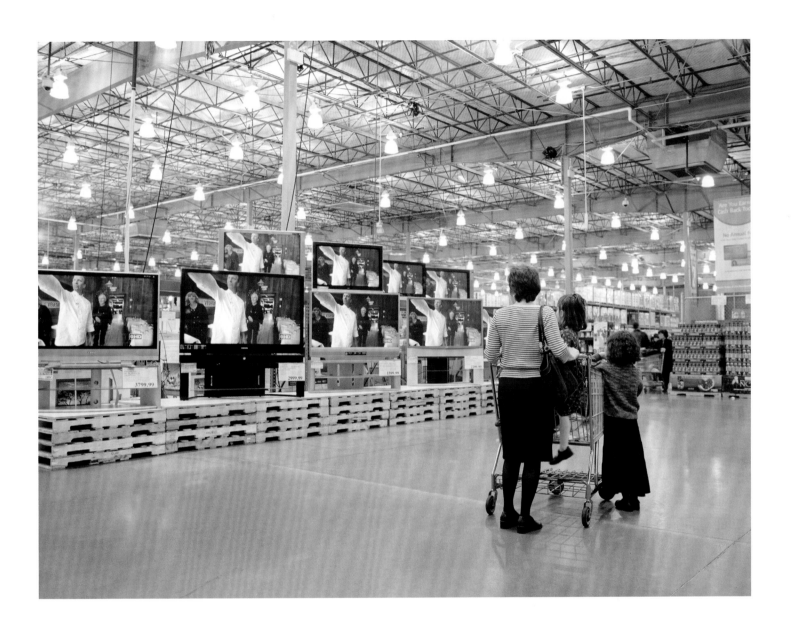

BRIAN ULRICH
Chicago, IL, from the series *Retail* 2006

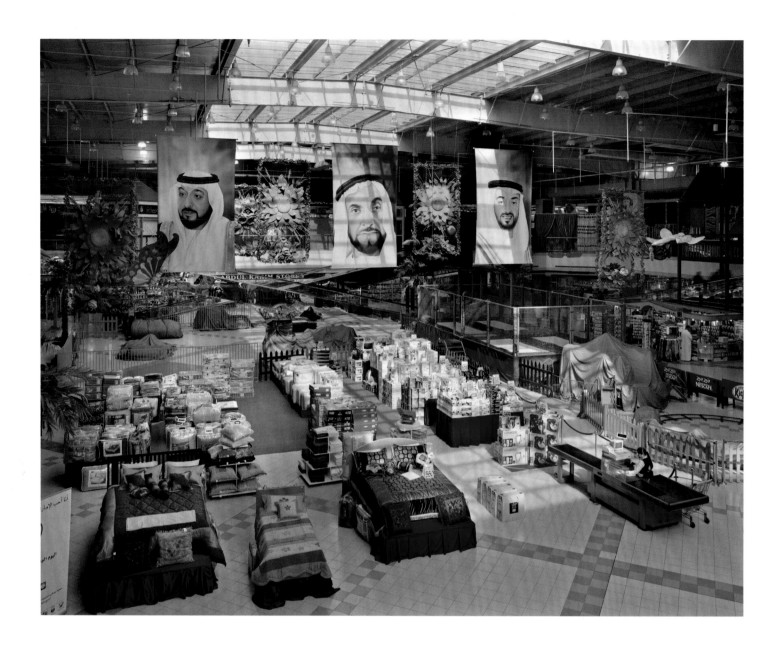

ANDREW MOORE
Al Meena Mall, Abu Dhabi, UAE, from the series *Abu Dhabi* 2009

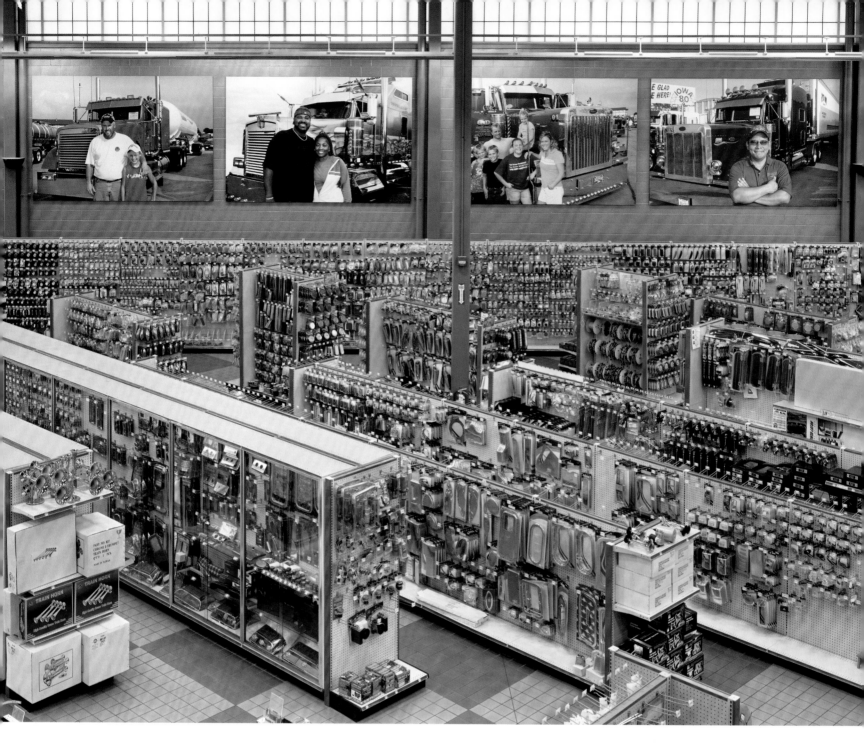

MITCH EPSTEIN

Iowa 80 Truckstop, Walcott, Iowa, 2008, from the series *American Power*

'The mechanisms used in places of worship and economic congresses are intimately connected and although they are represented by more "protestant" attributes, such assemblies preserve this idea of spectacularity.'

CYRIL PORCHET
Untitled, from the series *Meeting* 2012

MARK POWER
The funeral of Pope John Paul II broadcast live from the Vatican. Warsaw, Poland,
from the series The Sound of Two Songs 2005

SIMON ROBERTS
Battle of Britain Memorial Flight, Shoreham Air Show, UK, from the series Merrie Albion 2007

SIMON ROBERTS
Prime Minister Theresa May, Downing Street, London, UK, from the series *Merrie Albion* 2016

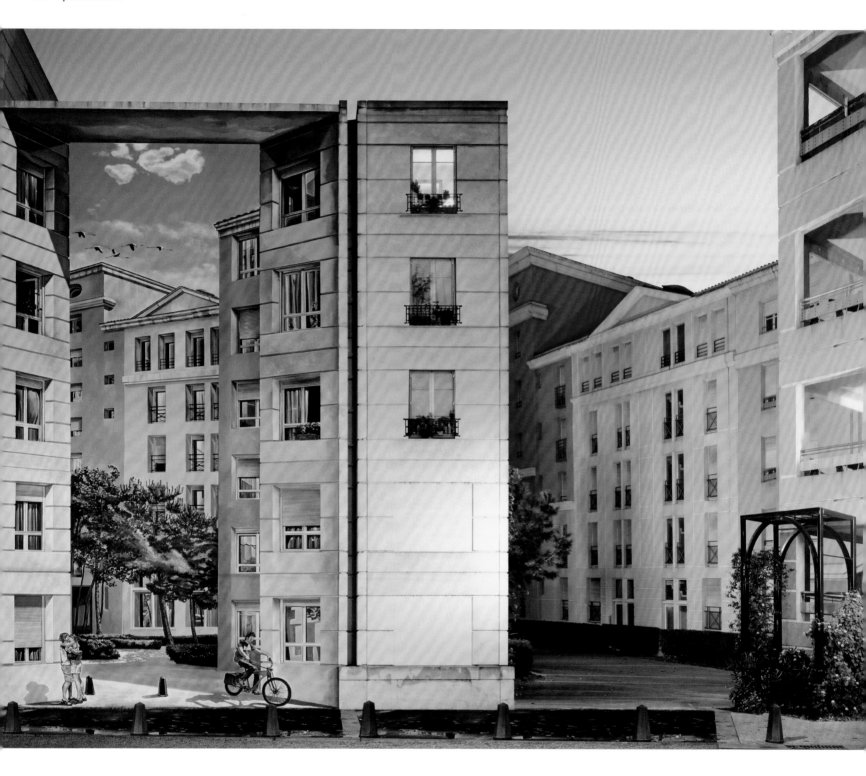

HAN SUNGPIL
Duplication, from the series *Façade* 2010

LAUREN GREENFIELD
Selena Gomez, 17, on an album photo shoot, West Hollywood, 2010. Gomez landed the lead role in the
2007 hit Disney Channel series Wizards of Waverly Place. Disney groomed her as a multiplatform star
– an actress and singer, with a huge social-media following

ANDREAS TSCHERSICH
peripher 1827 (Detroit) 2010 / 2011

The series shows images relating to the impact of the 2008 financial crisis,
with exteriors and interiors of dark stores, ghost boxes and dead malls.

BRIAN ULRICH
Powerhouse Gym, **from the series** *Dark Stores* **2008**

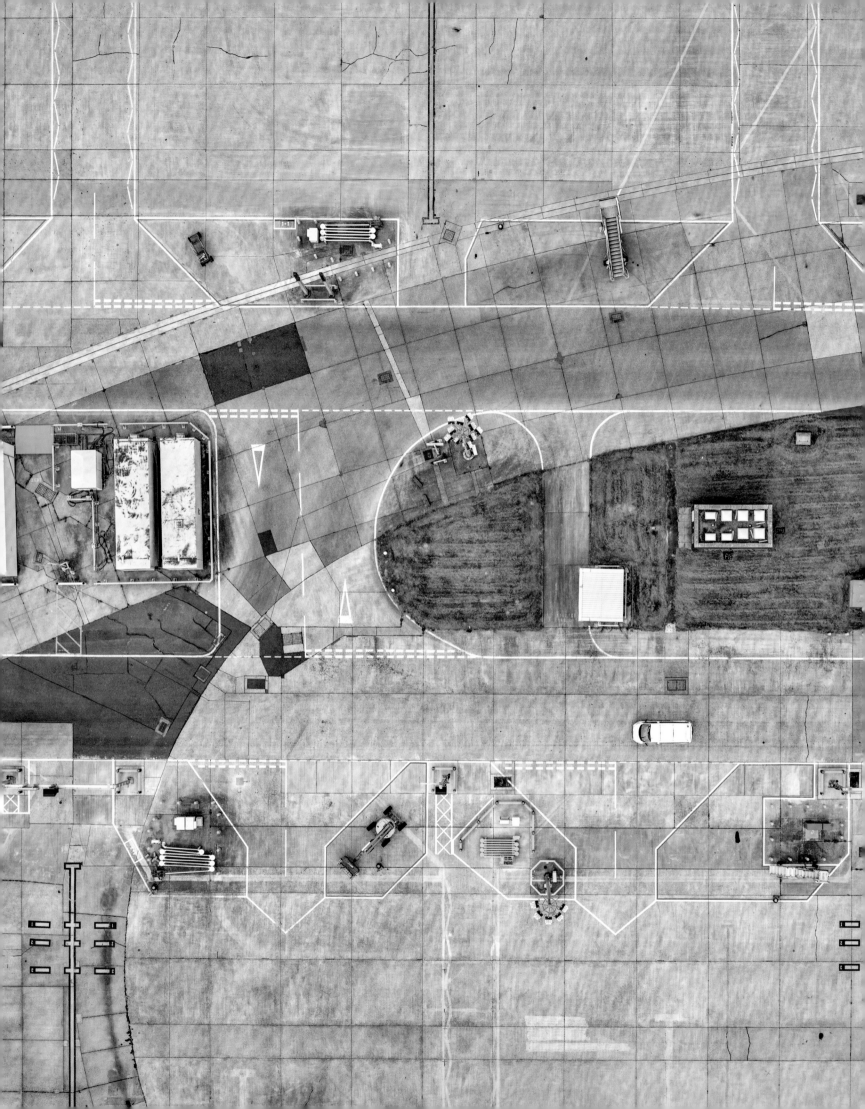

At a basic level of abstraction, civilizations can be likened to complex machines: with parts constantly repaired or replaced. The metaphor breaks down, however, when we realize that a civilization is never consciously designed; a civilization emerges and develops over millennia as the result of trillions of decisions and actions, some taking place rapidly, others at a glacial pace.

A civilization in reasonable health, though it may assume it's invincible, has only a degree of control over its existence. It must manage its given environment sufficiently to feed, clothe, house and protect its populations from natural forces, rival species and other civilizations. And if the civilization is equipped with supernatural powers, as ours is in the matter of nuclear bombs, genetic engineering, artificial intelligence and the like, it must protect itself...from itself.

And yet there can be no question that our civilization *works*, at least for the moment; we're all here to prove it. Despite ever-present chaos, the human species is living longer, reproducing robustly (possibly *too* well), diminishing poverty worldwide, and resolving major conflicts between constituent parts with less violence than ever before. We're now working towards even further control of natural forces, as shown by Christian Lünig's (p. 210) image of the installation of the Wendelstein 7-X, the world's largest fusion device of the stellarator type. An unidentifiable machine-like structure is also seen in Thomas Weinberger's *Synthesen, Nr. 7* (p. 203), titled not with the name of the structure itself, but the photographer's own technique, whereby he mixes two photographs, one made by day, one by night. What these two photographers clearly share – one of them thinking of function, the other of form – is a fascination with the astonishing complexity of these novel kinds of structures.

Vincent Fournier (p. 213) reminds us that our civilization also has designs on worlds yet to be discovered, while Simon Norfolk (p. 205) provides a glimpse of a space-age tool with more modest aims.

Such new marvels must, meanwhile, coexist with powerful technologies of proven worth, like those that harness the power of oil and water, as depicted by Mitch Epstein (pp. 220 and 221) and Edgar Martins (pp. 218 and 219). Still, mystery pervades some of these sites of control. Reginald Van de Welde's (p. 199) cooling tower seems like an image from a dream, while the glowing complex in Trevor Paglen's *They Watch the Moon* (p. 212) hides a secretive government operation, though evidently not as well concealed as it would like.

authority curb direction rule **control**

Sometimes photographers like to tease, framing reality so it first appears as something other than it is, such as Gerco de Ruijter's painterly abstractions (p. 202) or KDK's (p. 190) 'space faction' (spacial fiction?). By contrast, Andreas Gefeller (p. 191) takes the opposite tack: he starts with a mystery – the kind of smooth, impenetrable object we associate with complex electronic operations – and reveals its inner workings.

One can think of 'control' in various ways: on a grand scale, in the form of governments and armies, with their wars and diplomacy, their ideology and propaganda, etc.; or more specifically as police stations, prisons, courts, schools, boardrooms, etc. Photographers have found varied ways of portraying societal controls, as in Che Onejoon's (p. 194) prettified prison cells, such places being for Walter Niedermayr (pp. 214–15) normally 'in the margins of perception'. Lynne Cohen (p. 195) searches out odder places – in the margins of those margins – such as the dollhouse-like rooms where the police learn to prepare for situations of domestic violence.

Mitch Epstein (p. 188) alludes to the discrete watchfulness of Manhattan's authorities, as artificial eyes scan the city's perimeters for potential threats. Noh Suntag (p. 204) and Philippe Chancel (p. 217) fill their frames with soldiers prepared for massed battle, in shows of force designed to impress potential adversaries. Ashley Gilbertson (p. 192) and Alec Soth (p. 196), by contrast, choose off-duty moments when soldiers are more relaxed, though the basic message of preparedness is loud and clear. The war machine can also be presented in a formal, aestheticized manner, as do Jeffrey Milstein (p. 208) and Sean Hemmerle (p. 189), while An-My Lê's (p. 209) depiction of war games reminds us that not everything in 21st-century warfare is high-tech wizardry. Elsewhere, the future of warfare is chillingly foreseen in David Maisel's (p. 216) 'live agent testing chamber'. Just as disturbing are Raphaël Dallaporta's (pp. 206–07) 'anti-personnel' mines, arrayed like chic perfume bottles. Still, military precision is not necessarily restricted to martial matters, as Andrew Rowat's (p. 197) view of caddies at a Chinese golf course proves.

Control is often exercised through architecture. The Tate Modern's appropriation of a gigantic power station was a brilliant ploy, as Robert Polidori's (pp. 200–01) brave-new-world perspective makes clear. Austere authority is also projected by Luca Zanier's (p. 193) FIFA meeting room.

Jeffrey Milstein's airport (p. 184) reveals itself as a perfect illustration of contemporary civilization's degree of precision control over its environment: what remains of nature is purely decorative, even pathetic, sketched by a designer as a flourish.

JEFFREY MILSTEIN
Gatwick 01, from the series
Airports 2016

overleaf
LUCA ZANIER
*Humboldt University
Library I Berlin*
[detail, see p. 198]

'Technology pushes forwards hardest
during war-time. Its greatest advances
are purchased in blood.'

Simon Norfolk

'To photograph is to collect the world.'

Edgar Martins

'But you have to ask the question of how comfortable one really is with subjectivity?
What really interests me in the current climate is the artifice, the nuts and
bolts of propaganda, the crafting of a message. We are at a moment of high
aesthetic and have to contend with political conversations that are more
like what goes on during an art critique. Is this great art? Do you like it?
There is no such thing as facts. It is about subjectivity.'

An-My Lê

supremacy order restrict hegemony

'Humans are more than ever slaves to graphs and spreadsheets, expected to know the outcome before the event and generally more controlled and watched than ever before. Fear rises due to fierce competition resulting in anxiety and separateness.'

Nadav Kander

'Military sponsorship of technological research has shown that the more powerful a technology is, the more likely it will be abused. Indeed, there is an inherent paradox intrinsic to our technological age; we are both the masters of technology and slaves to it. As we contemplate the shift from the modernist, capitalist age to the Anthropocene era, what place does technological advancement have, and what does it mean? At what price does it occur?'

David Maisel

'Electric light is undoubtedly man's triumph over nature, freeing him from the constraints of the night. If this triumph will be lasting, or if we all end like Prometheus, remains to be seen.'

Thomas Weinberger

regulation command repress power

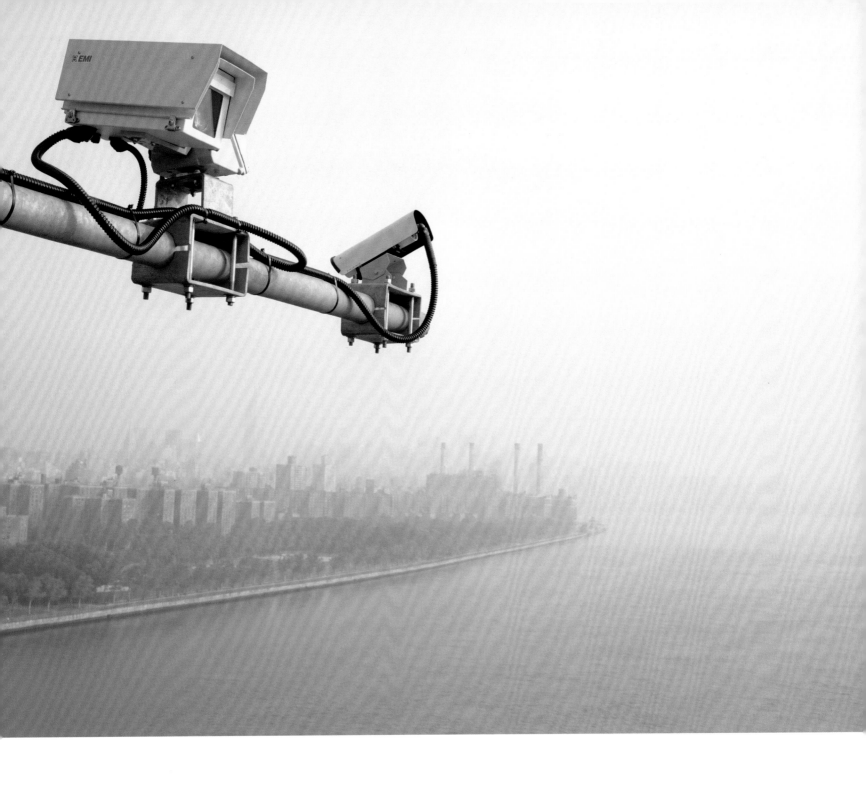

MITCH EPSTEIN
Untitled, New York #11, 1996, from the series *The City*

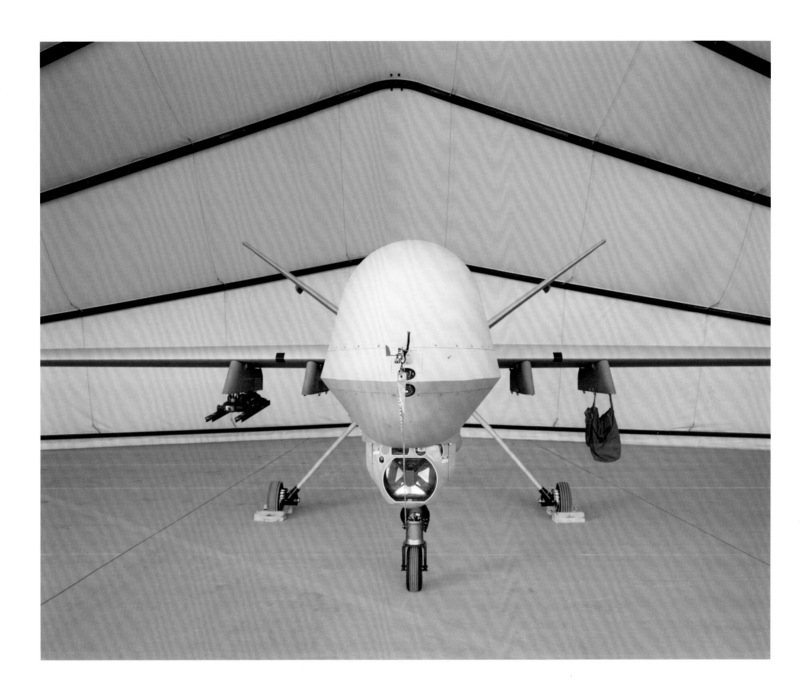

SEAN HEMMERLE
Predator Drone in a temporary hangar, Holloman Air Base, NM, 2012

KDK
sf.D-2, from the series *sf (Space Faction)* 2005

'I make the inside of a computer visible, while the outer shell becomes a paper-cut pattern. The black box becomes a white box, yet the technical elements reveal nothing of their function. The arithmetic processes elude the control of the viewer and develop a proverbial life of their own. Cables and processors are reminiscent of internal organs and evoke associations with a biological organism, furthered by the honeycomb-like structure in the foreground – programs on the threshold to artificial intelligence, computer between machine and human.'

ANDREAS GEFELLER
IP 33, from the series *Blank* 2014

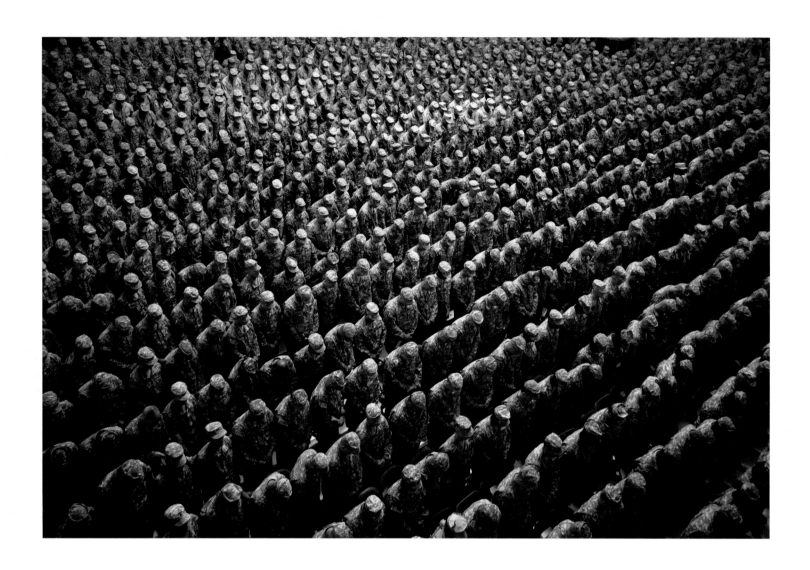

ASHLEY GILBERTSON
*1,215 American soldiers, airmen, Marines and sailors pray before a pledge of enlistment on July 4, 2008, at a massive
re-enlistment ceremony at one of Saddam Hussein's former palaces in Baghdad, Iraq, from the series Whiskey Tango Foxtrot*

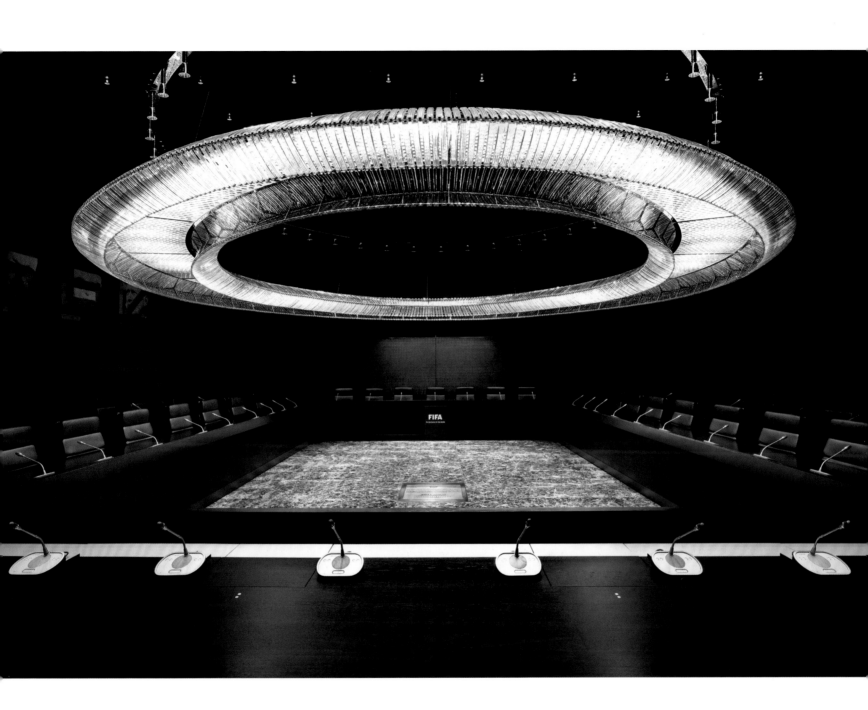

The football family's decision-makers gather in the subterranean conference room lit by a crystal chandelier in the shape of a football stadium. Ex-FIFA president Joseph Blatter thought that the light in places like this 'should come from the people themselves who are assembled there'.

LUCA ZANIER
FIFA I Executive Committee Zurich, from the series Corridors of Power 2013

CHE ONEJOON
Prison cell_Icheon Police Station, from the series *SET* 2006

LYNNE COHEN
Untitled [Police School Classroom, Aylmer] 2003

ALEC SOTH
West Point, New York, from the series *The Last Days of W* 2008

ANDREW ROWAT
Dongguan Mission Hills Caddies 2011

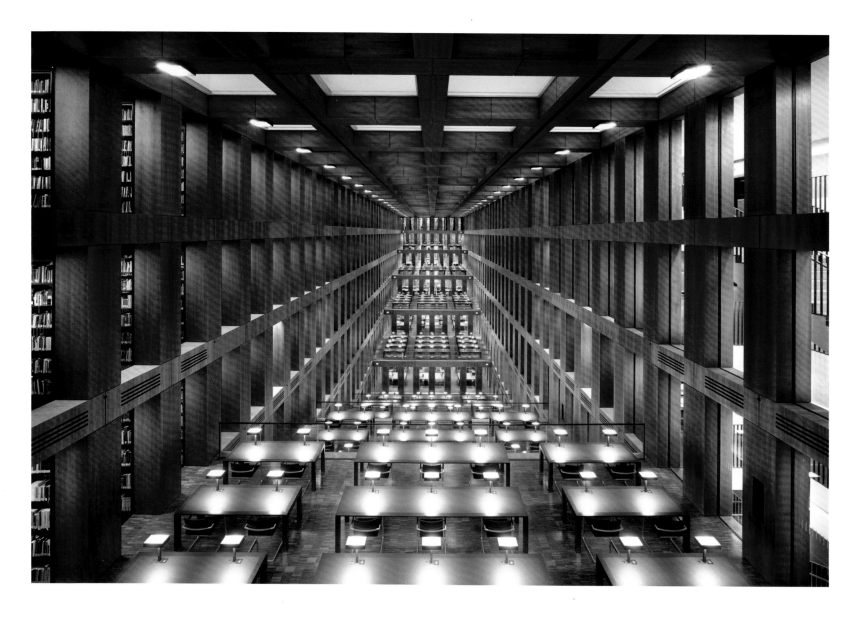

Reading Corners: The emptiness before the storm. During business hours the rush of people into the reading room on the sixth floor of the Jacob and Wilhelm Grimm Centre is so great that the library of the Humboldt University in Berlin imposed strict rules for users – whoever stays away from his table for more than 60 minutes loses his seat.

LUCA ZANIER
Humboldt University Library I Berlin, from the series *Corridors of Power* 2014

REGINALD VAN DE VELDE
*Inside the belly of an active cooling tower: billions of water drops fall down while releasing heat
to the environment. Belgium, from the series Landscapes Within* 2015

'I think it's fair to say
That museums can now be considered as new civilizational cathedrals
Intended for the non- and cross-denominational citizenry of the world,
And even those who don't quite fit those labels will often come to visit.

In fact,
In all the major cities I visit
The names of these institutions
Always figure prominently on the suggested tourist destination lists –
Exhibiting work mostly taken from a universal roster of art-saints
Canonized and controlled by a curatorial oligarchy
Residing throughout the Western Cultural World.

In a conceptual reflection moment
I find it interesting to perceive
Transient tourists viewing Timeless Stasis
In a relatively respectful and devotional silence,
As if museums have become the new temples
Of a collective secular memory.

The press loves to portray and feature for the public
Rare glimpses of what everyone will see
Before they actually get a chance to see it,
Getting the scoop before
– Or even better yet –
In place of all the others;
Power of access dressed up as an informative stance
Admiringly basking in its own social reflection.

I must admit, however,
That without my sanctioned media accreditation
I would not have been allowed to record
This image in the first place.'

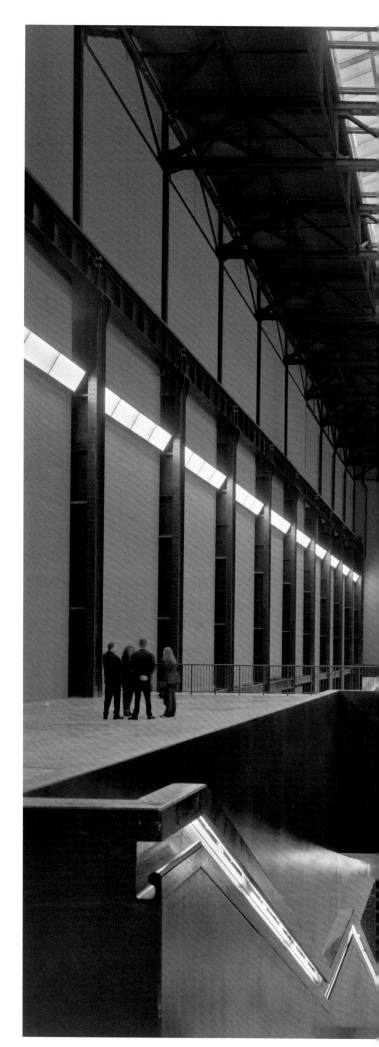

ROBERT POLIDORI
The New Tate Museum Before Opening 2000

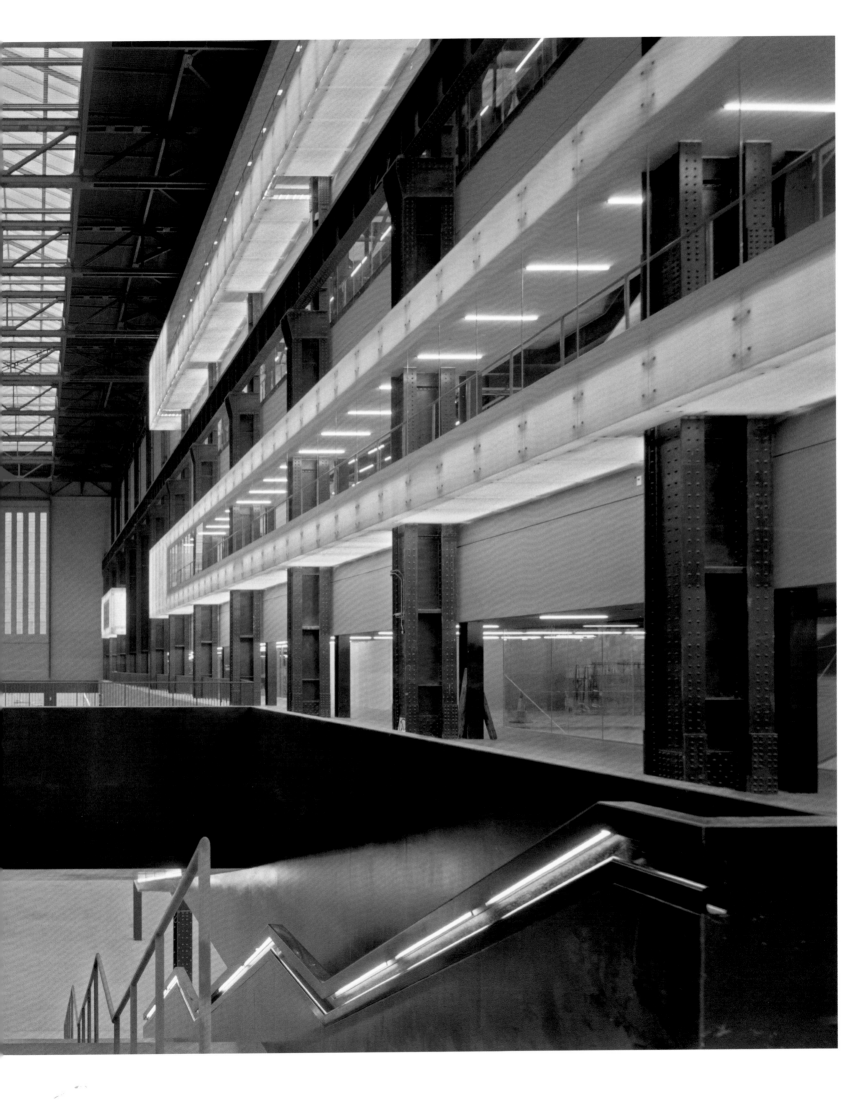

GERCO DE RUIJTER

Lot #2, from the series *Almost Nature* 2012

Tag #1, from the series *Almost Nature* 2014

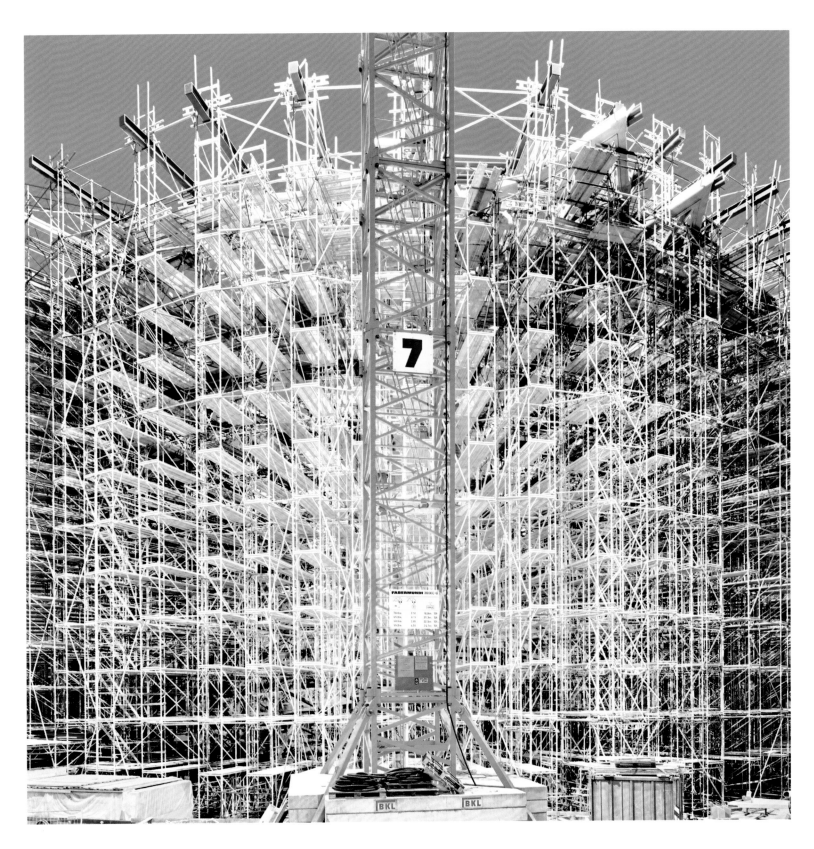

THOMAS WEINBERGER
Nr. 7, from the series *Synthesen* 2007

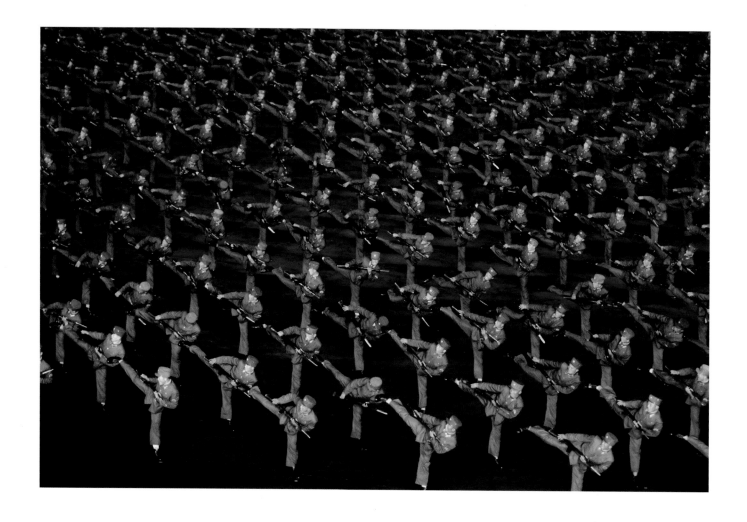

NOH SUNTAG
Red House I #74 2005

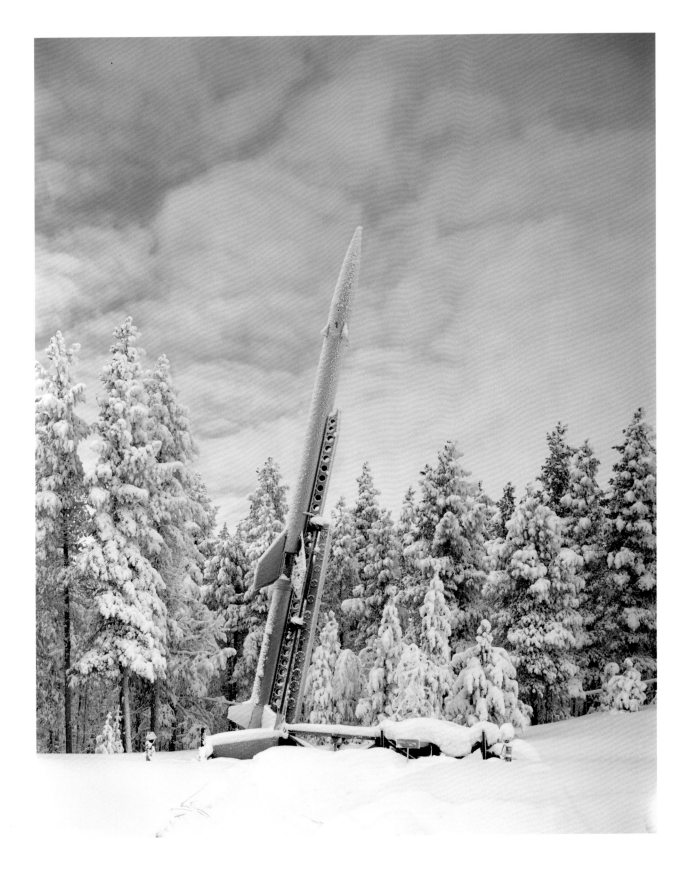

SIMON NORFOLK
*A Terrier research rocket in the winter cold at Esrange in northern Sweden. It is shot into
the upper atmosphere during experiments to scintillate the aurora 2005*

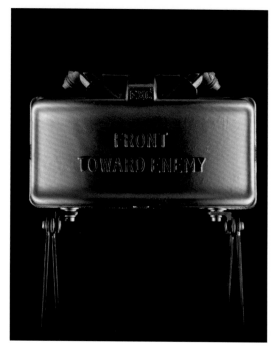

AP-12/ Antipersonnel Bounding Fragmentation Mine
V-69, Italy

AP-21/ Antipersonnel Directional Fragmentation Mine
M-18/A1, Iran

AP-16/ Antipersonnel Blast Mine P-5, Spain

AP-1/ Antipersonnel Blast Mine TYPE-72B, China

AP-17/ Antipersonnel Blast Mine MI AP DV 61, France

AP-20/ Antipersonnel Directional Fragmentation
Mine M-18/A1, USA

AP-5/ Antipersonnel Blast Mine ARTISANAL
LANDMINE, Bosnia

AP-30/ Submunition F1, France

AP-33/ Submunition AO-2.5RTM, Russian Federation

AP-8/ Antipersonnel Blast Mine No. 4, Israel

AP-34/ Submunition BLU-3/B, USA

AP-4/ Antipersonnel Blast Mine PFM-1,
Russian Federation

RAPHAËL DALLAPORTA
from the series *Antipersonnel* 2004

JEFFREY MILSTEIN
Lockheed Martin F-22A Raptor, from the series *Aircraft* 2008

AN-MY LÊ
29 Palms: Mechanized Assault [California] 2003–04

'The Wendelstein 7-X fusion reactor in Greifswald, Germany, delivers results about materials, techniques and operation processes for the global mission to create an eco-friendly way of making electricity. This is probably one of the biggest problems of civilization yet to be solved.'

CHRISTIAN LÜNIG
Installation process of the Wendelstein 7-X in 2011/
view inside, from the series fusion 2011

The 'listening station', deep in the forests of West Virginia, forms part of the global ECHELON system. The station was designed in part to take advantage of a phenomenon called 'moonbounce'. This involves capturing communications and telemetry signals from around the world as they escape into space, hit the moon, and are reflected back towards earth.

TREVOR PAGLEN
They Watch the Moon 2010

VINCENT FOURNIER
SLS project, RS-25 Engine Test on the A1 Test Stand at NASA's Stennis Space Center, Mississippi, USA, from the series *Space Project* 2017

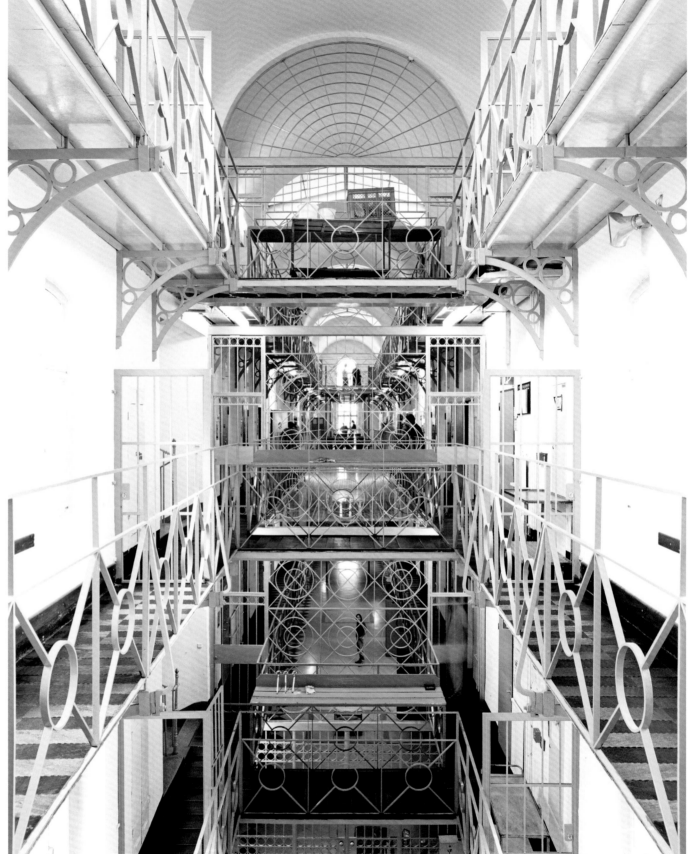

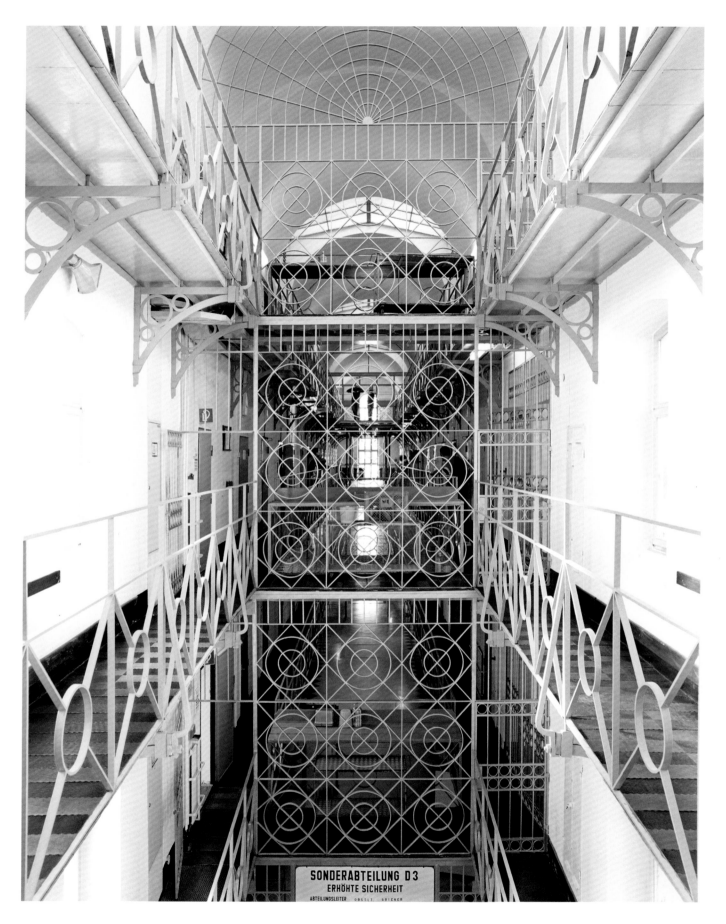

WALTER NIEDERMAYR
Raumfolgen 42, from the series *Raumfolgen (Space Con/Sequences)* 2004

'Our sites of technological experimentation embody our collective aspirations for the future, though they are often hidden from view and difficult to access. Embedded in the architecture, the laboratories and other zones of technological inquiry and experimentation are issues about how human imagination and endeavour are made physical.'

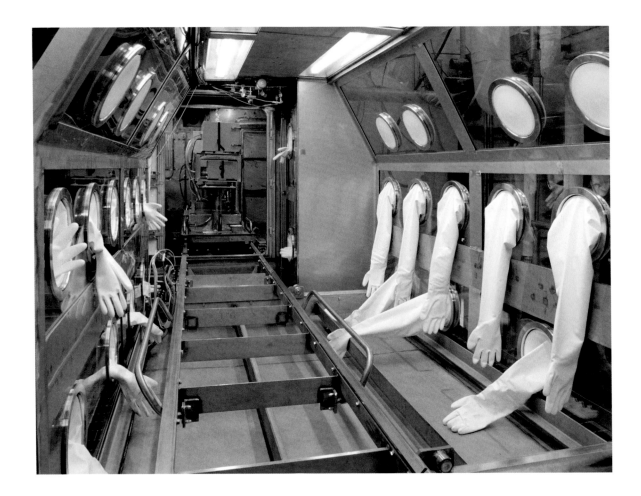

DAVID MAISEL
Interior, Referee Module 2, Whole System Live Agent Test Chamber (5370_04),
Dugway Proving Ground, Utah, from the series Proving Ground 2014

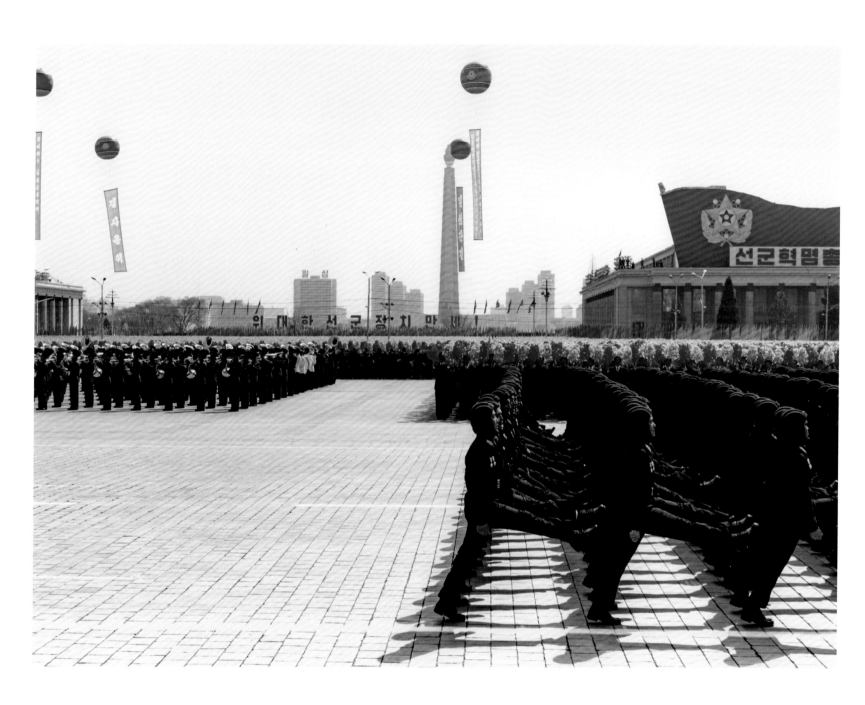

PHILIPPE CHANCEL
DPRK – North Korea, from the series *Datazone* 2006

EDGAR MARTINS
Picote power station: chart for scheduling the periodic maintenance of the generating sets,
from the series *The Time Machine* 2011

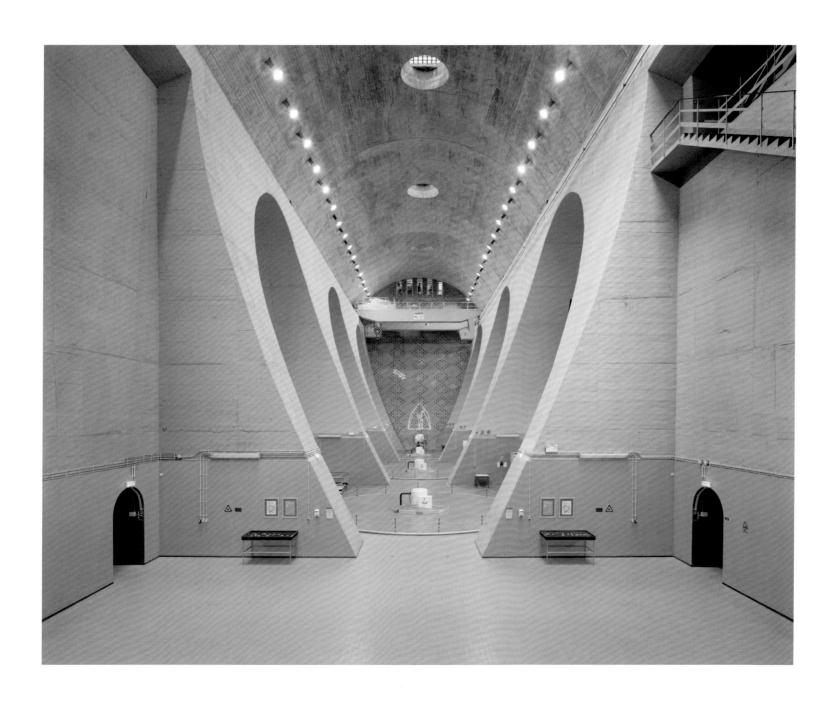

EDGAR MARTINS
Fratel power station: machine hall, from the series The Time Machine 2011

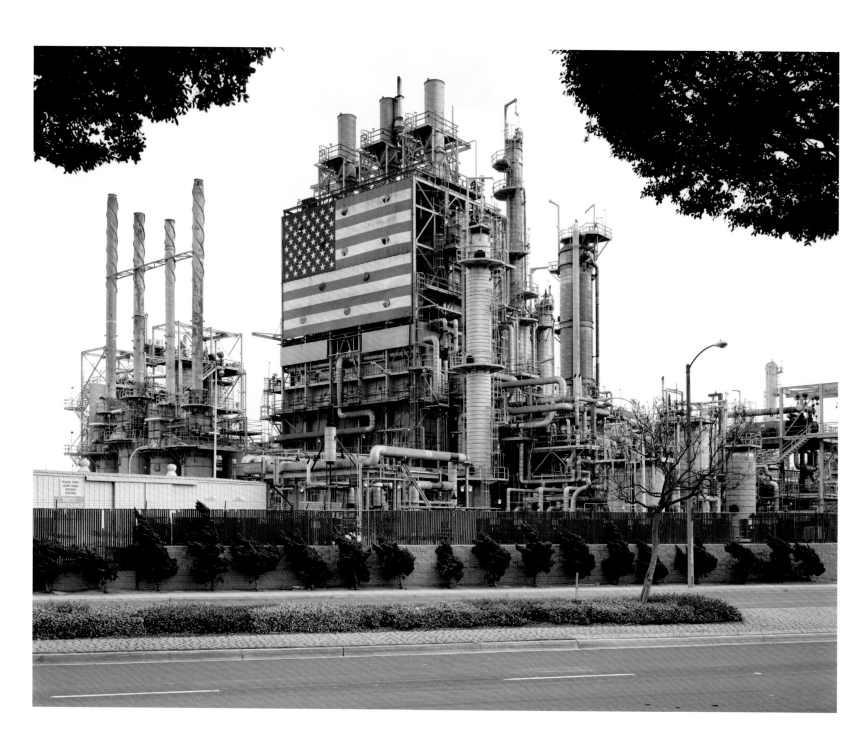

MITCH EPSTEIN
BP Carson Refinery, California 2007, from the series *American Power*

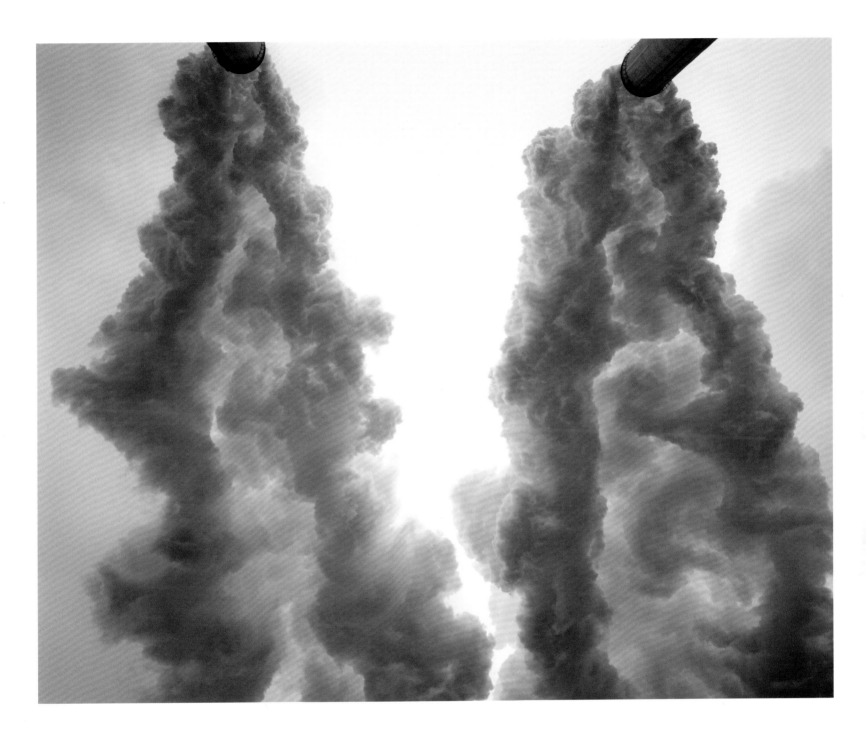

MITCH EPSTEIN
Gavin Coal Power Plant, Cheshire, Ohio 2003, from the series *American Power*

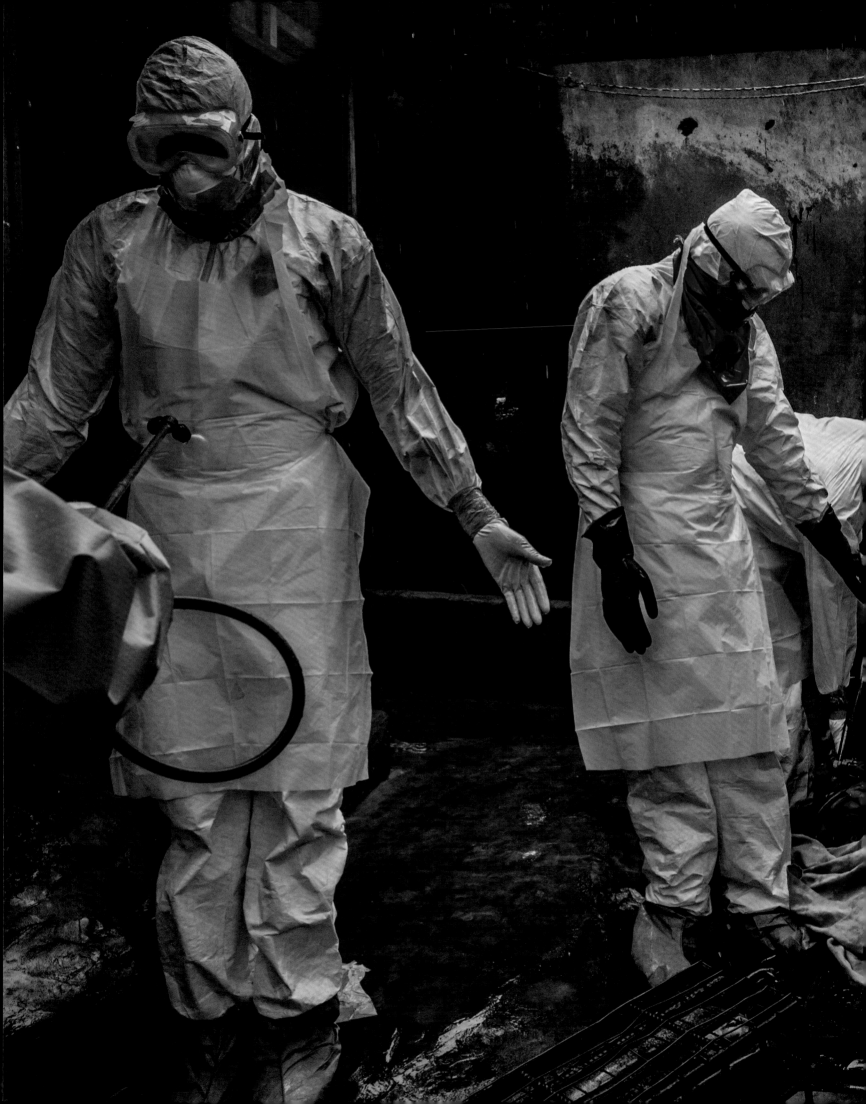

An emerging planetary civilization has for centuries now been defined by expanding international interconnectedness. Myriad macro and micro connections, partnerships, information sharing, and intermingling of populations and cultures have resulted in tremendous societal advancements. At the same time, as scholar Mary Evelyn Tucker reminds us, we face 'environmental degradation, crippling poverty, social inequities, and unrestrained militarism'. And if we narrowly escaped the 20th century's civilizational threats, some of them, like the atomic bomb, are still with us, a point made by Nadav Kander with delicious irony (p. 249). The 21st century had an early taste of new threats on 11 September 2001, with the destruction of the World Trade Center. Sean Hemmerle (pp. 226–27) framed the ruins with the insides of a Brooks Brothers store, an image all the more powerful for the juxtaposition of shattered steel shards with lightly ruffled shirts.

Collective troubles, breaks in the natural order, obstruction of justice or violation of human rights, displacement of peoples, the slow death of industries – photographers have been diligently telling these tales throughout the turbulent early years of our century, as in Will Steacy's (pp. 240–41) blow-by-blow account of the decline of a once great newspaper, while first-rate photojournalism continues elsewhere, as seen in heart-wrenching imagery of intractable problems by Daniel Berehulak (pp. 257 and 269), Gjorgji Lichovski (p. 268), Mauricio Lima (pp. 266–67) and Sergey Ponomarev (p. 260). These reporters and their colleagues respond as well to upheaval in their backyards, as do Sergey Dolzhenko (p. 262) and Natan Dvir (p. 263).

Forcing us to confront civilization's failures, and often blind spots, other highly skilled photographers such as Samuel Gratacap (pp. 264–65) and Francesco Zizola (p. 256) put a human face on the great tragedies of our time, shifting our awareness of human suffering from the abstract to the vividly personal. Drawn to the sacrifices of those who have to fight, Damon Winter (pp. 252–53) throws us into the heat of battle, while Ashley Gilbertson (pp. 254–55) reminds us of the heavy price families are forced to pay for the cold-blooded calculations of their politicians.

Distress in its infinite forms may be tackled no less forcefully through quiet reflection and stilled motion. Perhaps thinking of the wall of distrust between classes of citizens in her own country, Alexa Brunet (p. 261) reveals the distressed corners of French cities where the most vulnerable inhabitants must somehow find a modicum of shelter. Meanwhile, the rich and powerful, seemingly intent on gigantic and brutal urban forms, sweep aside the texture of the past, as

fracture schism division cleft **rupture**

Lois Conner (pp. 236–37) demonstrates in her panorama of an explosive Beijing, while in Hong Kong citizens struggle for democratic rights against a formidable foe – hence South Ho Siu Nam's (p. 236) defiant if wholly symbolic blacking out of what was intended to be the city's 'open door'.

Borders are areas of interest for many thoughtful artists. Their very existence, an intangible concept, gets at the root of many of our social problems. The scale of the walled-off spaces in troubled places is vividly illustrated by Richard Mosse's *Moria in Snow* (pp. 258–59), the poetic-sounding title belying the struggle to survive for uprooted peoples. Alejandro Cartagena (pp. 230–31) sees his photographs of a mother and her daughter not simply as a poignant reminder that families can be wrenched apart as a consequence of friction between nations, but also as an 'opportunity to rethink what this wall is and why it will never divide the life that surrounds it'. The absurdity of all this divisiveness is mocked by Richard Misrach (p. 228), who seems to suggest that our collective impulses would be better served by celebrating these structures as contemporary sculpture, while Pablo López Luz (p. 229) demonstrates the nonsense of such artifice in the greater context of geography. Brutal solutions aren't restricted to one part of the globe: 'welcome to Australia' (the lower case 'w' is intentional) by Rosemary Laing (pp. 232–33) serves as a savage reproach to a governmental stance whose solution to a humanitarian crisis is soul-destroying incarceration.

An oblique approach to walls and borders is taken by Taryn Simon (pp. 234–35), whose *Contraband* series shows items seized from passengers at New York's John F. Kennedy Airport during one full working week in 2010. The fruits of the authorities' efforts might be seen as proof of their efficacy, or conversely, as proof that people will never give up on efforts to circumnavigate checks in place. In contrast, Danila Tkachenko (p. 251) sees rupture in a historical sense, seeking out the relics of a defunct political system. Artefacts of an impressive size, they are presented by the photographer as if they were mere trinkets or souvenirs, a reminder that the power and bombast of one historical moment can give way to pathetic irrelevance the next.

The most serious rupture of our time is that of the environment, about which there is much talk and little action. Mishka Henner (pp. 244–45 and 248) appropriates satellite imagery to make clear the vast scale of today's industries. Xing Danwen (p. 242), Mandy Barker (p. 247) and Chris Jordan (p. 246) share alarm at the spectacular scale of plastic pollution in our landfills and in our lakes, rivers and oceans, not to mention the bodies of animals – probably not excluding our own.

DANIEL BEREHULAK
Liberian Red Cross burial team remove the body of suspected Ebola victim, Lorpu David, Monrovia, September 18, 2014 [detail, see p. 269]

overleaf
NADAV KANDER
Diorama of The Polygon Test Site (before the event), Kurchatov, Kazakhstan, 2011 [detail, see p. 249]

'Tons of outdated and broken computers, game-machines, mobile phones and other e-waste that were mostly manufactured in China, are shipped back there as "donations" from developed countries: Japan, South Korea and the United States...these forces are complicit in creating the environmental and social nightmare experienced in the remote corners of China. Confronted with millions of newly purchased products replacing millions of discarded ones, e-waste has become a matter of concern and a huge warning for the future.'

Xing Danwen

'The meat industry is a subject loaded with a moral and ethical charge. But when I think of these pictures [p. 248], I don't just see gigantic farms; I see an attitude towards life and death that exists throughout contemporary culture. These images reflect a blueprint and a horror that lie at the heart of the way we live.'

Mishka Henner

'Looking into the many dimensions of contemporary consumer culture, it is hard to avoid concluding that there is a slow-motion apocalypse in progress. I am appalled by the destructiveness of humanity's collective will, and yet also drawn to it with awe and fascination.'

Chris Jordan

break fissure disruption clash shatter

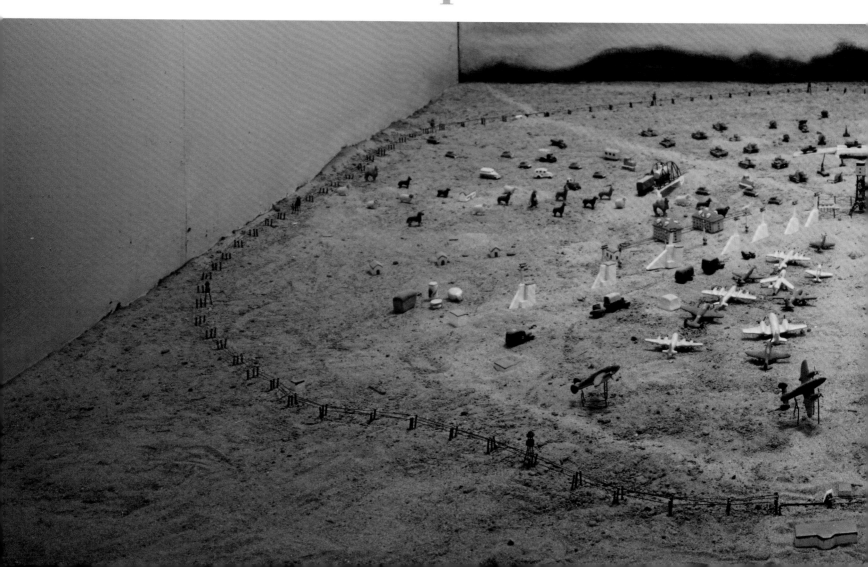

'While trying to accommodate the growing needs of an expanding civilization, we are reshaping the earth in colossal ways. In this new and powerful role over the planet, we are also capable of engineering our own demise. We have to learn to think more long-term.'

Edward Burtynsky

'The power of our economic system has now become so extensive and so complexly amorphous that it is very difficult to grasp. Corporations tend to react to legislation and other attempts to control their actions simply by strategically shifting their position. It is now clear that this planet is being changed ever more rapidly and uncontrollably by human overpopulation, high material expectations and general opportunism.'

Olaf Otto Becker

'A photograph breaks time's continuum, and marks something that is gone and lost.'

Taryn Simon

split breach quarrel parting obstruct

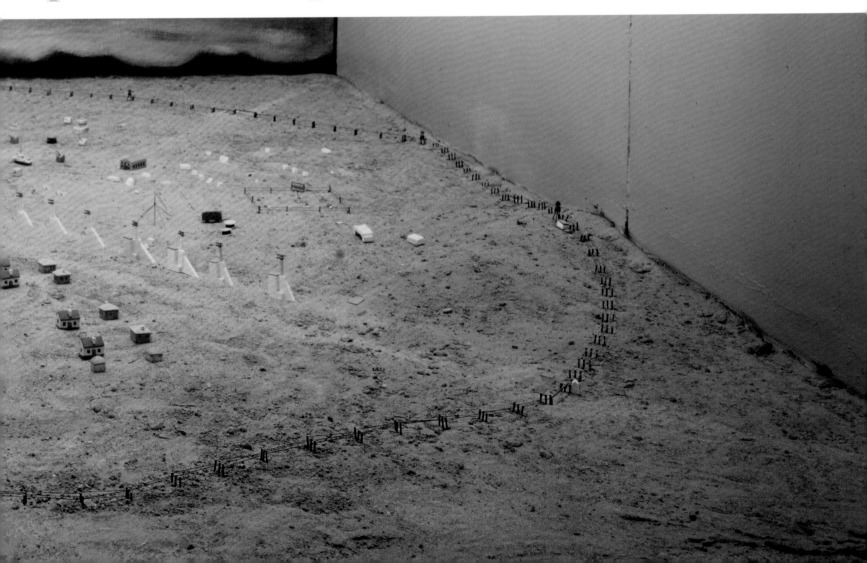

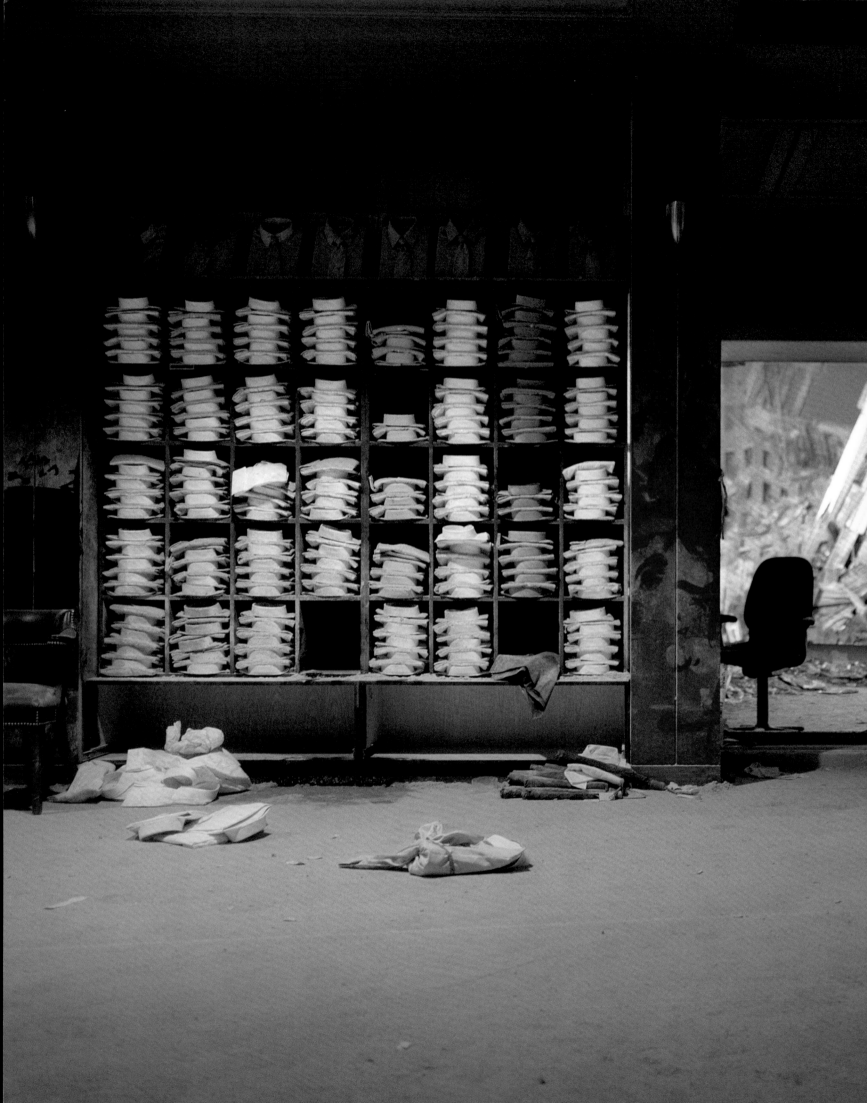

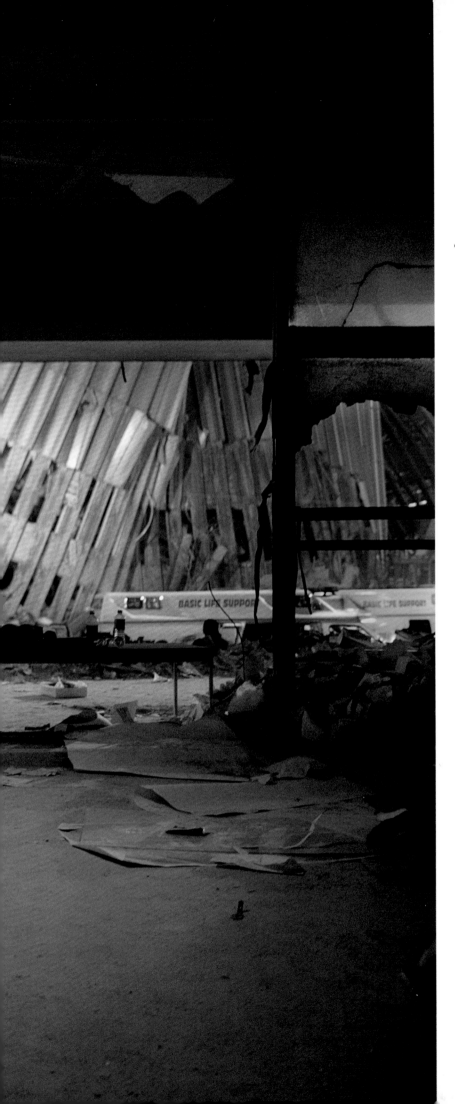

'To be powerless in the face of adversity is
an unsettling and humbling experience.'

SEAN HEMMERLE
Brooks Brothers, WTC, New York, 12 Sep 2001

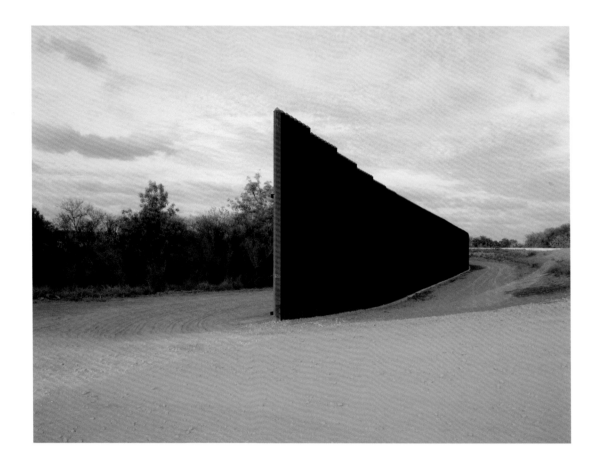

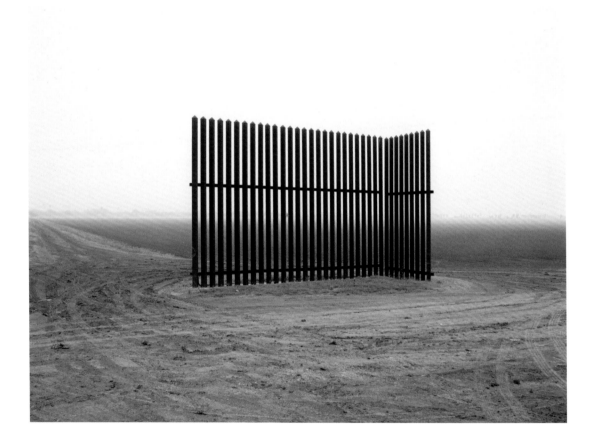

RICHARD MISRACH
Wall, near Brownsville, Texas, 2013, from the series *Border Cantos*

Wall, Los Indios, Texas, 2015, from the series *Border Cantos*

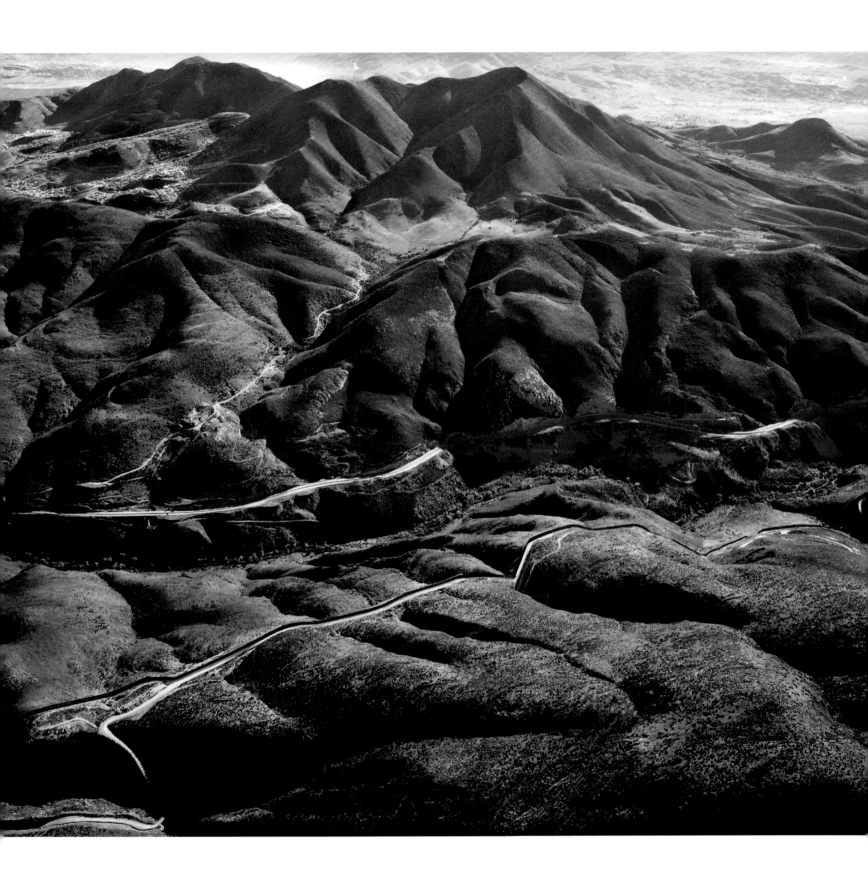

PABLO LÓPEZ LUZ
San Diego - Tijuana XI, Frontera USA-Mexico, from the series *Frontera* 2015

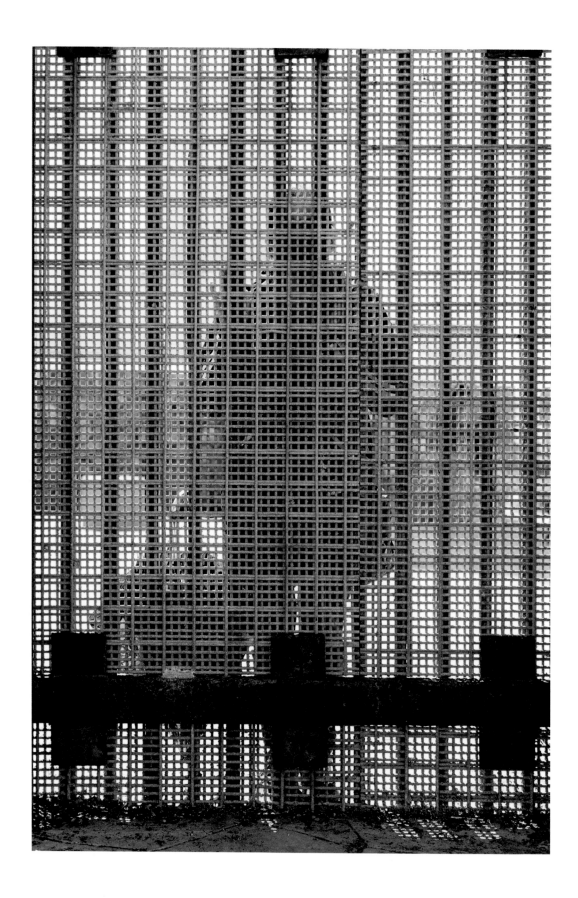

ALEJANDRO CARTAGENA
Mother at the Mexico–USA border wall, from the series Without Walls 2017

ALEJANDRO CARTAGENA
Daughter at the USA–Mexico border wall, from the series *Without Walls* 2017

ROSEMARY LAING
welcome to Australia, from the series *to walk on a sea of salt* 2004

TARYN SIMON
Contraband 2010

'Handbags, Louis Vuitton (disguised) (counterfeit)'
[Detail] Handbags, Louis Vuitton (Counterfeit)

Contraband (2010) comprises 1,075 photographs taken at both the US Customs and Border Protection Federal Inspection Site and the US Postal Service International Mail Facility at John F. Kennedy International Airport, New York. For one working week, Taryn Simon remained on site at JFK and continuously photographed items detained or seized from passengers and express mail entering the United States from abroad.

TARYN SIMON
Contraband 2010

Handbags, Louis Vuitton (Counterfeit)

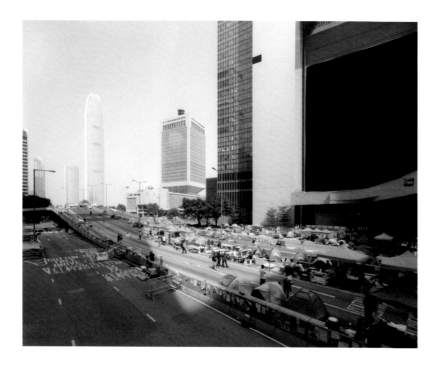

Open Door is a series inspired by the Occupy Movement, surrounding the Hong Kong Government Headquarters. The building is famous for its design, joining the two wings at the upper level, creating the visual metaphor of an open door in the space below. In the image, the 'open door' becomes a blackout. The effect is achieved by the artist cutting out directly on the negative film.

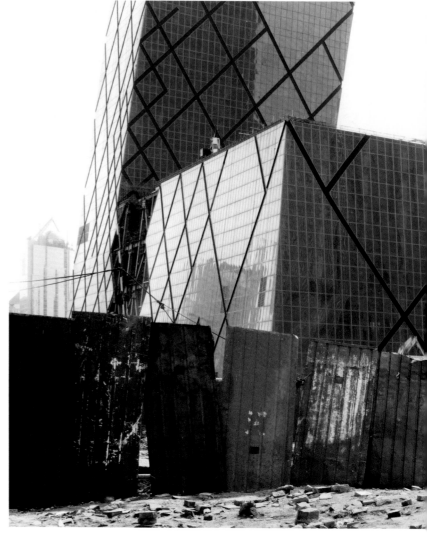

SOUTH HO SIU NAM
Open Door III 2014

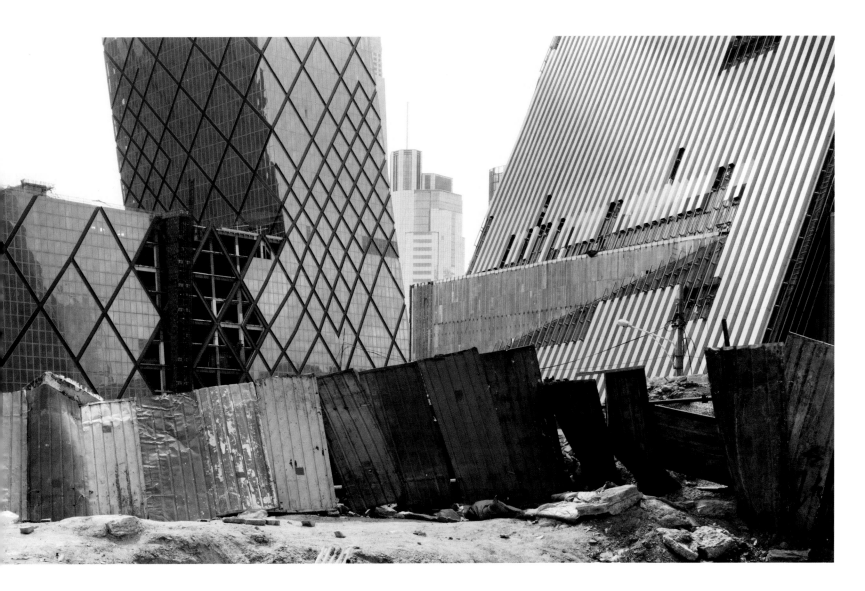

LOIS CONNER
CCTV, Beijing, China, from the series Beijing Contemporary and Imperial 2008

'Nowhere do we come closer, involuntarily, to our neighbour than in the underground.
The underground is a conspiratorial venue for human excesses: the enforced
compression of anxiety, sorrow, pain, madness and fury. In the realm of the
soulless underground, the suburban metro represents the ultimate test
for today's city-dweller, the place where the crucial focus of his inescapable
anxieties, constraints, neuroses, desires and hopes is revealed.'

Christian Schüle

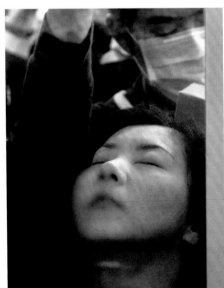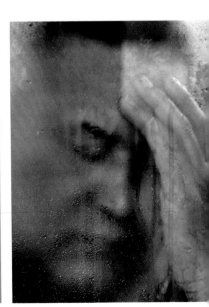

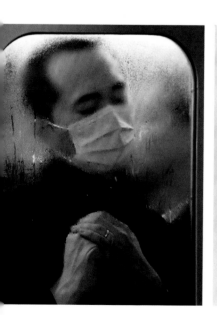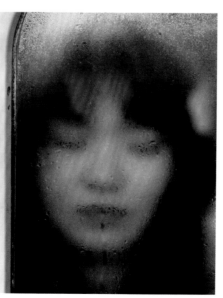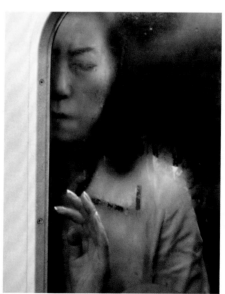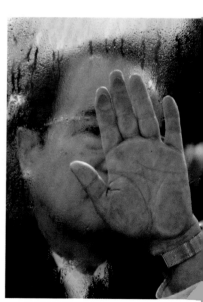

MICHAEL WOLF
Tokyo Compression #05, 82, 35, 109, 75, 106, 39, 80 2010

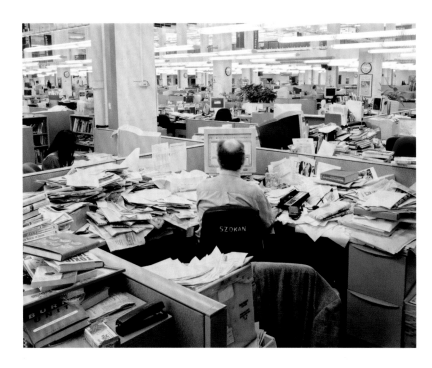 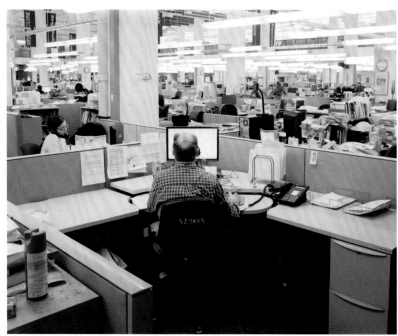

'Having shed 40 per cent of its workforce in the past decade, newspapers are America's
fastest shrinking industry. As we find ourselves amid a massive societal transition
into an information technology economy of the future in which technological
advances have eroded middle-skill, middle-class jobs, boosted productivity while
reducing the labour force, what has been the human cost of these gains?'

WILL STEACY
from the series *Deadline*
Don Sapatkin, Deputy Science & Medicine Editor, 6:44pm, 2009

Don Sapatkin, After Cleaning Desk, 3:10pm, 2010

The *Philadelphia Inquirer* moved their newsroom in 2012, from an entire building to a single floor in a nearby building, to accommodate a much smaller staff. At its peak in the 1990s the *Inquirer* had nearly 700 newsroom employees. Today it has just over 200.

Don Sapatkin's Desk, A Week Before The Move, 4:43pm, 2012

View From Don Sapatkin's Desk, Day After The Move, 3:17pm, 2012

XING DANWEN
disCONNEXION, A14, C4, B12, A6 2002–03

Mosquitos make a foothold in the Arctic.

Scientists prognosticate that human-caused global climate change will raise temperatures by at least five degrees Celsius by the end of this century.

OLAF OTTO BECKER
River 4, 07/2008, Position 2 69°38′26′′n, 49°43′53′′w, Altitude 817m,
from the series *Above Zero* **2008**

MISHKA HENNER
Wasson Oil Field, Yoakum County, Texas, from the series Fields 2013

MANDY BARKER
SOUP: Nurdles · Ingredients; nurdles – the industrial raw material of plastic collected from six different beaches 2011

'It is estimated that of the millions of tons of plastic ever produced almost 80 per cent is still in existence, in the sea or in landfill sites. Enough plastic has been produced to coat the entire earth in clingfilm, and it pollutes every corner of the earth, from the poles to the equator. Although it is not possible to determine when or where plastic entered the sea or to whom it belonged, it is almost certain that plastic will remain a threat in the oceans for hundreds of years to come.'

CHRIS JORDAN
Unaltered contents of Laysan albatross juvenile,
from the series *Midway: Message from the Gyre* 2009

CF000774

CF000668

CF000441

CF000534

MISHKA HENNER
Coronado Feeders, Dalhart, Texas, from the series *Feedlots* 2012

NADAV KANDER
Diorama of The Polygon Test Site (before the event), Kurchatov, Kazakhstan, 2011, **from the series** *Dust*

NADAV KANDER
Graveyard near Kurchatov, Kazakhstan, 2011, from the series *Dust*

DANILA TKACHENKO
from the series *Restricted Areas*
The world's largest diesel submarine. Russia,
Samara region 2013

Monument to the Conquerors of Space.
The rocket on top was made according to the design
of German V-2 missile. Russia, Moscow 2015

Headquarters of Communist Party. Bulgaria,
Yugoiztochen region 2015

DAMON WINTER
*Kunduz, Afghanistan. US Navy Petty Officer 1st Class John Kremer is
shielded from the wash of a medevac helicopter by US Army soldiers
from the First Battalion, 87th Infantry, after sustaining severe injuries
to both legs when he stepped on a mine on Qurghan Tepa Hill in Kunduz,
Afghanistan, Thursday September 17, 2010*

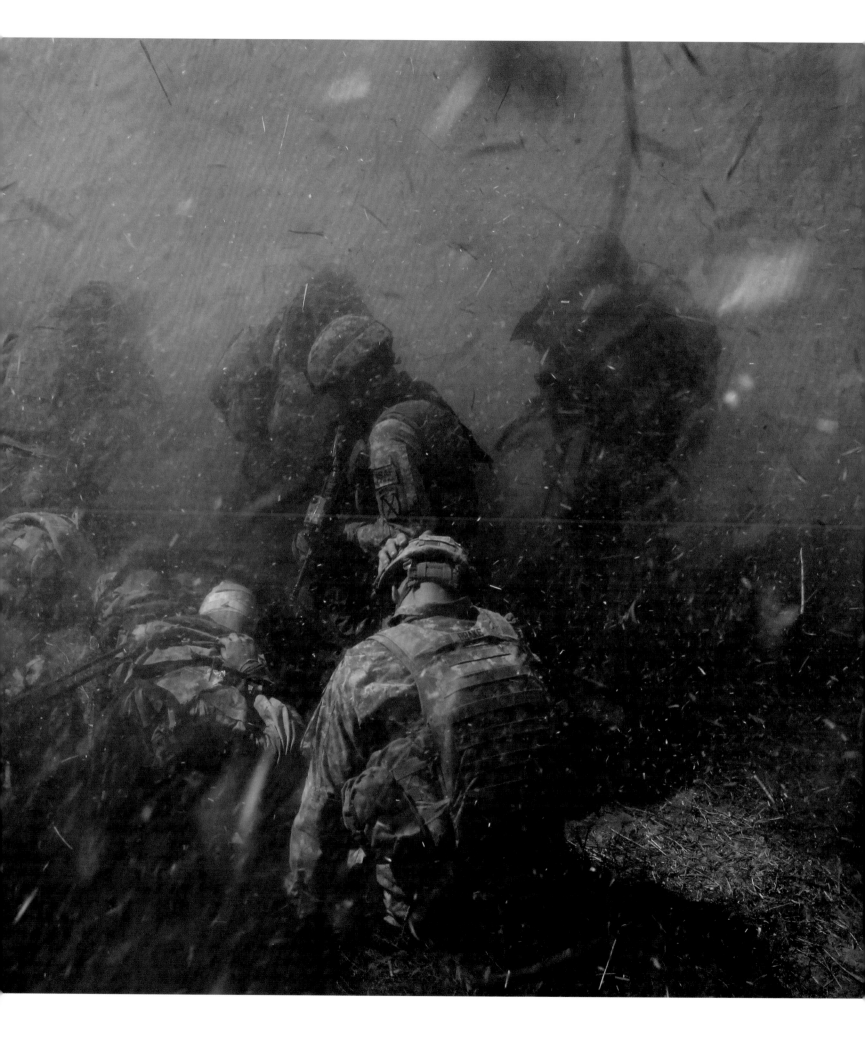

'You're talking on the telephone with a family in Indiana, then exchanging e-mails, then talking on the phone again and again. Then you visit them at home and have tea or lunch, and then you're invited into the bedroom. And all this time you've been talking about their son, and what he did in Iraq or Afghanistan and what he did when he was young and how he used to cover himself in cicadas. Then you walk into his room and you can almost touch him. When you go into the room it brings them to life again.'

ASHLEY GILBERTSON
Army Cpl. Brandon M. Craig, 25, was killed by a roadside bomb on July 19, 2007, in Husayniyah, Iraq. He was from Earleville, Maryland. His bedroom was photographed in February, 2010, from the series Bedrooms of The Fallen

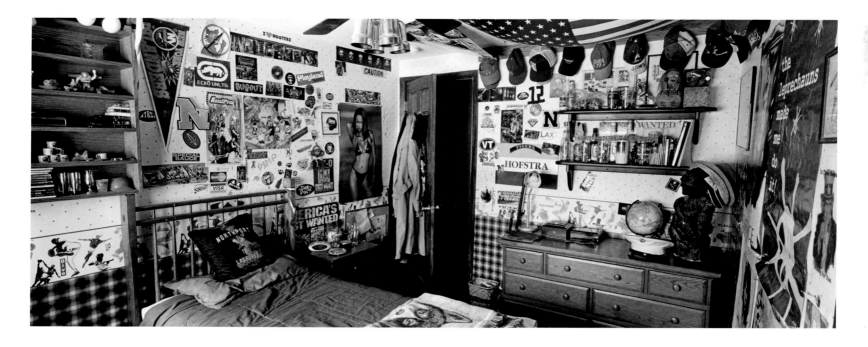

ASHLEY GILBERTSON

Marine Cpl. Christopher G. Scherer, 21, was killed by a sniper on July 21, 2007, in Karmah, Iraq. He was from East Northport, New York. His bedroom was photographed in February, 2009, from the series Bedrooms of The Fallen

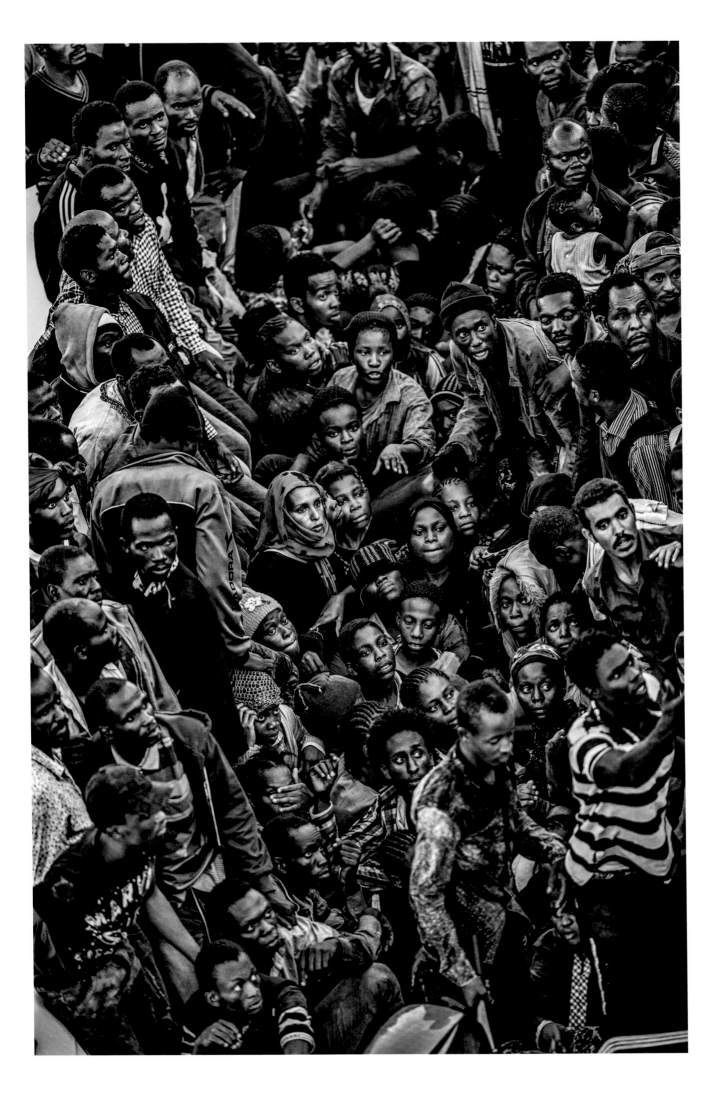

FRANCESCO ZIZOLA
In the same boat 2015

An overcrowded rubber dinghy sailed
from the Libyan coast is approached
by the MSF *Bourbon Argos* search
and rescue ship, 26 August 2015.

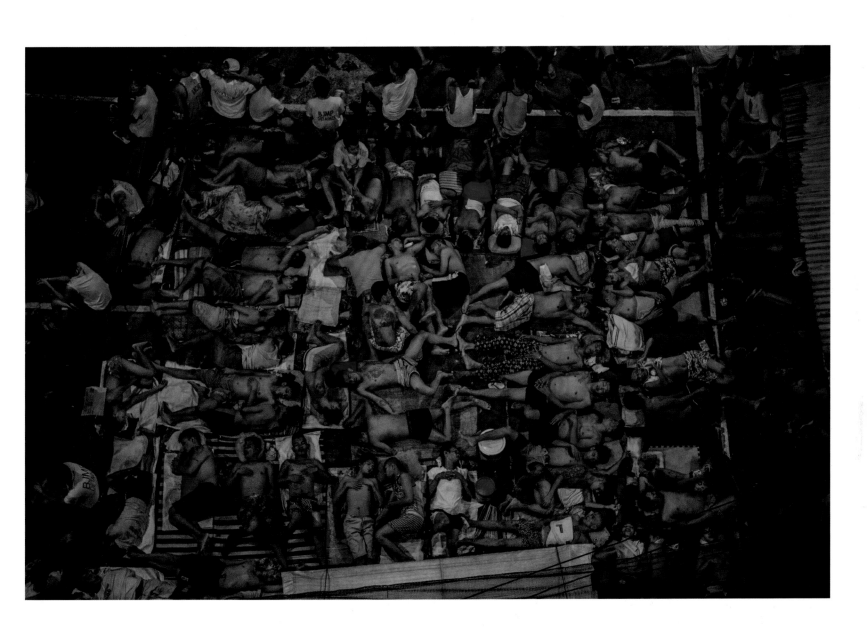

DANIEL BEREHULAK
*Inmates sleep on a basketball court in an overcrowded prison, taking turns on any available space at
Quezon City Jail, one of the country's most congested, in Quezon City, Philippines. There are over
3,500 inmates at the jail, which was built six decades ago to house 800. October 19, 2016*

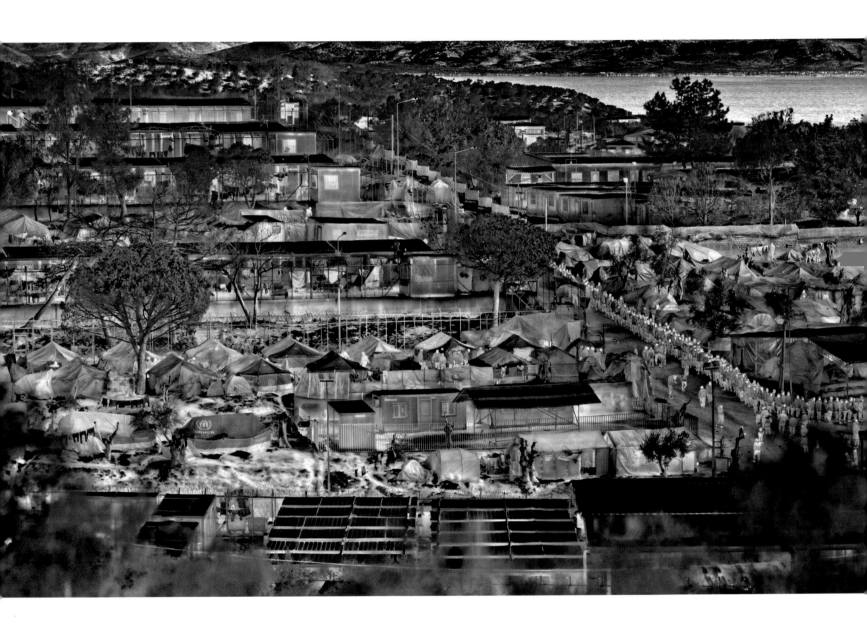

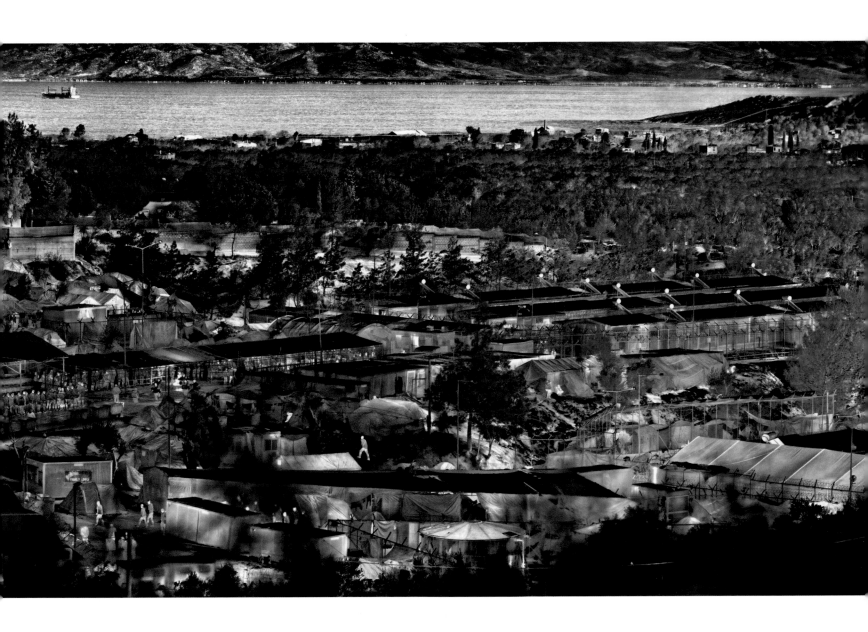

RICHARD MOSSE
Moria in Snow, Lesbos, from the series *Heat Maps* 2017

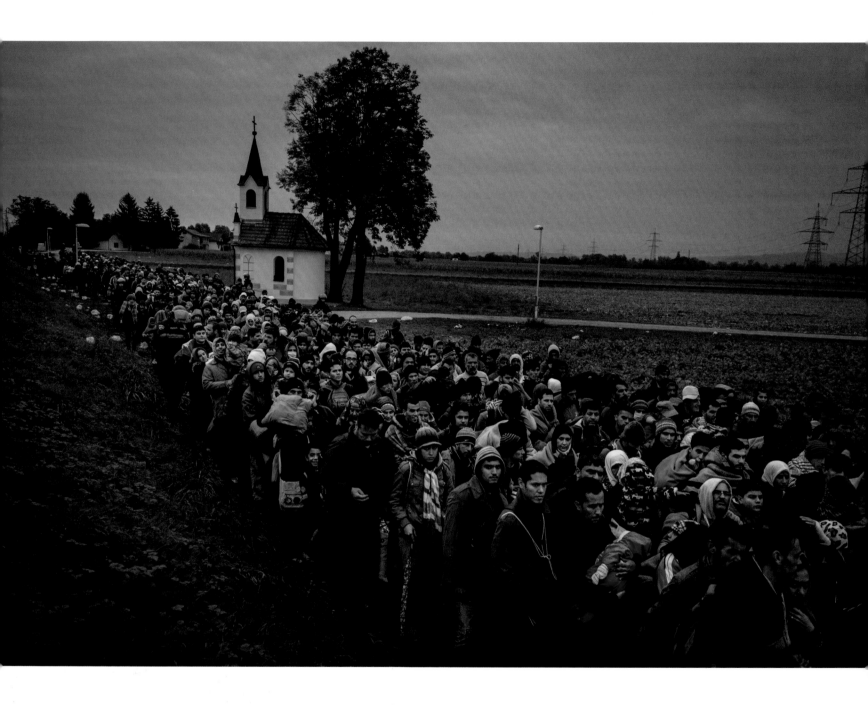

SERGEY PONOMAREV
Migrants walk past the temple as they are escorted by Slovenian riot police to the registration camp
outside Dobova, Slovenia, Thursday, October 22, 2015

'These images of a provisional and fleeting occupation show a different representation of life and death in the public sphere. They shed light on the various ways the city is appropriated, sometimes on the margins of the visible.'

ALEXA BRUNET
Terres communes: Paris les Halles (top right); *Marseille Saint-Charles* (centre, left); *Marseille rue de la Joliette* (centre, right); *Marseille centre Bourse* (right) **2011–2012**

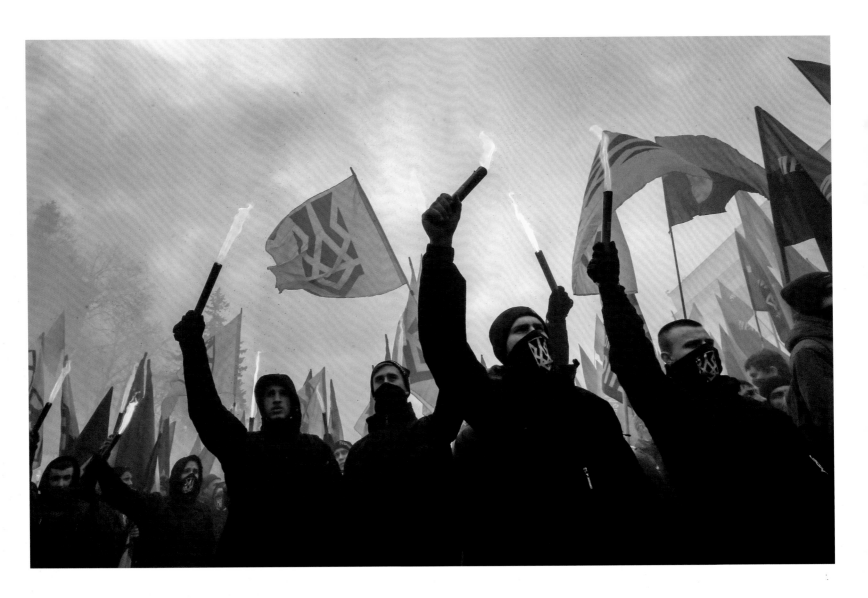

Members of different nationalist parties burn flares and wave flags during the so-called 'March of National Pride' in downtown Kiev, Ukraine, 22 February 2017. Ukrainian right-wing political parties, including 'Svoboda', the 'Right Sector' and members of the volunteer Corps 'Azov', announced combined efforts to put pressure on the Ukrainian authorities for the implementation of reforms. They also wished to stop the trade of Ukrainian businesses with Russian-backed separatists in the eastern Ukraine.

SERGEY DOLZHENKO
Nationalist parties attend the March of National Pride in Kiev 2017

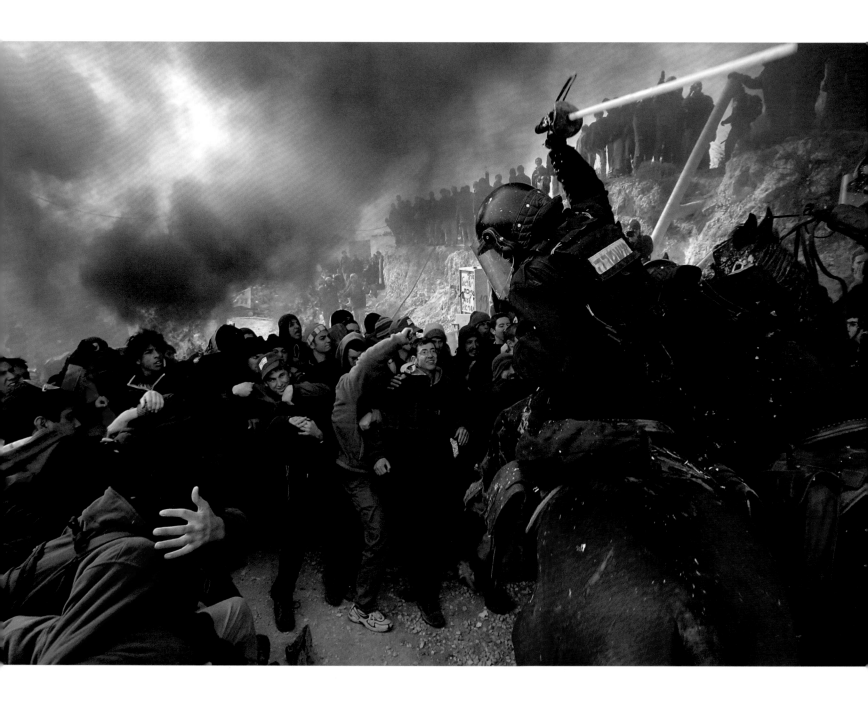

NATAN DVIR
Amona, from the series Belief 2006

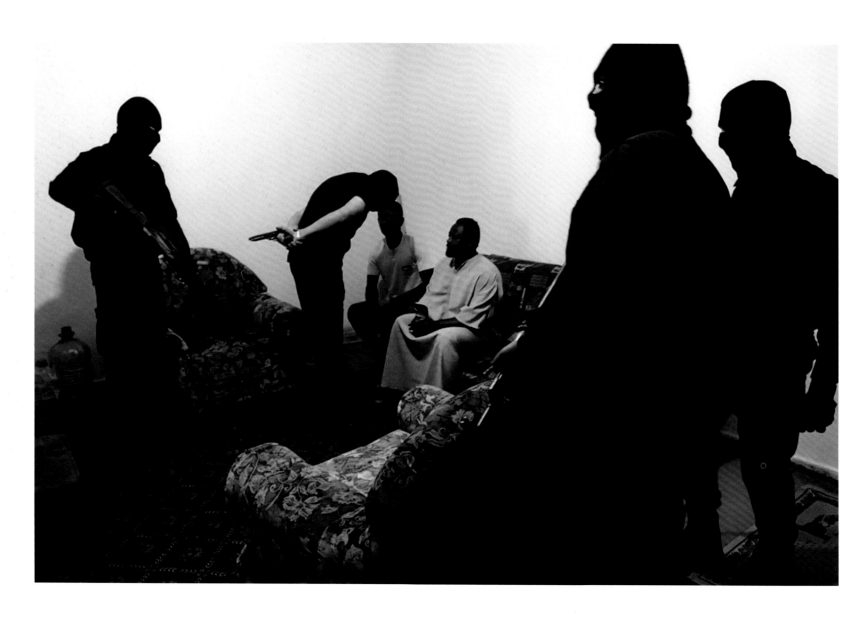

SAMUEL GRATACAP
Search in a house by anti-illegal immigration police, Tripoli, Libya, from the series fifty-fifty 2016

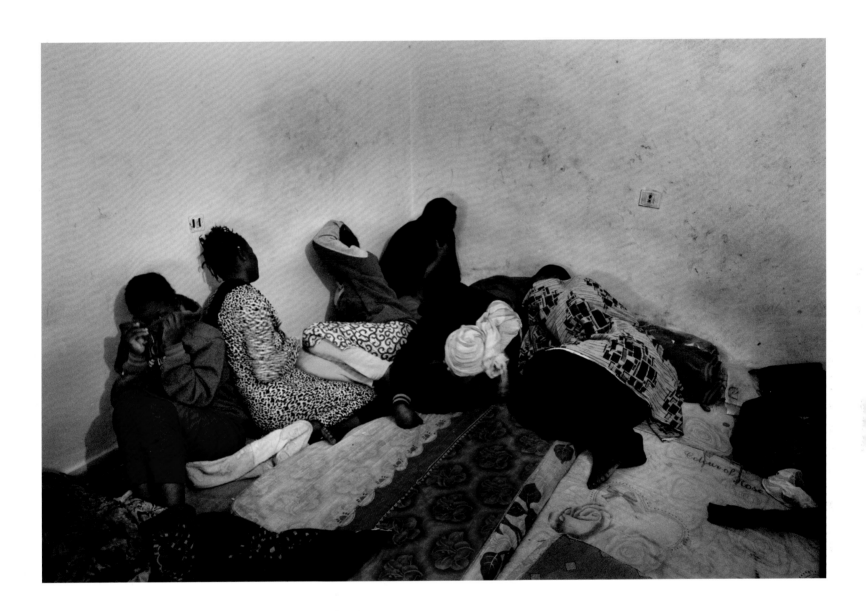

SAMUEL GRATACAP
Search in a house by anti-illegal immigration police; female migrants from West African countries found in a locked room,
Tripoli, Libya, from the series fifty-fifty 2016

MAURICIO LIMA
*Refugees watch a huge plume of smoke as dozens of fires burn
huts and makeshift shops at the camp called the 'Jungle', in
Calais, northern France, October 26, 2016*

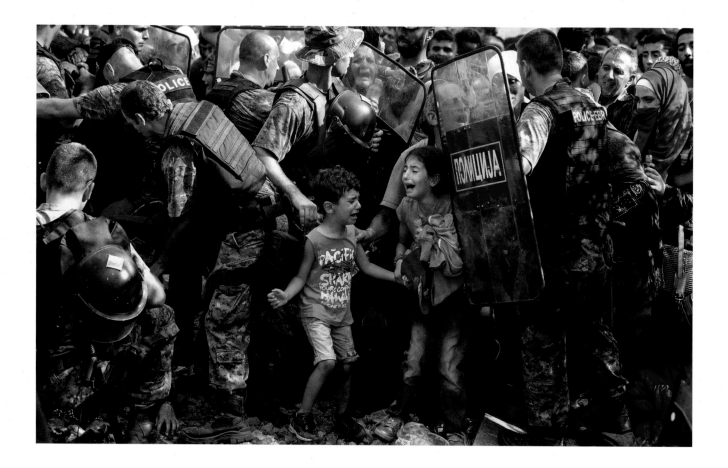

Children cry as migrants waiting on the Greek side of the border break
through a cordon of Macedonian special police forces as they try to cross
into Macedonia near the southern city of Gevgelija, 21 August 2015.

GJORGJI LICHOVSKI
Macedonian police clash with refugees at blocked border 2015

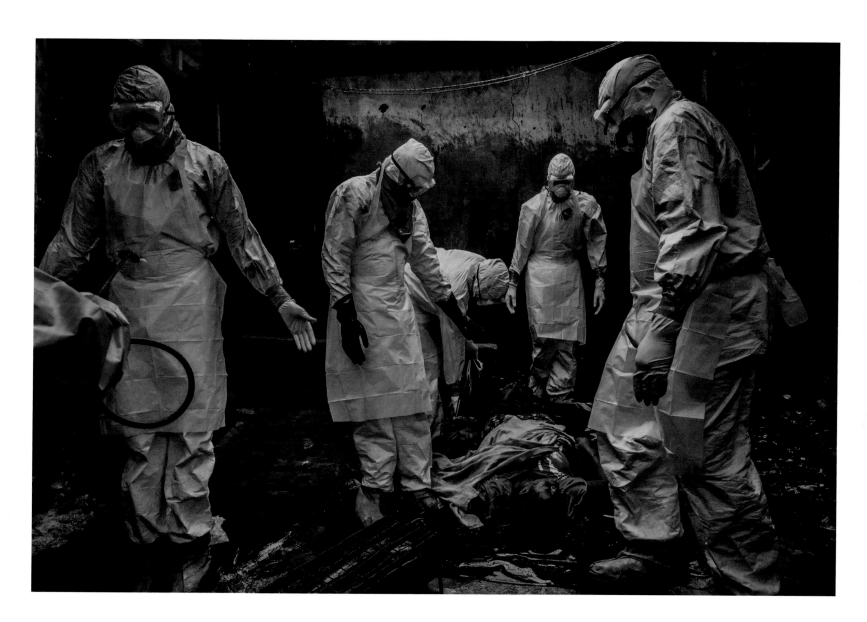

DANIEL BEREHULAK
Liberian Red Cross burial team remove the body of suspected Ebola victim, Lorpu David, Monrovia, September 18, 2014

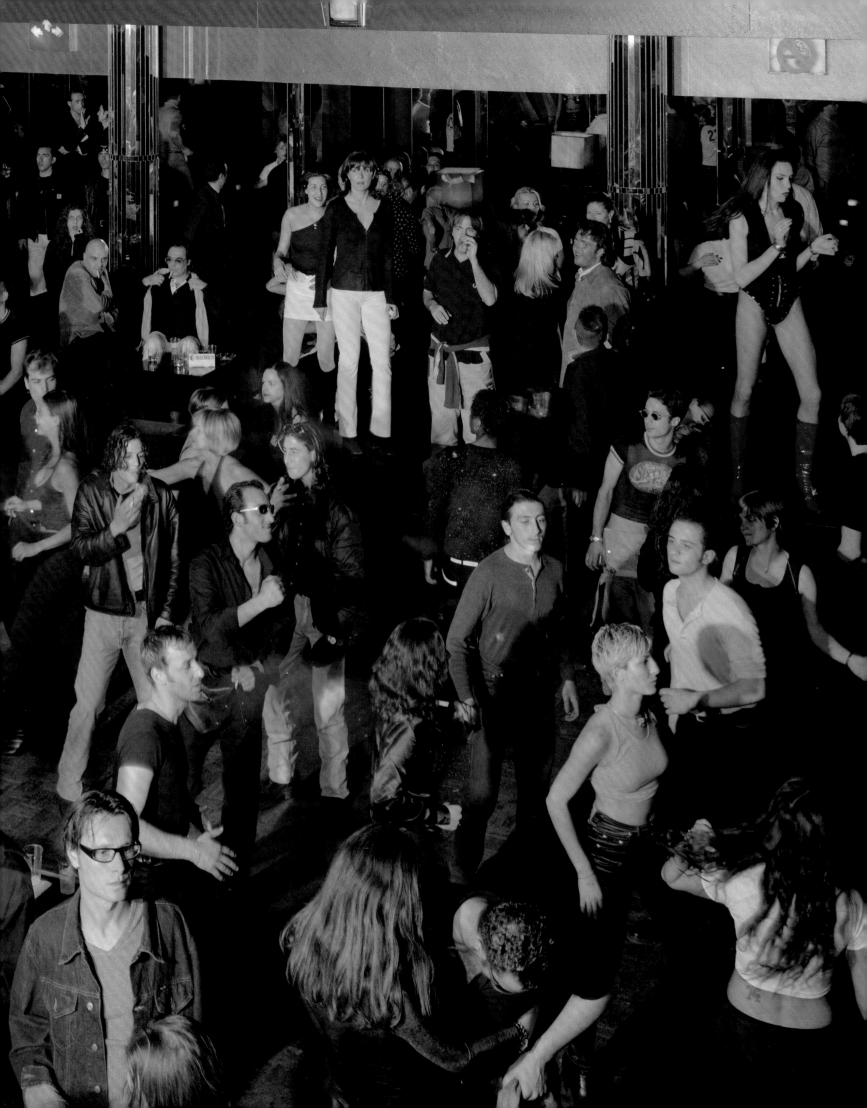

Escape is sometimes used as a term to describe breaking free from some form of confinement, physical or emotional, or generally fleeing any dire or merely disagreeable situation. In the previous chapter, we have seen how escape for millions of the world's inhabitants means fleeing from death, slavery and starvation. For the privileged inhabitants of the world, however, the term has less fraught connotations. In casual conversation we use the term more lightly, and generally more positively, to suggest removing oneself temporarily from a familiar environment or routine – as for example when we speak of 'being in a rut', either at home or at work, and 'getting away from it all'. We search for amusement, diversion or distraction. On the one hand, we seek relaxation and rest; on the other, we yearn for novelty, adventure, social stimulation and excitement. The unspoken thought: once away for a while, we'll be happy to come back to it all – those creature comforts that wealthier citizens of the world generally take for granted, and despite their habitual derision, would be lost without.

An industry of pleasure has risen up in the past century, offering a spectacular array of 'products' to its avid consumers, whether risk-averse or thrill seeking, catering for the sexes, all age groups, and tastes of all kinds. For many, it's a dance floor (Massimo Vitali, p. 274), where seeming abandon can disguise the rituals of the mating game. For others, a cruise signifies escape, and the operators have obliged, turning their vessels into glittering palaces of light entertainment, not to mention lucrative sources of commerce (Jeffrey Milstein, p. 275). On land, theme parks abound, sometimes the size of small cities, where time is either turned back on itself with a strong dose of nostalgia or pushed forward with utopian visions of the future. Reiner Riedler (pp. 284 and 291), for whom these often surreal places hold a particular fascination, brands them 'fake holidays' – and yet the pleasure of the participants is palpable. Isn't this simply an early manifestation of *virtual* reality? Even nature is best seen as a display: those polar bears may be dying off in the Arctic, but as Sheng-Wen Lo (p. 276) shows us, a handful are kept captive in order to thrill city folk. And we must not overlook the most successful dream factory of all time: Hollywood. An-My Lê (pp. 292–93) seems to pull back the curtain on the costly manufacture of the stories we collectively tell each other.

From the air, pleasure grounds can look like machinery, with gears and cogs, as Jeffrey Milstein (p. 294) reveals. Machines for manufacturing happiness abound, some built temporarily, like world fairs, where structures lasting often no more than a year or two but costing billions

bypass freedom avoid evasion **escape**

offer theatre of extraordinary complexity to millions (and countless more via television), whereby nations and corporations strive to mould ideas and beliefs in their favour. Giles Price's (p. 283) view of the Olympic Stadium under construction is rightly presented as just such a vast machine. Mark Power's view of the London event (p. 277) also shows a part of the grand spectacle in the making. His amusing view of a 'Gulliver' held in check by (we) Lilliputians highlights the massive effort we put into these fleeting, ever grander spectacles.

We seem to crave extremes when we speak of escape. Thousands of well-heeled and superbly equipped amateurs now routinely scale peaks that only the most hardened climbers would have dared to tackle a century ago. In Giles Price's (p. 280) range of snow-capped peaks, what looks at first like mere litter turns out to be the base camps for hundreds of teams hoping to scale Mount Everest. Other, less daunting, summits can be reached in comfort by 21st-century men and women, as Simon Roberts (p. 281) shows, along with all the amenities found in the valleys down below.

Simon Roberts (pp. 287 and 290) also captures the joys of communal sport, whether in the form of its energetic participants or its excited onlookers, reminding us that the current turmoil of British politics leaves more fundamental rituals untouched. Culturally very different are the communal gatherings of Americans as pictured by Edward Burtynsky (pp. 278 and 279), for whom concerts and jamborees act as *de facto* celebrations of the internal combustion engine.

And yet millions of us still take pleasure in simpler means of escape from our daily routines, content to find respite wandering majestic dunes (Massimo Vitali, p. 286), exploring the chilly caves of a famed glacier (Walter Niedermayr, pp. 288–89) or frolicking in the sea (Zhang Xiao, p. 295). The joy of solitude is captured by Richard Misrach's (pp. 296–97) tiny human being blissfully floating in an immensity of clear blue sea. However, his series' title, *On the Beach,* might recall for some a disturbing film that dared to look at nuclear apocalypse unsparingly; that beach signalled the end of humanity. Apocalypse aside, one might imagine this floating figure, staring up at Matthieu Gafsou's (p. 296) contrail-streaked sky, trying to recall the hopelessly out-of-date clouds of earlier times.

MASSIMO VITALI
Peter Pan Brutti Ceffi
[detail, see p. 274]

overleaf
GILES PRICE
Opening ceremony, London Olympic Stadium. E20 12 Under Construction
[detail, see p. 283]

'The existence of captive white bears embodies an ambiguity. Promoted as exotic tourist-magnets (*mega fauna*), the bears stand at the point where the institutions' mission of conservation, research and education is challenged by their interest in entertainment.'
Sheng-Wen Lo

'Who wouldn't want to fly around like a bird looking at anything and everything down below?'
Jeffrey Milstein

'Today, for us Europeans, beaches appear more dramatic because we have the problem with refugees, who come by sea. The beach is on the border; it's on the limit of the land, on the limit of Europe. And somehow the beach is not the same as it used to be twenty years ago.'
Massimo Vitali

circumvent bolt elude leave abscond

'It's fascinating to explore how humans function and how easily they can be manipulated by evident set-ups in places such as leisure parks. On the one hand it is great to see that we all still feel like children, but on the other hand we should think about the loss of nature and how we can live with these simulacra.'

Reiner Riedler

'During Chinese New Year, the hundreds of millions of people who come to the coastal areas for jobs each year travel home for family reunions; it is a huge migration from south to north and from east to west within a short period of time. On these journeys people often start questioning themselves about their actual homeland.'

Zhang Xiao

'The taste of present-day society for a return to authenticity has generated the development of a new type of tourism that seeks remote and unchanged regions and subjects them, in their turn, to becoming pure *commodity*. Is not the mountain an excellent example of this paradox?'

Matthieu Gafsou

disappear release flight vanish break

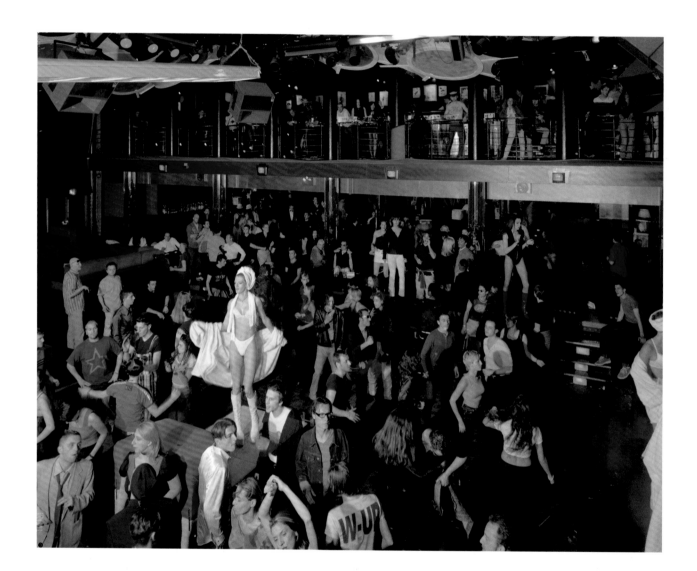

MASSIMO VITALI
Peter Pan Brutti Ceffi, from the series *Disco* 1997

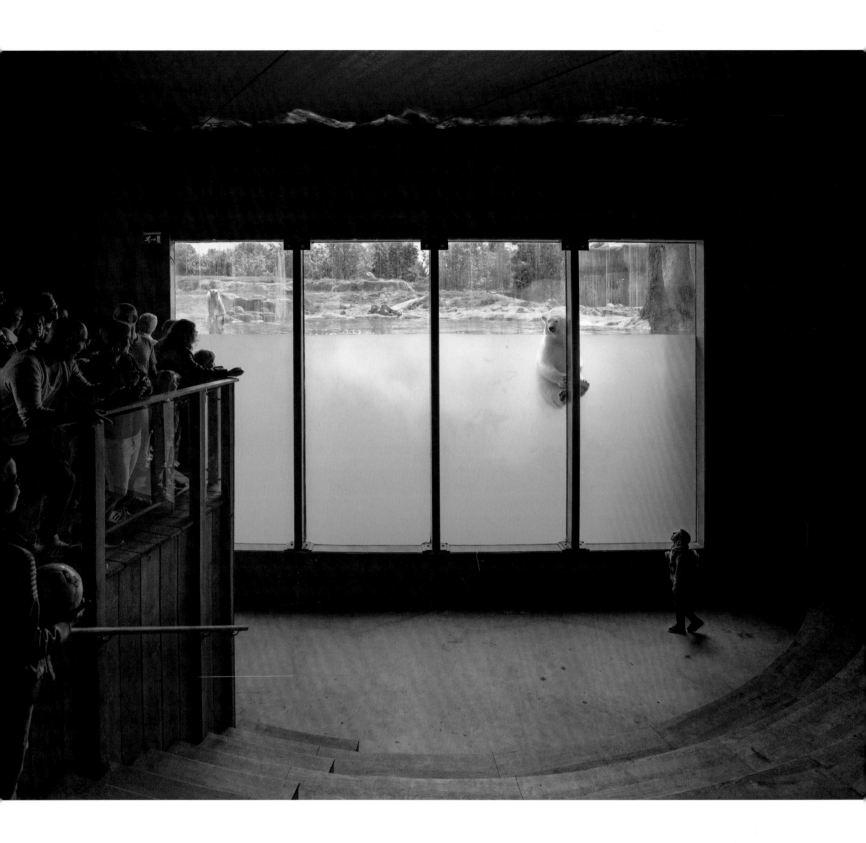

SHENG-WEN LO
Diergaarde Blijdorp Rotterdam, The Netherlands, from the series White Bear 2016

MARK POWER
The Mind Zone (Ron Mueck's 'Boy'). The Millennium Dome, London, UK, from the series *Superstructure* 1999

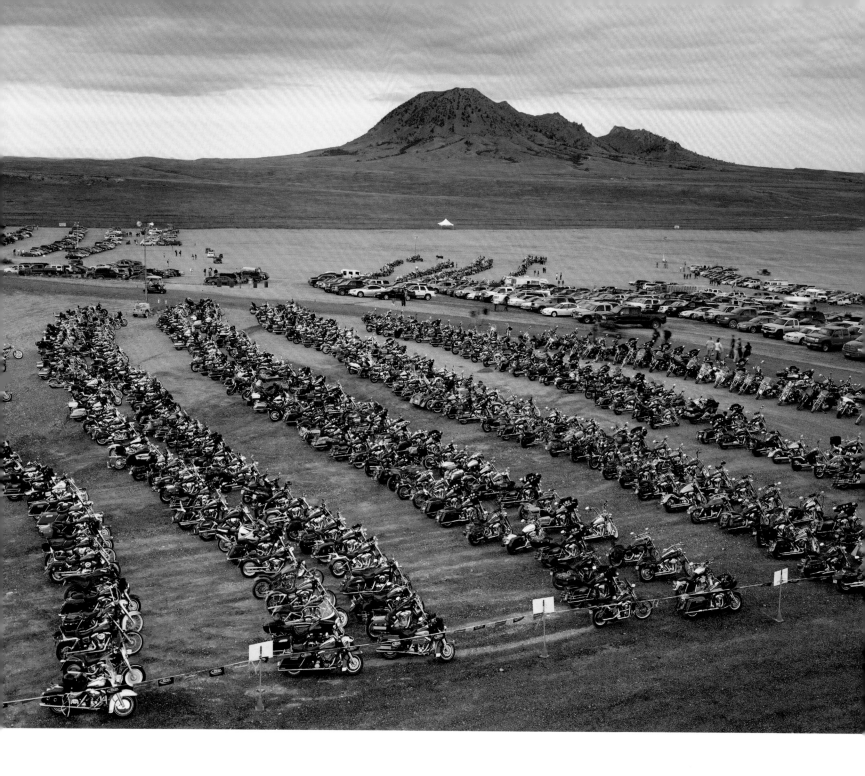

EDWARD BURTYNSKY
Kiss Concert Parking Area, Sturgis, South Dakota, USA, from the series OIL 2008

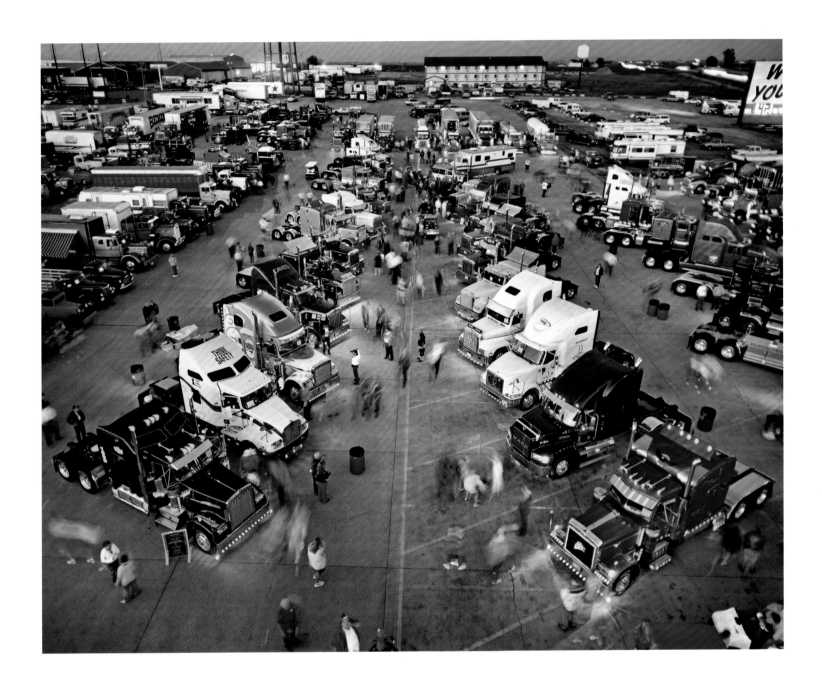

EDWARD BURTYNSKY
Truckers Jamboree #1, Walcott, Iowa, USA, from the series OIL 2003

'The image was taken two days before the site, at 5,364 metres, was destroyed by an avalanche triggered by the earthquake that hit Nepal in 2015. Estimates put the base camp population around 1,000–1,200; this included 359 paying climbers with the rest being Sherpa guides and support staff manning the camps. Nineteen people lost their lives.'

GILES PRICE
Everest Base Camp 1, Nepal. Human + Nature 2015

'Tourists are both performers and spectators, part of the circle of representation in which "all we see is seen through the kaleidoscope of all that we have seen before".'

SIMON ROBERTS
Mt Pilatus, Lucerne, Switzerland, from the series Sight Sacralization – (Re)framing Switzerland 2016

ALEX MACLEAN
Lazy River, Ocean City, MD 2011

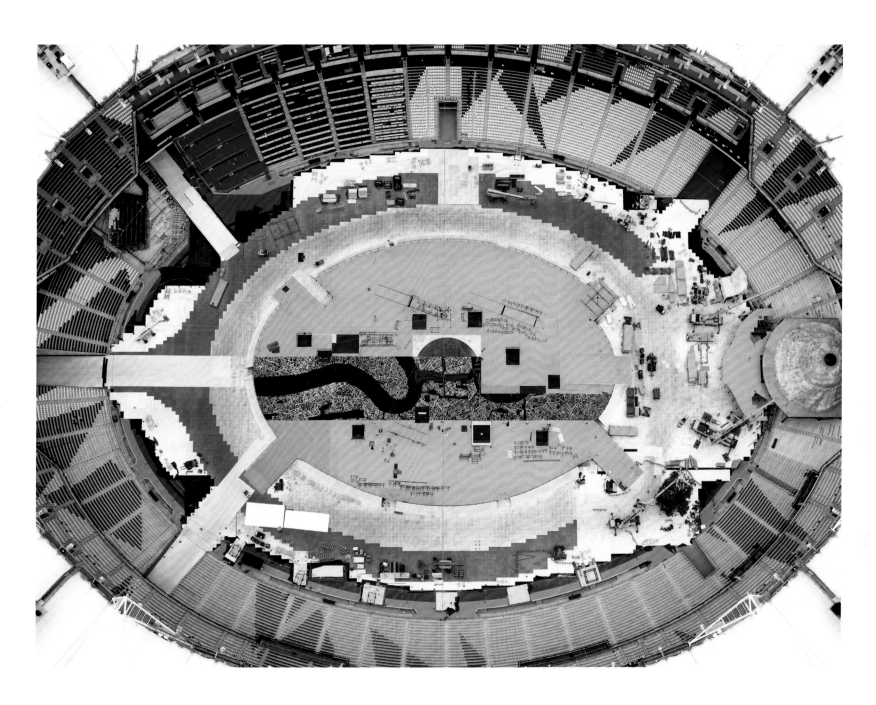

GILES PRICE
Opening ceremony, London Olympic Stadium. E20 12 Under Construction 2012

REINER RIEDLER
Horizon #01, Tropical Islands, Germany, from the series Fake Holidays 2007

An employee of 'Jetpack Cayman' demonstrates this new watersport, now available on the island. A 2000cc motor pumps water up through the Jetpack, propelling the client out of the sea (US$ 359 for a 30-minute session). Mike Thalasinos, the owner of the company, remarks, 'The Jetpack is zero gravity, the Cayman are zero taxes, we are in the right place!' Grand Cayman.

GABRIELE GALIMBERTI AND PAOLO WOODS
from the series *The Heavens* 2012/2015

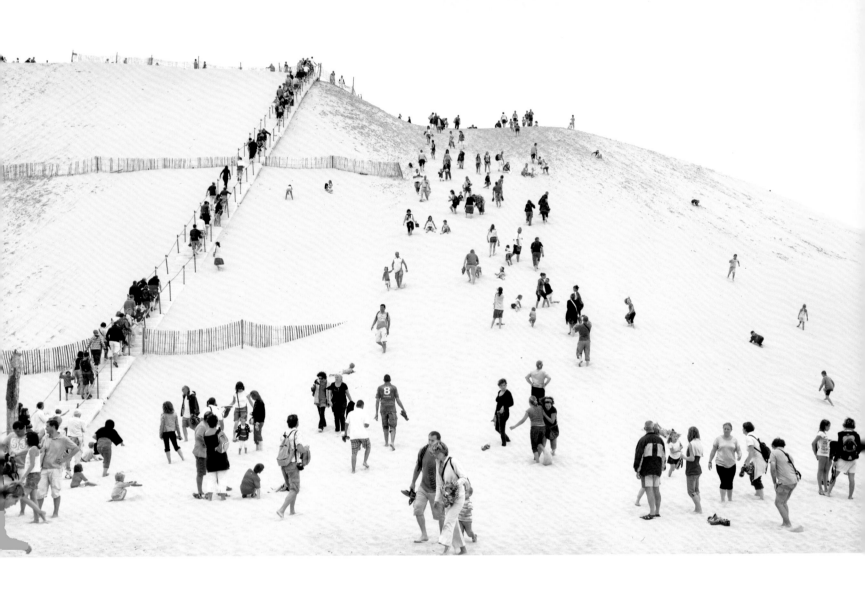

MASSIMO VITALI
Dune du Pyla [France] 2010

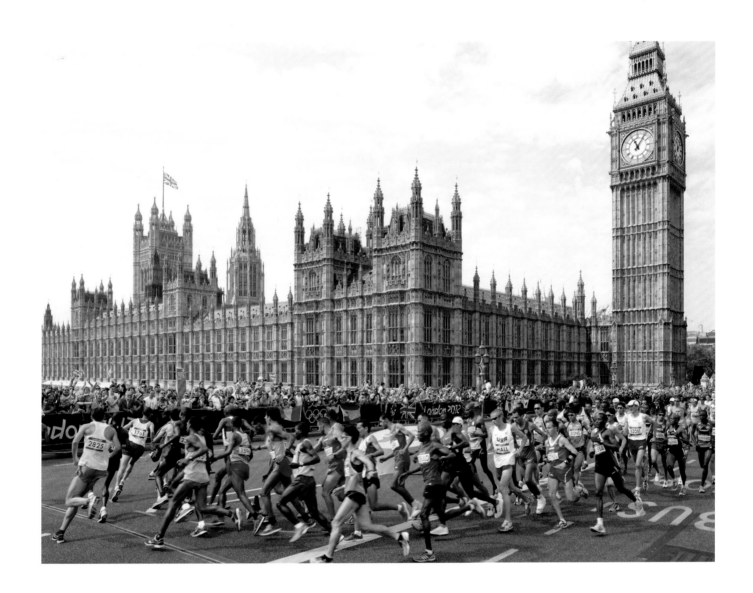

SIMON ROBERTS
Men's Marathon, Westminster Bridge, London, UK, from the series XXX Olympiad 2012

WALTER NIEDERMAYR
Mer de Glace 08, from the series *Alpine Landschaften (Alpine Landscapes)* 2008

SIMON ROBERTS
Annual Eton College Procession of Boats, River Thames, Windsor, UK, from the series Merrie Albion 2016

'When wishes are out of reach, simulation is taking over our leisure time and our holidays. Imaginary worlds are created, often under massive technological exertion, in order to offer us experience as reproducible merchandise. Although the quality of these adventures on demand sometimes proves to be rather dubious, the boom does shed light on one thing: the yearnings and dreams underlying people's daily lives.'

Jens Lindworsky

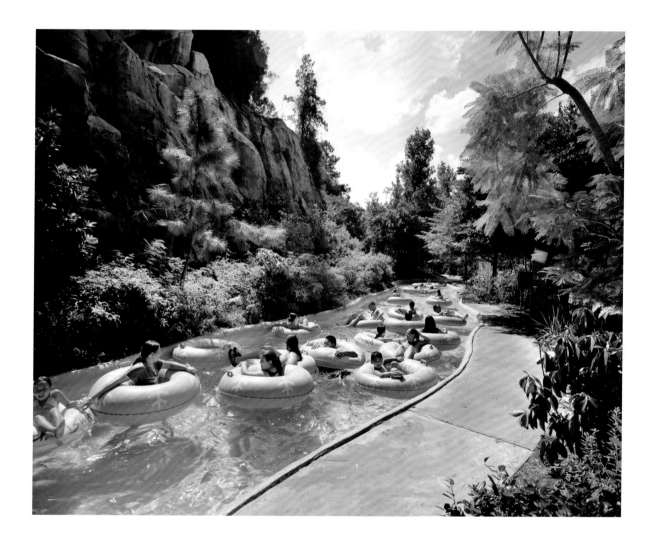

REINER RIEDLER
Wild River, Florida, from the series *Fake Holidays* 2005

'Michael Herr, who was a journalist in Vietnam during the war and wrote *Dispatches* as well as the script for *Full Metal Jacket*, has said that war can be beautiful. I am interested in the landscape of war, the phenomenology of war. Within that context, I have introduced beauty only to create tension and to complicate.'

AN-MY LÊ
Film Set ('Free State of Jones'), Battle of Corinth, Bush, Louisiana, from the series *The Silent General* 2015

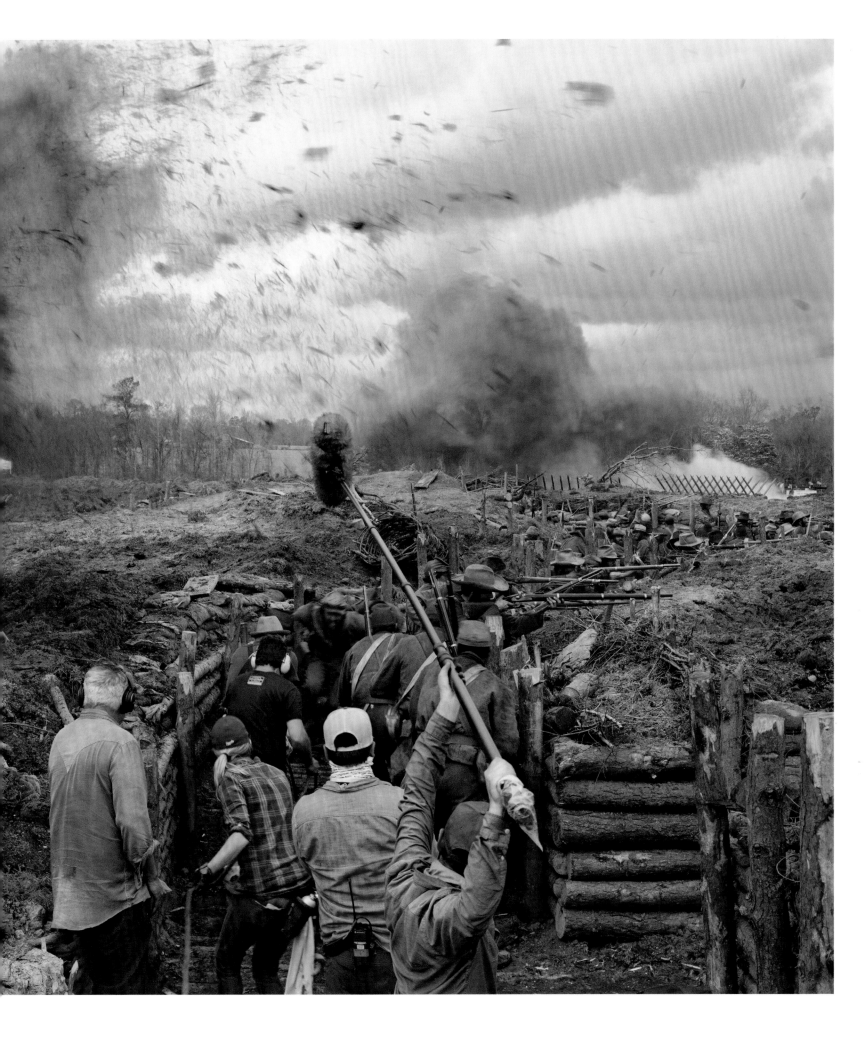

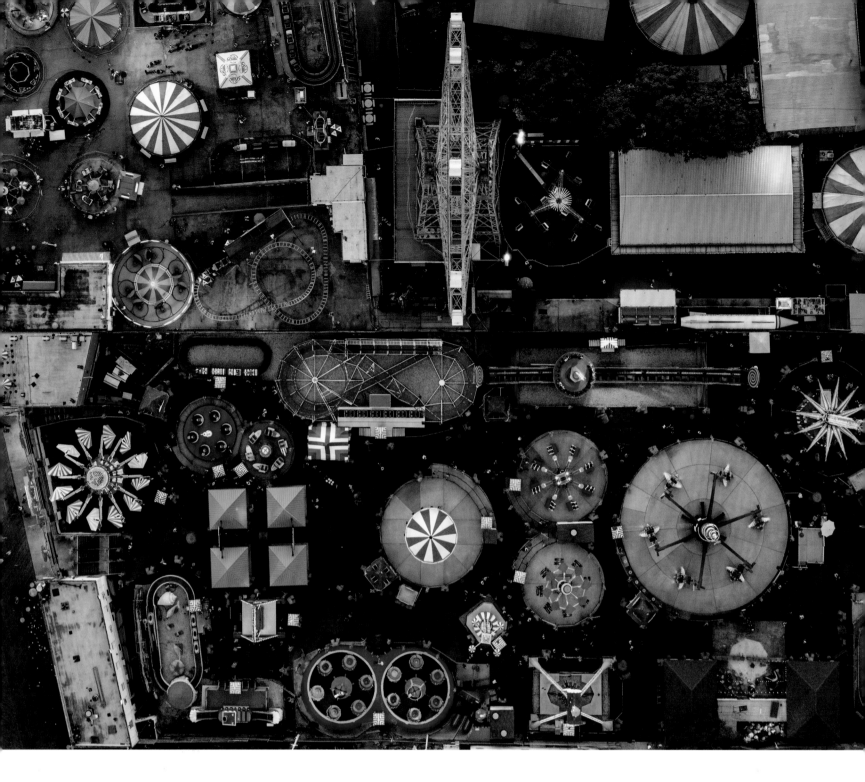

JEFFREY MILSTEIN
Coney Island 01, Brooklyn, NY, from the series *Parks and Recreation* 2015

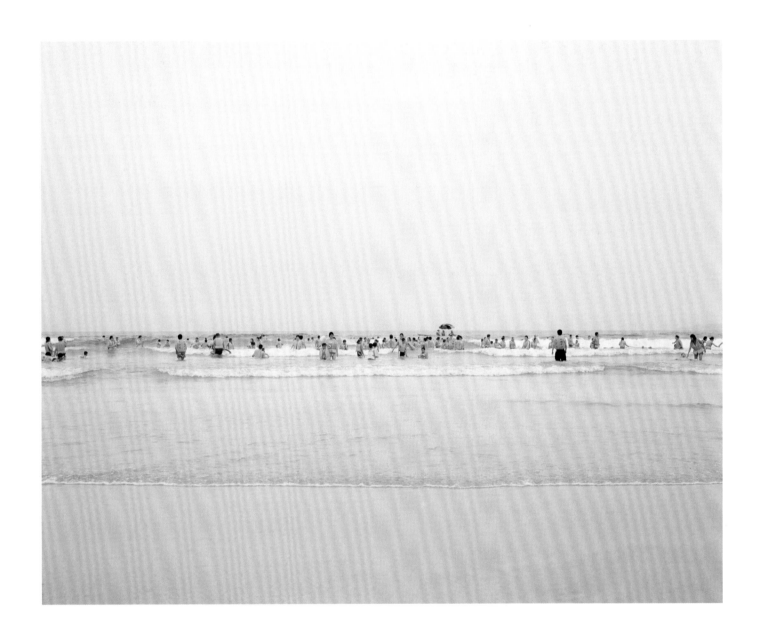

ZHANG XIAO
Coastline No.15 2009

MATTHIEU GAFSOU
Traces 3a, from the series *Ether* 2015

'Paradise has become an uneasy dwelling place;
the sublime sea frames our vulnerability,
the precarious nature of life itself.'

RICHARD MISRACH
Untitled #586-04 [Ophelia], from the series *On The Beach* 2004

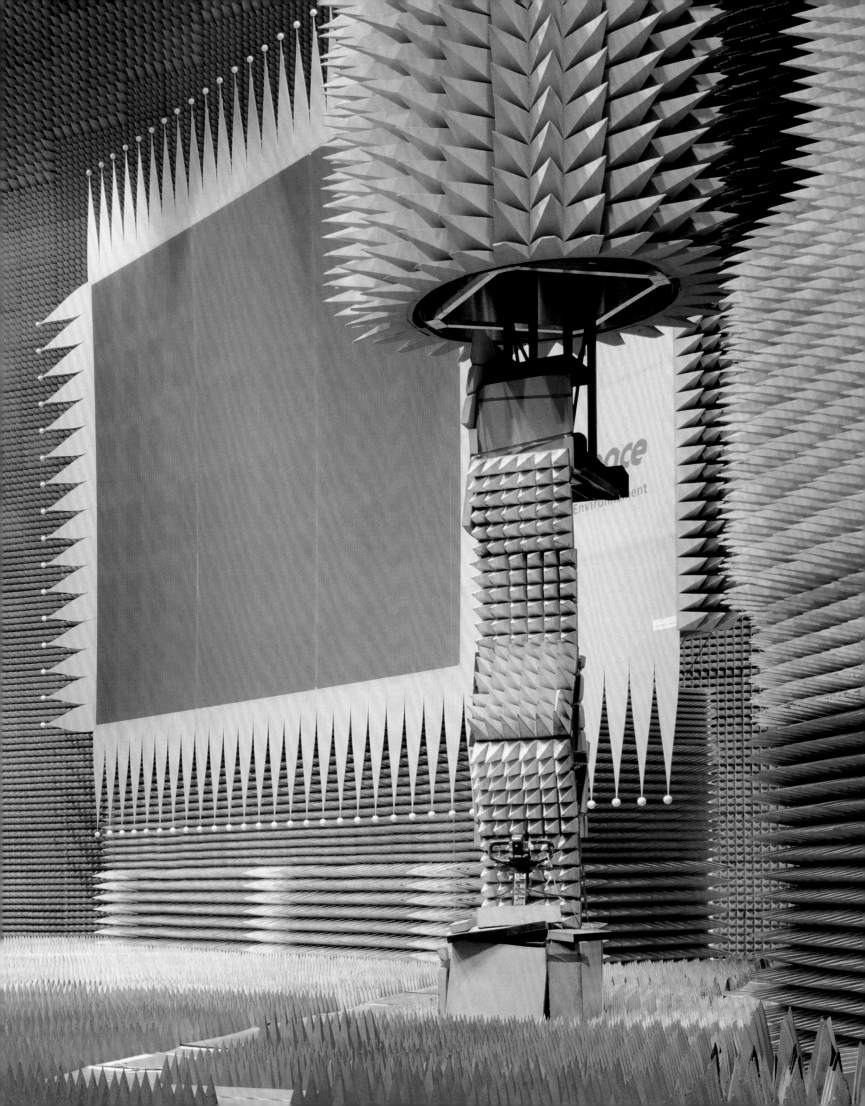

What's next? Sometimes with all the breathless talk, it seems 'next' has arrived – and it's already old hat. Driverless cars, trains, planes? Yawn. A robot mowing the lawn? We've got one out there working now. Artificial Intelligence? Already here. We've dropped the old question, *what's new*, pretty much, simply because the newness has become so routine, the norm. Once pure fantasies, inventions, even whole technologies, move from laboratories to the shelves of stores in short order. Novel military weapons and tools like the computer, the Internet, the GPS, or drones, once perfected, are handed over to civilian society for use and pleasure, but only after they've been upgraded militarily, and, it goes without saying, those upgrades remain tantalizingly out of our grasp. True, the process is not as quick as we often think it is. Widespread adaption may take thirty, forty or fifty years – the computer dates back to the Second World War, reliable computer networking to shortly after, and so on, but in terms of human history, these novelties are happening in the blink of an eye.

What we never seem to foresee are the ways in which our new toys fail, or can be corrupted. Viruses, worms, malware, infections...we use organic terms, dimly understanding that we are creating novel life-forms, some of which will prove extremely dangerous. Once driverless cars are the norm, how long before that first thousand-vehicle pile-up in Los Angeles or Beijing (software glitch? Hacker? Wrong button?), bringing the city to a standstill for days? Which new systems will be badly engineered or shoddily constructed, with dangerous flaws? Which one might, once turned on, be found impossible to turn off?

In *The Meaning of the 21st Century*, scholar James Martin lists the sixteen 'megaproblems' facing human civilization up through the year 2100, including global warming, excessive population growth, mass famines, pandemics, water shortages, runaway computer intelligence, etc., any of which could well usher in a new Dark Age. Martin's list is far from complete, of course.

It's clear that photographers have addressed and are addressing each of Martin's threats, either head-on or obliquely; in fact, we have seen many images dealing with these subjects earlier in the book. This chapter hints at the new world in the making, the seeds of which are planted, and some of which are sprouting. Max Aguilera-Hellweg (pp. 302–03), Edgar Martins (p. 315) and Reiner Riedler (p. 327) bring news of the revolution in robotics taking place everywhere (shouldn't we be a *little* concerned that Aguilera-Hellweg's *Joey Chaos* has 'extreme

following beside later ensuing **next**

political opinions'?). On the positive side, Reiner Riedler (p. 334) shows us the kinds of machines that are capable of looking ever deeper into our bodies, freeing us from the risks and trauma of invasive surgery, while Thomas Struth (p. 318) reveals the astonishing complexity of the modern operating theatre, and Jason Sangik Noh (p. 308) reminds us via an array of surgical tools that ancient practices will be with us for a good time to come.

Andreas Gefeller (p. 304), Olivo Barbieri (p. 305) and Walter Niedermayr (pp. 310–11) propose the rounded, wavelike look of 21st-century cities we'll be getting accustomed to inhabiting (note: those particular buildings are already here), new kinds of 'machines for living' where the experience of (what's left of) 'nature' is reduced to a pleasing picture. But the old has its place too; who knew a (decommissioned) church was the ideal structure to cool a supercomputer (Simon Norfolk, p. 317)?

Outdoors, the seeds of surreal new worlds are shown to us in the work of Toshio Shibata (pp. 331 and 332) and Olaf Otto Becker (p. 333), where nature is groomed for our pleasure or simply replaced. Remember the ancient 20th-century farm? Henrik Spohler (p. 306) shows us the kinds of laboratory-like places where our food supplies will be grown at accelerated rates, while Robert Zhao Renhui (p. 307) presents a few of the new forms the logic of our distribution systems and modern aesthetics demand: unbreakable eggs can be tossed into trucks and planes; tattooed fish fulfil the desire for a colourful pet. As for admiring beauty, scientist Richard Wallbank (p. 325) shares the new patterns he's genetically engineered on butterfly wings; could we be seeing the rudiments of a new art form?

Many visions of our future world are notable for their absence of humans, or at least humans as creatures dwarfed by their imposing structures (Vincent Fournier, p. 330). But many photographers are concerned primarily with human beings and in particular the human body, whether it's the desire for immortality (Murray Ballard, pp. 320–21), or a longing to achieve a norm of beauty (Valérie Belin, pp. 312–13; Cara Phillips, p. 309) – no new desire there, just enhanced means.

Otherworldly visions of civilization's future are an interest of Michael Najjar (pp. 314, 324, 326), who is actually training as an astronaut, while Vincent Fournier (p. 319), Simon Norfolk (p. 316) and Thomas Struth (pp. 322–23) are captivated by the phenomenal complexity of space-age machinery. Fournier (p. 330) brings two space explorers into the future, reminding us that we're not going to get anywhere unless we pull together.

SIMON NORFOLK
An anechoic chamber at EADS Astrium, Toulouse [detail, see p. 316]

overleaf
REINER RIEDLER
Myoelectric controlled hand prostheses on a test station, Otto Bock Healthcare Products GmbH, Vienna, Austria [detail, see p. 327]

'Art plays an increasingly important part in today's societies globally. Engaging in art extends us beyond our comfort level. It throws us questions that keep us from stagnating. The younger generations are more accepting of these ideas that art injects into our thought processes and emotions. Out of this, I see people being supportive, open hearted and generous to one another, and am struck by the naturalness of this state for human beings.

We are not meant to be islands: No Man Nor Woman Is An Island.'

Nadav Kander

'People look at a sunset, and they think it's beautiful, and the colours are pretty, but you're really staring at a star from the face of a planet. And your time on this planet is almost a statistical anomaly. None of us is here at all, relative to Deep Time...'

Penelope Umbrico

subsequent soon afterward coming

'Civilization is a teeming organism in which cultures overlap and intermix, constantly evolving into new forms.'

Priscilla Briggs

'We dreamed of building cities, fields of glittering towers, urban fantasies meant to house our hopes of progress; now we seek out dismantled landscapes, abandoned and collapsing on themselves. Rather than creating the next utopia, we uncover the vestiges of failed attempts, the evidence of obliteration.'

David Maisel

'We have been developing our civilization and gradually civilized society does not need humans. Our cities would work autonomously after the destruction of mankind. Probably civilization would be controlled by AI at that time.'

Sato Shintaro

connected adjacent thereafter closest

MAX AGUILERA-HELLWEG
*Joey Chaos, Android Head, Rock Star, Extremely Opinionated on Political Issues,
Especially Capitalism and What It Means to be Punk. Hanson Robotics, Plano, Texas,*
from the series *Humanoid* 2010

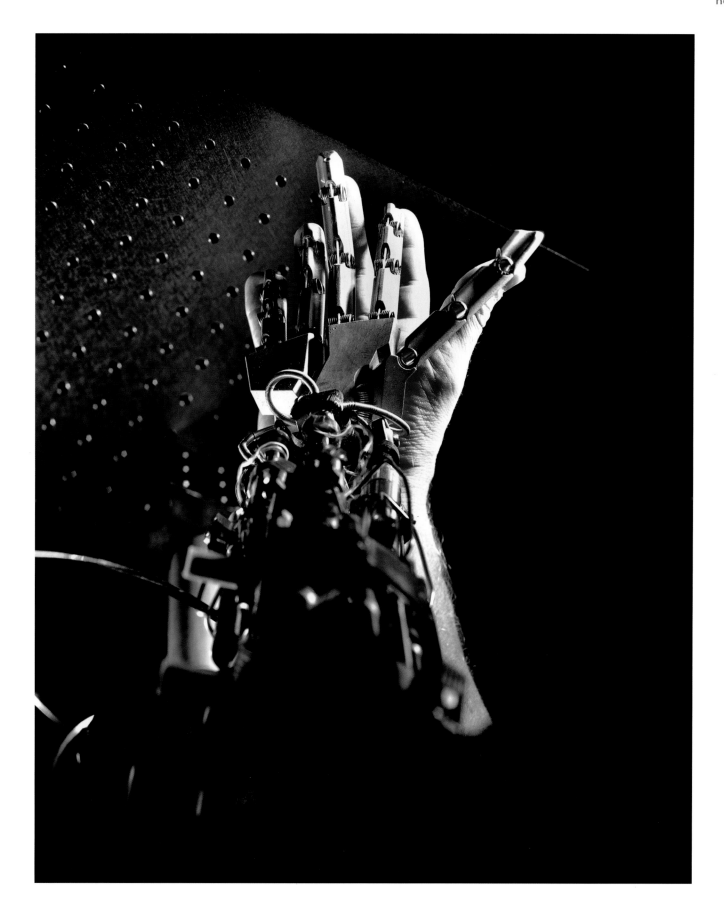

MAX AGUILERA-HELLWEG
Rocket Powered Arm, Vanderbilt University, Nashville, Tennessee, from the series Bionics 2010

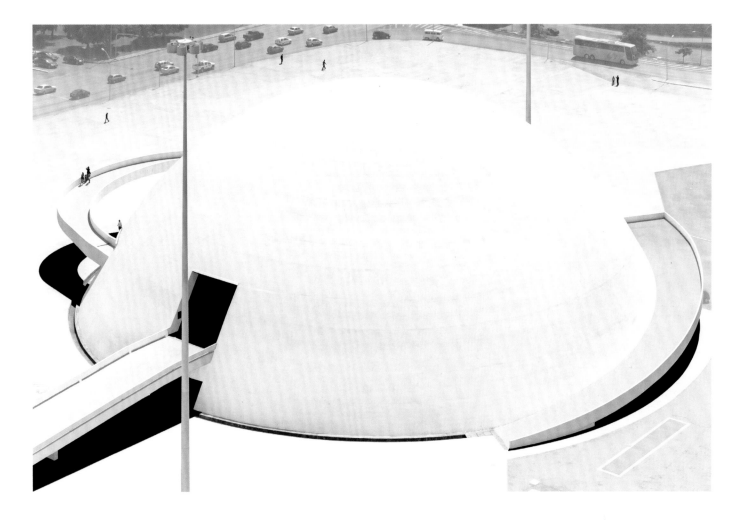

OLIVO BARBIERI
site specific_BRASILIA 09 2009

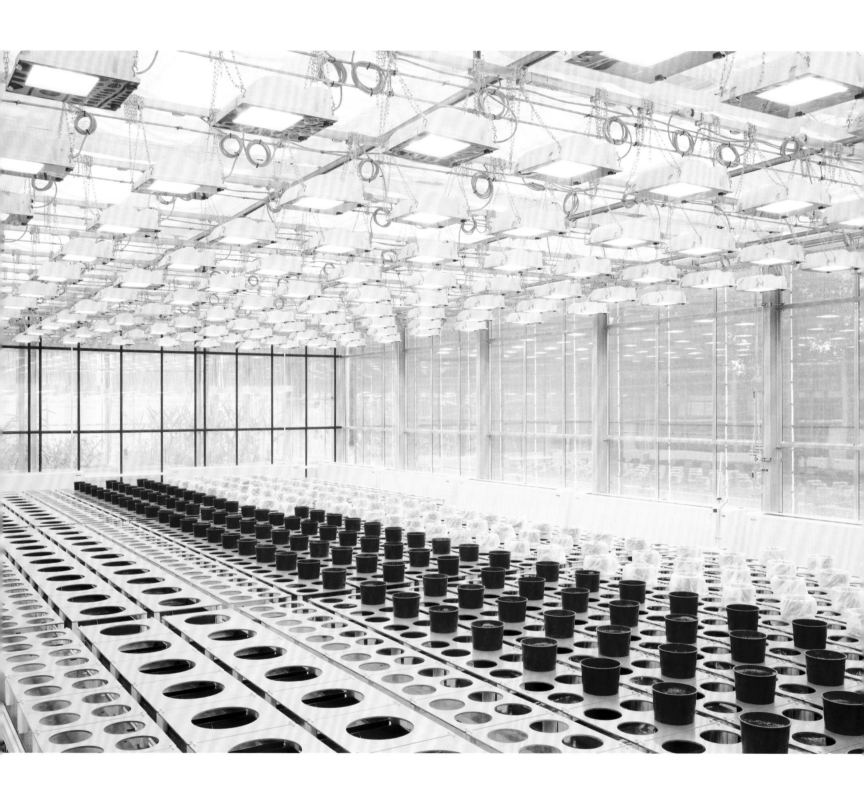

HENRIK SPOHLER
The Third Day, Cultivation and measurement of corn plants, German Research Institute nd

Sold in a department store in South Korea, these square apples were created as gifts for students taking the College Scholastic Ability Test, with some inscribed with the words 'pass' or 'success'. A similar square watermelon was developed in Japan in the 1980s. The cubic fruits are created by stunting their growth in glass cubes.

There are several methods to create artificial colours in fish and certain methods remain well-kept industrial secrets. A recent method is the use of dye lasers to tattoo aquarium fish with patterns, colours and text. It is similar to a method dating back to 1975 used by scientists to monitor movements of fish in the wild by marking them. The Rainbow Star Warrior variety created in Singapore in 2002 uses a sophisticated version of the dye laser to create colourful mollies with as many as 256 colours.

A company in Japan has developed a technique to create eggs that are so strong that they cannot be broken. The only way to access the contents is to puncture a hole in the shell with a pointed tool. The egg was created by adding the plant protein of a banyan tree to a chicken, thus creating an egg with a bark-like texture.

ROBERT ZHAO RENHUI
from the series *A Guide to the Flora and Fauna of the World* 2013

Square apple

Painted molly, Rainbow Star Warrior variant

Unbreakable egg

JASON SANGIK NOH
Entrance, from the series Biography of Cancer: Part I Introduction 2008

CARA PHILLIPS
White Before & After Room (Beverly Hills, CA), from the series *Singular Beauty* 2007

'I like to imagine the creation of an image of a space in which the observer is able to define their own point of view; that is to say, diversity in regard to content, diversity in regard to form and diversity in regard to further concern about the image.'

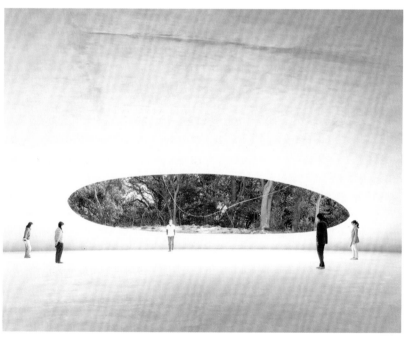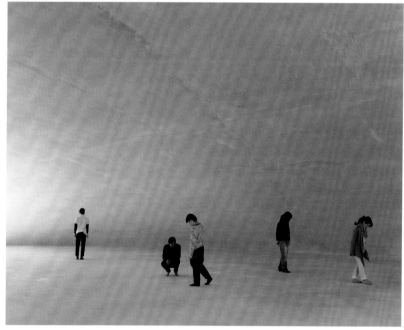

WALTER NIEDERMAYR
Bildraum S 299, from the series *Bildraum (Images–Spaces)* 2013

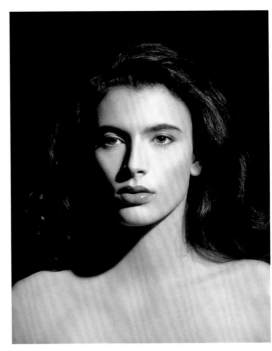

'Chimera: A vain imagining. See also fantasy, phantom, folly, idea, illusion, imagination, mirage, dream, utopia, vision. A chimerical being is an illusory being.'

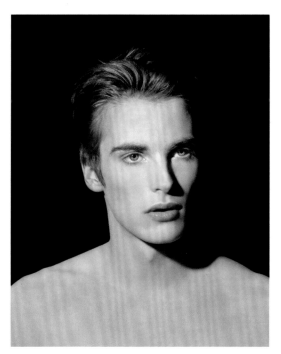
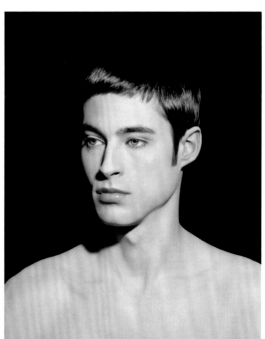
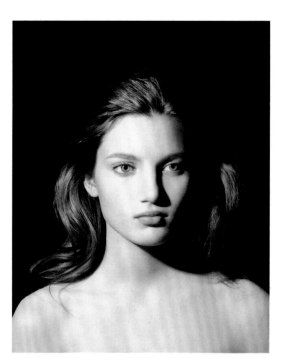

VALÉRIE BELIN
Untitled, from the series *Models II* 2006

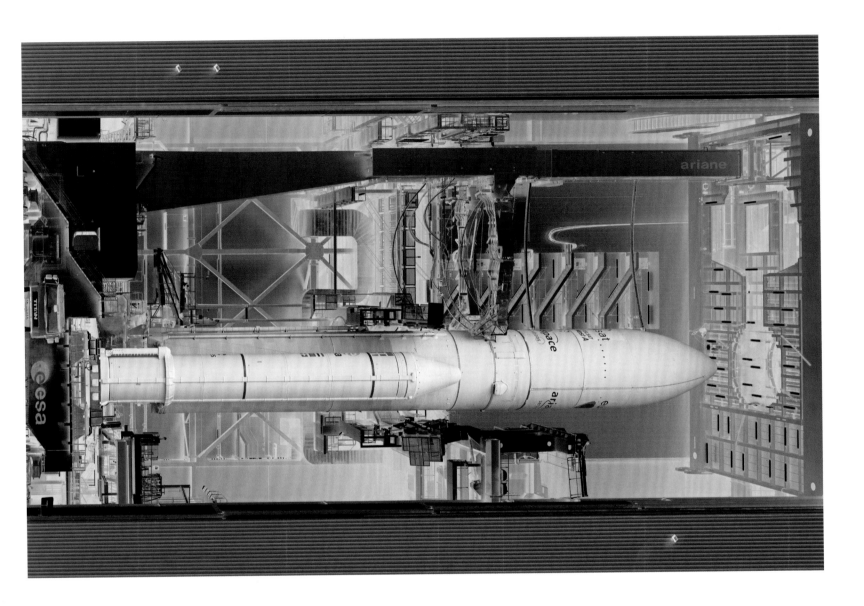

An Ariane 5 rocket in the Final Assembly Building at the Centre
Spatial Guyanais, Europe's spaceport located in French Guiana.
Ariane 5 is a heavy lift launch vehicle that forms part of the Ariane
rocket family, an expendable launch system used to deliver payloads
into geostationary transfer orbit (GTO) or low earth orbit (LEO).

MICHAEL NAJJAR
space launcher, from the series outer space 2016

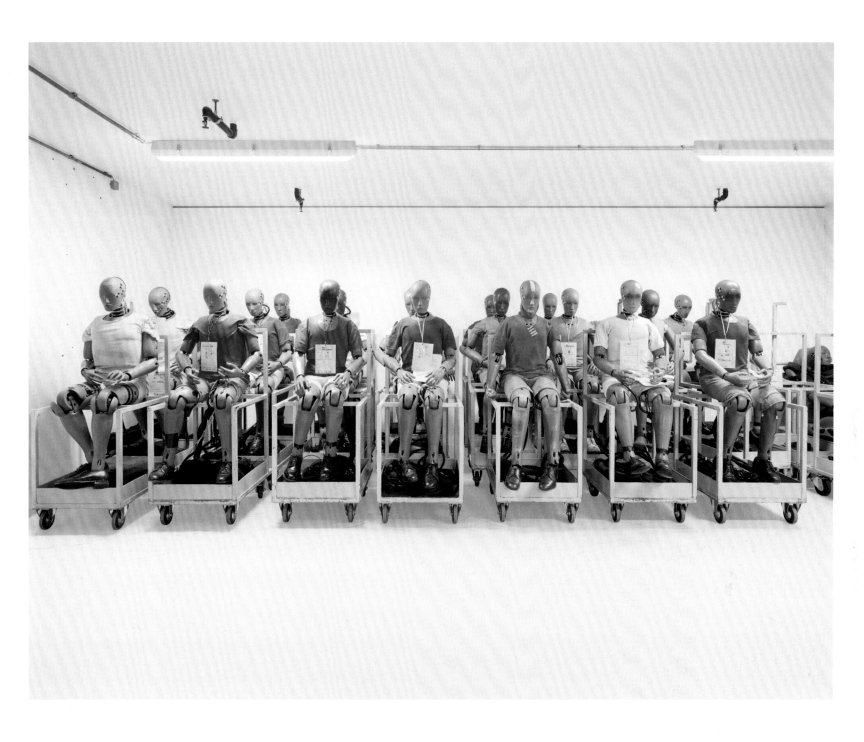

EDGAR MARTINS
Crash test centre, BMW Group Research & Innovation Centre (FIZ), Munich (Germany).
Storage area for the crash-test dummies, from the series 00:00.00 2015

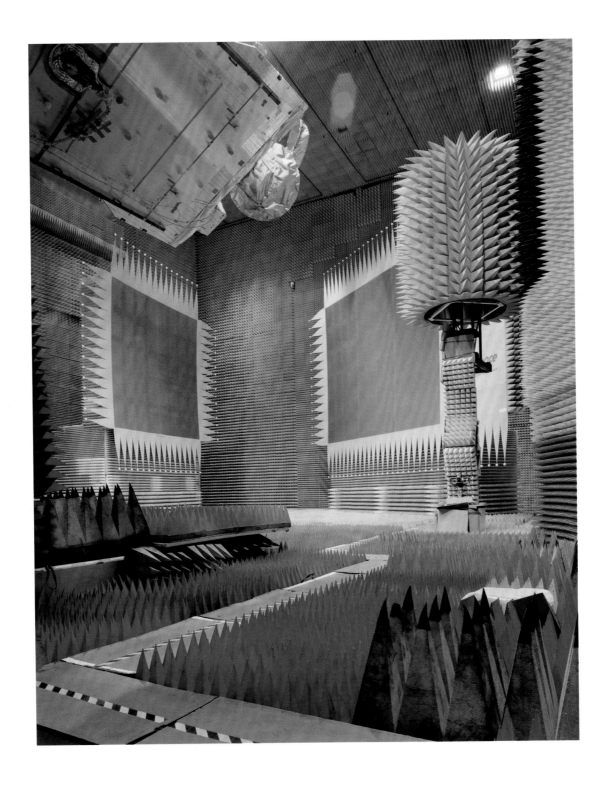

SIMON NORFOLK
*An anechoic chamber at EADS Astrium, Toulouse. Used for simulating the
deadness of outer space during a satellite's pre-launch testing 2006*

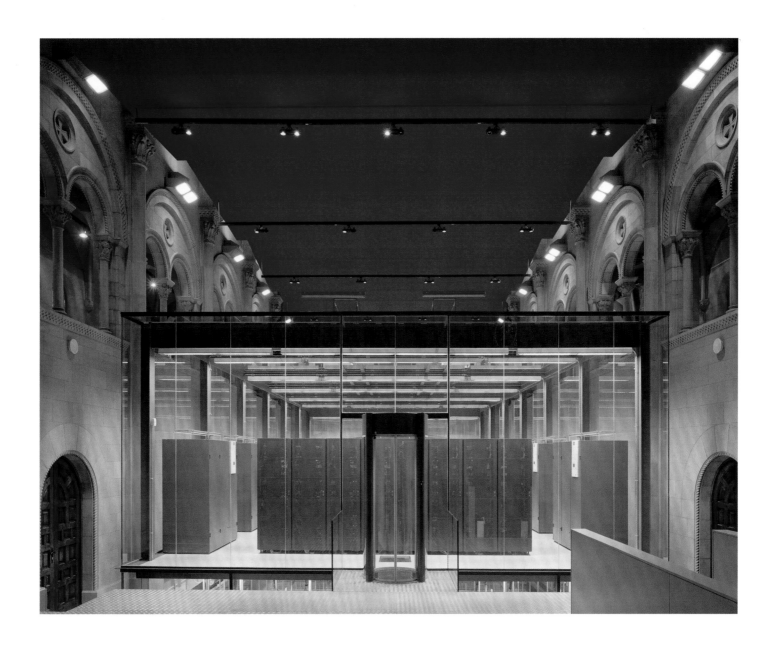

SIMON NORFOLK
The Mare Nostrum supercomputer at Barcelona Supercomputer Centre, built in the nave of an old church to help with its cooling. Among many tasks, the computer has been used to model wing shapes for fighter jets, a job that requires colossal computing power 2006

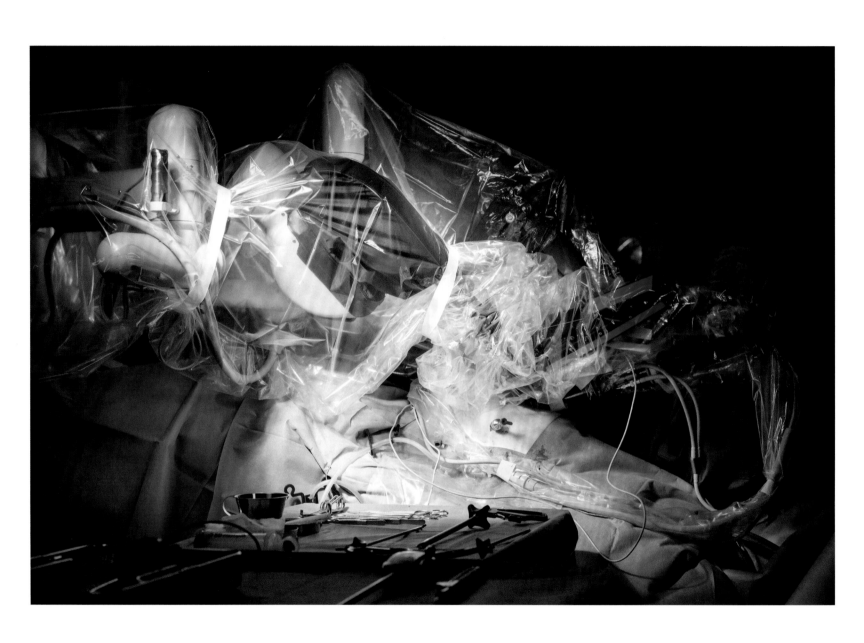

THOMAS STRUTH
Figure, Charité, Berlin 2012

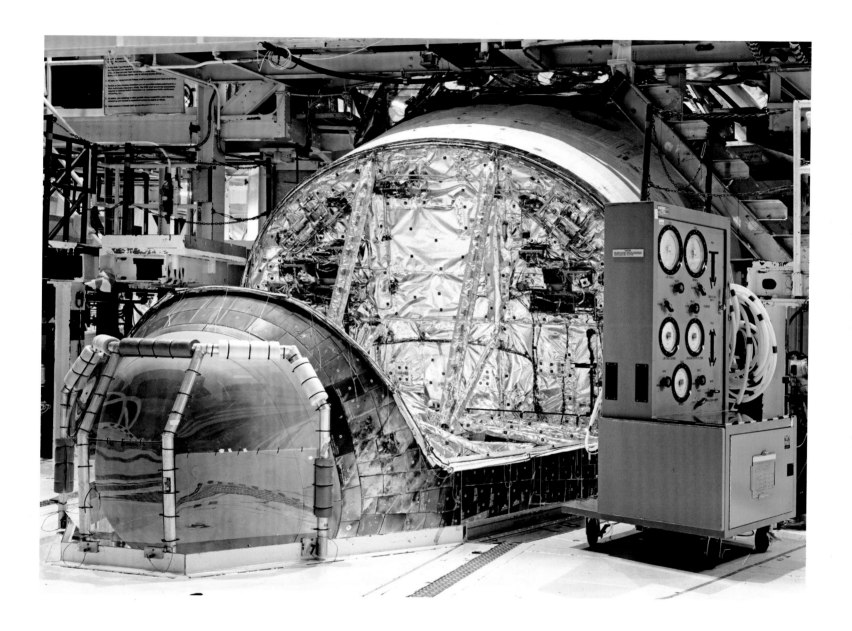

VINCENT FOURNIER
Space Shuttle Discovery Nose Landing Gear, J.F.K. Space Center [NASA], Florida, U.S.A.,
from the series *Space Project* 2011

MURRAY BALLARD
Meeting for prospective members, Alcor Life Extension Foundation, Scottsdale, Arizona.
October 2006, from the series The Prospect of Immortality

MURRAY BALLARD
*Patient Care Bay (Bigfoot dewar being filled with liquid nitrogen), Alcor Life
Extension Foundation, Scottsdale, Arizona. October 2006, from the series
The Prospect of Immortality*

THOMAS STRUTH
GRACE-Follow-On Bottom View, IABG,
Ottobrunn 2017

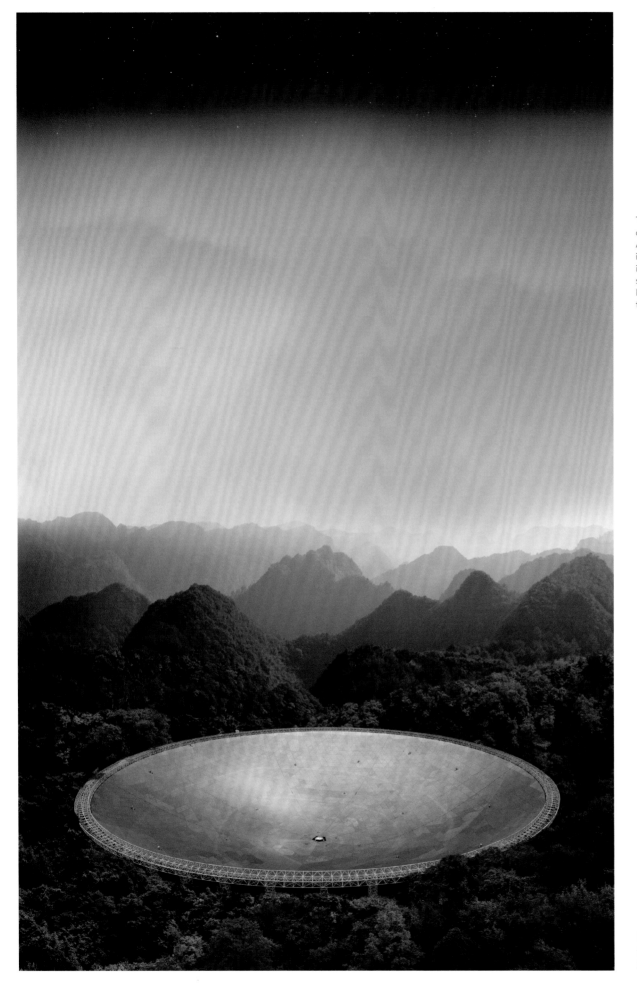

The largest astronomical radio telescope on earth, called the 'Five hundred-meter Aperture Spherical Telescope', is located in a remote region of China. The surface is made of 4,450 triangular metal panels shaped to the form of a geodesic dome. It can be tilted by computer to shift the focus to different areas in the universe.

MICHAEL NAJJAR
f.a.s.t., from the series *outer space*
2017

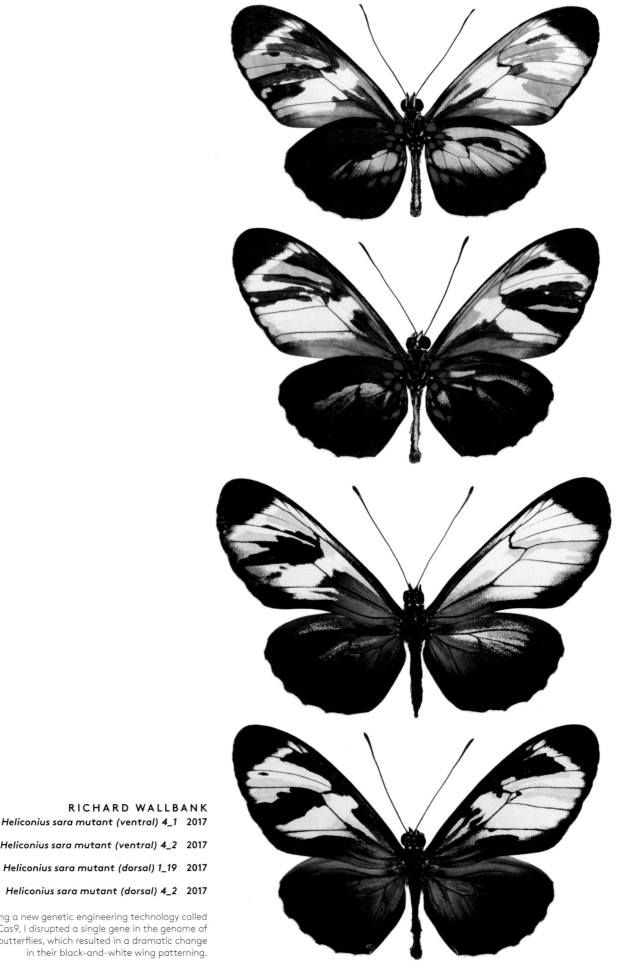

RICHARD WALLBANK

Heliconius sara mutant (ventral) 4_1 2017

Heliconius sara mutant (ventral) 4_2 2017

Heliconius sara mutant (dorsal) 1_19 2017

Heliconius sara mutant (dorsal) 4_2 2017

By applying a new genetic engineering technology called CRISPR/Cas9, I disrupted a single gene in the genome of these butterflies, which resulted in a dramatic change in their black-and-white wing patterning.

The world's largest centrifuge at the Yuri Gagarin Cosmonaut Training
Centre in Star City, Russia, is considered the 'mother' of all centrifuges.

MICHAEL NAJJAR
gravitational rotator, from the series outer space 2013

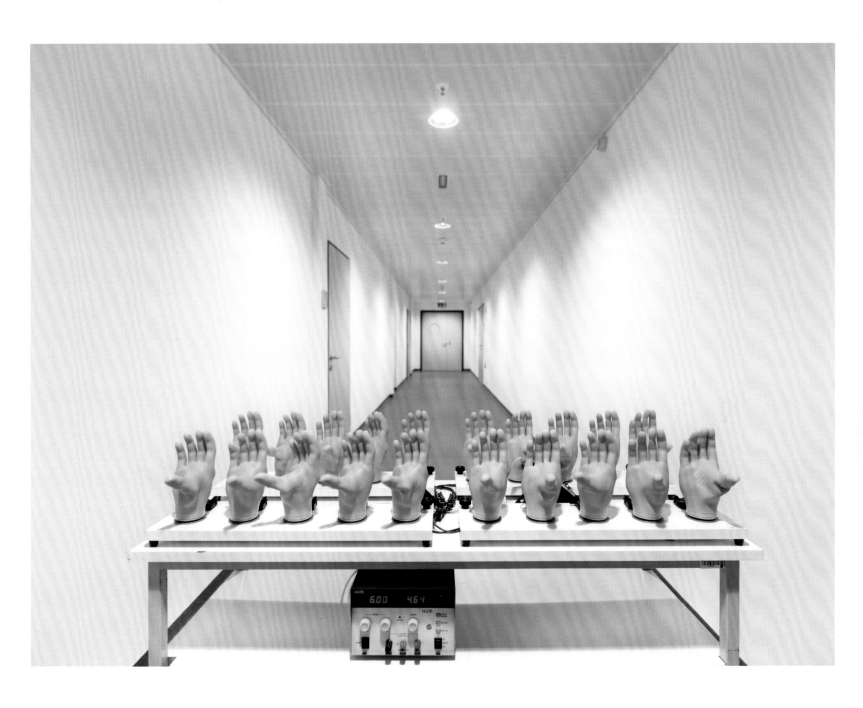

REINER RIEDLER
Myoelectric controlled hand prostheses on a test station, Otto Bock Healthcare
Products GmbH, Vienna, Austria, from the series WILL 2013

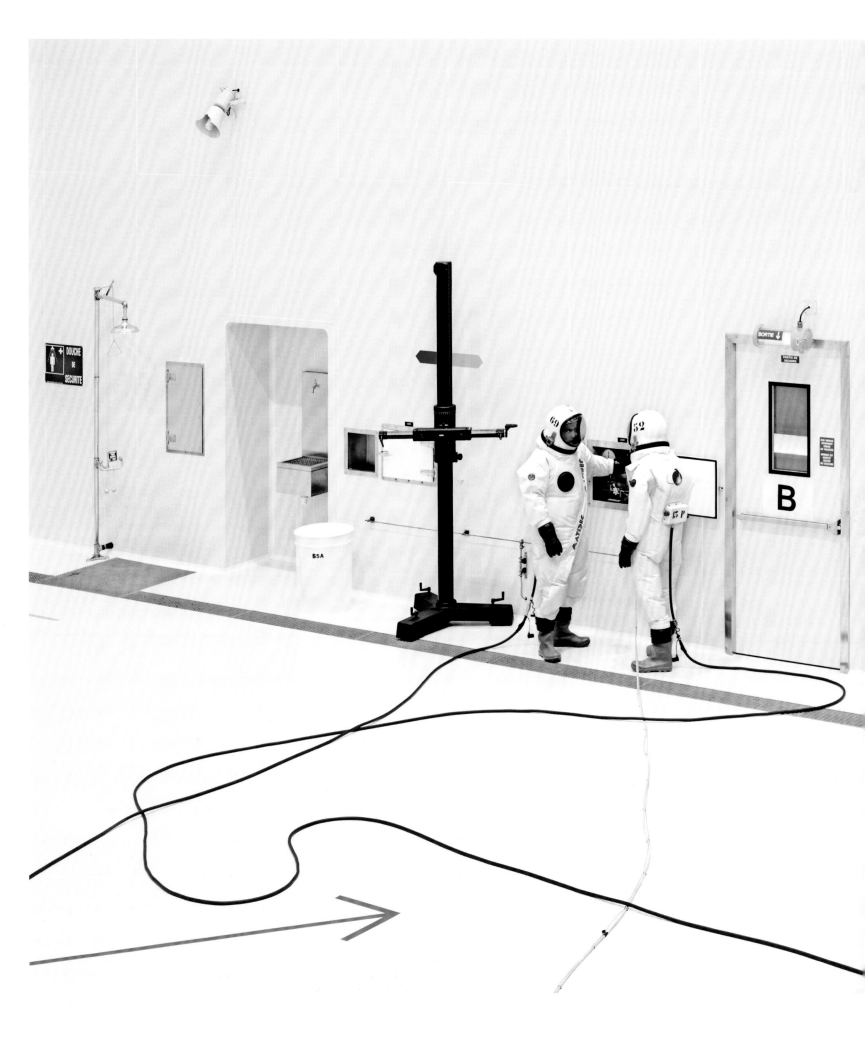

'I like it when the border between reality and fiction remains vague. To travel in space or to explore other planets is as much a collective dream as a desire of a child.'

VINCENT FOURNIER
Ergol #3, S1B clean room, Arianespace, Guiana Space Centre [CGS], Kourou, French Guiana, from the series *Space Project* 2011

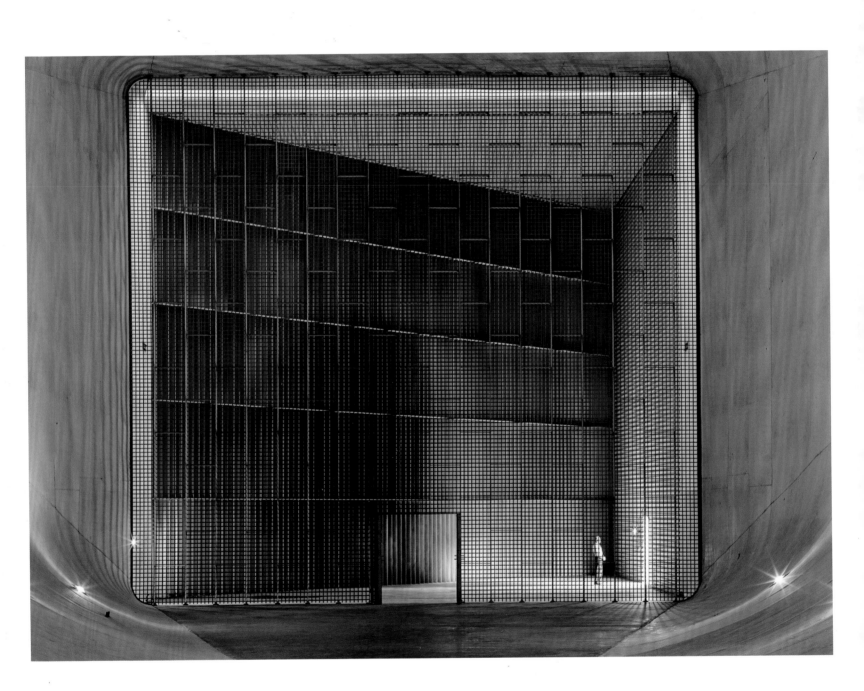

VINCENT FOURNIER
Subsonic Wind Tunnel #4, NASA's Langley Research Center, Hampton, Virginia, USA,
from the series *Space Project* 2017

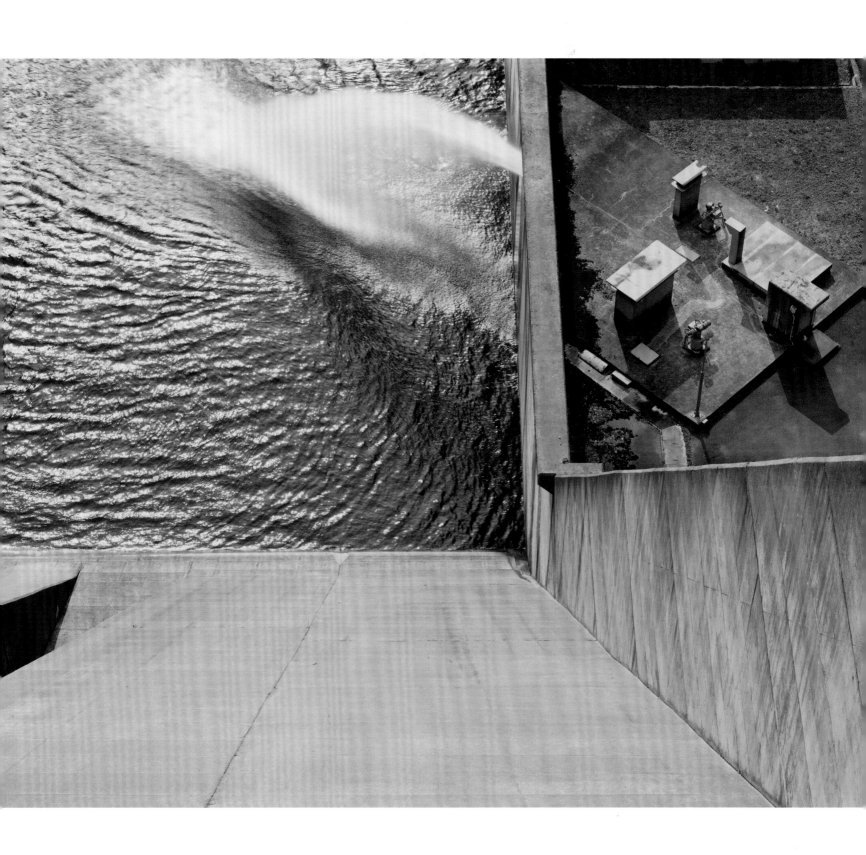

TOSHIO SHIBATA
Hino Town, Tottori Prefecture, 2009

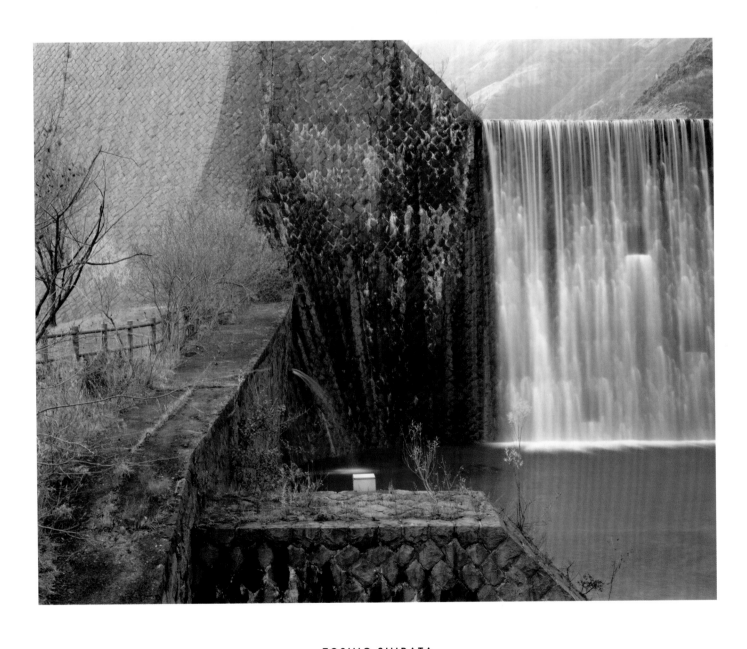

TOSHIO SHIBATA
Nikko City, Tochigi Prefecture, 2014

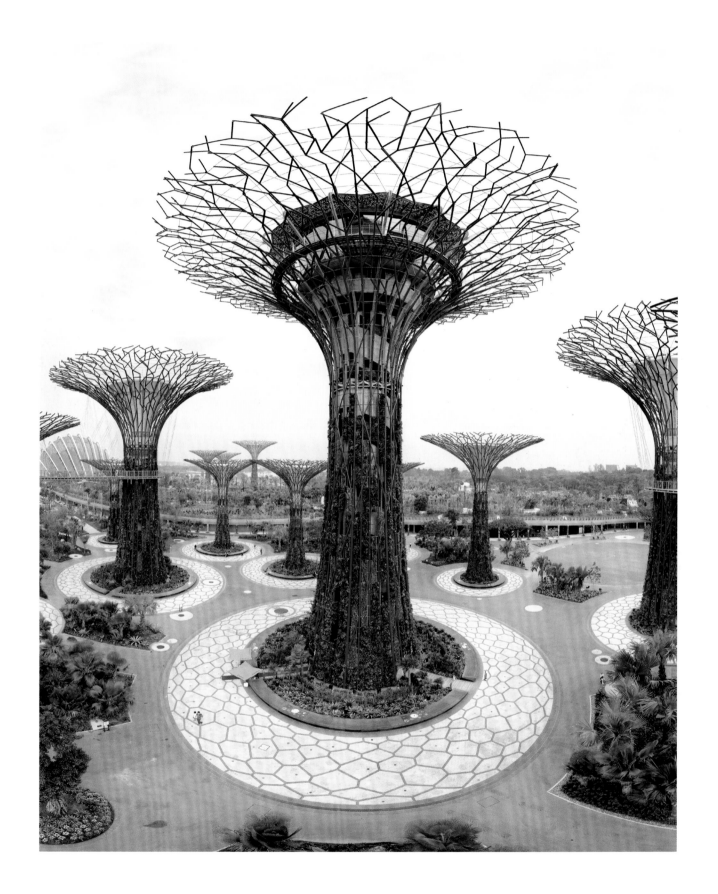

OLAF OTTO BECKER
Supertree Grove, Gardens by the Bay, Singapore 10/2012, from the series *Reading the Landscape*

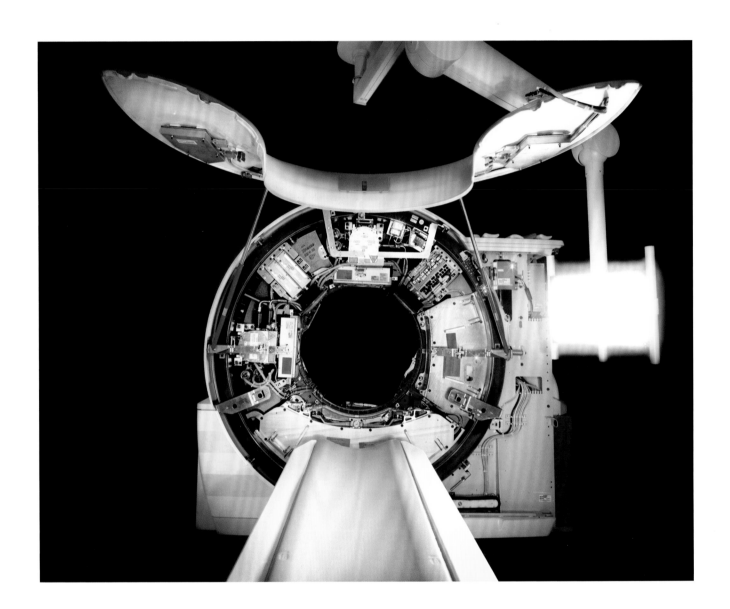

REINER RIEDLER
*Computerized tomography device SOMATOM Definition Flash from the company Siemens Healthcare
GmbH, photographed at Landesklinikum Mödling, Austria, from the series WILL* 2013

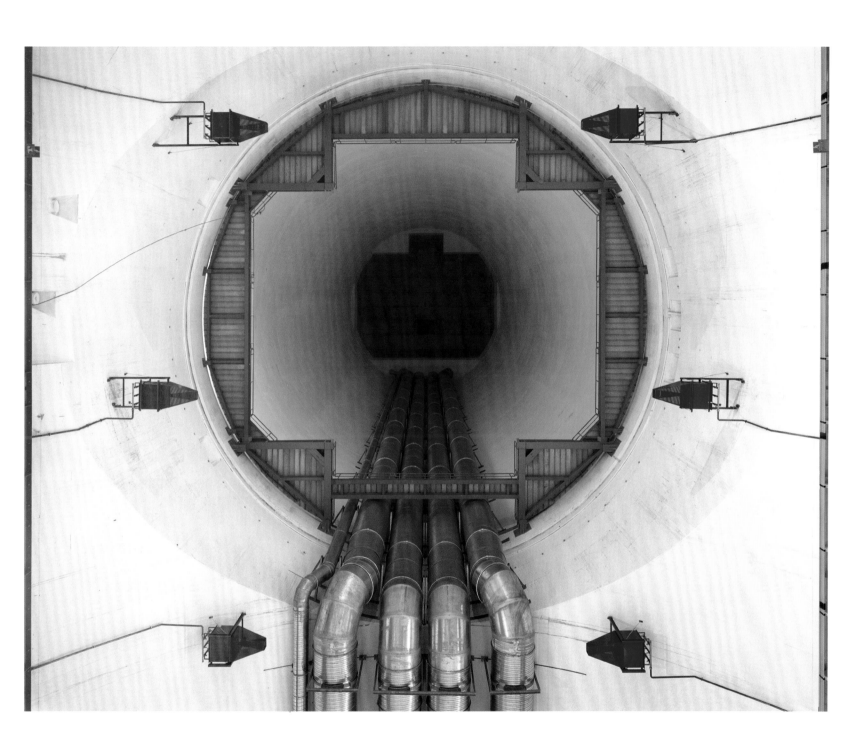

SIMON NORFOLK
The Compact Muon Solenoid cavern, part of the Large Hadron Collider at CERN in Geneva 2010

ARTISTS' VOICES

Each artist in *Civilization* was asked for a short statement about their work in relation to the project. The texts submitted by those who accepted our invitation are given here.

ANDREIA ALVES DE OLIVEIRA 151

I use photography as a tool to investigate things in the world through their image. My conception of photographic images about reality is that they constitute visual arguments about that reality. I work in series (not single images) and my process is research based, in the sense that it involves an extended investigation into subject matter, visual conventions and strategy employed.

I always carry a camera with me (which is not a smartphone). I use it when something presents itself to me as an image – this is what drives me to make a photograph when I am not photographing for a specific project. I also use this camera to document moments with people that I want to remember, or of which I think they will like to have a photograph.

My influences vary according to different projects, but include the writings and work of Victor Burgin, Martha Rosler, Allan Sekula and David Bate.

EVAN BADEN 95, 100, 101

Change may be constant, but the way we experience it today is entirely different from how it has been experienced in previous eras. This is because we are more connected to the rest of the world than ever before. Ideas, influences and revelations are transmitted at a speed that renders them obsolete almost as quickly as they gain favour. As Marshall McLuhan predicted in 1964, 'we have extended our central nervous system itself in a global embrace, abolishing both space and time as far as our planet is concerned.'

Today, change is the way that digital natives inhabit the technology they have never known a world without. It is the way that technology begins to redefine the notion of intimacy for an entire generation of young people. It is the way consumption of media begins to shape the malleable identities of the youth who consume it. Change is the way those media influences – combined with the instability that technology embodies – conflict with, and alter, the long established beliefs held by a particular culture.

My practice revolves around young people because they embody change. They have a mindset where identity is separate from them. They can adopt any identity they choose and, just as quickly, discard it for something new. The ways young people alter themselves and the world around them has a lasting effect on every aspect of the culture in which they live. I strive to provoke the viewer to consider the ramifications of these changes, heralded by the young people who inhabit my images.

OLIVO BARBIERI 60, 129, 142, 305

In the years ahead there will be exponential growth of cities and metropolises such as has never been seen before in human history; this is due to the huge increase in world population and the consequent abandonment of the countryside. The challenges to be faced are sustainability, building speculation and the unknowns that earth and society hold in store for us, such as hurricanes, earthquakes, migration and terrorism.

The project *site specific_* began in 2003. The cities investigated are viewed as *a temporary installation*: the centre and the suburbs, structures and infrastructures – a fundamental part of our sense of belonging and identity – seen from above appear like a miniature, a scale model where the hierarchical relationships, in terms of space and importance, are questioned and re-imagined in an unprecedented way.

The first limitation of representation is the point of view: altering it meant that a new level of meanings could be opened up. Adopting a fluctuating stance limited the risk of obligatory and predictable visions.

Through the development of this research, which involves more than forty cities worldwide, I continually ask myself how much reality exists in our system of life, or again, just how capable are we of understanding what surrounds us through our perception of space.

site specific_ is a global project that redefines *the space* of the contemporary city. It brings back this space and reinterprets it at planning phases like the scale model, the rendering, the drawing. The aim is to have the possibility of studying it, modifying it, transforming it, accepting or rejecting it.

MANDY BARKER 247

It is estimated that of the millions of tons of plastic ever produced almost 80 per cent is still in existence, in the sea or in landfill sites. Enough plastic has been produced to coat the entire earth in clingfilm, and it pollutes every corner of the earth, from the poles to the equator.

My aim is to raise awareness through visual engagement about the issue of plastic pollution in world oceans, while highlighting the harmful effect on marine life and ultimately ourselves. Although it is not possible to determine when or where plastic entered the sea or to whom it belonged, it is almost certain that plastic will remain a threat in the oceans for hundreds of years to come. Through my work I hope to engage the viewer, with them asking questions as to how their food packaging, hairbrush, computer, or shoe ended up in the ocean. If this shocks people to think, and to change, it will bring positive action to protect many species on our planet and ultimately man itself.

OLAF OTTO BECKER 243, 333

My pictures are an attempt to report what I've seen with my own eyes and what has deeply moved me. For many years I've been visiting places where human beings have encountered pristine nature, either directly or indirectly, and I've watched as the number of these places has shrunk at an alarming rate.

The power of our economic system has now become so extensive and so complexly amorphous that it is very difficult to grasp. Corporations tend to react to legislation and other attempts to control their actions simply by strategically shifting their position. It is now clear that this planet is being changed ever more rapidly and uncontrollably by human overpopulation, high material expectations and general opportunism.

Humans destroy primary forests, which have been growing for millions of years, within decades. At the same time, in the megacities of the world, humans create a version of nature according to their own imaginations, turning nature into a product.

Reading the Landscape shows three states of nature in the primary forests of Indonesia and Malaysia: intact nature, ravaged nature and artificial nature. Altogether, the project documents a fatal ecological and economic process that has progressed beyond the point of reversibility.

Above Zero shows the glacial inland ice melt and allows viewers to imagine the dramatic consequences. Scientists prognosticate that human-caused global climate change will raise temperatures by at least five degrees Celsius by the end of this century.

Only a rapid counter-movement can avert the destructive consequences of this way of behaving. If that doesn't happen, we will probably gamble away any remaining chances for future generations.

VALÉRIE BELIN 312, 313

The *Models II (Untitled)* series from 2006 comprises twelve photographs of young models (New Faces) chosen 'from the catalogue' in various modelling agencies. The series maintains parity with six photographs of boys and six of girls.

In contrast to the 'anthropometric' method that I chose for my earlier series of portraits, on this occasion I worked from a preconceived idea of the subject in order to make a stereotype. What emerges from this series is a particular aesthetic that brings to mind the avatars that we use to represent ourselves in virtual worlds. One could also say that this is a series of portraits of chimerical beings.

Here, I have chosen to work in colour, using selective lighting. This gives the portraits an unreal, even supernatural, character. In a way, these portraits can be viewed as images more than as photographs.

PETER BIALOBRZESKI 42, 337

Over the last seventeen years I have been executing photographic projects mainly in Asia, a continent where 'Civilization', as we refer to it, is interpreted in a very different way. In October 2017, while working on *No Buddha in Suburbia* in the Indian megalopolis of Mumbai, I noted the following thoughts in my diary:

4 October
I wonder whether Mumbai is already a city in Dystopia, or just a prequel of it. You can't be sure.

6 October
The day before my arrival, twenty-two people were killed in a stampede at Elphinstone railway station, where apparently five overcrowded trains arrived at the same time. It wasn't due to anyone's fault but an unfortunate incident, states Mumbai police.

8 October
The Slums of Bandra East are literally touching the poles of the construction. When one sees a family preparing Sunday lunch on a woodfire squatting on a railway bridge, you suddenly are sure that all you have achieved, all the comfort you are experiencing and taking for granted, is just based on the fate of being born on the affluent side of the planet.

17 October
Having been in a mosquito-infested slum just ten minutes ago, walking into the ECO Tower lobby, five star, so to speak, is like stepping out of the 'real' world. Up on the thirteenth floor, a whole family – father, mother, grandfather and uncle – is watching me while I set up my tripod on the terrace. The place is large, comfortable and airy. The TV shows prime minister Modi, watched by the grandfather wearing a gigantic bluetooth headset. Its large black Mickey Mouse ears form a stark visual contrast to his immaculate white clothing.

MICHELE BORZONI 70, 73

Since the beginning of my work I have always dealt with stories and themes that have to do with our present. However, I believe that not only documentary photography, but also the most conceptual and artistic photography, cannot renounce the roots that lie deep in our history.

I do not think photography has the ambition to change and improve our world, and the main motive that drives me to photograph is certainly not so ambitious. I do not conceive of photography as a witness document, instead I am driven by the desire to tell stories and to raise questions in the viewer, without necessarily pointing out the message I wish to convey. I think that photography is more interesting when it raises questions rather than giving answers.

In particular, I am moved by the desire to interpret the reality that surrounds us, offering my point of view on those stories and realities that are often less represented or are so evident that they are not observed carefully. I think of photography as a means of evoking rather than representing, but at the same time as a medium capable of recording and handing down questions to posterity.

PRISCILLA BRIGGS 150

Civilization is a teeming organism in which cultures overlap and intermix, constantly evolving into new forms. It is the intersections of cultures that interest me as global economies of manufacturing and trade shape the fate of people around the world and the future of the earth's environment. My photographs explore visual representations of capitalism and globalization as a witness to contemporary civilization. My photographs of the retail and manufacturing landscapes of China are specific to a historic moment of rapid economic growth. This growth has been largely engineered through the designation of Special Economic Zones along the coastal region, where experiments in capitalism opened the country up to foreign investment. Mega shopping malls became icons of economic progress during this period. My photographs of these malls reflect the influence of Western culture, and its preoccupation with wealth and luxury, within burnished marble halls of Prada, Louis Vuitton and Gucci.

ALEXA BRUNET 261

My photographic work combines reportage and staged images. When I discovered this medium, I started exploring the stories that were haunting me. It was the best way to make them tangible for me.

In my art process, I use staged photography to cover a wide range of topics, such as accommodation, environment, health, agriculture, beliefs. In my work, the documentary aspect is emphasized by a caption, either giving the image's origin, or its political meaning. The *mise en scène* allows me to treat topics I am concerned with and for which I am not satisfied with what reality can offer. The process itself is a collective exultation moment: photography becomes a tool, a pretext to invent strange situations that could not have occurred in any other way. My preferred subjects put documentary and exploration of the photographic form together; this free-style allows me to express my point of view while letting my imagination wander.

PAUL BULTEEL 71

Our civilization continuously bounces between collective needs and the aspiration of the individual, between

PETER BIALOBRZESKI *Paradise Now-18* 2008

the ideals of the citizen and the self-orientation of the consumer, between solidarity and greed, between inclusiveness and loneliness.

My photography does not seek specifically to document or answer or judge these dilemmas, but they certainly form a background against which I observe the interaction between people and our wider, mostly urban, environment. We all are often anonymous players in the public space, acting in a variety of scenes that can either be majestic or ordinary. And certainly in our urban environment the scenery is generally imposed on us, not chosen. Therefore, the relation and interaction with that scenery as captured by my images can sometimes be harmonious, sometimes quite uneasy – maybe a metaphor of our society?

EDWARD BURTYNSKY 48, 49, 278, 279, 340

I no longer see our world as delineated by countries, with borders, or language, but as 7.6 billion humans living off a single, finite planet. While trying to accommodate the growing needs of an expanding civilization, we are reshaping the earth in colossal ways. In this new and powerful role over the planet, we are also capable of engineering our own demise. We have to learn to think more long-term about the consequences of what we are doing, while we are doing it. My hope is that these pictures will stimulate a process of thinking about our legacy to future generations.

ALEJANDRO CARTAGENA 140, 141, 230, 231

There is a line; a physical yet invisible line. Families are divided by it, but they are determined to find a way to reunite. Since 2009 I have been portraying different aspects of the US-Mexico border. As much as this line is real, there are invisible cultural, economic and social aspects surrounding it. These three chapters of the border I live in and transit through, speak of those invisible traits that push and pull the boundaries of the line. *Between Borders 2009–2010, Americanos 2012* and *Without Walls 2017*, present an opportunity to rethink what this wall is and why it will never divide the life that surrounds it.

The Car Poolers is a project that continues my visual research on how the suburbs impact the landscape, the city and its inhabitants. In 2006 I started a documentation of Mexico's process of becoming a country of homeowners. This issue, pushed and subsidized by the federal government since 2001, has produced over 400,000 new houses in the state of Nuevo León, of which Monterrey is the capital. The evidently unplanned urban and suburban development carried out by the government and construction firms struck me as an issue that needed to be documented and addressed as something that not only would provide 'prosperity' but also have an impact on the new homeowners' daily lives. As such, my projects have concentrated on visualizing the invisible consequences

of this 21st-century Mexican progress. The rapid growth and construction of the houses outstrips that of the infrastructure needed to inhabit these homes. Proper public transportation is lacking and so people have devised their own solutions to getting to work, even though they might be illegal and dangerous ones. The images of workers carpooling from the new housing developments in the northern lower- and middle-class suburbs to the wealthy southern suburbs of Monterrey seek to present people's resilience and conviction, and how more often than not the cost of aspiring to a better life is paid at a higher price by those with no money.

PHILIPPE CHANCEL 3, 43, 217, 345
I must have been 15 years old when I first saw the sublime autochromes in Albert Kahn's *Archives of the Planet*, dating from the early twentieth century. They opened my eyes to near and remote civilizations.

Today, the age of exploration of the 'vast world' has been replaced by the questioning on major issues concerning the future of our planet.

Twelve years ago, I started to shape my project *Datazone* – taken from William S. Burroughs' book *Interzone* and its cut-up technique – to show fragmentary views of the world. It selects and reports on places representing the different and often-contradictory states of our time: cynical use of power, ecological destruction, natural disasters, rampant capitalism, surveillance of individuals, and religious, ethnic and territorial conflict. Seen in human terms, this can result in extremes: indecent levels of enjoyment and wealth juxtaposed with suffering and poverty.

Wherever I go I am caught in a Gordian knot, between the fascination of what I see and the persistent feeling of indignation, where the only photographic escape is the beauty of disaster.

OLIVIER CHRISTINAT 6–7
Even though war photography had a certain influence on the elaboration of this work (e.g., in the use of telephoto lenses, enlargement of details, absence of definition...), it was immediately clear to me that because of its aesthetic and formal interest I would photograph exclusively what I allow myself to call 'times of peace'.

This choice does not deny the cruel realities of our world. On the contrary, it aims to evoke a kind of urgency, wishing to keep track of a privileged civilization, which might one day disappear, I'm afraid.

It is clear to me that I was born during the European golden age. That allowed me to have a privileged access to education, culture, comfort, security, and freedom of thought. However, even though I am convinced that I live a privileged life in an exceptionally happy period of the Western world, I do not forget that humanity, since its origins, is a threatened species, and mainly because of itself.

Photography is an exceptional tool that allows us to represent life. It is certainly the most suited of all existing media to do that, if only because of its nature, which is so consistent with reality.

In this peaceful world, I photograph daily life, particularly that of the middle class: the ordinary moments that we usually forget and to which we can, through photography, offer the opportunity of a story, even a tiny one. The gesture of a hand, the furrowing of a brow, a pinched lip: to me, these ephemeral signs are punctuations from which imagination can wander.

LOIS CONNER 236–37
My subject is landscape as culture. I am not interested in an untouched, untrammelled world. What I am trying to reveal through photography in a deliberate yet subtle way is a sense of history. I want my photographs to describe my relationship to both the tangible and the imagined, to fact and fiction.

What initially sends me out into the world is often a story, photograph or painting: some aspect of the world that haunts me because of its absolute unfamiliarity, its beauty or incomprehensible existence. What I end up uncovering is unpredictable, surprising and exhilarating. Trying to render a visual encounter through photography is nearly impossible: attempting to twist what the camera faithfully describes into something of fiction; to give form and meaning to what exists in front of you. My camera's elongated rectangle can – with the confluence of light, circumstance, chance and a dozen other factors – conjure up a world, one seemingly half-imagined and breathing with the life of thousands of years of history.

Early photographs made in my home state of Pennsylvania – of trees and the open land – were an *hommage*, through style and form, to Cézanne, Constable, Van Gogh and Pollock, whose work I had studied as a young student. Later, working at the United Nations for more than a decade, I was directly exposed to diverse cultures, traditions, values and viewpoints. I became an obsessive collector and observer of the landscape and of cultures. My photographs are a result of these histories.

JOJAKIM CORTIS & ADRIAN SONDEREGGER 26
The image *Making of '9/11' (by Tom Kaminski, 2001)* (2013) shows a three-dimensional reconstruction of a news video still taken from a helicopter during the September 11 attacks in the United States. Nearly 3,000 people were killed, with thousands more injured. The terrorist attack was coordinated by the Islamic group al-Qaeda. The scene was aired live on countless TV channels worldwide and shows the moment before the second plane crashes into the South Tower of the World Trade Center. The image is part of our project *Icons* in which we rebuild meticulously faithful scale models of iconic historical events. Owing to the camera position, the staged scene condenses back into the familiar image. But for the final image we always pull back: the icons are surrounded with a studio-like atmosphere so that the 'making-of' of the photograph is revealed. The event is just a small part of studio reality, which is evident in the scene through the existence of strips of tape, plaster, tools, tripods, clips, lighting, or real windows framing sky.

GERCO DE RUIJTER 202
Growing up in the Netherlands, the cultural landscape is everywhere. Nature is preserved in fenced reserves, where you buy admission and enter through the gate. When you are allowed inside, just behind that fence could be room for industrial farming, soccer fields or the outskirts of suburbia.

The Netherlands is a dense conglomerate of functionalized landscapes; there is no space left without a sense of purpose. In my photography I am trying to visualize that sense, without prejudice or judgment.

RICHARD DE TSCHARNER 24–25
We are in Sudan, in Karima, the former Napata, on the right bank of the Nile, at the foot of Jebel Barkal, the sacred mountain of Nubian pharaohs and Ancient Egypt.

In the twenty-fifth century BC, at the beginning of the Ancient Egyptian empire, Nubia became the seat of three kingdoms of Kush, covering more than a thousand years of development and civilization. When, around 660 BC, the Kushite pharaohs were pushed back to their region of origin by their powerful northern neighbour, they formed a kingdom in Napata, marked by Nubian and Egyptian influences.

I had just visited the pyramids of Meroë. Arriving at the foot of Jebel Barkal, I discovered the pyramids of Napata and later those of Nuri. In all, 220 pyramids serving as tombs for kings and queens.

Every time I left the city of Karima, I was struck by the palpable indifference of these pyramids, witnesses to a very distant past, and the clear signs of the present, symbolized by the road and the power lines in the foreground. Each time, my inner voice told me that I had to capture this surprising relationship.

When we departed from Karima for the last time, at dawn on 24 January 2010, I finally asked my driver to stop. High clouds made the sky interesting; an orange filter accentuated the contours. I took the shot with my Hasselblad XPan and Ilford FP4 Plus film.

SERGEY DOLZHENKO 262
Nationalist parties attend the March of National Pride in Kiev (2017) shows the combined action of Ukrainian nationalist parties to put pressure on the country's leaders for the implementation of reforms promised after the 'Revolution of Honour'.

The fight for influence and votes between the different political parties continues. It's not easy for me to be impartial in these circumstances. I'm a normal guy and have my own views concerning political developments in my country, but as a journalist I don't think it's up to me to influence events. Yes, maybe I can foist my opinion onto others through my pictures but that will not be news journalism, it will be my view of a situation. I don't like that kind of propaganda because it provoked too much chaos, violence and death in the past. I prefer to give people a chance to draw their own conclusions.

NATAN DVIR 82, 146, 157, 167, 263
Platforms is a series exploring the unique New York underground architecture and the people who temporarily pass though it. New York City's transit ranks seventh among the world's subway systems with 1.763 billion annual rides through its 469 stations, most of which were built before 1940. Millions of commuters from all walks of life meet temporarily while waiting for their train yet few actually interact with each other. The stations' architecture is often repetitive and includes many square and rectangle motifs. The opposite subway platform is dissected by columns standing between the tracks and visually resembles a roll of photographic film. One needs to scan across in order to see the complete picture. The space is fragmented into virtual display windows inviting a voyeuristic opportunity to gaze at commuters travelling in the opposite direction. Interactions, or lack of, manifest themselves in the body language and spatial locations of the people observed. The platform becomes a stage of sorts where the 'actors' take their place until the train passes and invites the following act.

ROGER EBERHARD 56–57
For the project *Standard* I travelled to thirty-two countries on every continent. In each city I booked

a standard room at a Hilton hotel and photographed both the room and the view from it. The two images work as a diptych and create a typology of rooms that were built following the same pattern all over the world: bedside lamps left and right, armchair and floor lamp, always the same bed linen and often the same alarm clock, etc. Only by means of the view from the room one can guess in which country, on which continent, one is located. But even the views, especially in metropolises, are fascinatingly similar most of the time.

Why do we travel to foreign countries and cultures and yet stay at a place that always looks the same? How do standards come about, by whom and how are they set and where does a sense of localism still shimmer through the standardization? The series *Standard* raises questions about a world that becomes more anonymous through the increased standardization; about a society in which the known replaces the community and where only recognizability and repetition of experience offer a sense of wellbeing.

ANDREW ESIEBO 64–65, 86–87, 170

My art practice explores the human condition and the numerous spaces where it can be found. Through an intimate gaze and close-up details of daily life in urban African contexts, I seek to highlight and celebrate human experiences of empowerment. I am particularly interested in the role of identity, culture, sexuality and spirituality in contemporary African societies and the African diaspora.

In the effort to explore these themes, my projects have adopted many forms, strategies and approaches. For example, *God is Alive* (2006–16) focused on African spirituality and explored the emerging role of charismatic Christianity in Nigerian society and the African diaspora in Europe. *Living Queer African* (2007–10) sought to spotlight the silent voices, struggles and everyday realities of the homosexual community in Nigeria. *Pride* (2012) took the form of a multimedia and photographic exploration of the phenomenon of male hair barbering, and barbershops and salons within West African countries.

ANDY FREEBERG 69, 171

Over the last ten years I've used art as a background for documenting how we live today. I'm most interested in documenting the interaction of people with art as an insight into current civilization. I look for images that can be interpreted in different ways and the most successful ones for me have layers of meaning. My pictures in this book focus on the commercial side of contemporary art but they also reflect other aspects of society. When I photographed the large gallery desks in Chelsea I was reacting to the idea that people were on their phones and computers, connecting with the outside world yet not noticing the people standing right in front of them. Others interpreted the pictures as an example of how art galleries try to be cold and unwelcoming to their patrons as a way of intimidating them, possibly for business purposes.

The *Sean Kelly* image that is included here was taken in Miami at an art fair founded in Switzerland. The gallery owner is English, the director sitting next to him is French and the artist, Kehinde Wiley, is of Nigerian and African-American descent and has a studio in Beijing, where Chinese painters assist him. Borders seem to melt away in the contemporary art world today.

MATTHIEU GAFSOU 296

The series *Ether* makes highly aesthetic structures of human existence visible in the celestial sphere. It makes civilization photographically visible in the sky and shows how we have colonized what's above us. The resulting fine lines and delicate shapes seem to underlie unitary principles and appear as a higher-order structure that is reminiscent of the shape of nature.

The captured and seemingly structured phenomena recall chemical compounds, scientific classification systems and physical laws – the poetic structure of the world.

ANDREAS GEFELLER 126, 191, 304

The sight of black dots on a white ground changed my life forever. I was 15, became interested in astronomy and took photos of the starry sky. My camera opened the door to another world when I placed one of the negatives in the enlarger and observed the projected image in the darkened lavatory. Betelgeuze, a red supergiant 600 light years away, and other stars turned into pinpricks as tiny as grains of dust. The light from faraway suns travelled for centuries, only to come upon my film and expose it, leaving behind frail little dots on the celluloid. A boy, squatting on the floor and staring at the stars; Betelgeuze meets bathroom, contact done.

With my very first long exposures of the night sky I already seized the possibilities offered by photography to make what is invisible visible – an approach I have pursued further in later artistic projects, such as my series *Supervisions*, the images of which seem to show urban spaces from a great height. In reality, however, they are surface scans. While moving on the thin line between documentation and construction and making visible spatial contexts normally hidden to the naked eye, the excessive light in *Blank* literally disintegrates our fragile, modern world and becomes a metaphor for the flood of data that threatens to drown us.

Knowledge about astronomical dimensions helps me to cast an amazed, almost alien look at our small and fleeting 'brave new world' again and again. To depict it with photographic means is both comforting and critical for me.

CHRISTOPH GIELEN 122–23, 127

Built space expresses a society's material and political priorities. By documenting structures of prosperity in a technically highly developed society, I offer a telling glimpse of the present impasse of finding habitation for everyone worldwide while also preserving the planet.

Substantiating the widespread belief in the possibility of catastrophic climate change, my photographs also offer concrete insights as they trace the evidence of an energy-inefficient, urbanized existence. They aim to challenge our norms of comfort by jarring us loose from deeply held beliefs – the assumption that growth is unlimited and always beneficial.

Most American planners follow the path of least resistance, channelled in the postwar years by national legislation. Relying on maps, they draw subdivisions that ignore the laws of nature – rather than drawing a connection between the built environment, building practices and climate change.

To make my point, I show developments as invasions of the natural world: sharply demarcated architectural forms in a desert correlate with a struggle for self-preservation against seemingly hostile surroundings. Typically, settlements in such regions are manifestly un-ecological, requiring large water feeds not just for

basic existence in locations not suited for development. In Florida, the effects of sprawl are written all over a distinctly altered terrain: marshes reduced to a fraction of their former size, shrinking river-delta channels and plummeting water tables. Vital wetlands are regularly drained for the planning of neighbourhoods before water is artificially reintroduced for so-called 'natural features' that are neither integrated into the subsistence of the land nor into domestic usefulness, but rather pushed into 'design' forms that are purely decorative – and, ironically, evocative of nature.

SAMUEL GRATACAP 264, 265

Questioning the reality lying behind immigration figures, I stepped into the administrative detention centre in Marseille in 2007. There I discovered a transitory space, the '15-15', as a man I met in a visiting room called it: '15-day detention and 15-minute judgment'. I took pictures of men in search of a future, of what they call 'La Chance'. I also collected testimonies, which took me to the Italian island of Lampedusa, as a sort a backward journey. There again I strove to reveal the 'shameful' side of the island. Shaken by the castaways' fate, some of the inhabitants gathered objects washed ashore.

From documents that I discovered, I built a subjective story, which would lead me further and further, to the port city of Zarzis in southeastern Tunisia, then to the Choucha camp a few kilometres from the Libyan border. In the summer of 2013, when international organizations officially closed the camp, the migrants who did not manage to obtain refugee status headed to Libya.

I arrive in Libya for the first time: Ras Jdir, on the border with Tunisia, then the port city of Zuwara, known for the departures and sinking of boats carrying migrants heading to Italy – those who live *fifty-fifty*; life or death. In Zuwara, I meet Younes, aged 26, a telecommunications engineer who has become a fixer for journalists. He also fights in the war between Western and Eastern Libya, divided by two separate governments based in Tripoli in the west and Tobruk in the east. When I first meet him he asks me a question. It is both deeply affecting and pertinent: 'Are you here for the migrants or for the war?' Deeply affecting since it reveals the media's intentions and their interest in his country, pertinent and direct since it sets the context: is it possible to separate war from the migrants' fate? I answer I am here for the migrants but that I will find it difficult to ignore war because as we are speaking his own city is attacked.

HAN SUNGPIL 180

Photography has enabled us to expand our world view and to improve our technological socioeconomic and cultural knowledge; because of its vivid representation of our reality, photography plays a key role in contemporary civilization. But today, the boundary between the original and its duplicate has become blurred; virtual reality and reality are mixed up.

The *Façade* project explores the double aspect of reality and virtual reality by observing the strange surfaces and deceptively realistic paintings (*trompe-l'œils*) depicted on building exteriors, or, the virtual world as embodied in architectural façades. The *Memories and Spaces* project focuses on the border between mind and material amid the buildings and places disintegrating from the changes brought about by redevelopment. It notices the gap between anonymous memories and the traces of the former residents.

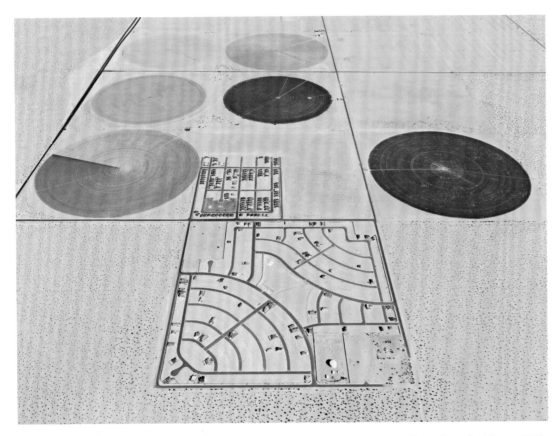

EDWARD BURTYNSKY *Pivot Irrigation/Suburb, South of Yuma, Arizona, USA, from the series* Water 2011

NICK HANNES 58

My photographic work has a strong political and social component. It deals with the problematic relationship we have with our environment. I'm not telling individual stories, but looking at the bigger picture. Searching for the dynamics that make our globalized world turn, I often focus on major contemporary issues such as migration, urbanization, consumption and crises of different kinds.

Our civilization is reaching social and ecological limits. The economy overrules politics and ecological concerns. Short-term financial benefits and corporate greed outweigh sustainable coexistence in the long term. The ecological impact of our consumer/throwaway society is huge. The ever-increasing gap between the *haves* and the *have-nots*, both on a local and a global scale, has a destabilizing effect on our society as a whole. It's my belief that radical changes are needed, in everybody's interest.

My photographic work reflects my personal concerns. Ambiguous and ironic imagery expresses my own confusion and incomprehension about certain contemporary tendencies. Photography can't provide ready-made answers but it can raise questions. By juxtaposing parallel realities within our society, I hope I can hold up a mirror to ourselves and create a moment of self-reflection.

SEAN HEMMERLE 152, 189, 226–27

Brooks Brothers, WTC, New York, 12 Sep 2001: I take pictures to understand the world around me. Photographs help me to digest events that in the moment are too dynamic to comprehend immediately. Each frame or sequence of images is a small homage to the moment lived. To photograph the World Trade Center burning and eventually collapsing was the most profound experience of my adult life.

On the corner of Liberty and Church, Brooks Brothers was across the street from the WTC. From inside the store, one could see the steel skin that had once been the upper floors of the south tower. The store was mostly dark, only a few emergency lights were working. Empty ambulances were parked at the curb. Most of the windows had been blown in from the force of the implosion. All colour was muted by the ubiquitous grey dust.

Predator Drone in a temporary hangar, Holloman Air Base, NM, 2012: Dawn on the desert is an extraordinary event in itself, with the light changing in hue from blue to gold, but to see these colours transform the technological aesthetics of the Air Force's wares is equal parts glorious and surreal. To consider the lethal purpose of these insect-like machines is troubling in pink or pale blue, and thrilling to behold.

MSNBC, Seacaucus, NJ, 2003: For ten years, I photographed the American news media. My grandfather was a newsman. My father was a cameraman for our local television station. I respect the work done by the people who doggedly pursue a story, check their facts, and continue digging. This is a view behind the curtain, beyond the front page, to the interior landscape of an industry in transition. The exact placement of each desk tells the story of that evolution.

While the monolithic Tiffany Network of Edward R. Murrow's day has yielded to a multi-ethnic chorus of decentralized contributors, the decision of which stories will be distributed, by whom and in what priority is still a process practised regularly in newsrooms across the US. Each person working in these offices has his or her own function; however, the organization portrayed (whether independent news or corporate conglomerate) has a unique mission, discernible by studying their interior spaces.

MISHKA HENNER 244–45, 248

The first time I encountered feedlots on Google Earth, I had no idea what I was seeing. The mass and density of the black-and-white dots seemed almost microbial. To understand what they were meant learning about the meat industry and its methods for maximizing yield in the minimum amount of time for the highest profit.

It used to take around five years for a cow to reach its mature weight, ready for slaughter and processing. Today, the structures and processes of feed yards have been perfected, reducing that time to less than eighteen months. Such speed requires growth hormones and antibiotics in cows' diets, and efficient feedlot architecture. Farmers can consult reports to calculate the maximum number of cattle that can fit in each pen, the minimum size of run-off channels that carry away thousands of tons of urine and manure, and the composition of chemicals needed to break down the waste as it collects in lagoons and drains into the soil. These chemicals explain the toxic hues of feedlot lagoons.

The pictures are made by stitching together hundreds of high-resolution screen shots from publicly accessible satellite-imaging software. The results are prints of great clarity and detail that capture the effects of feedlots on the land.

The meat industry is a subject loaded with a moral and ethical charge. But when I think of these pictures, I don't just see gigantic farms; I see an attitude towards life and death that exists throughout contemporary culture. These images reflect a blueprint and a horror that lie at the heart of the way we live.

SOUTH HO SIU NAM 236

27 September 2014 a.m. Sunny
My friend and I looked down from the footbridge. I asked him, 'What will become of our city?' He answered airily, 'The city will give us an answer in due course.' Thinking back of the days and nights that happened since, I find them as vivid as when I encountered them; and the strained emotions and nuances of the moving body constituted an unforgettable moment of my life.

'Good day good night', coming from strangers, who are also fellow beings. It is a simple yet strong sentence, which makes me still feel warm about this city.

Photography might have been an old friend, yet after this year of seemingly normal life, he has become more like a stranger to me. Just like the strangers on the streets, you no longer say 'good day' and 'good night' to them.

Though our bodies are not shredded into pieces like being tossed into a meat grinder, our spirits are indeed fallen into a burning furnace; we break apart from different people, and we blend with some others. One year has passed, and I stretch out my hand, touching the substance that flows out of the furnace. The outer layer has cooled down and become hard, and within there is still a consistent heat.

After another ten years, will we still be as tough and strong as on that day? Will our memories remain fresh after repeated washing by the tides of time? Friends may still be, or may be no more, and they say nothing matters anymore...

[From 'good day good night', South Ho's publication on his series *Umbrella Salad*.]

CANDIDA HÖFER 54, 349
'Civilization' is a grand word. Rather, what is important for me is to provide the opportunity for a 'slow view' on the built environment that has been created around us, a view that may help to understand how we are being influenced by what has been built and how we try to influence what is built.

HONG HAO 108–09
The *My Things* photography series is the result of the daily observation of my life, a record of the accumulation of time (like a laundry list). Started in 2001, the series was made by putting into the scanner one by one the items consumed or used each day, and after scanning them at their original size, saving the images as digital files in computer folders, then waiting until the next year to create a link of highlights. This is the daily repetitive work of an accountant and became my observation of surviving in this world. Such observation reveals the nature of contemporary civilization, how our life style and demands are being shaped and how we live our lives in accordance with our time.

CHRIS JORDAN 246
Looking into the many dimensions of contemporary consumer culture, it is hard to avoid concluding that there is a slow-motion apocalypse in progress. I am appalled by the destructiveness of humanity's collective will, and yet also drawn to it with awe and fascination. The immense scale of our consumption can appear desolate, macabre, oddly comical and ironic, and even darkly beautiful; for me its consistent feature is a staggering complexity.

The pervasiveness of our consumerism holds a seductive kind of mob mentality. Collectively we are committing a vast and unsustainable act of taking, but we each are anonymous and no one is in charge or accountable for the consequences. I fear that in this process we are doing irreparable harm to our planet and to our individual spirits.

As an American consumer myself, I am in no position to finger wag; but I do know that when we reflect on a difficult question in the absence of an answer, our attention can turn inward, and in that space may exist the possibility of some evolution of thought or action. So my hope is that these photographs can serve as portals to a kind of cultural self-inquiry. It may not be the most comfortable terrain, but I have heard it said that in risking self-awareness, at least we know that we are awake.

YEONDOO JUNG 102, 103
Seoul attracts all sorts of people from across the country for a variety reasons. Some of them work in factories, others in offices. In the city of strangers, the Evergreen Tower, with its identical living-room spaces, is a haven for the tired 'salary man' who returns from his hard day's work to find his family waiting for him. A modern, loving family scene can easily be created in this concrete square tower.

However, I like discovering what lies behind the image. There are many reasons for being curious about other people's lives but for me observing how other people live has always helped me to understand my own identity, like looking in a mirror. The question of who they are can never be answered merely by assessing their social position, in the same way that I don't view myself through the lens of my social status. Similarly, what kind of house they live in, what kind of work they do, hardly reveals anything but statistics. My photography stands at this point.

'What I like is what I am' is a good old-fashioned way of knowing someone's character. One of the subjects in my photographs might say 'Don't look at me that way. I am a good golfer, you see, and a champion member of the Korean bodybuilding club.' If you are fed up with somebody's life story, nothing will fulfil your need for answers. The coldness of the concrete walls and identical spaces at Evergreen Tower could never be more interesting than the families who posed for me.

NADAV KANDER 224–25, 249, 250
Although it takes a good picture to make a good print, it's what happens in the studio that is most decisive. Both in editing and in the printing stage I revisit my images again and again. How I feel when confronted with a subject, be it ruins, a river or a person, is what I wish to embed in the printed picture. When I manage to do that, I know it and hold the possibility that the viewer may feel the same. The form that was physically in front of my lens becomes a catalyst to an understanding in a viewer at more than one level.

The driving force behind all my work is the desire to express the basic human emotions we encounter day to day – tragedy, ecstasy, doom and so on, the vulnerability and paradoxes that make up our personal truths. There cannot be beauty without imperfection, health without unease or birth without death. These are facts and with them in mind it becomes clear that one project feeds the next and my outdoor and studio work can be more easily understood.

My pictures tend to be quiet and still. I look for the border where the banal meets oddness: a simple but slightly jarred composition, a surreal detail, a feeling of friction...I choose to photograph scenes that appear to be beautiful but have an undercurrent of otherness; putting a little mustard on top of chocolate cake. I'm drawn to what lies behind what seems to be going on.

Something Bill Brandt said means a lot to me: 'thus it was I found atmosphere to be the spell that charged the commonplace with beauty, and I am still not sure what atmosphere is'. This is an aspect I explore intuitively in all my work. Interestingly, you can never see atmosphere; it is something you feel.

MIKE KELLEY 138–39
Most photographs work to capture a single decisive moment. The image of Zurich Airport was captured over the course of eight hours, from morning until late afternoon. Using a stationary camera, every aircraft movement during this time period was meticulously captured. The hundreds of resulting images were then culled and each departing aircraft was cut, stitched and assembled onto the original background image to create a temporally expanded composite of the airport, showing a day's worth of air traffic and activity.

When viewed this way, a linear process becomes translated into a visible and understandable documentation of the spectacle of aviation. At countless airports around the world, tens of thousands of flights per day are taking off, landing, and crisscrossing the skies overhead. From Zurich, there are cargo flights to Frankfurt, passenger flights to Singapore, and to everywhere else between and beyond. Further, however, there are many more questions that this image and series generate. What of the environmental effects of aviation? One plane in the sky does not seem to have a huge environmental impact – but when we see a day's worth of traffic at one airport and multiply it by all the days in the year and all the airports in the world, these effects cannot be negligible. What about the economic impact of aviation? How many people are directly employed by the airline industry (and indirectly, for that matter)? Or the financial and business decisions that are made every day to keep this operation running smoothly? *Airportraits* not only allows us to appreciate the beauty of aviation, but invites us to explore the often-overlooked details of this incredible industry.

Aviation is a cornerstone of contemporary civilization and touches every aspect of our lives in ways we may not even realize. This image and the entire *Airportraits* series aim to capture accurately the character, beauty, impact and scale of modern aviation in a way that a single photograph could not.

KDK [KIM DOKYUN] 40, 190
As an artist, I am neither a passive witness nor active changer. My *sf* (space faction or science fiction) series is about imagining future space and searching for it in the present. Although my work starts with my very subjective imagination, I want to be an artist who poses questions to an audience or makes them think. My work may be interpreted in various ways concerning political position, environmental issues, or the 21st-century's collective civilization. It is interesting to see that my work is perceived differently according to each audience's personal context and experiences.

KIM TAEDONG 37, 81
Mankind endlessly rebuilds cities, and I occupy a part of such space day by day. My work attempts to capture the landscape and people that I encounter as I wander about different districts of a city. My interest lies in subjects that slightly deviate from what is considered 'the centre'. I find different kinds of vitality in the cracks of a metropolis: from the landscape and its people who at daybreak take a pause from their metropolitan lives (*Day Break*, 2011); from the unusual colours on the outskirts of Seoul (*Break Days*, 2013); and from the tiny city people placed within the structure of a metropolis (*Man-made*, 2008). As can be seen, I sense the spirit of out-of-centre places.

My pictures try to take the position of a third party, but I believe that they also reveal my predilections and point of view. I intend to leave behind a history of people's lives, which circle around the centre and outskirts of a city, day and night, now and in the past.

ALFRED KO 39
This is how a cycle gets locked into perpetual motion. The goal of prosperity requires relentless economic growth and a constant search for untapped resources. Human beings have to toil to secure a good life, and wealth has to be amassed if a quality – or, better still, a luxury – lifestyle is to be attained. Modern men are only capable of validating the worth of their existence in material terms.

Eventually, a class of people, especially those individuals who believe that urban life can make us all better people, move to make the most of the land that has been given to us by God. To maximize economic gain, the earth's resources are inexorably tapped, forcibly extracted and relentlessly exploited.

In recent years, living in a highly developed city like Hong Kong has been like living inside a park or zoo with an invisible boundary, especially in the aftermath of the 'umbrella movement' of 2014. It has so many dazzling colours, garnished by so many colonial memories. Unfortunately, it is like an imaginary dream: nothing but emptiness.

IRENE KUNG 61

I was a painter until recently when I added a camera to my tools. With a painter's mind, I work with my intuition and emotion.

My photographic work expresses and explores a personal longing for stillness and silence but paradoxically also evokes fear and anxiety. In *The Invisible City*, a project where an eerie mood settled into my images, I found that an underlying mystery was being revealed, both unsettling and strangely peaceful.

My medium is light. With it, I can explore darkness, both in myself and in a world where feelings of precariousness are prevalent. Our civilization is facing crucial challenges with man-made threats that imperil our collective future. Ancient ruins are poignant reminders that complex and sophisticated civilizations have collapsed.

Will our fabulous monuments be the only testimonies to our civilization?

Searching for balance, through a vast spectrum with many shades of grey, I too hope for peace.

ROSEMARY LAING 232–33

You cannot get past the fence.
Where land and sky should meet the horizon is obscured.

The Woomera Immigration Reception and Processing Centre (WIRPC) opened in 1999 and was closed in 2003.

The federal government had initiated a mandatory detention policy for people arriving in Australia without visas in 1990, and with a considerable increase in illegal immigration during the 1990s the Centre was opened as a place of detention while the claims to refugee status made by most arrivals were investigated. Designed to hold 400 people, by 2000 there were 1,500 inmates suffering overcrowding, inadequate facilities, staffing and medical attention, as well as the damaging psychological trauma of being locked up for an indefinite period with no certainty of outcome.

The township of Woomera and the adjacent Woomera Prohibited Area (WPA) were established by the Department of Defence in 1947 in a remote part of South Australia. This vast desert area was home to the Kokatha Aboriginal people until they were moved off to make way for nuclear bomb and missile testing.

Fences, prisons, borders, containment and exclusion extend deep into the Australian psyche. Non-indigenous Australia's origin as a penal colony and the subsequent taking of land from Aboriginal custodians has left a legacy of anxiety about demarcating, fencing, ownership and belonging. The barrier at Woomera is a zone between inside and out, belonging and not belonging. Some of the most powerful press images were of detainees who had thrown themselves on the razor wire and attacks on the fence by both inmates and protestors.

(From Wayne Tunnicliffe in Robert Storr (ed.), *Think with the Senses, Feel with the Mind: Art in the Present Tense – La Biennale di Venezia 52*, exh. cat., New York: Rizzoli, 2007, p. 54)

BENNY LAM 46

Forty square feet can be the size of a toilet, a kitchen, or a balcony. It is just enough for three or four people to lie down, four or five chairs, or fifty-seven pieces of tiled A4-sized paper. But for some people, it is the size of the entire house that they call home. The tiny space in this house (*Trapped*) compels you to do everything on or around the bed: sleeping, washing vegetables, having meals, writing letters and watching TV. For some people, it is also where the children do homework and play games. Living here is like being trapped in a cage. Dilemma is what it's all about. If you need to catch your breath, stay in the trap and entertain yourself.

GJORGJI LICHOVSKI [GEORGI LICOVSKI] 268

Considering that I started working in the photography business in 1986, and professionally in 1989, I can try and make a comparison between the end of the past century and the beginning of the current one.

I might be sentimental, but I think that at least in Macedonia we lived much better and worked with much more enthusiasm in the last twenty years of the 20th century than we do today. From the present perspective, I don't see any social progress except for the declarative statements of the world's leading governments; I think that we live in highly hypocritical societies where everybody talks about democracy and freedom, but rarely does anybody truly apply it.

In my view, photography hasn't progressed as I expected it would. We have amazing technological progress, but we are losing the soul...although I believe that photography offers a way of expressing deep messages and can make a difference in certain situations. Working during the European refugee crisis in 2015, my colleagues and I cried at the time of the incident when the photo of Macedonian police clashing with refugees was taken. It's a terrible feeling to be present in a situation where you can see children living through terrible trauma because the world is just not interested in helping. That is the main reason I worked day after day, published countless photos, hoping that something might change if I managed to capture and present the exodus that was happening before my eyes. The world needs to be constantly informed in order to react. In fact, I am deeply convinced that this is the essence of our profession. Despite all the harshness in the world, our job is to inform about every anomaly that we see, hoping it may change something. Even though I am a sceptic, I believe we should continue photographing and informing – that is our way to try and change the world for the better.

MICHAEL LIGHT 144

All of my work of the last twenty or so years could be called 'What We Do'. My particular interest is in showing how we live on the land as tool-bearing humans and shape it to our purposes; my preferred region is the American arid West, and for reasons of scale and perspective I like to work from the air. I keep a small, 100 horsepower aircraft that weighs 600 pounds when empty, and I prefer to fly it and put my own skin on the line with camera in hand rather than use a robotic drone. There is a classic sense of exploration, photographic and otherwise, in my practice – a wonder at uncovering the subtleties of the thing I am moving around and looking at in space, in a certain kind of light. Sometimes things are made to seem small, sometimes vast, but I always try and make the land itself an equal actor facing the human manipulations visited upon it. Beauty and horror are often my tools, with vertigo and the sublime often my goals.

The aerial vantage point is an excellent one from which to examine civilizational structures, offering a relentlessly wholesale view of our excessively retailed lives. Otherwise ignored infrastructure is laid bare, and one can see the duplicative structures of global capital running downhill like water to find its return on investment. As in Las Vegas, so in Dubai. As in Los Angeles, so in Shenzhen. Enormous manipulation driven by fossil fuels is the planetary norm; we reluctantly geo-engineer not only the climate but also the biome itself: the earth is now an anthropic human park.

PABLO LÓPEZ LUZ 34, 229

I explore multiple themes through my photographic practice. I have spent a considerable amount of time working with landscape, focusing on the relationship between man and his surroundings, both natural and urban. I believe that landscape offers a unique perspective to approach specific socio-political contexts. The changes and interventions in a landscape document man's footprint and evolution throughout history, offering a more objective narrative than the one usually found in history books.

The two photographs presented here belong to two different photographic projects almost ten years apart: *Terrazo* and *Frontera*.

With the *Terrazo* series (2006) my intention is to portray the disproportionate and highly disorganized growth of cities, and the tragic, overwhelming misunderstanding of what it means to inhabit a shared space. In a megalopolis like Mexico City, with more than 20 million inhabitants sharing a territory of nearly 16,000 square kilometres (6,177 sq. miles), the already fragile relationship between man and his living space has reached a point of imminent collapse, with catastrophic political, social, economic and environmental consequences. The rapid expansion of the city, which has derived from an ill-devised urban plan that reinforces inequality rather than integration, reflects the situation of many contemporary megacities, characterized by an exhaustion of natural resources, severe economic disparity, pollution, traffic congestion, crime and social unrest. The landscape of Mexico City has shifted dramatically, from being a valley, rich in natural resources and fauna, full of potential, to an almost failed human experiment.

The *Frontera* project (2014–15) seeks to spark a new conversation by approaching the subject of the border from a different perspective, entering the political space by exploring the original imposition of the territorial boundary. The notion of the border is redirected to the physicality of the landscape itself, which acts as the primary imposition that precedes the political and social discourses, as well as the emergence of the border city and the problems derived from it. The border, therefore, appears as a visual as well as symbolic scar in the topography and social construct of the region; a barrier inscribed in nature that has permeated the collective imagination of border societies, and whose imposing conditions are determined by man.

CHRISTIAN LÜNIG 210–11

The Wendelstein 7-X nuclear fusion reactor (stellarator) in Greifswald, Germany, delivers results about materials, techniques and operation processes for the global mission to create an eco-friendly way of making electricity. This is probably one of the biggest problems of civilization yet to be solved.

In southern France, thirty-five nations are collaborating to build the ITER (International Thermonuclear Experimental Reactor, and 'the Way' in Latin) tokamak. Once completed, it will be the world's largest magnetic confinement plasma physics experiment, designed to test the feasibility of nuclear fusion (whereby atoms join at extremely high temperatures and release large amounts of energy) as a large-scale and carbon-free source of energy based on the same principle that powers our sun and stars.

The experimental campaigns at W7-X and in due course ITER are crucial to advancing fusion science and preparing the way for the fusion power plants of tomorrow, and are among the most ambitious energy projects in the world today.

VERA LUTTER 124, 162–63

My approach is a critique of the more common definition of photography. Time is just one of various elements in the work, and it basically introduced itself into my exploration of the possibilities of working with the camera obscura. My first approach to the work was mostly related to architecture. I wanted to use architecture to record an experience and I began experimenting. I was working with architecture in the sense that I turned my room into a camera. The room should see – see what I saw. Experimenting with that, and trying to make it work, I learned that very long lapses of time are needed to record an image with the device I had built. So it was mostly a learning process in the beginning. I did not set out to work about or to experiment with time. I was observing what options I had in recording, and not recording, time. I was actually rather interested in recording evidence of a lapse of time, because there are certain time lapses that just do not inscribe themselves in an image. Motion inscribes itself if it unfolds slowly enough in front of the camera. The triangle between light, time and motion in relation to the camera forms an image. I was, and still am, learning how best to orchestrate these forces in a fashion that will allow me to achieve the results I desire.

ALEX MACLEAN 119, 136, 282

I learned how to fly a plane in 1973, while I was studying for my degree in architecture at the Harvard Graduate School of Design. After learning to fly, I became more interested in looking at the big picture, particularly the spatial and environmental relationships of our built and natural worlds. Flying was a way to quickly view and explore land patterns and human activity over larges expanses. My interests expanded beyond architecture to consider landscape; urban design and planning; conservation; agriculture; and social and political patterns. Handheld aerial photography was an accessible and low-tech tool to rapidly gather and convey visual information at a scale and perspective not realized from the ground. Even more, aerial photography was an exciting way to communicate and message information, feelings, thoughts and insights about the world we inhabit. I have always felt my photography to be purposeful in sharing this unique view; one I can use as an activist to promote environmental and social justice. Recently, I have been working on ways to illustrate the causes and impacts of climate change. My pictures are drawn and composed as a response to what I see on a self-directed course through the sky in search of understanding the earth below.

DAVID MAISEL 132, 216

In *The Age of Emptiness: Essays on Contemporary Individualism*, the philosopher Gilles Lipovetsky characterizes the hypermodern as a condition marked by American hyper-power, hyper-consumption and hyper-narcissism. The hypermodern world is the subject of my inquiry; it is driven by technology's dominance, and by the belief that technological advancements are occurring so rapidly that history is not a valid indicator of our society's future.

Our sites of technological experimentation embody our collective aspirations for the future, though they are often hidden from view and difficult to access. Embedded in the architecture, the laboratories and other zones of technological inquiry and experimentation are issues about how human imagination and endeavour are made physical.

Poised as we are within the Anthropocene era, in which we have an unprecedented ability to affect our surroundings, the notion of advancement through technology can no longer be embraced blindly. Military sponsorship of technological research has shown that the more powerful a technology is, the more likely it will be abused. Indeed, there is an inherent paradox intrinsic to our technological age; we are both the masters of technology and slaves to it.

As we contemplate the shift from the modernist, capitalist age to the Anthropocene era, what place does technological advancement have, and what does it mean? At what price does it occur? The hypermodern world characterized by the passion for new technologies is also defined by divestment from the public sphere, a loss of the meaning of the great social and political institutions, and the dissolution of collective memory. With *Picturing the Contemporary Imagination: Sites of Technological Research and Production*, I attempt to explore both the light of advancement and the dark zones of human endeavour contained within our immersive technology experiment.

ANN MANDELBAUM 80

Civilization…

Born to a root which offers a choice:
we turn toward or back, plug-in or reject,
group and regroup, sit still or branch out,
as order reverses and time fans the race.

We learn and then teach – see the need to re-learn.
With enough of the lessons, community grows.
Membership options some calm, renewed trust.
Layers give roles to the active and slow.

The spaces and clubs are spread outward.

Some ask to compete; those others create.
Both draw an audience, each its own place.
The competitors tense, while the art viewers breathe.
They wait in red seats, and choose inner observe…

lost – yet with focus, the richness infused

We members of public effect our safe spot,
hoping for freedom from tarnish or bruise….
Forgetting that growth comes from stumble or fail,
that the collective protects and lets risk prove its use. AM

EDGAR MARTINS 218, 219, 315

00:00.00 resulted from an unprecedented, eighteen-month long collaboration with the BMW Group and surveys the fabrication, tooling and assembly of the modern-era automobile vehicle. The project focuses solely on BMW's plant and R&D centres in and around Munich in Germany. However, these images also look beyond the mere referent, representing therefore a point of resistance.

Conceived around the simple premise of 'slowing down time', this project examines and interrogates the world of flux and flow that we live in, a world defined, haunted and consumed by mobility and transience. Symptomatically titled *00:00.00*, this series was produced with long exposures of 5–45 minutes. Photographing with prolonged exposures in a fast-moving environment represented a significant challenge, thus requiring a great deal of coordination and support from BMW.

All the images were therefore produced during scheduled and, at times, unscheduled production breaks, a process that goes against the grain of a factory.

00:00.00 represents the final phase of an overarching project that has engaged with environments as varied as hydropower plants (*The Time Machine*, 2012) and space facilities (*The Poetic Impossibility to Manage the Infinite*, 2014) and whose main goal has been to examine and re-evaluate our relationship with technology and industry and its impact on our social and cultural consciousness.

JEFFREY MILSTEIN 184, 208, 275, 294

To a large extent my work documents contemporary civilization, although that is not my primary intent, which is to make compelling images. Aircraft are an example of technology that has transformed the way we see the world, shrinking the planet and spreading ideas and products. I began my aircraft typology project seventeen years ago, because I think the aircraft are beautiful and amazing; seeing them fly directly overhead and landing at the end of the runway is a thrilling experience I want to share. Since I started, many of the airlines and some of the aircraft I have photographed are no longer in operation.

My aerial photography project documents the man-made landscape, which is also constantly changing. Looking from above, I often ponder as to why the buildings, cities, ports and airports look the way they do. Cultural patterns of civilization can be seen everywhere: how people spread out on a beach; the way we stack containers at a port; light up an amusement park; and taxi and park aircraft around terminals.

From a political standpoint, economic inequality is readily seen from above: the tightly packed working-class housing near the industrial areas of Los Angeles adds an overall brown tone to the image, in contrast to the mansions of the wealthy foothills north of the city lined with trees and pools, where the images have an overall green blue cast.

My work is informed by my lifelong interest in aviation and technology, and my earlier work as an architect and graphic designer. As an architect, I was taken with the work of Hilla and Bernd Becher, which influenced the aircraft typology. In 1961, when I was 17, I earned my pilot's licence and flew around LA in a Cessna 150 photographing the city with a 8mm film camera. I shoot now with the highest resolution medium-format digital cameras mounted to a stabilizing gyro that is hand held in steep turns, flying in small helicopters with the door removed, and small aircraft. Some of the images I currently produce with a 100 MPXL camera can be printed up to 60 x 80 inches or larger.

MINTIO 112

'Civilization' culturally ingrains in us the ideas of progress, expansion and human supremacy. In the environment of a 'civilized' society, architecture is one of the mediums where humans pursue urban progress to dominate and separate themselves from the natural world. In my work, I am interested in picturing this phenomenon, photographing urban environments as extra-terrestrial space, void of any semblance to things natural or living.

Digital technology is also a hallmark of 'civilization' today. This artwork may look like an outcome of digital manipulation whereas it is in fact created with the use of analog techniques. In this age where our day-to-day lives are bombarded with digital media and images, my work is intended to encourage viewers to encounter time, with means from outside the digital world, as an alternative experience to reality.

DAVID MOORE 83

David Moore's practice concerns itself with explorations of institutional and hegemonical power via state, social or corporate apparatus. He most often employs the document as a genre and has also worked with film and performance genres.

His practice considers agency of the subject within historical and contemporary contexts, and the effect of corporate or political hegemony as expressed or visible in a variety of contexts. He seeks bespoke, useful and accessible responses to modern social conditions within critically informed practice.

Described as a 'Northern Eggleston' by the writer Sean O'Hagan, Moore's current practice returns to the virtual site of his 1988 series *Pictures from the Real World*. It addresses agency and a critique of documentary as a genre using collaboration, installation and documentary theatre in the series and stage play *The Lisa and John Slideshow* performed for the first time at Derby Theatre in March 2017.

His work is held in public and private collections and he has been the recipient of several major funding awards from Arts Council England and the British Council.
David Chandler

MICHAEL NAJJAR 3, 314, 324, 326

My work takes a critical look at the technological forces shaping and drastically transforming the 21st century. It fuses science, art and technology into visions and utopias of future social orders emerging under the impact of cutting-edge technologies. Under the exponential development of our technological environment, our present-day civilization is transforming at a speed we could never have imagined decades ago.

As a photographer, I embrace an interdisciplinary understanding of art. My work constantly questions the relationship between reality and representation in the photographic image. I seek to guide the viewer into a complex construction of simulated reality generated by the montage of multiple-image sources and elements.

My current work series *Outer Space* deals with the latest developments in space exploration and the way they will shape our future life on earth, in earth's near orbit and on other planets. Today the human species is facing growing threats on planet earth including overpopulation, climate change, diminishing resources, and shortages in the energy, food and water supply. Even though obviously we need to protect our home planet, colonization of our solar system and terraforming might well be the ultimate solution to guarantee survival of

our civilization and our species. We need to extend our existential framework of reference from one that is purely earth-bound to one which includes earth's orbit and outer space in general.

WALTER NIEDERMAYR 52, 53, 214, 215, 288, 289, 310, 311

A central aspect of my work involves exploring the boundaries of the image itself in different variations. By displaying one image as a sequence in order to create duplications, overlaps and fractures, one begins to bring into play the very nature of the chronological sequence. It is my intention to desist from the cult of the single image and to photograph the same motif in different time phases and across different features, in order to make the changes visible, even if only slightly. Moreover, image sequences and image fractures accentuate the actual or supposed fractures in the topography itself, similar to what happens in perception. The strategy of repetition in the form of minimal differences, intersections and opposing points of view can cause unsettling or confusing effects that repeatedly undermine the short circuit between reality and image. In addition, the serial method of operation gives a dynamic to the image narrative.

I like to imagine the creation of an image of a space in which the observer is able to define their own point of view; that is to say, diversity in regard to content, diversity in regard to form and diversity in regard to further concern about the image. There are different approaches, such as social or landscape-specific processes or aesthetic questions regarding the landscape, spatial consciousness and environmental awareness; as well as questions regarding perception, such as the reality of the image, its spatial reality or the limits of our imagination and of the image itself.

SIMON NORFOLK 205, 298, 316, 317, 335

For many years now, my work has been an exploration of the Sublime in the landscape; those sights whose boundless beauty is countervailed by feelings of fearfulness and powerlessness. There is an appalling beauty in what human ingenuity can achieve when (given endless resources) it thinks only of more elegant and more brilliant ways to kill people.

These photographs are taken from the larger *Et in Arcadia Ego* project attempting to understand how war, and the need to fight war, has formed our world. How so many of the spaces we occupy, the technologies we use and the ways we understand ourselves are created by military conflict. The battlefields of Afghanistan and Iraq are the most obvious manifestations of this process. Conflict, however, can show itself in all manner of landscapes and surfaces created by war: from the extraordinary instant cities thrown up by refugees; to the bizarre environments created by electronic eavesdropping; to the cordons thrown up around US presidential hopefuls or the face of a young girl dying from AIDS in a country where an already feeble health system has been smashed by years of civil war.

Military strategists no longer talk about a 'battlefield'; they prefer the term 'battlespace' because this century has seen an astonishing inflation of the arena of warfare. A century ago warfare was a two-dimensional activity; men in fields or at sea shooting at other men they could see in the distance. In a hundred years the battlespace has grown into the clouds and further into the depths beneath the waves. It has grown into the electromagnetic spectrum (radar and electronic warfare and surveillance) and it has grown into cyberreality and cryptographic security.

What these 'landscapes' have in common, their basis in conflict, is fundamentally downplayed in our society – technology pushes forwards hardest during war-time. Its greatest advances are purchased in blood.

NEIL PARDINGTON 50

The New Zealand economy is highly reliant on the export of primary products, with meat and edible offal the second biggest export group behind milk powder, butter and cheese, and represents 3.2 per cent of New Zealand's GDP. Over half of New Zealand's land area is pasture and arable land.

The red-meat sector in New Zealand comprises approximately 26,000 commercial sheep, beef cattle and deer farms and over sixty processing plants, altogether employing around 80,000 people. Each year about NZ$7.5 billion of red meat and edible offal is exported to over 120 markets. This represents around 12 per cent of the value of New Zealand's total merchandise exports and 22 per cent of primary sector exports.

The slaughter chains and processing departments pictured in *The Abattoir* handle lamb, sheep, beef, goat, venison and bobby veal. The photographs were taken in 2010 at a single processing plant that slaughtered 1,500,000 animals annually.

GILES PRICE 4–5, 116, 272–73, 280, 283

My work looks at civilization's major structural and built interventions, landscapes transformed by protest and mass gathering as well as those activated by traces of human existence and survival in extremity. Within this view of mankind's impact and actions the work comprises political, environmental and economic concerns. I use scale to show this, frequently from above, where I am interested in the documentary and reportage aspects of capturing change and specific moments.

This viewpoint including Google Earth, satellite and drone, both military and consumer, has become ubiquitous in 21st-century life through our interaction with technology.

SIMON ROBERTS 178, 179, 281, 287, 290

In our current stage of social development as an increasingly digitized civilization we have become accustomed to the distractedness of mobile devices in public spaces, whether on the street or in the mall. Being there but not there, being explicitly detached, would seem to be a common sign not only of an increasingly affectless public realm, but also of fundamental shifts in the way we understand and value communal experience. It is becoming clear that we now inhabit a plurality of publics and communities, manifest in overlapping physical and digital spaces that have reconditioned our sense of belonging as well as changed our patterns of social interaction. The nature of public, communal experience has been an implicit theme of my photographic work for the last decade. Since I embarked on my project *We English* in 2007, I have documented events and places across Britain, and further afield, that have drawn people together, all the while compiling evidence that the desire for common presence and participation, for sharing a sense of being 'in place', not only endures but might also harbour something distinctive about a national character and identity. That these gatherings are also set in specific landscapes and are embedded in unfolding social histories of place has been a distinguishing feature of my investigation.

ANDREW ROWAT 197

My work explores societal change and commentary by photographing the spaces and places that people inhabit. Each individual space adds a single brushstroke to a larger theme – a mosaic built from its constituent parts. Change, collision and catagenesis are all elements that feature heavily in my work. People are sometimes included in the images, but more often than not I want to let the viewer build up their own picture of the person who lives in that space from the artifacts and details that I have chosen to include.

With my Yangon project in Myanmar I have focused on a particular moment in the country's history as democracy collides with military dictatorship; as development threatens to destroy heritage architecture; as Buddhism, Islam and Christianity all jostle for space; as so-called modernity careens into traditional ways of life.

Much of what I photograph is ephemeral, a photo that I will never be able to take again, not because it is some sort of 'decisive moment', but more because I have chosen to turn my lens on fragile subjects that are emblematic of a time, place and people – the date and location embedded into their visual DNA.

My work has been informed by the eight years I lived in Shanghai and seven in New York City, as well as the travel work I do with magazines. This global exposure allows me to see my subjects in a wider connected context, both geographically and temporally.

VICTORIA SAMBUNARIS 134

Geography – a fairly recent science – maps the relationships between the earth and its inhabitants. I think of 'social geography' as a term to describe my photographic work and methodology. I isolate images of the natural world together with the superimposition of a relentless grid of human interactions and interventions. The meanings of each oscillate and are determined by the other.

The myth of America and particularly its western landscape largely underwrote the ideas of freedom and frontier independence found in much national political rhetoric and as the basis of much popular cultural imagery. Today these same landscapes are deeply charged with social interventions that contradict those mythologies and instead present a harshly pragmatic yet sometimes sublime and sometimes negative set of images. These mythic spaces are both aesthetically and politically linked, now inextricably.

For many years now I have been on a personal quest to understand such complex landscapes and our engagement with them.

My work has concerned itself with the massive mining operations, native fossil fuel and burgeoning fractal energy infrastructure. As well, I spent three years following and working along the US-Mexico border and have recently begun to incorporate the escalating trade industries that thrive at our ports.

Essentially, I am recording anonymous modern-day monuments that have settled onto the contemporary landscape, telling a conflicted story in geographical, environmental, political and cultural terms. The photographs that I produce question traditional and clichéd notions of landscape, our place within it, and the collective roles and responsibilities in how and why we shape it the way we do.

The philosopher and media theorist Boris Groys stated in 2009: 'The goal of art...is not to change things – they are changing themselves all the time anyway. Art's function is rather to show, to make visible the realities

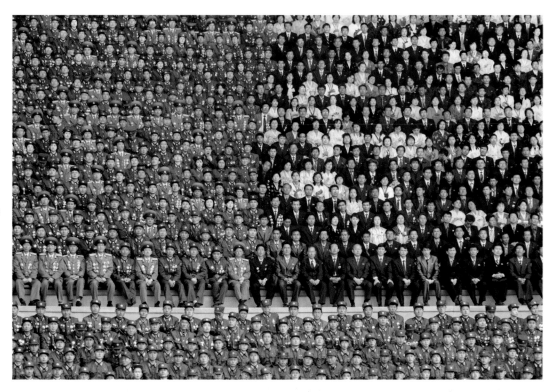

PHILIPPE CHANCEL *DPRK, North Korea*, from the series *Datazone* 2006

that are generally overlooked.' It is with this idea in mind that I am contributing to a taxonomy of contemporary landscapes that continues to lead me onto the roads, thruways, highways, freeways and turnpikes between the US coasts and beyond.

SATO SHINTARO 168–69

Entertainment districts in Japan are full of places that cater to human desires for food, sex and amusement. Gaudy billboards aiming to attract customers are all over the place, looking like flowers that bloom while breathing the air of obscenity in such places. As I walked through the streets attracted by that feeling of squalidness, I noticed that the billboards – randomly placed and a far cry from elegant or beautiful sights – create intriguing rhythms of colours, lights and shapes when seen from certain perspectives. Touched by the beauty generated from the crush of vulgar elements, an unintended beauty born out of necessity, I started taking photos.

When shooting, I eliminated human figures in order to capture the city itself. Even at crowded street corners it happens every once in a while that the tide of people is interrupted for a few seconds. Those are the moments when I open my lens, and I quickly cover it with a sheet of black paper as soon as they start coming again. By repeating this procedure several times, I accumulate the necessary exposure time between thirty seconds and one minute. The photos are in a way multi-exposure shots gathering moments when no people are around.

When removing human figures from streets that are usually crowded with people, the city reveals a face that one normally doesn't get to see. In empty streets, the excessive colours and lights of neon signs seem deprived of their original purpose of attracting people. The spectacle of lights that glitter as if only for the sake

of the glitter itself looks to me like a living organism that goes on and on forever, even without humans, and is out of their control.

DONA SCHWARTZ 92, 93

My photographic work is informed by my training as a qualitative social scientist. There is a strong connection between my experiences doing ethnographic fieldwork and making photographs – each requires acute attention to interactions, activities and events as they take place in our midst. I focus on the ways in which culture is expressed in everyday rituals and routines – that focus provides me with a window through which to examine contemporary social life – ur *civilization*.

The global connectivity made possible by digital technologies has changed the way we live and navigate our world. The Internet seems like a magic carpet that can take us anywhere and everywhere. We feel as if we are omniscient – we have seen all that civilization has to offer – but of course that's not possible. Despite our sense that we grasp the contours of our civilization, there are vast areas we have yet to colour in. Certainly, we have extended our reach but have we also extended our understanding of what we've encountered? Do we embrace civilization's rich diversity or circle the wagons to keep difference at bay?

As an ethnographically trained photographer I like to work small, trying to learn as much as I can about the subject of my investigation. Then I try to see how far what I've discovered resonates beyond the boundaries of my focused framework. The majority of my photographic work has centred on the family. I am drawn to studying the family for several reasons. For me, the transition to parenthood was the most momentous change I have experienced: becoming a parent forever changed

my identity and my worldview. My photographic work examining the nature of family and domestic life is personal. But at the same time, I think family is the crucible in which individual identity is formed. Family is the starting point for what becomes our collective culture. For me, family is where civilization begins.

PAUL SHAMBROOM 85

My *Meetings* series was made from 1999 to 2003. I photographed elected government meetings in over 150 small communities across the United States. It was an amazing experience to meet the men and women who govern towns and villages, who receive little or no pay or thanks. I sometimes disagreed with what I heard and they did not all strike me as the most capable leaders, but I came to have respect for those who stepped up to do something. I saw how strong leadership can lift one town up, and how in the next town down the road the leaders' mediocrity and selfishness can infect the whole community.

SHENG-WEN LO 276

White Bear (2014–) depicts polar bears on display in their artificial habitats around the world; I attempt to engage with dilemmas concerning captive animal programmes. Thus far I have visited twenty-six zoos* across Europe and China.

White Bear is not simply about polar bears – it studies the issue of putting animals on display in artificial habitats by focusing on one specific species. I realized that these habitats are designed to satisfy both the spectators (audience) and the dwellers (animals), and with their effort to mimic the arctic environment, the uncanny structures combine 'nature', 'home' and 'stage'. The man-made backgrounds – grasslands, plateaus, swimming pools, car tyres, fake seals, stone stairs, painted icebergs, yachts, aeroplanes and even skyscrapers – and enclosures are juxtaposed with their furry protagonists to create a certain vision. But there are various issues lurking beneath the surface, whatever the constraints of limited space and resources.

As natural habitats are being destroyed, it may be reasonable to keep certain species in controlled environments; however, I think it is questionable whether some results are a true reflection of the original motive. The existence of captive white bears embodies this ambiguity. Promoted as exotic tourist-magnets (*mega fauna*), the bears stand at the point where the institutions' mission of conservation, research and education is challenged by their interest in entertainment.

*In this context 'zoos' includes aquariums, wildlife parks, conservation parks, bioparks and all institutions that meet the definition from the World Zoo Conservation Strategy (1993).

TOSHIO SHIBATA 331, 332

My goal is to create with each photograph an independent work that is called a 'tableau'. It is not my aim to make a depiction in order to explain, nor to make images to illustrate an essay; it is to pursue the possibility of new expression by means of photography.

I choose infrastructure as the main subject for my photography. Usually, by their nature these things are considered as serviceable – the opposite of art. But they represent the time and space of an era, as well as the daily life. It depends on how you look at it; infrastructure contains many elements of landscape such as environment, economic condition and technology. These are very interesting subjects for me.

I am interested in people. But I like indirect representation, such as not photographing a human being directly. I prefer making an indirect approach that feels as if someone were there.

When I am taking a photograph, I try to keep a neutral relationship with my subjects. It is as if I am only borrowing the place and the scene. I believe that the preconceptions we have concerning a place, such as its political and historical associations, should be set to one side at the time of shoot. I admire work that has the capability of being seen from different points of view by an audience.

I believe the camera is a suitable tool with which to see the world.

WILL STEACY 240, 241

I spent five years photographing the newsroom and printing plant of the *Philadelphia Inquirer* with unrestricted access. Through a depiction of the *Inquirer's* efforts to prevail in a digital era despite depleted ad revenue, steady decline in circulation, lay-offs, buy-outs and bankruptcy, my intent with *Deadline* (2009–13) was to reveal the challenges and harsh realities confronting the newspaper industry.

Having shed 40 per cent of its workforce in the past decade, newspapers are America's fastest shrinking industry, yet more than half of American adults know little to nothing about the financial struggles that have eviscerated newsrooms.

As we find ourselves amid a massive societal transition into an information technology economy of the future in which technological advances have eroded middle-skill, middle-class jobs, boosted productivity while reducing the labour force, what has been the human cost of these gains? The newspaper for centuries has served as a cornerstone of American society holding its institutions, CEOs, politicians and big businesses accountable for their actions, upholding the values, laws and morals that democracy was founded upon.

When we lose reporters, editors, newsbeats and sections of papers, we lose coverage, information and a connection to our cities and our society, and, in the end, we lose ourselves. Without the human investment, rather an algorithm, to provide news content it becomes a zero sum game on the information highway to nowhere. The fibres of the paper and the clicks of the mouse are worthless unless the words they are presented on have value. The newspaper is much more than a business; it is a civic trust.

LARRY SULTAN 90, 91

To me the documentary side of this work – or the illusion of documentary – is very important. I want to refer to life rather than to the films. My photographs reference the artifice of pornography, but they also capture real people in their own genuine moments. For example, a man is shown standing in the kitchen, looking out the window. He happens not to have any clothes on, but for me, that picture recalls a really poignant moment where, in the middle of the day, you have a glass of cold water and you look out the window and wonder, what am I doing here?

SHIGERU TAKATO 154

Television media portrays our world through reporting and storytelling. The media holds the power of influencing our perceptions of the world.

A television studio is a place where an enormous amount of energy converges from many different corners of the world. TV-cameras witness conflicts, wars, natural

and human disasters and historical events, and this audio-visual information is directed back to the television studio. A television studio is also a centre of concentrated human energy itself, where heated discussion, debates and dramas take place. All of this activity is transformed into electronic and electro-magnetic signals, which are transmitted into the sky and through cables to reach a global audience.

The *Television Studios* project is a series of empty television studios photographed in various cities around the world. The studios in the photographs are set up exactly as they would be for airing – lighting and all – but without people: no news anchors, guests or studio crew. These photographs eliminate the expected characteristics of television screens such as sound, humans and movement. At the same time, the photographs show what usually remains hidden: lighting equipment, cables and taped markings on the floor. These studios remain silent, although they are primed to tell their stories. A muted studio is deprived of its basic function.

The media is a dominant player in civilization with its information-hungry populations. As a viewer sitting comfortably on the couch in the living room, I can allow myself to be bombarded by an endless stream of content. My response is to intercept this mono-directional flow of information and to re-present it in photographic form. I step out of my living room, camera in my backpack, and trace my way back to the source of the information – the television studio.

Since 2001, I have photographed over 200 television studios across Europe, Asia, South America and the Middle East. This is an ongoing project.

DANILA TKACHENKO 251

The project *Restricted Areas* is about the human impulse towards utopia; about our striving for perfection through technological progress.

Humans are always trying to own ever more than they have – this is the source of technical progress. The by-products of this progress are various commodities as well as the tools of violence in order to hold power over others.

Better, higher, stronger – these ideals often express the main ideology of governments. To achieve these standards, governments are ready to sacrifice almost everything. Meanwhile, the individual is supposed to become a tool for reaching these goals. In exchange, the individual is promised a higher level of comfort.

For *Restricted Areas*, I travelled in search of places that used to hold great importance for the idea of technological progress. These places are now deserted. They have lost their significance, along with their utopian ideology, which is now obsolete.

Many of these places were once secret cities that did not appear on any maps or in public records. These places were the sites of forgotten scientific triumphs, abandoned buildings of almost inhuman complexity; the perfect technocratic future that never came.

Any progress comes to its end sooner or later and it can happen for different reasons: nuclear war, economic crisis or natural disaster. What's interesting for me is to witness what remains after the progress has ground to a halt.

EASON TSANG KA WAI 47

The rooftop is a private space, yet exposed to the surrounding buildings and thus the gaze of some form of public.

In the *Rooftop* series, my approach involves physical and visual intrusion of these private spaces. In an act of

trespassing, I entered rooftops of private and commercial buildings and took pictures of surrounding rooftops in a bird's-eye view.

Old districts in Hong Kong, in particular, contain a mishmash of buildings and skyscrapers of drastically different age and height, making them ideal settings for these images.

PENELOPE UMBRICO 88, 89

For *TVs from Craigslist* (2008–) I downloaded images of used TVs for sale on Craigslist, cropped all but the screens from them, and enlarged them to the scale of the TV. Although these images are purely utilitarian, made only to sell a TV, they all have embedded in them the subjectivity and individuality of the photographer/seller. The inadvertent reflections of the sellers become the subjects, within the dark screens of their unwanted used-TVs. Viewed on Craigslist these images are very small – it's likely that the sellers are unaware that they are visible. But I wonder, given the promise of connection that the Internet fosters, if there's a subconscious undercurrent of exhibitionism here; a plea for attention. Here one finds gestures of intimate and private exposure, all accessible to an entirely anonymous public. Travelling virtually from city to city in search of TVs for sale on Craigslist, I am invited into people's living rooms and bedrooms, and there they are, the sellers with unmade beds, dirty laundry, in various states of undress, sometimes completely naked, reflected in the surface of a TV they no longer want. It's sad really – at one time the centre of the family room, now rejected, the last picture of the TV that will exist holds on to a little ghostly image of its owner. Or, the ghostly image is forever stuck in the machine that its owner doesn't want.

CARLO VALSECCHI 128, 130

I have always worked in a field in which landscape, industry, architecture and urbanism indistinctly and imperceptibly blend into each other. The foundation of my approach is the relationship between mental space and actual physical space.

My primary interest is located in the connection, through the mediation of analogical thought, between man and what surrounds him. I adopt a mode of work that is open, correlated with and contaminated by the composition of physical, cultural, social, historical and contemporary elements of our lives.

I cannot say whether or not my artistic practice is of any interest to the times in which I live; the only measure or criterion of judgment for me is the time yet to come.

I believe in the political being of each individual subject.

The artist is just such a subject and therefore every one of his or her actions participates in the collective development of thought within the frame of the experience of our existence.

I have never believed in the use or existence of a political, social or environmental artistic practice.

Art asks questions of itself and of each of us, but it does not give responses.

REGINALD VAN DE VELDE 199

J. M. Barrie once wrote: 'All children, except one, grow up.'

I eventually grew up but what seeped into my adulthood as well as into my photographs was the undeniable Peter Panish thirst for adventure and a wish to stop time. Or at least make it flow a little slower.

I consider myself a hunter for moments perfectly still in time, audibly quieter than the deafening humanity around us busy with its realities and worries. And in those moments my work begins. Instead of a wooden sword and a red-feathered hat, I play with symmetry and cameras, continually searching for the freshness of a new sight.

It is quite ironic, in a sense, to seek out freshness precisely in those places where there is none left. Yet in a world in which all the information is readily available at the tips of our fingers, that freshness remains a precious commodity, as well as time. I wish to offer my viewers both of these things. To distort their perception of time as much as it is distorted in the places they are looking at; to offer them a tiny fraction of solitude in a world moving too fast; to let them catch their breaths; to put a wooden sword in their hands and a red-feathered hat on their heads.

CÁSSIO VASCONCELLOS 10–11

My series *Collectives* reveals a contemporary look at life stories from a globalized world seen through mosaics of constructed images. The observer is faced with large panels of aerial photos: if seen from afar they appear to be textures or geometric forms but if inspected closely they surprise the viewer with a richness of detail that reveals patterns of daily consumption in the urban lifestyle.

The work on view reveals the enormous quantity of products and land that human beings use living on our planet. All the images, which are made of hundreds of different pictures that together create imaginary landscapes, depict the reality featuring huge areas that humanity increasingly needs to achieve all the steps of the consumption chain. *Verde* is concerned with the big demand for food, showing large areas used for plantations, and *Ceasa* presents the complex operation for distributing the food. Our society produces an immeasurable quantity of disposable items and *Arizona* shows us an incredible boneyard comprised of old aircraft. *Coletivo* represents a nightmare scene of what is happening in all big cities in the world where the car has a growing presence.

Aeroporto is a surreal airport that is a portrait of globalization, mobility and the speed of our way of life. Composed of more than a thousand photos clicked at several airports in Brazil and in the United States, the work presents the relationship between humanity and its new way of interacting with time and space, reinforced by the striking resemblance to the shape of neurons.

ROBERT WALKER 156, 160, 164, 165

Times Square, rather than being just a tourist Mecca, for me acts as a metaphor for the excesses and pathologies of contemporary society. Overconsumption and sensual indulgence are seductively encouraged by a hysterical *mélange* of signs and symbols, coupled with the notion that everyone is entitled to a few moments of celebrity, regardless of real achievement or not.

RICHARD WALLBANK 325

Heliconius butterflies from the tropics of Central America exhibit a myriad of colourful wing patterns, configured during the animal's development through the interactions of genes. The mechanisms by which these patterns are generated are fundamentally similar to the way that all animals, including humans, pattern and order their bodies. By applying a new genetic engineering technology called CRISPR/Cas9, I disrupted a single gene in the genome of these butterflies, which resulted in a dramatic change in their black-and-white wing patterning. This mutation hints at how such genes have evolved to generate the many wing patterns observed in the wild.

My method generates mosaic animals – part mutant, part wildtype – as revealed by their marbled patterns. CRISPR/Cas9 is just a few years old and yet it's difficult to exaggerate just how revolutionary this technology, and its future iterations, will be for humanity. The ability to specifically edit an organism's DNA will not only accelerate our fundamental understanding of biology but will also be vital for medical advances – such as curing cancers, combatting viruses, and alleviating congenital diseases – and may even help avoid future famines by bypassing the problems associated with industrial agriculture. This immense and far-reaching potential must, however, be approached with responsibility, and like all science will continually benefit from transparent and inclusive debate. To me these photos highlight how – due to the remarkable commonality of life's processes – technology that today affects a butterfly's wing will eventually and inevitably affect us all.

WANG QINGSONG 104–05

Work, Work, Work was created in 2012 in collaboration with the well-known architectural office headed by Ole Scheeren in China. At that time, construction of all sorts of buildings was rampant in Beijing. Many landmarks were created by foreign architects.

I was approached by the architect to create a photograph to be published in *Wallpaper* magazine. After several rounds of visits and discussions, I came up with the idea of mapping this architect's office creating future glories as a manic madhouse of chaos. I asked the office clerks/architects to put on patients' pyjamas and behave as if they were rushing to finish projects before the deadline approached. In line with the government slogan from many years ago promoting study, 'Study, Study, Further Study', I created the imperative command, 'Work, Work, Work'. The overall tone was made to seem very gloomy and the upcoming landmark a hopeless colour.

Clothing, catering, living and travelling are the four major prerequisites for people in general to live a civilized life. However, people have been massively producing and making more complicated ways of enjoying their life in this world. They create various forms of leisure and consumption that are to the detriment of the environment and humanity. I feel that what the civilization of the old times appreciated – simplicity and clarity – has been forgotten and should be re-evaluated and revived.

PATRICK WEIDMANN 158

The main subject and the meaning of my work is probably photography itself.

I have no particular point of view, except a moral one about the purpose of representation, which is a disruptive fiction. I'm looking for symptoms, distortions, nonsense, emptiness or overloaded displays; I'm looking for contradictions, tensions, ambivalences and oxymoronic situations. It's some kind of intellectual quest; it's a permanent mental state with no beginning and no end. Time seems also a part of the fiction. The subject should become an independent object. It's important not to identify immediately what is in the picture. I try to escape from reality but also from unreality. I look into reality as if it has never been real before.

Consumerism is the hard core of our globalized civilization. My aim is also to examine the juxtaposition between the promises of instant happiness and all kinds of accidents and unexpected disasters. I don't think that photography is art, but photography needs art to become an acceptable 'ersatz'.

THOMAS WEINBERGER 203

The key to comprehending my *Synthesen* series lies in the reflection on time and light in photography. I see light as the photographer's language just as colour is the painter's. By fusing several exposures of the same subject at different times, I thereby create a static image of perpetuity. I create a new, synthetic reality composed of parts of reality, just as our brains do while we are dreaming. In view of the irrational exuberance in our world, a surreal visual conception represents my attitude to contemporary civilization more than a documentary one. In my *Synthesen* series I show civilization in the light of its fragility, but at the same time my works also celebrate the creative power of man.

XING DANWEN 242

During 2002–3, I travelled several times to Guangdong Province in Southern China, one of the country's most developed areas. Along the coast, more than 100,000 people from Guangdong and migrant workers from Western China make their living by dismantling and burning piles of computer and electronic components to extract bits of copper, brass, aluminium and zinc for resale, operating in tough environmental and social conditions. These tons of outdated and broken computers, game-machines, mobile phones and other e-waste that were mostly manufactured in China, are shipped back there as 'donations' from developed countries: Japan, South Korea and the United States. However, this round-trip business is transformed into noxious trash threatening the health of the area's inhabitants and contaminating the water and soil.

Confronted with millions of newly purchased products replacing millions of discarded ones, e-waste has become a matter of concern and a huge warning for the future. In China, the rapid changes have taken place under the influence of the West and have contributed to a strong and powerful push for development, but at the same time these forces are complicit in creating the environmental and social nightmare experienced in the remote corners of the country.

My intention is to depict a picture of our environment by carefully choosing intimate moments. The aesthetic beauty of the imagery almost transports the photographed objects from their social and economic context. But I cannot forget the facts and the reality of what I see.

There are more than forty images with an almost monochrome tonality that capitalizes on a disturbing and cool cast, which emphasizes the cruel conditions. My intention is to display disCONNEXION in a large-scale multi-image installation that conveys the immensity of the problem as well as the unbearable details I witnessed in these e-wastelands.

ANNE ZAHALKA 96, 97

These photos (*Open House*) taken of my social milieu in their rented homes in the mid-1990s document the relationships and living situations of the occupants through the small rituals performed within daily life. They draw on the language of documentary photography, genre painting and TV sitcoms, and parody these to construct everyday narratives of the urban dweller. Within each interior, figures engage in subtle plays of social interaction, or appear caught in their own internal dialogues to enclose and disclose the contingencies of contemporary life. They are defined as much by their surroundings as they are through the collection of objects that gather on available surfaces. The camera, although an introduced observer to these scenes, nevertheless exposes the intimacies and behaviour of this generation at a particular time in history.

LUCA ZANIER 186–87, 193, 198

I discover and show the hidden universes of our society, but not in a documentary approach. My intention is to capture these locations in an artistic manner. Pure information is in the background. The idea is more about perspectives, colours and shapes. What I am proposing is to dissipate information into aesthetics, at least to a certain extent. Only the caption will remind the beholder of what he or she is contemplating: highly complex systems of our civilization upon which our modern life depends.

My intention is to show unexpected perspectives and to surprise the viewer. The images provoke us to think about the complexity of civilization's achievements: the thirst for energy; the manifestation of organizations' identities; the beauty of technology; the distribution of power; the leadership of our society.

I don't want to comment on the images myself, but I always provide quite elaborate captions to explain the circumstances. The interpretation is up to you.

ZHANG XIAO 295

China has a long, continuous 18,000 kilometres of coastline, starting from the mouth the river Yalu in Liaoning Province in the north to the mouth of the river Beilun in Guangxi Province in the south. After thirty years of economic reform and opening up, tremendous changes are happening in China every day. The cities are like large building sites with an increasing pace of construction to catch up with the rest of the world; this phenomenon is particularly obvious in China's coastal areas, where the movement of Chinese from the interior is taking place on a massive scale. While rapid urbanization is continually developing, the growth of people's spiritual life is slowing down and has even stagnated.

During Chinese New Year, the hundreds of millions of people who come to the coastal areas for jobs each year travel home for family reunions; it is a huge migration from south to north and from east to west within a short period of time. On these journeys people often start questioning themselves about their actual homeland. Traditional living habits have been deeply affected by the radical changes that are taking place while many conventional values and customs have also been undermined. Perhaps a lack of sense of belonging is a collective conflict at the heart of the Chinese people today.

On my journey, I was always being asked, 'What are you doing here?', 'What can you photograph in here?'. I often asked myself the same questions. I always answered: 'To look around.' I think I just wanted to document with my camera the lives of these real people and the landscape in today's China.

When I was a child, I was drawn to the sea: the sea is mysterious and it cannot be encompassed. I still feel the same. (This mystery has nothing to do with the fact that I cannot swim.) I come here to seek those strong emotions and rich imagery, and perhaps there are also disappointments. The sea is the beginning of lives and dreams; at the same time, I am looking for the homeland in my heart.

ROBERT ZHAO RENHUI 307

A Guide to the Flora and Fauna of the World (2013) seeks to document and reflect on the myriad ways in which human action and intervention are slowly altering the natural world. The guide presents a catalogue of curious creatures and life forms that have evolved in often unexpected ways to cope with the stresses and pressures of a changed world. Other organisms documented in the series are the results of human intervention, mutations engineered to serve various interests and purposes ranging from scientific research to the desire for ornamentation.

Several specimens in this project are based on fact; others are based on proposals, hypothesis and papers written by scientists. The line between these two is often an indistinct one, as scientific advances within the last half-century have made possible what was previously believed to be impossible. While drawing on the encyclopedic tradition, which is premised on the basic human desire to catalogue and to order knowledge so as to better understand – and command – the world, the project also questions the limits of these systems of collating, ordering and disseminating knowledge, by blurring the lines between fact and fiction, and oscillating between the modalities of science and art, thereby inviting us to consider the roles of these disciplines in our apprehension and understanding of the world.

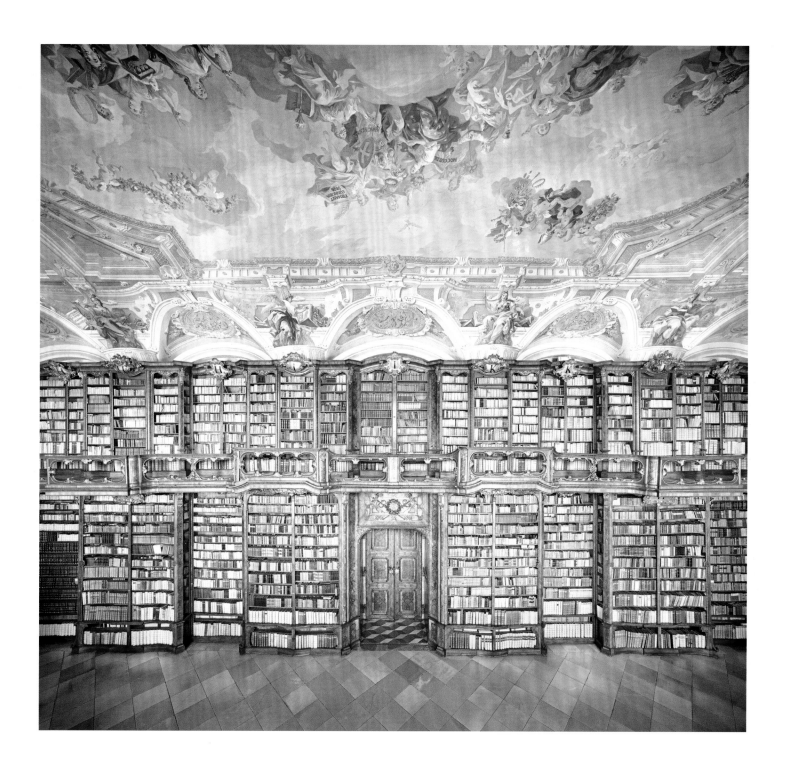

Civilization is cumulative

CANDIDA HÖFER *Augustiner Chorherrenstift Sankt Florian III 2014*

NOTES

1 Oswald Spengler, *The Decline of the West* (1918), Vintage, New York, 2006, p. 73.

2 On 4 July 2012, the ATLAS and CMS experiments at CERN's Large Hadron Collider announced they had each observed a new particle which conformed to the theoretical particle 'consistent with the Higgs boson predicted by the Standard Model': https://home.cern/topics/higgs-boson. The discovery of the Tau neutrino was announced in July 2000 by the DONUT collaboration: http://news.fnal.gov/2000/07/physicists-find-first-direct-evidence-tau-neutrino-fermilab/

3 'January 3, 2018 – Persistence pays off. Jonathan Pace, a GIMPS volunteer for over 14 years, discovered the 50th known Mersenne prime, $2^{77,232,917}-1$ on December 26, 2017. The prime number is calculated by multiplying together 77,232,917 twos, and then subtracting one. It weighs in at 23,249,425 digits, becoming the largest prime number known to mankind. It bests the previous record prime, also discovered by GIMPS, by 910,807 digits.' www.mersenne.org

4 www.guinnessworldrecords.com/world-records/480712-most-slices-of-carrots-sliced-while-blindfolded-in-30-seconds

5 www.indiatvnews.com/business/india-facebook-working-on-technology-that-could-let-you-type-with-your-brain-377902

6 www.guinnessworldrecords.com/world-records/loudest-scream-by-a-crowd

7 https://som.yale.edu/blog/peter-thiel-at-yale-we-wanted-flying-cars-instead-we-got-140-characters

8 Yuval Noah Harari, *Homo Deus: A Brief History of Tomorrow*, Vintage, New York, 2017, p. 58.

9 http://lgbtqia.ucdavis.edu/about/index.html

10 www.apnews.com/f9845e18b1de475e9f8f26711b37452b/She's-only-5,-but-Beckham-daughter-gets-brand-protection. 13 April 2017

11 Karl W. Butzer, *Early Hydraulic Civilization in Egypt*, 1976: https://oi.uchicago.edu/sites/oi.uchicago.edu/files/uploads/shared/docs/early_hydraulic.pdf

12 Zygmunt Bauman, *Liquid Modernity*, Polity Press, Cambridge, 2000, p. xiv.

13 Alexandra Alter, 'Boom times for the new dystopians', *New York Times*, 30 March 2017: www.nytimes.com/2017/03/30/books/boom-times-for-the-new-dystopians.html

14 Fiona MacDonald, 'The highest radiation level has been recorded since the 2011 meltdown. A new radiation reading taken deep inside Japan's damaged Fukushima Daiichi nuclear reactor No. 2 shows levels reaching a maximum of 530 sieverts per hour, a number experts have called "unimaginable": www.sciencealert.com/radiation-levels-in-the-fukushima-reactor-have-started-unexpectedly-climbing. 4 February 2017

15 Kurt Andersen, 'How America lost its mind', *Atlantic*, September 2017: www.theatlantic.com/magazine/archive/2017/09/how-america-lost-its-mind/534231/

16 Louis Lucero II, 'Charlie Rose has honors from two journalism schools rescinded', *New York Times*, 24 November 2017: 'In a statement, Christopher Callahan, dean of the Walter Cronkite School of Journalism and Mass Communication at Arizona State, said he believed Mr Rose's alleged transgressions were "so egregious that they demand nothing less than a reversal of history".' www.nytimes.com/2017/11/24/us/charlie-rose-awards.html.

17 George Orwell, 'Looking back on the Spanish War', 1942: https://ebooks.adelaide.edu.au/o/orwell/george/looking-back/

18 In one of the first uses of the term 'singularity' in the context of technological progress, Stanislaw Ulam tells of a conversation with John von Neumann (1903–1957) about accelerating change: 'One conversation centered on the ever accelerating progress of technology and changes in the mode of human life, which gives the appearance of approaching some essential singularity in the history of the race beyond which human affairs, as we know them, could not continue.' Stanislaw Ulam, 'Tribute to John von Neumann', *Bulletin of the American Mathematical Society*, 64:3 (May 1958), p. 5. The term was popularized by Vernor Vinge in his essay 'The coming technological singularity', 1993.

19 James Martin, *The Meaning of the 21st Century*, Riverhead Books, New York, 2006, p. 28.

20 Hunter Stuart, 'Ethan Couch, "affluenza" teen, facing 5 lawsuits', *Huffington Post*, 12 December 2013: www.huffingtonpost.co.uk/entry/ethan-couch-affluenza-lawsuits-car-crash-texas_n_4461585

21 Malcolm Bradbury, introduction, Aldous Huxley, *Crome Yellow* (1921), Penguin Books, Harmondsworth, 1964.

22 Winston Churchill, *The World Crisis 1911–1918*, Folio Society, London, 2007, vol. 1 (1911–1914), pp. 13–23.

23 Cade Metz and Keith Collins, 'How an A.I. "cat-and-mouse game" generates believable fake photos', *New York Times*, 2 January 2018: www.nytimes.com/interactive/2018/01/02/technology/ai-generated-photos.html

24 Brian Droitcour, 'Let us see you see you', *DIS Magazine*, 3 December 2012: http://dismagazine.com/blog/38139/let-us-see-you-see-you/

25 Fernand Braudel, *Grammaire des Civilisations* (1963); *A History of Civilizations*, Penguin Books, London, 1995, p. 3.

26 Joseph Drew, 'Editor's note', *Comparative Civilizations Review*, 56:56 (Spring 2007).

27 Kenneth Clark, *Civilisation: A Personal View*, BBC and John Murray, London, 1969; Episode One: 'The Skin of Our Teeth', *Civilisation*, BBC TV series, 1969.

28 Eric Schlosser, *Fast Food Nation: What the All-American Meal is Doing to the World*, Allen Lane, London, 2001, p. 2.

29 Terry Eagleton, *Culture*, Yale University Press, New Haven, 2016, p. 12.

30 Andrew Bosworth, 'The genetics of civilization: an empirical classification of civilizations based on writing systems', *Comparative Civilizations Review*, 49 (Fall 2003), p. 9.

31 Feliks Koneczny, *On the Plurality of Civilisations*, Polonica Publications, London, 1962, p. 112: www.scribd.com/doc/4464979/ON-THE-PLURALITY-OF-CIVILIZATIONS-Feliks-Koneczny-Entire-Book

32 Meier's website bears the impressive name www.civilization.com

33 Quoted in Strobe Talbott, *The Great Experiment*, Simon & Schuster, New York, 2008, p. 199.

34 Robert W. Cox, 'Civilizations and the twenty-first century: some theoretical considerations', *International Relations of the Asia-Pacific*, 1:1 (2001), pp. 105–30.

35 Juliet Macur, 'Terrorism and tension for Sochi, not sports and joy', *New York Times*, 4 February 2014: www.nytimes.com/2014/02/05/sports/olympics/terrorism-and-tension-for-sochi-not-sports-and-joy.html

36 Brian Castner, 'A disappearing home in a warming world', *Atlantic*, 12 October 2016: www.theatlantic.com/international/archive/2016/10/canada-globalization-climate-change-dene/503672/

37 Quoted in Nicholas Wade, 'Supremacy of a social network', *New York Times*, 14 March 2011: www.nytimes.com/2011/03/15/science/15humans.html

38 Quoted in James Tulloch and Greg Langley, *Maintainers Make the World Go Round*, 2017: https://projectm-online.com/investing/why-maintenance-means-more-to-peoples-lives-than-innovation/

39 David Graeber, *The Utopia of Rules, On Technology, Stupidity, and the Secret Joys of Bureaucracy*, Melville House, Brooklyn and London, 2015, p. 175.

40 Niall Ferguson, *Civilization: The West and the Rest*, Allen Lane, London, 2011, p. 8.

41 Ian Goldin and Chris Kutarna, *Age of Discovery, Navigating the Risks and Rewards of Our New Renaissance*, Bloomsbury, London, 2016, p. 35.

42 Braudel, *op. cit.*, p. 22.

43 See Trevor Paglen, *The Last Pictures*, Creative Time Books, New York, 2012: 'Human civilizations' longest lasting artifacts are not the great Pyramids of Giza, nor the cave paintings at Lascaux, but the communications satellites that circle our planet. In a stationary orbit above the equator, the satellites that broadcast our TV signals, route our phone calls, and process our credit card transactions experience no atmospheric drag. Their inert hulls will continue to drift around Earth until the Sun expands into a red giant and engulfs them about 4.5 billion years from now.' www.paglen.com

OTHER REFERENCES

Flow
p. 113 'Cars multiplied human mobility...': Jesse H. Ausubel, 'Cars and Civilization', William & Myrtle Harris Distinguished Lectureship in Science and Civilization, California Institute of Technology, 30 April 2014. Revised 18 May 2014. http://phe.rockefeller.edu/docs/Cars and Civilization.pdf

SOURCES OF QUOTATIONS

The authors and publishers acknowledge the sources of quotations reproduced in this book on the pages listed.

p. 2 Wilhelm Mommsen, quoted in Fernand Braudel, *A History of Civilizations*, Penguin Books, London, 1995, pp. 5–6.

p. 6 Ian Goldin and Chris Kutarna, *Age of Discovery, Navigating the Risks and Rewards of Our New Renaissance*, Bloomsbury, London, 2016, p. 51.

p. 24 Fernand Braudel, *Grammaire des Civilisations*, 1963; *A History of Civilizations*, Penguin Books, London, 1995, p. xxxvii.

p. 29 Henry Kissinger, *World Order*, Allen Lane, London, 2014.

p. 33 https://cyrilporchet.com/texts/les-foules-silencieuses/ Courtesy of Novembre Magazine

p. 44 https://bombmagazine.org/articles/robert-polidori/ Courtesy of Bomb Magazine

p. 64 www.rookiemag.com/2013/05/money-changes-everything-an-interview-with-lauren-greenfield/ Courtesy of Rookie

p. 111 Blake Gopnik, 'Ready for Her Close-Up', *The New York Times*, April 24, 2016: AR1, AR 18. Courtesy of The New York Times

p. 164 William S. Burroughs, 'Robert Walker's Spliced New York', *Aperture*, 101 (Winter 1985). Courtesy of Aperture Foundation

p. 176 https://cyrilporchet.com/texts/les-foules-silencieuses/ Courtesy of Novembre Magazine

p. 186 http://stories.daylight.co/an-my-le-the-landscape-of-conflict/ Courtesy of Daylight

p. 225 www.interviewmagazine.com/art/taryn-simon-armory#slideshow_48799.6/ Courtesy of Interview Magazine

p. 238 www.flowersgallery.com/exhibitions/view/michael-wolf-tokyo-compression-1/ Courtesy of Flowers Gallery. © Christian Schüle

p. 254 https://6thfloor.blogs.nytimes.com/2011/05/17/a-conversation-with-photographer-ashley-gilbertson/ Courtesy of Miki Meek, The New York Times

p. 272 http://passionpassport.com/qa-jeffrey-milstein/ Courtesy of Passion Passport

p. 272 https://www.artspace.com/magazine/interviews_features/qa/massimo-vitali-interview-54858/ Courtesy of Artspace, Phaidon

p. 273 From Reiner Riedler artist's statement, William A. Ewing, *Landmark: The Fields of Landscape Photography*, Thames & Hudson, London, 2014, p. 251.

p. 273 From Matthieu Gafsou artist's statement, Ewing, *Landmark, op. cit.*, p. 248.

p. 291 www.photography.at/_fake_holidays.html/ © Jens Lindworsky

p. 292 http://stories.daylight.co/an-my-le-the-landscape-of-conflict/ Courtesy of Daylight

p. 297 Richard Misrach, *On the Beach*, Aperture Foundation, NY, 2007 p. 34. Courtesy of Aperture Foundation

p. 300 http://aphotoeditor.com/2016/04/27/penelope-umbrico-interview/ Courtesy of A Photo Editor (APE).

p. 301 From David Maisel artist's statement, Ewing, *Landmark, op. cit.*, p. 250.

ACKNOWLEDGMENTS

The project of which this book is an essential part is a departure from the usual museum project. From the beginning, we curators had decided to borrow work only from photographers and their galleries, rather than from museums and private collections. This was strategic: in addition to key works which have already been widely seen, we wanted to be free to also select work that was fresh (meaning recent), that hadn't yet made it into collections – and sometimes hadn't even made it as far the artist's own gallery. We often started off by asking a photographer for specific works, only to have them show us new work that was equally or more interesting than what we'd proposed.

First of all, therefore, we wish to thank the photographers themselves. We greatly appreciate the care and thought they gave the concept of civilization in relation to their own practice, and we have thoroughly enjoyed the back and forth discussions. We are also grateful for the statements they have contributed. Keeping these 'Voices' brief, for the obvious reason of space limitations, was no simple task given the serious thought photographers have given the question. These texts greatly enhance the value of our publication.

We also worked with galleries, agencies, estates and artists' management firms, often receiving excellent advice while learning about photographers who had been unfamiliar to us. We wish to thank their owners, directors and staffs: Rózsa Farkas and Ruth Pilston of the Arcadia Missa Gallery; Mimi Chun, Lesley Kwok and Nick Yu of the Blindspot Gallery; Oliver Wien of the European Pressphoto Agency; Jeffrey Fraenkel, Amy R. Whiteside and Emily Lambert-Clements of the Fraenkel Gallery; Freja Harrell of the Gagosian Gallery; Laëtitia Ferrer of Galerie Les Filles du Calvaire; Thomas Zander and Christine Tebbe of Galerie Thomas Zander; Matt Shonfeld of INSTITUTE; Katrin Lewinsky of James Fuentes; Steven Harris of M97 Shanghai; Mélanie Rio and Milena Stagni of Mélanie Rio Fluency; Tom Heman, Pericles Kolias and Jake Zellweger of Metro Pictures; Olga Korper and Aaron Guravich of the Olga Korper Gallery; Chloe Shi and Carolyn Su of Pace Beijing; Takayuki Ogawa of PGI: Photo Gallery International; Lori Reese of Redux Pictures; David Furst of The New York Times; Alex Pigeon of Yancey Richardson; Yossi Milo and Neal Flynn of the Yossi Milo Gallery.

Thanking the artists themselves is not always enough; their studio managers and assistants were also responsive to our needs. We are deeply grateful to Serena Scarfi of 10b Photography; Eli Durst of the An-My Lê Studio; Anne Caroline Müller, Susanne Partoll and Vanessa Enders of the Atelier Thomas Struth; Ryan Spencer of Black River Productions Ltd; Victoria Sloan Jordan of the Chris Jordan Studio; Ilya Fomin of the Danila Tkachenko Studio; Zack Sumner of the David Maisel Studio; Marcus Schubert of Edward Burtynsky Photography; Kate Collins and Irene Panzani of the Massimo Vitali Studio; Zoe Tomlinson of the Nadav Kander Studio; Anne Ganteführer-Trier of Office Höfer; Daria Menozzi of the Olivo Barbieri Studio; Alessandro Teoldi of the Penelope Umbrico Studio; Anke Loots of the Pieter Hugo Studio; Douglas Parsons of the Richard de Tscharner Studio; Cecilia Borgenstam of the Richard Misrach Studio; Jamie Marshall of the Simon Norfolk Studio; Carrie Thompson of Soth Photography Inc.; Helena Kaminski of the Studio 331; Patricia Röder of the Studio Michael Najjar; Kelly Sultan, Angela Berry and Desiree Cannon Warris of the Studio Sultan Studios; Kerin Sulock of Taryn Simon Projects; Cheryl Arent of the Vera Lutter Studio; Cristina Busin Niedermayr and Thina Adams of the Walter Niedermayr Studio; and Zhang Fang of the Wang Qingsong Studio.

We would also like to thank Andrew Lugg, husband of the late Lynne Cohen for facilitating the inclusion of her work, as well as Daniel Boetker-Smith; Mathieu Borysevicz; Sheila Zhao and Sunyoung Kim for their helpful advice and connections to artists.

We also wish to thank the Foundation for the Exhibition of Photography [FEP], Minneapolis, New York, Paris and Lausanne, FEP's director, Todd Brandow, and the board members for their encouragement and support: Arthur Ollman, Michael Benson, Deborah Berg McCarthy, Neil Cuthbert, Richard Grosbard, Carl D. Lobell, Evan Maurer, Steve Rooney, Phil Rosenbloom, Andrea Wallack and Thomas Walther. We express our gratitude as well to the director of the National Museum of Modern and Contemporary Art, Seoul, Korea, Bartomeu Marí, for his enthusiastic engagement from the start, and the contributions of his colleagues Seungwan Kang, Soojung Kang, Sunkang Chang, Suhyun Bae, Jungmin Lee and Joowon Park. We also benefited from the knowledge and guidance of the National Gallery of Victoria, Melbourne. Director Tony Ellwood and his colleagues, Andrew Clark, Isobel Crombie, Susan van Wyk, Don Heron and Maggie Finch opened our eyes to the fine work being produced in Australia.

We would also like to express our profound appreciation of the staff at Thames & Hudson: commissioning editor for photography Andrew Sanigar, who embraced the proposal immediately; assistant Sam Palfreyman; editor Julia MacKenzie; and production controller Ginny Liggitt. Last but not least, special thanks to designer Maggi Smith, who put up stoically with the constant changes to the contents of the book – the 'last-minute' curatorial revisions and sudden inclusion of 'new' pictures – all the while suggesting ways of tweaking the layout for maximum impact.

Finally, our heartfelt thanks to FEP's Swiss staff, who never lost faith in the project as it took its many twists and turns, necessitating huge patience and tolerance for our curatorial vacillations; Juliette Hug, Cynthia Gonzalez-Bréart and Laura Gómez-Schaer worked as a close team to make this ambitious project a success.

William A. Ewing and Holly Roussell

PHOTOGRAPHIC CREDITS